OXFORD–WARBURG S

General Editors

T. S. R. BOASE *and* J. B. TRAPP

GIOTTO AND THE ORATORS

Humanist observers of painting in Italy
and the discovery of pictorial composition

BY

MICHAEL BAXANDALL

OXFORD
AT THE CLARENDON PRESS

OXFORD

UNIVERSITY PRESS

Great Clarendon Street, Oxford OX2 6DP

Oxford University Press is a department of the University of Oxford.
It furthers the University's objective of excellence in research, scholarship,
and education by publishing worldwide in

Oxford New York

Athens Auckland Bangkok Bogotá Buenos Aires Calcutta
Cape Town Chennai Dar es Salaam Delhi Florence Hong Kong Istanbul
Karachi Kuala Lumpur Madrid Melbourne Mexico City Mumbai
Nairobi Paris São Paulo Singapore Taipei Tokyo Toronto Warsaw
with associated companies in Berlin Ibadan

Oxford is a registered trade mark of Oxford University Press
in the UK and in certain other countries

Published in the United States
by Oxford University Press Inc., New York

British Library Cataloguing in Publication Data

Baxandall, Michael
Giotto and the orators: humanist observers
of painting in Italy and the discovery of
pictorial composition 1350–1450.—
(Oxford-Warburg studies)
1. Painting 2. Composition (Art)
I. Title
750'.1'8 ND1475
ISBN 0–19–817387–3

9 10 8

Printed in Great Britain
on acid-free paper by
Biddles Ltd, Guildford and King's Lynn

IN MEMORY OF
GERTRUD BING

PREFACE

THIS book is concerned with two related problems, one of them general, the other more local. First, in Chapters I and II I have tried to identify a linguistic component in visual taste: that is, to show that the grammar and rhetoric of a language may substantially affect our manner of describing and, then, of attending to pictures and some other visual experiences. Chapter I discusses humanist Latin—a language in which formal pressures are stronger than in most—from this limited point of view; it sets out to demonstrate the sort of linguistic and literary conditions within which humanists were operating when they made remarks about painting. Chapter II is a looser and more general survey of these remarks; it describes how the more important modes of humanist comment on painting developed between 1350 and 1450.

The second problem is the particular one of how the concept of pictorial 'composition'—the humanists' most interesting contribution to our expectations of painting—came to Alberti in 1435. This is discussed in Chapter III and it is approached as a special case of the general problem raised in Chapter I. I argue that the notion of pictures having a 'composition' was prompted by a humanist predicament as well as by the condition of painting in 1435; the sources of the concept lie, in fact, in an identifiable set of linguistic preoccupations and predispositions. In some degree Chapters I and II are intended as the preparation for Chapter III and its account of the discovery of 'composition', but my interest in the material handled in them derived from an interest in the relation of language habits to visual attention, and any reader of Chapter I is likely to need some such interest too.

The longer humanist texts are printed *in the Latin* in Chapter IV, which is intended as a small anthology. Most of them appear *in translation* in Chapter II. A Roman numeral after such a translation in Chapter II—thus: (XVII)—refers to the number of the text in Chapter IV; correspondingly, a page reference after a Latin text in Chapter IV—thus: (p. 87)—refers to its translation or discussion in Chapter II.

I have used manuscript sources for texts only where there was no printed edition or when the printed edition seemed seriously undependable; and when a printed source is used, it is reprinted here unchanged. Whether or not to translate the texts presented a problem: the point of the book—which is that the Latin language was the humanists' point of view—was an argument against offering translations at all. But it seemed best to do so, because many people interested in Renaissance painting are disinclined to read Latin texts without some prompting. The translations are offered as cribs, not as substitutes for the Latin.

I am indebted to the libraries from whose manuscripts I took material used in this book: Biblioteca Medicea Laurenziana, Florence; Biblioteca Nazionale Centrale, Florence; Biblioteca Riccardiana, Florence; Biblioteca Ambrosiana, Milan; Biblioteca Estense, Modena; Bibliothèque Nationale, Paris; Biblioteca Nazionale, Rome; Biblioteca Apostolica Vaticana, Vatican City; Biblioteca Nazionale Marciana, Venice; Biblioteca Querini-Stampalia, Venice. I am also indebted to the museums who let their objects be reproduced in the plates.

Some of the material used in the third and fourth sections of Chapter II was published by me in the *Journal of the Warburg and Courtauld Institutes*, volumes xxvii, 1964, and xxviii, 1965, and I am grateful to the Editors for permission to use it again.

A number of friends gave me advice while I was writing: Tilmann Buddensieg, Charles Burroughs, Susan Connell, Christopher Ligota, James Longrigg, Brian McGregor, Anne Marie Meyer, Thomas Puttfarken, and Peter Ucko helped variously by discussing, correcting, and pointing texts out. P. O. Kristeller, whose *Iter italicum* I used assiduously, sent me information about Bartolomeo Fazio and his manuscripts. E. H. Gombrich gave me references and commented on the book in typescript. J. B. Trapp gave me references, chastened my style, read the proofs and did very much more than an editor should have to. I owe a particular debt to Michael Podro, who not only criticized much of the manuscript in detail, but endured and responded to many monologues on its theme.

CONTENTS

LIST OF ILLUSTRATIONS

I

Humanists' opinions and humanist points of view

1. THE HUMANISTS

'HUMANIST' is not a word the early Italian humanists themselves knew; neither is 'humanism'. It seems that the term *humanista* grew out of late fifteenth-century university slang, where it was used of a professional teacher of the *studia humanitatis*.[1] The *studia humanitatis* was a phrase and a programme developed by the early humanists from some remarks in Cicero, and it referred to a specific syllabus: grammar, rhetoric, poetry, history, and usually ethics, studied in the best classical authors. 'Humanism' is a nineteenth-century abstraction from all this; it quickly acquired various humanitarian and even agnostic connotations. Few of these bear directly on the early humanists. In this book the term 'humanist' is used of fourteenth-, fifteenth-, and sixteenth-century people who read and wrote about literature, history, and ethics in classical Latin and sometimes in Greek; 'humanism' simply refers to their activity.

When the early humanists wanted a term to describe themselves as a class—for instance, as one section in a classified collection of biographies—the word they generally used was *orator*, or occasionally *rhetoricus*. This met the case quite well, because the central skills and common preoccupations of the early humanists were—in a sense one may have to enlarge on—rhetorical. Within the range of the *studia humanitatis* the interests of individuals naturally varied; many wrote about ethics, some more particularly on history, very many wrote little epistolary pieces on life and letters, relatively few wrote verses, and so on. What they all had in common was the very singular and demanding medium of neo-classical Latin, neo-classical not just in its grammar but in its

[1] A. Campana, 'The Origin of the Word Humanist', *Journal of the Warburg and Courtauld Institutes*, ix, 1946, 60–73; P. O. Kristeller, *Renaissance Thought: The Classic, Scholastic and Humanist Strains*, New York, 1961, pp. 110–11 and p. 160, nn. 61 and 61a; G. Billanovich, 'Auctorista, humanista, orator', *Rivista di cultura classica e medioevale*, vii. 1, 1965, 143–63.

whole style and character. Because this was so difficult they gave much attention to it and, by their own account, skill at it was the special measure of their individual stature. Many of them, besides, made a career with this skill, as secretaries in the Curia at Rome or the Chancellery at Florence, as school-masters in Mantua or Ferrara or Padua, or as appointed historians at the courts of Milan or Naples. Latin grammar and rhetoric was the humanists' art.[2]

Their linguistic situation was therefore a very singular one. They were native speakers of Italian—in a number of local variations—who set out to discourse in a literary language that had not been in use for a thousand years, carefully distinguishing this language from debased versions of it still current among such people as lawyers and priests. The classical language was more precisely differentiated within itself than any of these versions, and more elaborate in its syntactical resources than the vernacular languages of the time.

But there is a danger of seeing their situation as simpler than it really was, if only because the humanists themselves for rhetorical reasons described it in very black-and-white terms. In fact, their classical Latin was a specialized complement to Italian, not a serious alternative; and it was much more continuous with medieval Latin than they themselves admitted. Not even the most enthusiastic humanist thought of Ciceronian Latin replacing the vernacular Italian in the fields and workshops; its place was in the higher intellectual life, and its difficulty—which the humanists were well placed to appreciate—set it apart. In an extreme case the Florentine humanist Leonardo Bruni even argued that the common people of ancient Rome could not have managed the difficulties of Latin: what they had spoken was a sort of Italian, and Latin had been an élite culture language.[3] When they discussed the virtues of classical Latin, their enthusiasm was stated in strong terms which we should not misunderstand: epideictic discourse takes the form of praise or of blame, and qualified

 [2] The most authentic account of the early humanists' use of language is Paolo Cortese, *De hominibus doctis dialogus*, Florence, 1734; this was written in 1489 and discusses the Latin of all the important humanists in their own neo-classical terms. Two invaluable books by Remigio Sabbadini on how humanists worked are *La scuola e gli studi di Guarino Guarini Veronese*, Catania, 1896, and *Il metodo degli umanisti*, Florence, 1922. A summary of the range of the humanists' activity is P. O. Kristeller, op. cit. There is an accessible historical summary in the article 'Humanism' by Charles Trinkaus in the *Encyclopedia of World Art*, vii, New York, 1963, 702–43. This also has a useful bibliography.
 [3] Bruni, *Epistolarum libri VIII*, ed. L. Mehus, ii, Florence, 1731, 62–8 (vi. 10).

approval has no place in it; and in a dialogue the representative of a point of view argued it complete. The real issue was always about quite how much of the higher intellectual activity was to happen in Latin and quite what sort of Latin this was to be. Many of the best humanists—Petrarch, Boccaccio, Vittorino da Feltre, Leonardo Bruni, Alberti—took the vernacular and its cultivated practice very seriously indeed.

Similarly the division between humanist Latin and medieval Latin was not as sharp as some humanist remarks suggest or as the humanists might have liked. There is of course no one such thing as medieval Latin, only many varieties of post-classical Latin. Certainly the scholarly Latin of the thirteenth and fourteenth centuries was not the knotted monkish Merovingian thing of the stereotype; at its best it was most refined and classical, and the humanists were sometimes ready to admit this. Correspondingly their own Latin was rather less classical than they thought, as sixteenth-century Ciceronians could point out.[4] Though they did not talk about it much, many of their handbooks were still the old medieval ones. They deplored the barbarous eleventh-century dictionary of Papias or the solecizing thirteenth-century *Doctrinale* of Alexander of Villedieu, but they often used them because there was little else. At best they used the same late antique grammars—the *Ars Minor* of Donatus and *Institutiones* of Priscian—as the Middle Ages had used. Not until the 1430s and Lorenzo Valla's *Elegantiae* did the humanists start producing important new handbooks in the image of their own pretensions. Even the range of their reading is disconcerting. It is not so much that they lacked a few classical books we possess —this was a position which they were correcting energetically— as that many books that do not now appear to us central to the classical achievement were very important to them. Any humanist library was likely to have a rather high proportion of medieval encyclopedias, of late antique rhetoricians, of spurious Aristotelian treatises in Latin translations. In other words, the re-evaluation of classical literature was still under way.

And again, when the humanists called themselves orators, this does not mean they exercised all the rhetorical functions of

[4] For example, the Ciceronian interlocutor Nosoponus in Erasmus's *Ciceronianus*, in *Opera Omnia*, i, Leiden, 1703/Hildesheim, 1962, cols. 1008–9, where Nosoponus disposes of the early humanists one by one.

Cicero or even Libanius—nor could they have. Greek and Roman rhetoric itself had been two-faced. On one side it was a practical art of persuasion directed towards effectiveness in courts of law and political assemblies; on the other it had a sophistic, pedagogical aspect where the rhetorical techniques and skills were exercised more independently, and standards were directed to correctness and virtuosity more than to actual persuasiveness. But though the educational and the applied aspects of classical rhetoric often stood in an uneasy relationship to each other, the ideal situation for both did still remain that of a man standing in front of others, making a case. In the Italy of the early humanists there were few real equivalents for the institutional functions of oratory in the courts and assemblies of Greece and Rome. The humanists took what opportunities there were for getting on their feet— weddings, funerals, the investiture of magistrates, the beginning of the academic year—but these lacked urgency; most humanists could only allow themselves demonstrative performances now and then. For the Renaissance, rhetoric must be taken primarily in the sense of a systematic study of verbal stylishness—words perhaps read more often than heard—based on the models and manuals of the classical rhetoricians. Secondarily, because of the power and versatility of the classical system and its central position in a neo-classical education, it became more than this; its categorization of artistic experience became a critical system of very general usefulness and application. But no humanist was ever an orator as Cicero had been one.

Making all these qualifications, one runs some risk of whittling away at the early humanists' originality until they seem not much more than a transitional interlude between the scholastics and the international humanists of the sixteenth century. The later Renaissance itself knew better than this; Samuel Daniel in 1603 :

And is it not a most apparent ignorance, both of the succession of learning in *Europe* and the generall course of things, to say 'that all lay pittifully deformed in those lacke-learning times from the declining of the Romane Empire till the light of the Latine tongue was reuiued by Rewcline, Erasmus and Moore'? when for three hundred yeeres before them, about the comming downe of *Tamburlaine* into *Europe*, *Franciscus Petrarcha* (who then no doubt likewise found whom to imitate) shewed all the best notions of learning, in that degree of excellencie both in Latine, Prose and Verse, and in the vulgare Italian, as all the wittes of

posteritie haue not yet much ouer-matched him in all kindes to this day . . . And with *Petrarch* liued his scholar *Boccacius*, and neere about the same time *Iohannis Rauenensis*, and from these, *tanquam ex equo Troiano*, seemes to haue issued all those famous Italian Writers, *Leonardus Aretinus, Laurentius Valla, Poggius, Biondus*, and many others. Then *Emanuel Chrysoloras*, a Constantinopolitan gentleman, renowmed for his learning and vertue, being imployed by *Iohn Paleologus*, Emperour of the East, to implore the ayde of Christian Princes . . ., stayed still at *Venice*, and there taught the Greeke tongue, discontinued before in these parts the space of seauen hundred yeeres. Him followed *Bessarion, George Trapezuntius, Theodorus Gaza*, and others, transporting Philosophie, beaten by the Turke out of *Greece*, into christendome. Hereupon came that mighty confluence of Learning in these parts, which, returning as it were *per postliminium*, and heere meeting then with the new inuented stampe of Printing, spread it selfe indeed in a more vniuersall sorte then the world euer heeretofore had it . . .[5]

The early humanists may have used decadent manuals in the absence of better ones, but they knew they were decadent; their manner of imitating classical models does indeed reflect the late-medieval formular attitudes of the *artes dictaminis*, but they tried to be less mechanical than the notaries, and in any case their models were different. Above all, the early humanists had a new determination to recapture and work within the language of Cicero, and they set about doing this with a quite new energy and zest.

It is precisely this, of course, that raises difficulties of sympathy for us, since we do not see the writing of pastiche Ciceronian Latin as a self-evidently worthwhile thing; our sympathies are with quite occasional facets of humanism—talk of the dignity of man, republican propaganda by some Florentine humanists, Virgilian descriptions of landscape, and such. Yet it is the pastiche Cicero that is the heroic and consistent thing about the early humanists: their best energies went into retrieving linguistic facilities that had been lost for a thousand years. In medieval Latin and even more in the vernacular languages descended from vulgar Latin—Italian, French, Provençal, and Spanish in their many local varieties—many of the more complex and refined

[5] Samuel Daniel, 'A Defence of Ryme', in *Elizabethan Critical Essays*, ed. G. G. Smith, Oxford, 1904, ii. 368–9. The passage is cited, and its sources and background discussed, by H. Weisinger, 'Who began the Revival of Learning? The Renaissance Point of View', *Papers of the Michigan Academy of Sciences, Arts and Letters*, xxx, 1944, 625–8.

lexical and grammatical resources of classical Latin did not exist. In an imaginary conversation with Dante, Machiavelli asked why he had taken so many Latin words into the *Divine Comedy*; Dante explains: '. . . perchè le dottrine varie di che io ragiono, mi costringono a pigliare vocaboli atti a poterle esprimere; e non si potendo se non con termini latini, io gli usavo . . .'[6] Though this is a Cinquecento view of Dante's predicament, it is no more than the truth; if one wanted to say complex and precise things, one used Latin. But the Latin Dante wrote his prose treatises in, including the treatise *De vulgari eloquentia*, had not yet the range of differentiation and exactness of the classical language the humanists reconstructed. In 1300 a man could not think as tightly in words as he could by 1500; the difference is measurable in categories and constructions lost and found. To retrieve these facilities, to repossess the concepts involved not just in words like *decus* and *decor* but in a mood like the Latin subjunctive—concepts often not transferable with any available in languages then current—was much more than a grammarians' *tour de force*; it implied a reorganization of consciousness on a more complex level. The fact that natural vigour may have been sacrificed to fastidiousness, and that the early humanists themselves did not make athletic use of the facilities they enjoyed rediscovering, is not the point here.

For this reason the classicism of the early humanists is quite different from the sixteenth-century classicism of Erasmus's Ciceronian character Nosoponus, who indeed had a poor opinion of the early humanists' prose style. For Petrarch Ciceronianism was an intellectually adventurous and muscular undertaking in itself; by the time of Erasmus it could no longer be that, since the important grammatical routes through classical consciousness had been explored and mapped. Indeed this is a matter on which one will want to be assertive: the imitation of Cicero lost most of its interest and dynamic at the moment when a reasonable imitation of Cicero became possible, in the sense that at this moment the exercise ceased to be expansive and became instead restrictive. By the second quarter of the fifteenth century there were a number of men in Italy able to produce verbal constructions which, though they were clearly distinguishable from real Cicero, still

[6] 'Discorso o dialogo, intorno alla nostra lingua', *Opere storiche e letterarie*, ed. G. Mazzoni and M. Casella, Florence, 1929, p. 774.

made use of most of the syntactical and many of the lexical facilities Cicero had enjoyed. At this moment the more lively talents among the humanists lost interest in strict Ciceronianism as an end. Some, like Lorenzo Valla, turned to other potentialities of the ancient languages; others, like Alberti, set about the vernaculars. In general their interest in classical civilization became broader and more diversified, now the first linguistic contribution had been made; it was known more or less how classical Latin, and the manner of thought carried within it, worked. Their new skills were disseminated, and in the sixteenth century classical forms were offered to the vernaculars through the Italian of a Bembo, or the French of a Du Bellay, or the English of a Sir Thomas Elyot. Some of the classical facilities retrieved by the humanists were eventually absorbed into the vernaculars; many others were not. The importance of the early humanists' efforts lay in the action of offering to Europe for review a series of linguistic possibilities and, to put it no higher, rational conveniences, many of which we still depend on. In any view the early humanists' Ciceronianism was an epic affair.

This being so, any question about a contribution of the humanists to such a marginal field as painting, or notions about painting, becomes very much a matter of their habits with language. The preliminary question becomes: in what way was the exercise of Latin words and grammar on the subject of painting likely to affect people's attitudes and notions about painting? Obviously this raises old problems about language and cognition not solved and only intermittently recognized in this book; it is clear too that humanists brought other things to painting than just Latin words and syntax. But this preliminary question will set the character of the first chapter, both because it seems historically the proper thing, and because humanist criticism of painting is specially interesting as a linguistic case: here highly formalized verbal behaviour bears, with little interference, on the most sensitive kind of visual experience.

The humanists this book is about worked in the hundred years between 1350 and 1450. They are headed by Petrarch and finish with a number of outstanding men—the generation of Alberti and Lorenzo Valla—who in one way or another were becoming a little cramped by the range of their predecessors.

Petrarch (1304–74) was the paragon; he spent long periods in
Provence, Milan, and in and around Padua. Three admirers of his
were Boccaccio (1313–75) and Coluccio Salutati (1331–1406),
both Florentines, and Giovanni Conversino da Ravenna (1343–
1408), who was much in Padua. Gasparino Barzizza (d. 1431)
taught in Milan and Padua, where his Ciceronianism was very
influential. One of his pupils was Vittorino da Feltre (d. 1446),
who in 1423 established a school in Mantua. The Byzantine
humanist Manuel Chrysoloras (d. 1415) first came to Italy about
1395 and taught Greek in Florence and Lombardy. Among his
pupils were Pier Paolo Vergerio (1370–1444) of Padua, Leonardo
Bruni (1370–1444) who was a protégé of Salutati's in Florence,
and Guarino of Verona (1374–1460). Guarino later spent some
years (1403–9) in the East himself and eventually established
a school at Ferrara in 1429. His pupils included Bartolomeo
Fazio (d. 1457), who later settled in Naples; the two Venetians,
Leonardo Giustiniani (d. 1446) and Francesco Barbaro (1398–
1454); and Angelo Decembrio (d. after 1466), who was the much
less distinguished brother of the Milanese humanist Pier Candido
Decembrio (1392–1477). Three humanists more or less based on
the Curia at Rome were the Florentine Poggio Bracciolini (1380–
1459); the antiquary and historian Flavio Biondo (1388–1463);
and Aeneas Sylvius Piccolomini (1405–64), who became Pope
Pius II in 1458. Francesco Filelfo (1398–1481), a pupil of Bar-
zizza, was in the East in the 1420s and afterwards worked in
many Italian towns. Lorenzo Valla (1407–57) worked mainly in
Pavia, Naples, and Rome. Leon Battista Alberti (1404–72), who
was educated at Padua and Bologna, was one more Curia
humanist.[7]

2. WORDS

All languages are, from one point of view, systems for classifying
experience: their words divide up our experience into categories.
Each language makes this division in a different way, and the
categories embodied in the vocabulary of one language cannot
always be transferred simply into the vocabulary of another

[7] There are convenient short notes on individual humanists in the second volume of Sir
John Sandys, *A History of Classical Scholarship*, vol. ii, Cambridge, 1908, but this is now
rather old. The standard of the articles on individual humanists in the *Enciclopedia Italiana*,
Milan, 1929–39, is very high, and even more so is that of the articles so far published in the
Dizionario biografico degli Italiani, Rome, 1960– , in progress. M. E. Cosenza, *Dictionary of
the Italian Humanists, 1300–1800*, Boston, 1962–7, contains much bibliographical information.

language. So English has separate names for the colours 'blue' and 'green' where some other languages have not; linguists say blue–green is an area of experience 'more differentiated' in English than in, say, Iakuti.[8] A speaker of Iakuti could of course make statements about the colour blue, just as we differentiate further by speaking of sky-blue or navy-blue, even though his statement might be a little more cumbersome than ours. What is much more important is that English actively insists on greater specificity in statement about the area blue–green. Since it has no generic term for blue-and/or-green its categories are not easily evaded except by saying that we are uncertain or choose to be vague; the language puts pressure on us to discriminate in its way and in this sense every language is tendentious. Similarly classical Latin used two words—*ater*, lustreless black and *niger*, glossy black—where we simply use 'black', and Vulgate and ecclesiastical Latin used only *niger*; and two words—*albus*, dead white, and *candidus*, gleaming white—where we use 'white': 'aliud est candidum, id est quadam nitenti luce perfusum esse; aliud album, quod pallori constat esse vicinum.'[9] A humanist using Ciceronian Latin, therefore, was forced to discriminate about blacks and whites as we are not and as St. Jerome was not. The languages the humanists were concerned with—classical Latin, medieval Latin, Trecento and Quattrocento Italian—are closely related languages as English and Iakuti are not, and their categories balance out much more. But there are areas in which one language differentiates more than another, or in a different way, and this put identifiable pressures on what humanists said; observation was linguistically enforced.

The humanists realized very well that classical Latin categorized some kinds of experience differently from their vernacular because this presented itself as a difficulty in their own learning of the language. On the whole they tended to define words for which they had no exact synonyms mainly by quoting them in contexts and by noting shades of difference between contiguous words. This second method, noting the *differentiae*, best suited elementary handbooks:

Inter formam et pulchritudinem. Formam oris proprie. Pulchritudinem totius corporis dicimus.

[8] R. Brown, *Words and Things*, Glencoe, Illinois, 1958, p. 238.

[9] Servius ad Vergilium, *Georg.* iii. 82.

Inter venustatem et dignitatem. Venustatem muliebrem. Dignitatem virilem pulchritudinem dicimus.

Inter decus et decorem. Decus honoris. Decor forme est.

Inter decentem et formosum. Decens incessu et motu corporis. Formosus excellenti specie dicitur.

Inter decorem et speciem. Decor in habitu. Species in membris.[10]

Much of Lorenzo Valla's *Elegantiae*, the best lexicographical book produced by the early humanists, is a more exact and richer version of the same thing:

Decus, decor, and *dedecus*

Decus is the honour, so to speak, which is gained from things well done: thus the *decora* of war are the praise, honours, and dignities acquired by a soldier in battle. *Dedecus* is the contrary of *decus* . . . *Decor* is a kind of beauty or *pulchritudo* derived from the suitability (*decentia*) of things and persons to both place and time, whether in action or speech. It is also applied to virtues, when it is called *decorum*. this refers not so much to virtue itself as to what common opinion considers to be virtuous, beautiful, and fitting . . .

Facies and *vultus*

Facies refers more to the body, *vultus* more to the soul and disposition or *voluntas*, from which word it is derived, *vultus* being the supine form of *volo*, I wish. Therefore we speak of an angry or sorrowful *vultus*, not *facies*; and of a broad or long *facies*, not *vultus*. (*Superficies* is a compound from *facies*, and does not much differ from it. We speak of the *facies* of the sea or earth just as much as of their *superficies*, and the *facies* of a man is the first thing we look at in observing a man.) Sometimes we can use either word: an ugly *facies* and also an ugly *vultus*, an agitated or changed *facies* or *vultus*. There are many such cases.

Fingo and *effingo*

Fingere refers, strictly speaking, to the potter or *figulus* who makes forms from clay. From this it is extended in a general way to other things skilfully made by a man's talent and skill, especially if they are unusual or novel. *Effingere* is to *fingere* in the form of something else, to portray by means of *fingere*, as in Cicero (*De oratore* ii. 90): 'tum accedat exercitatio, qua illum, quem delegerit, imitando effingat atque exprimat . . .' From *effingere* is derived the noun *effigies*, which is a figure made in the living likeness of something or someone else, or in the image of truth, including both paintings and sculptures. (XVIII (*b*), (*c*), (*e*))

[10] Bartolomeo Fazio, *De differentia verborum latinorum*, in Pseudo-Cicero, *Synonyma*, ed. Paulus Sulpitianus, Rome, 1487, fols. 26b, 30b, 31b.

So an Italian who learned to use a phrase like *vultus decorem effingere* properly was also learning to categorize his observation of art and artists in a new, or rather an old, way. Relatively little of the ground could be covered by handbooks; each good humanist was his own lexicographer, learning his way by tact round the classical pigeon-holes, and to the extent that he set himself to be Ciceronian in his diction, he committed himself to use the classical categories in his own discourse.

It is difficult to judge quite how much difference this made to the humanist's description of visual things, but it made some difference. Here are two short exclamations about the painting of Pisanello. The first, in neo-classical Latin, is by the humanist Guarino of Verona and was written around 1427:

> Quae lucis ratio aut tenebrae! distantia qualis!
> Symmetriae rerum! quanta est concordia membris!
> (XI, lines 60–1)

> What understanding of light and shade! What diversity!
> What symmetry of things! What harmony of parts!

The second was written in 1442 in Italian by Angelo Galli, who was secretary to Federigo da Montefeltro, Count of Urbino:

> Arte mesura aere et desegno
> Manera prospectiva et naturale
> Gli ha data el celo per mirabil dono.[11]

No doubt Guarino and Galli did indeed observe different things in Pisanello, although there is no means of knowing how closely their remarks related to the way they had attended to the paintings. But it is certain that Galli is directing attention to qualities in Pisanello which Guarino could not, even if he had so wished, have verbalized in Latin. Galli's view of the painter is triumphantly vernacular. *Mesura*, *aere* and *maniera*, in particular, are a coherent group of terms used in the Quattrocento terminology of polite dancing, and whether or not they were already painters' terms, much of their very rich reference depends on this.

[11] Vatican Library, MS. Urb. lat. 699, fol. 181ʳ⁻ᵛ, and see Vasari, *Le vite*, I, *Gentile da Fabriano ed il Pisanello*, ed. A. Venturi, 1896, pp. 49–50. The poem has been widely discussed: see particularly W. Paatz, *Die Kunst der Renaissance in Italien*, Stuttgart, 1953, pp. 15–16; J. Shearman, '*Maniera* as an aesthetic ideal', in *Acts of the 20th International Congress of the History of Art*, II, *The Renaissance and Mannerism*, Princeton, 1963, p. 204; and, particularly full, M. Boskovits, 'Quello ch'e dipintori oggi dicono prospettiva. Contributions to 15th century Italian art theory, Part I', in *Acta Historiae Artium Academiae Scientiarum Hungaricae*, viii. 3–4, 1962, 251–3 and 260, n. 128.

Domenico da Piacenza, who wrote some time around 1440–50 the earliest Quattrocento treatise on dancing to survive, listed five parts of dancing much as humanists listed five parts of rhetoric; the parts of dancing were *mesura, memoria, maniera, mesura di terreno, aere*,[12] and Galli, with a fine critical sense, transfers to Pisanello those three of the parts that might reasonably apply to the painting of figures : *mesura, maniera, aere. Mesura,* according to Domenico the most important part, is the rhythmical quality. It is 'tardeza ricoperada cum presteza'; it measures, that is, 'tutte presteze e tardeze segondo musica'. *Maniera* is associated with a *zentile azilitade* of the figure:

nota che questa azilitade e maniera per niuno modo vole essere adoperata per li estremi : ma tenire el mezo del tuo movimento che non sia ni tropo, ni poco, ma cum tanta suavitade che pari una gondola che da dui rimi spinta sia per quelle undicelle quando el mare fa quieta segondo sua natura, alzando le dicte undicelle cum tardeza et asbassandosse cum presteza.[13]

Aere is more elusive : 'e quella che fa tenire el mezo del tuo motto dal capo ali piedi'. The term was glossed by Domenico's followers. According to Antonio Cornazano it was 'un' altra gratia tal di movimenti che rendati piacere a gli occhi di chi sta a guardarvi';[14] according to Guglielmo Ebreo '. . . e un atto di aierosa presenza et elevato movimento, colla propria persona mostrando con destreza nel danzare un dolcie et umanissimo rilevamento'.[15] Thus Galli, the court poet, was assimilating the painted figures of Pisanello, the court painter, with specific visual qualities of the contemporary courtly dance, and these were qualities any gentleman had studied and indeed himself practised. It is very acceptable criticism, the cleverest of the contemporary criticisms of Pisanello's paintings, and it is essentially vernacular criticism. Humanist Latin could not possibly offer categories with the same reference or resonance, even

[12] 'De arte saltandi et choreas ducendi / De la arte di ballare et danzare', Bibliothèque Nationale, Paris, MS. it. 972, fols. 1ᵛ–2ʳ. The treatise has not been printed. It is discussed by A. Michel, 'The earliest dance-manuals', *Medievalia et Humanistica*, iii, 1945, 119–24; there is a useful summary in M. Dolmetsch, *Dances of Spain and Italy 1400–1600*, London, 1954, pp. 2–8.

[13] Op. cit., fol. 1ᵛ.

[14] C. Mazzi, 'Il libro dell'arte del danzare di Antonio Cornazano', *La Bibliofilia*, xvii, 1915–16, 9.

[15] *Trattato dell'arte del ballo di Guglielmo Ebreo Pesarese*, ed. F. Zambrini, Bologna, 1873, pp. 17–18.

though it too depended, as we shall see, on metaphorical characterization of visual qualities. In using Latin Guarino was cutting himself off from resources like Galli's and his own list of qualities is just as inescapably neo-classical. *Ratio*, to take only the first, is a word of extraordinarily rich and suggestive complexity: with such a term Guarino can point to a carefully judged and systematic quality, consistently carried through with a proper causal basis, in Pisanello's light and shade, a quality tied to *scientia*.

Italian and Ciceronian Latin could exist together in a complementary and unstrained way, since each had its own territory. What the humanists had to be critical about was the debased vocabulary of medieval Latin: here classicism committed them to a thorough purge. Many classical words were revived; many post-classical words of the type of *pulchrificatio* or *deiformitas* were excluded; most important of all, the reference of very many words such as *ratio* was redirected in the light of classical use. Naturally this revision was not a matter of a single campaign. It was conducted piecemeal—a new word used here, an old barbarous word excluded there, and a changed or more limited use of a familiar word somewhere else; in the early humanists' time the process was not by any means completed. Yet gradually, from the time of Petrarch on, the balance of the lexical repertory was transformed and, simply on the level of the availability of words, it became easier to talk about some things and much more difficult to talk about others without compromising one's classicism.[16] For instance, means for making discriminations about *splendor* were much reduced. The scholastic vocabulary was very rich in words for different kinds of splendour, but for the humanist a noun like *resplendentia* or *refulgentia*, a verb like *supersplendeo*, or a phrase like *perfusio coloris*, was no longer permissible. As an area of experience splendour had become lexically *louche* perhaps even to the point of over-correction, since even good classical words in the area are rare in humanist Latin; *splendor* itself is not a word the humanists were fond of, except in superior tropical senses of moral or literary excellence. For this reason one will not confidently equate absence of statement about splendour

[16] A convenient way of weighing the importance of this is to look through the splendidly full index of terms (*Table analytique*) in E. de Bruyne, *Études d'esthétique médiévale*, iii, Bruges, 1946, 380–400, especially references to the third volume, which covers the thirteenth century.

in humanist texts with a corresponding lack of interest in paintings that were splendid; *splendor*—as also, for that matter, such a pre-eminently Renaissance quality as *proportio*—was an area in which, for his own technical reasons, the humanist could not have much taste for verbal performance. It is fascinating to watch the Florentine humanist Ambrogio Traversari responding to the Byzantine splendours of Ravenna within irreproachably classical categories—*magnificus, candidus, discolor, insignis, lucidus, speciosus, conspicuus*—without using *splendor* at all.[17]

The actual exclusion of monkish words and recovery of classical words are both easy things to follow in the early Renaissance; what is in practice less clear and just as important is a change in the meaning of many words common to classical and medieval Latin, for very often the change does not lend itself to definition simply in terms of what the words refer to or denote. Meaning is use, and in classical Latin much of the meaning of words lay in an institution of relationships with other words, a system of cross-reference, distinctions, contraries, and metaphorical habits that had been blurred or overlaid in medieval Latin, which after all had constructed systems of its own. When the humanists set about becoming Ciceronian again this cross-articulation of the lexicon was one of the things they had to reconstruct. Often they found it difficult to do so:

Pulcher can stand for *fortis* and *fortis* for *pulcher*, as in Virgil, *Aeneid* vii. 656–7: *satus Hercule pulchro | pulcher Aventinus*. For unless in Hercules' case *pulcher* stands for *fortis* the epithet must seem incongruous. Correspondingly *fortis* may be used to praise women in place of *pulcher*. *Virtus* and *pulchritudo* are interchangeable, as are also *malitia* or *vitium* with *deformitas*: see Virgil, *Aeneid* iv. 149–50, *haud illo segnior ibat | Aeneas*—that is, not more *deformis* . . .[18]

The difficulty is understandable. The complex of bearings and cross-bearings, implications that by using this word one was avoiding that word, tacit understandings that the opposite of the

[17] For Traversari's letter on Ravenna, see Text IX.

[18] Guarino, *De vocabulorum observatione*, in Biblioteca Estense, Modena, MS. α K 4, 17 (415), fol. 126ʳ: 'Pulcher pro forti et fortis pro pulchro positum est: vir satus Hercule [pulchro] pulcher Aventinus. Nam nisi de Hercule pulcher pro forti dicatur, satis incongruum epiteton est. Pro laude mulieris quidem etiam fortis, id est pulcher. Virtus enim et pulchritudo in vicem ponuntur, sicuti etiam e contra malitia et vitium pro deformitate: apud Vergilium, haud illo segnior ibat Eneas, id est non deformior . . .' The lexicon is based on Servius' Commentary on Virgil: see R. Sabbadini, *La scuola e gli studi di Guarino Guarini Veronese*, Catania, 1896, pp. 54–5.

word one was using was a certain other word, was inherently elusive. Even in the classical world it was a system sustained by an élite with a uniform education and intellectual range. The humanists could never recover the system as something whole and comprehensively felt, but some of the more conspicuous parts of it, particularly parts which had been explicitly discussed and clarified by ancient writers, became very prominent in their discourse.

The word *ars* (skill; craft, profession; theory, treatise) is an example. *Ars* had been used in medieval Latin in most of its classical senses; among others it was usual to speak approvingly of the *ars*, the skill or workmanship, of an artist or a work of art one liked. Petrarch and the humanists used the word to refer to quality in the same area. However, once it was set in a context of self-consciously Ciceronian prose forms and usages it began to carry a quite different weight, and particularly it was no longer possible to take lightly the fact that *ars* was a word that had very crisply defined relationships with certain other categories. One of these was *ingenium*, the relation of which to *ars* had been fully discussed and explained in the classical rhetorics. As *ars* was the skill or competence that was learnt by rule and imitation, so *ingenium* was the innate talent that could not be learnt:

. . . ars erit quae disciplina percipi debet.

Ea, quae in oratore maxima sunt, imitabilia non sunt, ingenium, vis, facilitas et quidquid arte non traditur.[19]

Each of the words took part of its meaning from the distinction with the other; either, standing by itself, brought to mind but did not include the other. Further, in any artistic undertaking each had its own province: *ingenium*, for example, was particularly associated with invention, *ars* more with style. Medieval writers knew many of the classical rhetorics almost as well as the humanists, but they were not committed to using the system in such a consequential or exclusive way. For the humanists the coupled *ars et ingenium* became at once a critical and polemic weapon; it was fully exercised already in the Trecento defence of poetic writing.[20] In many contexts the association between *ars*

[19] Quintilian, *Inst. Orat.* II. xiv. 5 and x. ii. 12.
[20] One account of this is F. Tateo, *'Retorica' e 'poetica' fra Medioevo e Rinascimento*, Bari, 1960, especially pp. 82–92.

and *ingenium* was therefore so intimate that one could not speak of *ars* alone without making the omission of *ingenium* a positive action. This was very much so in contexts of praise; by 1400 to praise a man for his *ars*, simply, was not much short of suggesting that he had no *ingenium*, and so the binary *ars et ingenium* or some subsuming word like *scientia* is almost always the thing that is praised. The humanists praised each other for *ars et ingenium*, and without any discontinuity and probably without much thought they praised the same qualities in such other people as painters, far more punctiliously, in fact, than the ancients themselves had ever done: in the texts printed in the back of this book *ars et ingenium*—or *ars et natura* or *artificium et ingenium* or *manus et ingenium*—is one of the commonest phrases. There is little sign of any reflective background to its use for painters and sculptors; indeed it is not before the middle of the fifteenth century that any of our texts takes stock of the situation and asks whether *ingenium* is a term properly applied to such people. In Angelo Decembrio's dialogue *De politia literaria*, written around 1450, one of the interlocutors, Leonello d'Este, suggests during a long argument that it is not:

Age nunc scriptorum *ingenia* uti rem divinam et pictoribus incomprehensibilem omittamus: ad ea redeundum quibus humana *manus* assuevit . . .

. . . poetarum *ingenia*, quae ad mentem plurimum spectant, longe pictorum opera superare inquam, quae sola *manus ope* declarantur.[21]

In terms of his own restrictive view of the painter's function he was right, but his conclusion had really come a hundred years too late to have any effect—apart from anything else, *arte e ingenio* had long become a vernacular cliché too.[22] It is quite in character that elsewhere in the book Leonello should speak of the artist's *ars et ingenium* like everyone else; his arguments were no match for his diction. For however casual and unthinking the humanists' day-to-day use of the phrase may have been, they were saying something about what painting was. *Ars* had become by antithesis

[21] Baxandall, 'A dialogue on art from the court of Leonello d'Este', *Journal of the Warburg and Courtauld Institutes*, xxvi, 1963, 321–5.

[22] By the first half of the fifteenth century the distinction becomes important in vernacular discussion of the arts; for instance, Ghiberti: 'lo ingegnio sança disciplina o la disciplina sança ingegnio non può fare perfecto artefice' (*I commentarii*, ed. J. v. Schlosser, I, Berlin, 1912, p. 5). It is apparently reflected even in Cennino Cennini, *Il libro dell'arte*, Cap. I (ed. D. V. Thompson, New Haven, 1932, pp. 1–2): 'fantasia e hoperazione di mano'.

more exact in its reference: skill capable of teaching and learning from rules and models. *Ingenium* brought with it a powerful set of associations which presented themselves in the form of issues about the genius and imagination of the artist. The seeds of much of the heavy-footed sixteenth-century theoretical discussion of art lie in humanist Latin and its vocabulary having categorized creative ability in a certain way. The words were the system.

Another disconcerting characteristic of the classical system was the ease with which it brought intersensory metaphor into play. Quite a high proportion of the terms of ancient rhetoric were metaphors from visual experience, metaphors sometimes half-dead it is true, but which the humanists necessarily re-activated simply in the course of learning them from outside: diction could be *translucidus* or *versicolor*. In the much smaller body of classical art criticism there was a similar ease of metaphor, and here a high proportion of the terms carried connotations from rhetoric.[23] When Pliny describes a painter as 'gravis ac severus idemque floridus ac umidus',[24] the words refer back to a complex of critical uses in rhetoric. This habit of metaphor—both the established repertory of the ancient terms and the institution as such—was potentially one of the humanists' most effective critical resources; we shall see later that much of Alberti's accomplishment in his treatise *De pictura* depends on it.

The humanists were not always in control of this terminology. In Angelo Decembrio's *De politia literaria* Leonello d'Este is concerned to distinguish between two portraits of himself, one by Jacopo Bellini and the other by Pisanello:

Meministis nuper Pisanum Venetumque, optimos aevi nostri pictores, in mei vultus descriptione varie dissensisse, cum alter macilentiam candori meo *vehementiorem* adiecerit, alter pallidiorem tamen licet non *graciliorem* vultum effingeret . . .[25]

Two of the terms used here, *gracilis* and *vehemens*, are saturated with meaning acquired as rhetorical terms. The primary meaning of *gracilis* is 'slender'; in relation to diction, on the other hand, it was used in the sense of simple or unornamented. *Vehemens*

[23] There are interesting studies of ancient critical metaphor by S. Ferri, especially 'Note esegetiche ai giudizi d'arte di Plinio il Vecchio', in *Annali della R. Scuola Normale Superiore di Pisa*, serie II, vol. xi, 1942, fasc. ii–iii, pp. 69–116; and also in general, G. Becatti, *Arte e gusto negli scrittori latini*, Florence, 1951, especially pp. 50–60, with a bibliography. See also E. R. Curtius, *European Literature and the Latin Middle Ages*, New York, 1953, pp. 414 ff.

[24] *Nat. Hist.* xxxv. 120. [25] Baxandall, op. cit., pp. 314–15.

could be used in the sense of powerful or violent, both of living
things and of verbal style. But each of the words—*gracilis* and
vehemens—denoted one of the three *genera dicendi* or levels of
style.[26] The *genus gracile* was another name for the *genus humile*, the
unornamented style in which purity and perspicuity are the
virtues. The *genus vehemens* was a version of the *genus sublime*, an
abruptly rhythmed, heavily ornamented style. The one is familiar,
the other epic. If Decembrio had been using these words with
a controlled sense of their metaphorical reference, this would
have been very distinguished criticism. It seems likely he was not,
but in any event aspects of the secondary meanings would have
been present in the minds of any humanist readers. Decembrio
was saying more than he knew.

There are other cases where the humanists made very advanced
use of the rhetorical metaphors. For instance, Bartolomeo
Fazio's discussion of painters in his *De viris illustribus* set out from
an analogy between painting and writing. Fazio insisted that the
figures in paintings should be expressive and lively. He quoted
Horace on the need for poetry to move the hearts of its hearers:

> non satis est pulchra esse poemata; dulcia sunto
> et quocumque volent animum auditoris agunto.[27]

—and then said: 'In the same way it is proper that painting
should not only be embellished by a variety of colours but, far
more, that it should with a certain vigour be—so to speak—
figuratus.'[28] *Figuratus* was a word of Quintilian's, and Fazio was
appealing to Quintilian's classic definition of the function of
rhetorical *figurae*:

It is often expedient and sometimes also becoming to make some change
in the traditional arrangement, in the same way as in statues and
paintings we see variation in dress, expression, and attitude. For when
the body is held bolt upright it has little grace; the face looks straight
forward, the arms hang down, the feet are together and the work is
stiff from head to toe. The customary curve and, if I may call it such,
movement give an effect of action and animation. For the same reason
the hands are not always disposed in the same way and there are
a thousand different kinds of expression for the face. Some figures are
moving forward vigorously, others sit or recline; some are naked,
others clothed, and some are part clothed, part naked. What attitude

[26] For example, Cicero, *Orator ad Brutum* xxi. 69 and Quintilian, *Inst. Orat.* XII. x. 66.
[27] *Ars poetica* 99–100. [28] See p. 164.

could be as violent and elaborate as that of Myron's *Discobolus*? Yet if someone criticized this work for not being upright, he would be lacking in understanding of the art, for it is its very novelty and difficulty that most deserve our praise. Rhetorical *figurae*, whether of thought or of speech, produce the same effect of grace and charm. For they introduce a certain variation of the straight line and have the virtue of departing from ordinary usage.[29]

The passage develops Fazio's point for him more precisely, perhaps, and certainly more authoritatively than he could have managed himself.

One can leave this matter with a case of such complex critical categories being translated into the vulgar. In 1424 Leonardo Bruni wrote a famous letter to Niccolò da Uzzano and the *deputati* responsible for the doors of the Baptistery in Florence, giving advice about Ghiberti's second pair of doors, soon to be undertaken: its burden is that the narrative panels should be both *illustre* and *significante*, and Bruni goes to the trouble of defining both these terms:

Io considero che le dieci storie della nuova porta, che avete deliberato, che siano del vecchio testamento, vogliono avere due cose, e principalmente l'una, che siano illustri; l'altra, che siano significanti. *Illustri* chiamo quelle, che possono ben pascer l'occhio con varietà di disegno; *significanti* quelle, che abbino importanza degna di memoria.[30]

Bruni is adapting and explaining critical terms which he was used to applying to artistic language. *Illustris* was both ornate and vivid:

Style is *illustris* if the words used are chosen for their weightiness and used metaphorically and with exaggeration and adjectivally and in duplication and synonymously and in harmony with the action and with representation of the facts. It is the part of style that almost sets the fact before the eyes, for it is the sense of sight that is most appealed to . . .[31]

In a book Bruni had not read, *De vulgari eloquentia*, Dante had used the word as his term for the high vernacular style, corresponding to the grand style of Latin, the style of epic, tragedy,

[29] *Inst. Orat.* II. xiii. 8–11.

[30] Richa, *Notizie istoriche delle chiese Fiorentine*, v, Florence, 1757, p. xxi.

[31] Cicero, *De partitione oratoria* vi. 20: 'illustris autem oratio est si et verba gravitate delecta ponuntur et translata et superlata et ad nomen adiuncta et duplicata et idem significantia atque ab ipsa actione atque imitatione rerum non abhorrentia. Est enim haec pars orationis quae rem constituat paene ante oculos, is enim maxime sensus attingitur . . .'

and the *canzone*.[32] *Significans*, in the sense of 'full of clear meaning', had been a favourite word of Quintilian: Homer was the master of *significans* narrative—'narrare . . . quis significantius potest quam qui Curetum Aetolorumque proelium exponit?'[33] In his own way Bruni is inviting the sculptor to be Homeric. In time this sort of thing enriched vernacular criticism very much.

3. SENTENCES

The humanist joined his neo-classical categories together in a neo-classical way, so far as he was able. This depended in the first place on the special grammatical facilities of literary Latin, the subtlety of its tenses and moods, the variety and precision of its connectives, and its expressively flexible word order. None of the vernacular languages descended from vulgar Latin had such resources for setting words in relation to each other. In the second place humanist Latin followed Cicero and other admired classical authors as models in how to exploit this medium fully. It is not useful to distinguish very much here between language and, so to speak, style; one might say Latin grammar encouraged and Latin rhetoric required sentences more complex and tightly articulated than was usual in fourteenth- or fifteenth-century Italian.

The pattern of the grand neo-classical sentence was the period: that is, the sentence combining a number of thoughts and statements in a number of balanced clauses.

There are two types of period. One is simple, with a single thought extended through a rather long and well rounded sentence; the other is made up of phrases and clauses, containing a number of thoughts . . . The period has at least two clauses. The average number seems four, but it often includes more.[34]

In some of the more punctilious statements of classical theory the first section of the periodic sentence (*protasis*) is seen as inducing suspense and a second section (*apodosis*) as resolving it: if A, then B; though A, yet B; as A, so too B; and so on. This is a

[32] *De vulgari eloquentia* i. xvii. [33] *Inst. Orat.* x. i. 49.

[34] 'Genera eius duo sunt, alterum simplex, cum sensus unus longiore ambitu circumducitur, alterum, quod constat membris et incisis, quae plures sensus habent . . . Habet periodus membra minimum duo. Medius numerus videntur quattuor, sed recipit frequenter et plura' (Quintilian, *Inst. Orat.* ix. iv. 124).

periodic sentence of the kind the humanists most admired in Cicero:

Ut qui pila ludunt non utuntur in ipsa lusione artificio proprio palae-strae, sed indicat ipse motus didicerintne palaestram an nesciant, et qui aliquid fingunt, etsi tum pictura nihil utuntur, tamen utrum sciant pingere an nesciant non obscurum est, sic in orationibus hisce ipsis iudiciorum contionum senatus, etiam si proprie ceterae non adhibean-tur artes, tamen facile declaratur utrum is, qui dicat, tantummodo in hoc declamatorio sit opere iactatus an ad dicendum omnibus ingenuis arti-bus instructus accesserit.[35]

Just as ball-players do not use skills proper to the gymnasium in their actual game, but yet their way of moving shows whether they have learned gymnastics or know nothing of it; and just as, when people are sketching something, even though they are not using the art of paint-ing at that moment, yet it is clear whether they know how to paint or not: so too in these discourses in courts, assemblies, and Senate, even though the other liberal arts may not be brought into use particularly, yet it is very evident whether the speaker has just precipitated himself into this business of oratory only, or whether he has come to the task of speaking after a training in all the liberal arts.

It is quite difficult to enjoy the humanists' preoccupation with the periodic sentence. It was one of their most anti-popular interests because its length and stylized word order denied so completely the structures of vernacular language, and the mark it later left on the vernacular literatures is often unsympathetic. But one cannot come to historical terms with the humanists' verbal performance without recognizing how supremely impor-tant it was for them, and in how many different ways. The periodic sentence is the basic art form of the early humanists. It was a test of prowess, a focus for criticism, the full flower of the classical way with words and notions, the medium of most state-ments about relationships, and—as it will be suggested later—it became at a critical moment a humanist model of artistic composition in general.

Reviving the periodic sentence was a complement to reforming the Latin vocabulary and syntax, and it had the merit of being very difficult. It is not possible to assemble a periodic sentence, with all its delicate setting over of components against each

<hr>

[35] *De oratore* I. xvi. 73.

other, unless the reference of the component words and their inflections is relatively precise; correspondingly a humanist's ability to construct true periods demonstrated among other things that he had mastered the classical vocabulary and grammar. In medieval Latin many of the sharper distinctions in the meaning of Latin conjunctions and connective adverbs had disappeared—*at*, *sed*, *autem*, *tamen*, *vero*, for instance, and *enim*, *etenim*, *nam*, *namque*; such words had come to act with not much more than a general sense of transition, and many of the more specialized connective words were not used at all. Again, many medieval writers in Latin used pronouns of the type of *idem*, *hic*, *ille*, *is*, *iste*, and *ipse* in a quite undifferentiated way, taking little advantage of the special force of each. The same blurring of distinctions affected the inflections of words. Imperfect, perfect, and pluperfect were sometimes used almost interchangeably without much real difference in meaning; the indicative mood also often stood where in classical use a subjunctive mood was necessary, particularly in subordinate clauses; the comparative forms of adjectives and adverbs might be used without comparative force; the system of substantival cases weakened to a point where accusative and dative were encroaching on each other's ground.[36] In respects like this much medieval Latin had relaxed the system of classical Latin to a point where the delicate differentiation on which a periodic sentence depends became practically impossible. Medieval Latin writers often write long and complicated sentences but these are not often periodic.

An obstacle to reconstructing the sort of pleasure the humanists took in periodic language is that practical criticism of particular texts was not usually part of their procedure, at least not in any permanent form. Of course they discussed literary style a great deal, usually prescriptively and sometimes also descriptively, but the discussions are normally very general. One lively exception to this is Leonardo Bruni, the best descriptive critic among the early humanists. Bruni was a particularly energetic and sensitive translator from Greek to Latin, and one supposes this brought

[36] For a bibliography on this field, K. Strecker, *Introduction to Medieval Latin*, tr. and ed. R. Palmer, Berlin, 1957, pp. 11–38.

[37] The treatise is printed, omitting only some of Bruni's examples, in the edition of Hans Baron, *Leonardo Bruni Aretino, Humanistisch-philosophische Schriften*, Leipzig–Berlin, 1928, pp. 81–96. There are a number of manuscripts, fully discussed by Baron, of which the best is probably Vatican Library, MS. Pal. lat. 1598, fols. 109ʳ–120ᵛ.

him into close touch with the problem and character of the classical languages; a need to defend his translations from attacks then stimulated him to describe his experience in more detail than was usual. His most substantial essay is an unfinished treatise *De interpretatione recta*,[37] written probably in the years round 1420, in which he criticizes the medieval Aristotle translations and justifies his own. The first section of the treatise includes an exposition of the beauty of the language of Plato and Aristotle, on the basis however of Bruni's own translations into Latin. His first example, one of the shorter ones, is from Plato:[38]

The whole of the passage is handled by Plato in a very distinguished and brilliant way. For in it there are both (so to speak) a charming elegance of words and a wonderful splendour of sentences. The whole discourse, moreover, is made to move in a rhythmic measure. Both *in seditione esse animum* and *circa ebrietates tyrannidem exercere* and other metaphors of the kind light up the discourse like inset stars. And *innata nobis voluptatum cupiditas* and *acquisita vero opinio, affectatrix optimi* are phrased as antitheses; for *innatum* and *acquisitum* are opposites, and so also are *cupiditas voluptatum* and *opinio ad recta contendens*. Then *huius*

[38] *Phaedrus* 237 b–238 c, given here in Bruni's own translation: 'O puer, unicum bene consulere volentibus principium est: intelligere, de quo sit consilium, vel omnino aberrare necesse. Plerosque vero id fallit, quia nesciunt rei substantiam. Tamquam igitur scientes non declarant in principio disceptationis, procedentes vero, quod par est, consequitur, ut nec sibi ipsis neque aliis consentanea loquantur. Tibi igitur et mihi non id accidat, quod in aliis damnamus. Sed cum tibi atque mihi disceptatio sit, utrum amanti potius vel non amanti sit in amicitiam eundum, de amore ipso, quale quid sit et quam habeat vim, diffinitione ex consensu posita, ad hoc respicientes referentesque considerationem faciamus, emolumentumne an detrimentum afferat? Quod igitur cupiditas quaedam sit amor, manifestum est. Quod vero etiam qui non amant cupiunt, scimus. Rursus autem, quo amantem a non amante discernamus, intelligere oportet, quia in uno quoque nostrum duae sunt ideae dominantes atque ducentes, quas sequimur, quacumque ducunt: Una innata nobis voluptatum cupiditas, altera acquisita opinio, affectatrix optimi. Hae autem in nobis quandoque consentiunt, quandoque in seditione atque discordia sunt; et modo haec, modo altera pervincit. Opinione igitur ad id, quod sit optimum, ratione ducente ac suo robore pervincente *temperantia* exsistit; cupiditate vero absque ratione ad voluptates trahente nobisque imperante *libido* vocatur. Libido autem, cum multiforme sit multarumque partium, multas utique appellationes habet. Et harum formarum quae maxime in aliquo exsuperat, sua illum nuncupatione nominatum reddit nec ulli ad decus vel ad dignitatem acquiritur. Circa cibos enim superatrix rationis et aliarum cupiditatum cupiditas *ingluvies* appellatur et eum, qui hanc habet, hac ipsa appellatione nuncupatum reddit. Rursus quae circa ebrietates tyrannidem exercet ac eum, quem possidet, hac ducens patet, quod habebit cognomen? Et alias harum germanas et germanarum cupiditatum nomina, semper quae maxime dominatur, quemadmodum appellare deceat, manifestum est. Cuius autem gratia superiora diximus, fere iam patet. Dictum tamen, quam non dictum, magis patebit. Quae enim sine ratione cupiditas superat opinionem ad recta tendentem rapitque ad voluptatem formae et a germanis, quae sub illa sunt circa corporis formam, cupiditatibus roborata pervincit et ducit: ab ipsa insolentia, quod *absque more* fiat, *amor* vocatur' (op. cit., pp. 88–9).

germanae germanarumque cupiditatum nomina and *superatrix rationis aliarum-
que cupiditatum cupiditas.* Or again, *utrum amanti potius vel non amanti sit in
amicitiam eundum . . .*? Such gay and witty interrelationships of words,
set together like a vermicular pavement or mosaic, have the utmost
charm. Again, *cuius gratia haec diximus, fere iam patet; dictum tamen, quam
non dictum, magis patebit*: two clauses, phrased with similar pauses, what
the Greeks call *cola.* After this is set a full, finished period: *quae enim
sine ratione cupiditas superat opinionem ad recta tendentem rapitque ad volupta-
tem formae et a germanis, quae sub illa sunt circa corporis formam, cupiditati-
bus roborata pervincit et ducit: ab ipsa insolentia, quod absque more fiat, amor
vocatur.* In all of these you see a splendour of apophthegms, an opulence
of words, and a measured harmony of discourse . . .[39]

It is clear from what Bruni says that the attraction of the periodic
style lies very much in an antithetical or parallelizing character;
as he describes it elsewhere in the treatise, 'paria paribus reddun-
tur aut contraria contrariis vel opposita inter se'.[40] Member is
balanced against member, and the inventive basis is the setting
of one thing against another.

Humanists imitated what they admired, and their own periods
are constructed on the lines Bruni has described. An example may
be taken from Bruni himself, a page or two before his analysis of
Plato in *De interpretatione recta*, and for once it may be fair to
explode the sentence into parts to suggest how the mosaic is
made up. He is discussing how far the translator of a text should
try to reproduce the form as well as the matter of what he is
translating:

[39] 'Totus hic locus insigniter admodum luculenterque tractatus est a Platone. Insunt
enim et verborum, ut ita dixerim, deliciae et sententiarum mirabilis splendor. Et est alioquin
tota ad numerum facta oratio. Nam et "in seditione esse animum" et "circa ebrietates
tyrannidem exercere" ac cetera huiusmodi translata verba quasi stellae quaedam interpositae
orationem illuminant. Et "innata nobis voluptatum cupiditas", "acquisita vero opinio,
affectatrix optimi" per antitheta quaedam dicuntur; opposita siquidem quodammodo sunt
"innatum" et "acquisitum", "cupiditasque voluptatum" et "opinio ad recta contendens".
Iam vero quod inquit: "huius germanae germanarumque cupiditatum nomina" et "supera-
trix rationis aliarumque cupiditatum cupiditas"; et "utrum amanti potius vel non amanti sit
in amicitiam eundum?"": haec omnia verba inter se festive coniuncta, tamquam in pavi-
mento ac emblemate vermiculato, summam habent venustatem. Illud praeterea quod
inquit: "cuius gratia haec diximus, fere iam patet; dictum tamen, quam non dictum, magis
patebit": membra sunt duo, paribus intervallis emissa, quae Graeci "cola" appellant. Post
haec ambitus subicitur plenus et perfectus: "quae enim sine ratione cupiditas superat
opinionem ad recta tendentem rapitque ad voluptatem formae et a germanis, quae sub illa
sunt circa corporis formam, cupiditatibus roborata pervincit et ducit: ab ipsa insolentia,
quod absque more fiat, amor vocatur." Videtis in his omnibus sententiarum splendorem ac
verborum delicias et orationis numerositatem; quae quidem omnia nisi servet interpres,
negari non potest, quin detestabile flagitium ab eo committatur' (op. cit., p. 89).
[40] Op. cit., p. 87.

(*a*) ut

 ii, qui ad exemplum picturae picturam aliam pingunt,

 (1) figuram et statum et ingressum et totius corporis formam
 inde assumunt,

 (2) nec, quid ipsi facerent,
 sed, quid alter ille fecerit,
 meditantur:

(*b*) sic

 in traductionibus interpres quidem optimus

 (1) sese in primum scribendi auctorem
 tota mente et animo et voluntate
 convertet et quodammodo transformabit

 (2) eiusque orationis
 figuram, statum, ingressum coloremque et lineamenta cuncta
 exprimere meditabitur.[41]

As those who are painting after the model of one picture a second picture take over from their model the figure, posture, movement, and form of the whole body, and study not what they themselves might do but rather what that other painter did: so too in translations the good translator will with all his reason, sensibility, and purpose change and in a measure transform himself into the original author of the text, and will study to imitate the figure, posture, movement, colour, and all the lineaments of his discourse.

The careful parallelism is clear, and Bruni decorates and varies the general symmetry of his sentence in many subtle ways. For instance, the present tense of the protasis acts as a base line for the slightly more assertive future tense of the apodosis; again, the plural subject of the protasis (*ii qui pingunt* . . .) is set against the slightly more particular, because singular, subject of the apodosis (*interpres*). The humanist would have enjoyed other things about the sentence: *a*(1) takes advantage of the series of terms to offer a polysyndeton; *a*(2) is phrased as a neat antithetical isocolon; *b*(2) presents the expanded series of terms as an asyndeton modulating back, with the entry of two new terms, into a synonymic (-*que* and *et*) polysyndeton; and Bruni ends his apodosis with the same verb (*meditari*) as the protasis, so rounding the period off with a polyptoton. There are many such good things in this sentence.

41 Op. cit., p. 86.

It seems almost out of place to look very closely at the actual matter of the protasis, and yet this is instructive in a way. The statements about painters one can derive from the sentence are these: (1) painters sometimes paint pictures after the model of other pictures; (2) they then adopt the figure, posture, movement, and bodily form of the model; (3) they also think not of their own but of the copied painter's method; (4) in these respects they resemble the translator of a text . . . As observations about painting—either absolutely or as likely to throw light on the translator's art—these are clearly vapid to a degree that raises questions about the nature of Bruni's inventive habits in a sentence of this kind. In fact, as the context of the sentence makes clear, the kernel of sense in Bruni's period is a proposition about literary translation: 'interpres optimus formam primae orationis exprimit.' This proposition blossoms into a period through a process of ornamental comparison with another activity, painting. But the basis of the comparison is not the proposition. It is rather the fact that a number of critical terms Bruni was used to applying to literature—*figura*, *status*, *ingressus*, *color*, *lineamenta*, *forma*—were by origin visual metaphors and so applicable to painting too. This double applicability, a typically humanist sort of *tertium comparationis*, was a lexical fact, the classical habit of metaphorical interchange between the critical terminology of literary and art criticism. *Figura* is both a body or its shape, and a rhetorical figure of speech; *status* is an attitude or posture, and also the type of issue being argued; *ingressus* is a man's gait or movement, and also the opening of one's discourse; *color* is both hue and rhetorical embellishment; *lineamenta* and *forma* are the features and form of both bodies and speech. To accent all this, Bruni holds back the most specially visual of his terms, *color* and *lineamenta*, and applies them to literature only; in the protasis and for painting they are merged in the more general term *forma*, and only in the apodosis is *forma* broken down into its constituents *color* and *lineamenta*. The period therefore grows out of two kinds of thing: a proposition about writing, and a series of terms that happen to make a bridge between writing and painting. The first is the matter open to ornamental development; the second is the means through which this development is to take on the form of a comparison. Given these and the will to assemble a period, the actual development becomes fairly predictable: a

proposition will be phrased about painting parallel with that about writing.

In short, Bruni's references to painting lack colour and edge because they are a product of the periodic sentence, not of his experience of painters. It is true that he would hardly have said these things if he had thought them obviously untrue, but they are something less than propositions springing direct from experience. In periodic diction a disposition to symmetrical *verba* is liable at least to suggest *res*; the period has slots which need to be filled, and they may be filled with matter generated in the various ways of rhetorical invention from the basic propositions that are being ornamented. Often the period may demand a form more parallel or symmetrical than the material of experience very insistently demands, and then the result is a sentence like Bruni's, though not necessarily quite as symmetrical.

Let us take the case of a humanist in need of a self-depreciating *captatio benevolentiae*; he wishes to say that he is aware that his hearers know much more about the subject he is to talk about than he does himself. To decorate this he will use an analogy from art: he is an apprentice, they are masters, and they must not expect a masterpiece of exposition from him. The basis of the analogy will be that master sculptors, who do produce masterpieces, leave the earlier rough work to their assistants but do the finishing themselves; the assistant, able to do the rough work but not the finished piece, is himself. One can start with three assertions on the basic pattern, subject + object + transitive verb:

(1) *statuarii rara spectacula effingunt*
 (sculptors fashion masterpieces)
(2) *primas partes operis iunioribus tradunt*
 (they entrust the beginning of the work to apprentices)
(3) *ipsi extremam manum apponunt*
 (they add the finishing touch themselves)

These are easily articulated; (2) being the main point of the analogy must be the main clause, with (1) as a subordinate adverbial clause before it and (3) as a dependent participle after it:

Statuarii, cum rarum spectaculum effingunt, primas partes operis iunioribus tradunt, ipsi extremam manum apponentes.

But this is shamefully bald. It can be developed by introducing doublets of one kind and another. In (1) we can particularize about materials of sculpture, avoiding bronze because it does not fit the analogy—'sive e ligno sive e lapide'. (2) can qualify the *primas partes operis*. It can also be more punctilious about placing the moderate skill of the *iuniores*, with whom we ourselves correspond—'iuniores non omnino imperiti at neque penitus docti'. As a participle (3) has become very tame indeed. It can be expanded by giving it a pair, which itself can be made up of a smaller doublet—'aut extremam manum apponentes aut quaedam praestantiora difficilioraque polientes'. With these five doublets one now has:

Statuarii, cum *sive e ligno sive e lapide* rarum spectaculum effingunt, primas *ineundi dolandive* operis partes iunioribus *non omnino imperitis at neque penitus doctis* tradunt, ipsi *aut* extremam manum apponentes *aut quaedam praestantiora difficilioraque polientes.*

This is still rough—the brash directness of the verbs must be softened and some of the doublets accented—but it is basically ready for the oration.

nam quo pacto ausim in gravissimo consessu vestro non dixerim docere, at vel verbum aliquod summa sine animi perturbatione in medium referre? neque enim is certe sum, qui quod nesciam sim dicturus, neque vos ea audire exspectetis, quae vobis sunt clariora luce. quid igitur faciam? quo me convertam? unde aggrediar? faciam certe quod eximii statuarii iis, quos erudiendos acceperint, delegare solent. *hi namque cum sive e rudi ligno sive e lapide rarum aliquod spectaculum effingere voluere, iunioribus quibusdam non omnino illis imperitis, at neque rursus penitus doctis quidem primas ineundi dolandive operis partis tradere consuevere, ipsi quidem non nisi aut extremam manum apponentes aut praestantiora quaedam difficilioraque polientes.*[42]

How could I, in this most solemn assembly, ever venture—I will not say to *teach*—but even publicly to utter words without a sense of the utmost disquiet? I am truly not one to speak of things I do not know about; nor have you a mind to listen to things you know more clearly than I. What, then, shall I do? Whither can I turn? Where shall I begin? Indeed, I must simply perform that part which master sculptors usually delegate to their pupils. *For these masters, when they have*

[42] *Francisci Philelphi oratio de visendae Florentinae urbis desiderio in suo legendi principio habita Florentiae* (1429), in K. Müllner, *Reden und Briefe italienischer Humanisten*, Vienna, 1899, pp. 148–51.

resolved to fashion some rare masterpiece out of raw wood or stone, have been used to entrust the first tasks of beginning and rough-hewing the work to some apprentices (not quite unskilled, but yet not deeply versed in it), they themselves either just adding the finishing touch or improving such parts as are more conspicuous or more difficult.

Much humanist discourse, especially the more business-like kind, was less expansive than Bruni's or Filelfo's *oratio vincta*; the natural or deliberately casual *oratio soluta*[43] of familiar letters ruled out the grander periodic constructions. But this does not mean that shorter sentences excluded periodic motifs. In a sense the periodic sentence, the early humanist's art form, was a central pattern to which all humanist discourse more or less inclined. When a humanist wrote a treatise in *oratio soluta*, with short sentences and not too many subordinate clauses, the periods might be short but much of the symmetrical or antithetical quality persisted, in smaller units however.

Alberti's treatise *De pictura* is written unassumingly, as a treatise on such a subject should be, but Alberti's Latin is still of a periodic character in the limited sense of being disposed in detail to symmetrical, counterpoised arrangements of words, phrases, and clauses. For example, towards the end of Book II of *De pictura*, speaking of the need to be very reserved in the use of pure white and black pigment, Alberti says: 'Ergo vehementer vituperandi sunt pictores qui albo intemperanter et nigro indiligenter utuntur.'[44] White and black are treated in parallel phrases: it is wrong to use white *intemperanter*, and black *indiligenter*. The adverbs set up a delicate but intelligible distinction between the respective temptations presented by either pigment. We must not use white *extravagantly*; we must not use black *negligently*. In the Italian version of the treatise Alberti made later, *Della pittura*, this distinction is dropped: 'Per questo molto si biasimi ciascuno pittore il quale senza molto modo usi bianco o nero.'[45] Simply, it is wrong to use white or black without much moderation. The greater differentiation of the Latin version is not

[43] 'There are two kinds of style: the one is *vincta* and woven together, while the other is *soluta* or loose, such as one sees in dialogues and letters except when these are dealing with something above their natural level like philosophy, affairs of state, and so on. I do not mean that even this looser type does not have its own rhythms, perhaps especially difficult to pin down.' Quintilian, *Inst. Orat.* IX. iv. 19–20.

[44] 'De pictura', Vatican Library, MS. Ottob. lat. 1424, fol. 22r–v.

[45] *Della pittura*, ed. L. Mallè, Florence, 1950, pp. 100–1.

purely trivial, since a little later the distinction between white and
black becomes a matter for development. In the Italian: '... meno
si riprenda chi adoperi molto nero che chi non bene distende il
biancho.' The Latin again differs. First Alberti decorates his
opinion with a *topos* from Cicero, Zeuxis' warning against excess:
'hinc solitus erat Zeusis pictores redarguere quod nescirent quid
esset nimis.'[46] This is applied only to white. The Latin then pro-
ceeds more on the lines of the Italian: '. . . minus redarguendi
sunt qui nigro admodum profuse quam qui albo paulum intem-
peranter utantur.' But here again the antithesis is reinforced by an
elegant playing of *paulum* (*intemperanter*) against *admodum* (*profuse*):
so, *very* profuse black is less bad than *rather* intemperate white.
It is a new twist of the distinction prefigured in the adverbs of
the first Latin statement. Finally both Latin and Italian state
a psychological basis for the greater dangers of white:

Natura enim ipsa in dies atrum et horridum opus usu pingendi odisse
discimus. Continuoque quo plus intelligimus, eo plus ad gratiam et
venustatem manum delinitam reddimus. Ita natura omnes aperta et
clara amamus, ergo qua in parte facilior peccato via patet, eo arctius
obstruenda est magis.

Di dì in dì fa la natura che ti viene in odio le chose orride et obscure;
et quanto più faccendo inpari, tanto più la mano si fa dilicata ad vez-
zosa gratia. Cierto da natura amiamo le cose aperte et chiare, adunque
più si chiuda la via quale più stia facile a peccare.

It is part of Alberti's distinction as a humanist that what begins
as a small symmetry of adverbs—*albo intemperanter, et nigro indili-
genter*—blossoms into something that is not only much larger,
but also interesting. There is no need to fix on the first parallel
form as a kernel or cause of his distinction between black and
white; one may say that Alberti's Latin appears as friendly and
responsive to differentiation between approximating cases, in the
sense that the distinction finds a correlative in the structure of the
Latin prose that it does not in the Italian. Since *Della pittura*
is quite a close, not to say lazy, translation of *De pictura* we see
Alberti's Italian discourse here only in its lapses from the Latin,
not in any of its positive constructiveness; Quattrocento Italian
had its own syntactical habits just as it had its own categories.
But obviously the distinction stated in the Italian is not just more

[46] Presumably Cicero, *Orator* xxii. 73, where the painter is Apelles, not Zeuxis.

fully verbalized in the Latin, it is part of the physiognomy of the prose. Alberti's play with *intemperanter/indiligenter* and *admodum/ paulum* is decorative and enjoyable on neo-classical terms, and the firmness of the Latin statement cannot really be separated from its Latinity.

Aristotle says: 'The clauses of periodic diction are either separated or compared.'[47] One could not describe better the relation between the forms of periodic diction and the matter they admit most gracefully. In much humanist discourse patterns of thought consistent with a periodic form become a substitute for what in another culture might have been some convention of dialectic, and involved all but the most unsuggestible humanists in a slovenly kind of sub-dialectical dichotomizing and syllogizing: 'paria paribus redduntur aut contraria contrariis vel opposita inter se' with intolerable insistence. A little drunk with the Ciceronian music he was making, the humanist paired and balanced, compensated and connected words, clauses, sentences —and so, almost incidentally, notions—into big conjunctive masses. So it is that one important measure of distinction in humanist writing is the degree to which the writer rides his diction, the degree to which the antithetical bias of neo-classical diction is creatively used, as Alberti uses it, to state an authentically humanist, because periodic, point of view.

4. THE RHETORIC OF COMPARISON

When Leonardo Bruni uses his telling phrase about Plato's style —'paria paribus redduntur aut contraria contrariis vel opposita inter se'—one is reminded of a phrase of Quintilian's: comparative arguments, Quintilian said, are taken from things that are 'aut similia aut dissimilia aut contraria'.[48] The classical rhetoric used two main methods of inventing matter for discourse. The first was ratiocination: one could invent arguments by asking a set series of questions, the *loci*—one asked why, where, when, how, and by what; and one brought to bear definition, similarity, comparison, supposition, and circumstantial information. The second was induction: that is, one used comparative arguments of the kind Quintilian was talking about.

[47] τῆς δὲ ἐν κώλοις λέξεως ἡ μὲν διῃρημένη ἐστὶν ἡ δὲ ἀντικειμένη (*Rhet.* III. ix. 7, 1409ᵇ13–14).
[48] *Inst. Orat.* v. xi. 5.

It is not characteristic of humanists to use the classical system
of rhetorical invention in a very comprehensive or consequential
way. There were excellent reasons for this; one reason was that
the system was particularly an instrument of forensic and political
argument, not something adapted to the general discussion of life
and literature the humanists typically practised. The ratiocinative
loci especially, well enough suited to inventing arguments about
the guilt of a criminal or even the desirability of a law, had little
to offer a humanist writing on the means to a happy life or an
elegant prose style, and humanist discussion owes correspond-
ingly little to these. But induction, on the other hand, in the very
general sense of comparative arguments, is half of the structure
of their discourse. Any reader of humanist texts is constantly
teased by a half-elusive predictability of development; and, given
a proposition of some importance to the humanist, one learns to
expect that it will be supported and decorated with one or some
of a limited range of comparative devices, and the function of
these is not always clear. These comparative proofs and orna-
ments—for comparison in rhetoric has the status both of an
argument (a part of invention) and of an ornament (a device of
style)—are not systematically developed as a rule. They are
rather the fragments or shadows of certain comparative drills or
routines, pattern procedures for developing a theme, that seem to
underlie movement of the humanist mind, at least as it appears in
their scripts. This inductive curvetting does not really respond to
any system of dialectic or even any abstract system of rhetorical
invention. It is a comparative habit, best associated with certain
comparative exercises : one is concerned with formulas, not rules.

There is really nothing obscure about the sort of drill that
might induce or reinforce a comparative disposition of this kind.
A good example, because it was widely known and fits the pat-
tern of much humanist discussion very closely, is the *chria*,
'refining a theme'. It was an exercise met by humanists in their
standard handbook of elementary rhetoric, the pseudo-Ciceronian
Rhetorica ad Herennium,[49] where it appears as a figure of thought,
and also in the *Praeexercitamenta rhetorica* of Priscian,[50] a sixth-
century Latin translation of the second-century *Progymnasmata*

[49] iv. xliii. 56–xliv. 57.
[50] Priscian, *Praeexercitamenta*, in *Grammatici Latini*, ed. H. Keil, iii, Leipzig, 1859/Hildes-
heim, 1961, pp. 431–2.

of Hermogenes,[51] where it is the third of twelve preliminary exercises there described. The *chria* is a treatment of a theme in eight parts: (1) statement of theme, (2) reasons, (3) restatement, (4) reasons, (5) argument from contrary, (6) argument from comparison, (7) argument from example, (8) authority. Its centre is therefore a series of three comparisons—successively negative, positive, and positive exemplary—and this is a recurrent pattern; another of the twelve *praeexercitamenta*, the maxim or *sententia*, has a similar sequence of arguments *a contrario, a comparatione, ab exemplo*. It is routines like these, the exercise of schoolboys, that the humanists' comparative habit most seems to reflect. This is not to say that humanist discourse consists of a string of strict *chriae* and the like, though these occur, so much as that patterns practised rigidly in these exercises are in a looser and incomplete way characteristic of the humanists' development of themes; for instance, by Petrarch:

In imitating a literary model the writer should take care that what he writes be similar to but not the same as what he is imitating (*sententia*). The similarity should not be like that of a portrait to the man it is portraying, for in this case the more similar it is to its model the more the artist is praised (*a contrario*), but like that of a son to a father. In this case, even though there may often be a great dissimilarity of individual features, yet there is a sort of shadow, what painters now call *aria*, which one specially sees in face and eyes, and this causes a similarity that reminds us of the father as soon as we see the son, even though every feature may be different if we resort to measuring; something hidden there has this effect (*a simili*). So too we writers should see that, though something may be similar to the model, yet many things should be dissimilar . . .[52]

[51] There is a convenient translation of the *Progymnasmata* in C. S. Baldwin, *Medieval Rhetoric and Poetic*, New York, 1928, pp. 23–38; another is in D. L. Clarke, *Rhetoric in Greco-Roman Education*, New York, 1957, pp. 177–212.

[52] 'Huius hic amore et illecebris captus, sepe carminum particulas suis inserit; ego autem, qui illum michi succrescentem letus video quique eum talem fieri qualem me esse cupio, familiariter ipsum ac paterne moneo, videat quid agit: curandum imitatori ut quod scribit simile non idem sit, eamque similitudinem talem esse oportere, non qualis est imaginis ad eum cuius imago est, que quo similior eo maior laus artificis, sed qualis filii ad patrem. In quibus cum magna sepe diversitas sit membrorum, umbra quedam et quem pictores nostri aerem vocant, qui in vultu inque oculis maxime cernitur, similitudinem illam facit, que statim viso filio, patris in memoriam nos reducat, cum tamen si res ad mensuram redeat, omnia sint diversa; sed est ibi nescio quid occultum quod hanc habeat vim. Sic et nobis providendum ut cum simile aliquid sit, multa sint dissimilia, et id ipsum simile lateat ne deprehendi possit nisi tacita mentis indagine, ut intelligi simile queat potiusquam dici' (Petrarch, *Le familiari*, ed. V. Rossi, iv, Florence, 1942, xxiii. 19, p. 206).

Similarity and dissimilarity, grist to the periodic style's mill, responded to a rhetoric wider than that of the sentence itself. This busy comparative activity is important for us, because very many of the humanists' remarks and notions about the visual arts grow out of their disposition to compare. One of their favourite subjects was naturally their own art of writing; in their long discussions of verbal style and performance the nature of their discourse called for comparisons, and they took the material for many of these comparisons from the arts of painting and sculpture. There were various reasons for this choice, but much the most important was classical precedent: Cicero and most other ancient authors of books on literary style had made conspicuous play with such comparisons, and to do the same was a minor aspect of the humanists' neo-classicism. The product was often mechanical and absurd; Gasparino Barzizza:

All good literary imitation comes from adding, subtracting, altering, transferring, or renewing. Adding is, for example, if I have found some short piece of Latin in Cicero or some other learned orator and I add some words to it, so that the piece is seen to take on a form that is new and different from before. An example: suppose Cicero has said *Scite hoc inquit Brutus* (Brutus shrewdly says this), I shall add to it by saying *Scite enim ac eleganter inquit ille vir noster Brutus* (Shrewdly indeed and elegantly does my friend, the well-known Brutus, say this). You see how it has evidently a different form from before. This is next proved by *similitudo*: a painter has painted the figure of a man without its right or left hand; I take the brush and add the right or left hand, and also paint horns on the figure's head. Observe how the figure appears very different from before.[53]

But most humanists kept out of trouble of this kind by relying on classical materials, 'altering, transferring, or renewing' comparisons which Cicero and other authors had used before. Here

[53] 'Omnis bona imitatio fit aut addendo, aut subtrahendo, aut commutando, aut transferendo, aut novando. Addendo ut sic, si invenero aliquam brevem latinitatem in Cicerone, aut in alio docto oratore, adiungam ei aliqua verba ex quibus videbitur illa latinitas aliam accipere formam et diversam a prima. Exemplum: si ponatur quod Cicero dixerit, Scite hoc inquit Brutus, addam et dicam, Scite enim ac eleganter inquit ille vir noster Brutus. Ecce quomodo videtur habere diversam formam a prima, et hoc post probari a similitudine. Aliquis pictor pinxerit figuram hominis absque manu dextra aut sinistra, accipiam ego pennellum et adiungam manum dextram vel sinistram, et etiam pingam cornua in capite. Vide quomodo videntur ista signa multum diversa a prima' (Gasparino Barzizza, 'De imitatione', Biblioteca Marciana, Venice, MS. XI. 34 (4354), fol. 29ʳ⁻ᵛ). For an extended attempt at an original *similitudo* and a contemporary criticism of it, see Coluccio Salutati's comparison of ethical studies begun in early and late life with three painters beginning pictures in different inefficient ways—Text IV, p. 145.

the anecdotes of classical art history, the mythology of art history, had a special part.

We are familiar ourselves with many of the classical common-places of this kind—Apelles and the cobbler, perhaps, or the birds and the grapes—but the humanist had been drilled in them in a way we have not, both in the texts of, say, Cicero's rhetorical handbooks and even more importantly in the commentaries on these handbooks. The relentless hammering in of every accessible nail by the great standard commentaries of late antiquity was such an essential humanist experience that one example must be given here. Cicero refers in his *De inventione* to the story of Zeuxis and the maidens of Croton:

Then the people of Croton by public decree assembled the maidens together in one place and gave the painter authority to choose the one he wished as his model. But he chose five, and many poets have com-memorated their names for having been approved by a man who must have had the truest judgement of beauty. For he did not think that everything he needed for beauty could be found in a single body, since in no single kind has nature perfected and finished the body in every part. Therefore, as if she would have no gifts to offer the others if she gave everything to one, she endows each with some advantage yet joined with some disadvantage. In the same way when I decided to write a handbook on diction, I did not take up one single model . . .[54]

Here is the great fourth-century commentary of Victorinus:

This whole introduction is a sort of simile for what is later going to be said . . . Cicero's introduction is leading to the point that many things have been selected here from many writers of treatises, and that into this one treatise of Cicero's have been collected many precepts from many sources, to make the book finer. So the matter of the introduction is this: that Zeuxis, a noble painter, painted an image of Helen after having chosen all that was most beautiful from five maidens who had been assembled and called together for the purpose. This, as one sees, fits the case in general since both Zeuxis and Cicero are taking many things from many sources. Yet Cicero is setting his own work in a good light, since it is he who is taking the greater number of things, as he took into consideration writers of both past and present, and of more than one city or language inasmuch as they include both Greeks and Romans. Zeuxis, on the other hand, could choose just from one city and one moment of time.

[54] *De inventione* II. i. 3–4.

If one compares the details of the analogy and they all fit, the introduction will be considered a fine one. The 'people of Croton' are the Romans: their 'flourishing with every kind of wealth' fits the Romans; so does their 'being counted among the most prosperous people of Italy'. Then there is the 'temple of Juno, which they wished to enrich with fine paintings': so too one wishes to enrich the temple of eloquence and fine speaking. 'Zeuxis' is Cicero. Though there are many modes of speaking, yet, just as a Helen stands out among many maidens, so too the rhetorical kind of discourse stands out among all the other kinds; and as Zeuxis was supreme in painting women's faces, so Cicero was supreme in his orations. Zeuxis painted many things that are still remembered; so too later centuries remember anything that Cicero's oratory depicted. Zeuxis said he wanted to paint an image of Helen; what he intended to hand down to posterity was not Helen, but an image of her. Similarly Cicero in writing his treatise intended to hand down not orations, not even eloquence itself, but an image of eloquence: this also fits another remark here, that 'out of an animate model truth was translated into the mute image'. For a treatise of eloquence is a mute image, while eloquence itself is animate. Thus the matter of this introduction partly fits the matter it is compared with, apart only from the one thing pointed out later in the text—namely, that Cicero sought many things from all countries and every period, but Zeuxis sought many things from one city and one moment of time.[55]

[55] 'Hic, ad quod ducitur praefatio, illud est, ex multis artium scriptoribus electa multa et ad unam quam scripsit artem, quo pulchrior redderetur, praecepta ex multis multa collecta. Huic igitur rei praefatio illa est, Zeuxin, pictorem nobilem, Helenae simulacrum pinxisse, sed cum conductis et in unum vocatis quinque virginibus quidquid esset pulcherrimum delegisset. Hoc, ut perspici licet, in summa convenit, quia hic et ille multa de multis; verum praefert Tullius opus suum, quod magis multa ipse, si quidem praeteriti temporis scriptores et praesentis in iudicio habuit, et non unius civitatis nec unius linguae, quippe cum et Graecos et Latinos: at vero Zeuxis ex una civitate et ipsius temporis eligendi habuit facultatem.

'Si partibus conductis tota conveniunt, pulchra semper et praecipua dicetur esse praefatio. "Crotoniatae" Romani sunt: "cum florerent omnibus copiis" Romanis convenit: item convenit "et in Italia cum primis beati numerarentur". "Iunonis" vero "templum, quod locupletare egregiis picturis voluerunt": sic et eloquentiae vel facundiae templum. "Zeuxis" Tullius. Cum multa dicendi genera sint, ut inter picturas multas Helena, ita inter ceteras dictiones eminet semper oratoria, et ut Zeuxis in femineis pingendis vultibus summus, ita in orationibus Tullius. Pinxit Zeuxis multa, quae usque ad nostram memoriam manent: saecula posteriora tenent, quidquid pinxit oratio Tulliana. Zeuxis Helenae se simulacrum pingere velle dixit; non enim Helenam, sed simulacrum fuerat traditurus: ita Tullius scribendo artes, non orationes, non ipsam eloquentiam, sed simulacrum eloquentiae fuerat traditurus: hoc convenit et illa sententia: "quod ex animali exemplo mutum in simulacrum veritas transferebatur". Mutum enim simulacrum eloquentiae ars eius, ipsa autem eloquentia quasi animal. Ita pro parte poterit ei rei, ad quam confertur praefatio, convenire, relicto eo, quod postea praeponitur, quod, cum Tullius ex omnibus multa quaesierit et omni tempore, Zeuxis ex una civitate et uno tempore conparavit' (Victorinus, *Explanationes in Rhetoricam Ciceronis*, ed. C. Halm in *Rhetores Latini Minores*, Leipzig, 1863, p. 258).

The commentaries, therefore, as well as the texts themselves, carried the commonplaces to the humanists, and these were immediately present to the humanists as they are not to us. They could be used as a reservoir of comparative material, as Boccaccio uses the story of Zeuxis in his Commentary on Dante:

Fu la bellezza di costei [Elena] tanto oltre ad ogni altra maravigliosa, che ella non solamente a discriversi con la penna faticò il divino ingegno d'Omero, ma ella ancora molti solenni dipintori e piú intagliatori per maestero famosissimi stancò: e intra gli altri, sí come Tullio nel secondo dell'*Arte vecchia* scrive, fu Zeusis eracleate, il quale per ingegno e per arte tutti i suoi contemporanei e molti de' predecessori trapassò. Questi, condotto con grandissimo prezzo da' crotoniesi a dover la sua effigie col pennello dimostrare, ogni vigilanza pose, premendo con gran fatica d'animo tutte le forze dello 'ngegno suo; e, non avendo alcun altro esempio, a tanta operazione, che i versi d'Omero e la fama universale che della bellezza di costea correa, aggiunse a questi due un esempio assai discreto: percioché primieramente si fece mostrare tutti i be' fanciulli di Crotone, e poi le belle fanciulle, e di tutti questi elesse cinque, e delle bellezze de' visi loro e della statura e abitudine de' corpi, aiutato da' versi d'Omero, formò nella mente sua una vergine di perfetta bellezza, e quella, quanto l'arte poté seguire l'ingegno, dipinse, lasciandola, sí come celestiale simulacro, alla posteritá per vera effigie d'Elena. Nel quale artificio forse si poté abbattere l'industrioso maestro alle lineature del viso, al colore e alla statura del corpo: ma come possiam noi credere che il pennello e lo scarpello possano effigiare la letizia degli occhi, la piacevolezza di tutto il viso, e l'affabilitá, e il celeste riso, e i movimenti vari della faccia, e la decenza delle parole, e la qualitá degli atti? Il che adoperare è solamente oficio della natura.[56]

Rather more rarely they could become a source or confirmation of views on the visual arts themselves; Alberti in *De pictura*:

The ancient painter Demetrius fell short of the highest merit because what he applied himself to representing was likeness rather than beauty. So it is that one should pick out from the most beautiful bodies each of their most admirable parts. It is beauty, above all, that we should strive keenly and assiduously to understand, perceive, and represent. Yet this is the most difficult thing of all, since not all the glories of beauty are disclosed in any one place; rather are they scattered here and there. Nevertheless it is on this—on thoroughly inquiring and learning about beauty—that every effort should be spent . . . When even the most practised people can hardly make out the Idea of beauty, it quite

[56] Boccaccio, *Il Comento alla Divina Commedia*, ed. D. Guerri, Bari, 1918, ii. 128-9.

eludes the unpractised. Zeuxis, the most famous, learned, and skilful of all painters, when he was to make a picture for public dedication in the temple of Juno at Croton, did not rashly rely on his own talent in setting about painting, as almost all painters of the present day do. Rather, since he considered all that he needed for beauty could not be found in any one body, either with his own talent or indeed even from Nature, he chose for this reason out of the whole youth of the city five maidens of the most exceptional beauty, so that he might translate into painting what was most admirable in each girl's form. He was indeed wise to do so.[57]

Very rarely indeed they might become an argument for actual artistic procedures; Alberti in *De statua*:

I took these proportions not from one particular body but rather, so far as possible, I tried to note and record the great beauty shared out, as it were, by Nature among many bodies—imitating in this the painter who, when he was to make an image of a goddess at Croton, selected all the more remarkable and graceful beauties of form from a number of the more handsome maidens there and translated them into his work. In this way I too chose a number of bodies considered very beautiful by knowledgeable judges and took their measurements. I then compared these with each other, excluding those that were extreme either in excess or deficiency, and extracted such mean dimensions as a number of measurements of internal proportions agreed on and confirmed. After measuring the principal lengths, breadths, and thicknesses of the members, what I found was the following.[58]

This sort of seriousness, however, is not typical.

[57] '. . . Demetrio pictori illi prisco ad summam laudem defuit, quod similitudinis exprimende fuerit curiosior quam pulchritudinis. Ergo a pulcherrimis corporibus omnes laudate partes, eligende sunt. Itaque non in postremis ad pulchritudinem percipiendam, habendam, atque exprimendam, studio et industria contendendum est. Que res tametsi omnium difficillima sit, quod non uno loco omnes pulchritudinis laudes comperiantur, sed rare ille quidem ac disperse sint, tamen in ea investiganda, ac perdiscenda omnis labos exponendus est . . . Fugit enim imperitos ea pulchritudinis idea quam peritissimi vix discernunt. Zeusis prestantissimus et omnium doctissimus et peritissimus pictor, facturus tabulam, quam in templo Lucine apud Crothoniates publice dicaret, non suo confisus ingenio temere, ut fere omnes hac aetate pictores, ad pingendum accessit. Sed quod putabat omnia, que ad venustatem quereret, ea non modo proprio ingenio non posse, sed ne a natura quidem petita, uno posse in corpore reperiri. Idcirco ex omni eius urbis iuventute delegit virgines quinque forma prestantiores ut, quod in quaque esset formae muliebris laudatissimum, id in pictura referret. Prudenter is quidem' (Alberti, 'De pictura', Vatican Library, MS. Ottob. lat. 1424, fol. 23ʳ).

[58] 'Ergo non unius istius aut illius corporis tantum, sed quoad licuit, eximiam a natura pluribus corporibus, quasi ratis portionibus dono distributam pulchritudinem, adnotare et mandare litteris prosecuti sumus, illum imitati, qui apud Crotoniates, facturus simulacrum Deae, pluribus a virginibus praestantioribus insignes elegantesque omnes formae pulchritudines delegit, suumque in opus transtulit. Sic nos plurima quae apud peritos pulcherrima

The institution of comparing writing with painting became a humanist game. The Venetian humanist Francesco Barbaro, in a not particularly long letter congratulating Bartolomeo Fazio on his appointment as historian to Alfonso V of Naples, contrived to put in five separate commonplaces of this kind— Alexander the Great's employment of Apelles, Lysippus, and Pyrgoteles; Aristotle's advice to Protogenes; Phidias and the statue of Athene; Apelles and the unfinished Venus; the dictum of Zeuxis on working slowly—as well as various conceits of the kind of 'non corporis simulachrum sed effigies animi' and 'statua literaria togata et militaris'.[59] Again, in the 1420s Antonio Panormita published a collection of poems, *Hermaphroditus*. Many of the poems are indecent and Panormita was widely criticized. Defending himself in a letter to Poggio Bracciolini, he appealed to the standard commonplace for these matters, the opening of Horace's *Ars poetica*:

> pictoribus atque poetis
> Quidlibet audendi semper fuit aequa potestas.[60]

Poggio, remonstrating with Panormita in a friendly way, turned this with a new image from painting:

Even the painters, to whom as also to the poets all things are permissible, though they may have painted a naked woman, yet they cover the privy parts of the body with some sort of drapery, imitating their guide Nature, which has hidden far from sight those parts that are in some degree shameful.[61]

Poggio could have found this idea in Cicero.[62] Guarino of Verona, who liked the poems very much, took up Poggio's

haberentur corpora, delegimus et a quibusque suas desumpsimus dimensiones, quas, postea cum alteras alteris comparassemus, spretis extremorum excessibus, si qua excederent aut excederentur, eas excepimus mediocritates, quas plurium exempedarum consensus comprobasset. Metiti igitur membrorum longitudines, latitudines, crassitudines primarias atque insignes, sic invenimus' (Alberti, *De statua*, in *Kleinere kunsttheoretische Schriften*, ed. H. Janitschek, Vienna, 1877, p. 201).

[59] The commonplaces are from Pliny, *N.H.* vii. 125, xxxv. 106, xxxvi. 18, xxxv. 92; and Plutarch, *Pericles* 13, respectively. Barbaro's letter is printed in A. M. Quirini, *Diatriba praeliminaris in duas partes divisa ad F. Barbari et aliorum ad ipsum epistolas . . .*, ii, Brescia, 1743, 158–60.

[60] *Ars poetica* 9–10. The letter is printed in *Antonii Bononiae Beccatelli cognomento Panhormitae Epistolarum libri V*, Venice, 1553, p. 81a.

[61] 'Etiam pictores quibus omnia licent, item ut poetis, cum nudam mulierem pinxere, tamen obscena corporis membra aliquo contexere velamento, ducem naturam imitati, quae eas partes quae haberent aliquid turpitudinis, procul e conspectu seposuit' (*Epistolae*, ed. Thomas de Tonelli, i, Florence, 1832, 183).

[62] *De officiis* I. xxxv. 126.

point and turned it again with another extension of the image of the painter:

I would not esteem the man's poem and talent any the less for his jokes being highly flavoured. Shall we praise Apelles or Fabius or any painter the less because they have painted naked and unconcealed those details of the body which nature prefers hidden? If they have depicted worms and serpents, mice, scorpions, flies and other distasteful creatures, will you not admire and praise the artist's art and skill?[63]

Guarino is using a remark from Aristotle's *Poetics*:

Things which in themselves we view with distress, we yet enjoy contemplating if they are represented with great accuracy—the forms of the basest creatures, for example, and even of dead bodies.[64]

The commonplaces are used here in an unambiguously decorative and playful way, but in other cases they seem to bear on the humanists' stated view of the contemporary scene. There is a passage in the *Rhetorica ad Herennium* important to the humanists for its negative views on stylistic eclecticism. The writer, whom the humanists thought to be Cicero, argues that a student should form his style on the basis of models taken from one master, not on the basis of models taken from a variety of sources. This view is decorated with an argument from an example:

Chares ab Lysippo statuas facere non isto modo didicit, ut Lysippus caput ostenderet Myronium, brachia Praxitelis, pectus Polycletium, sed omnia coram magistrum facientem videbat; ceterorum opera vel sua sponte poterat considerare.[65]

Not in this way did Chares learn from Lysippus how to make statues: Lysippus did not show him a head by Myron, arms by Praxiteles, a chest by Polycleitus, but rather did Chares see at first hand his master making every part of the figure. He could study the works of other sculptors on his own, if he wished.

The humanists read this with close attention. Here are notes

[63] 'Nec idcirco minus carmen ipsum probarim et ingenium, quia iocos lasciviam et petulcum aliquid sapit. An ideo minus laudabimus Apellem, Fabium ceterosque pictores, quia nudas et apertas pinxerint in corpore particulas, natura latere volentes? Quid? si vermes angues mures scorpiones ranas muscas fastidiosasque bestiolas expresserint, num ipsam admiraberis et extolles artem artificisque solertiam?' (*Epistolario*, ed. R. Sabbadini, i, Venice, 1915, 702).
[64] *Poetics* 1448[b]10–12. [65] *Rhet. ad Her.* IV. vi. 9.

taken at lectures on the *Rhetorica ad Herennium* given by Guarino
of Verona:

Chares was a famous painter who had been a pupil of the famous painter
Lysippus; and indeed here the author too, in fact, makes his point by
example, the point being that models should not be taken from other
people. *Non isto modo*, that is, like those teachers who use other people's
models, as if Lysippus were to show his pupil a head by Myron, who
was a famous painter. For Lysippus did not instruct Chares by saying:
'Myron makes beautiful heads on his images', or 'Praxiteles the famous
painter makes beautiful arms on his images', or 'Polycleitus makes
beautiful chests'; rather does he himself produce models, and he did
not take them from other people. *Coram*, that is 'on the spot', as here;
the word means what we call in Italian 'a bocca'. *Magistrum facientem
omnia*, on his own, that is, and not using other people's models.
Ceterum qualifies *pictorum*: Chares could afterwards consider other
people's models by himself, even though his teacher did not tell
him to.[66]

Here was a clear and well-known commonplace against artistic
eclecticism.

The humanist using it might or might not choose to clothe
Lysippus in modern dress and call him, say, Giotto. One must be
clear that this choice reflected the technical requirements of style,
particularly the level of diction—grand periodic or low—in
which the humanist was operating. Two otherwise uninteresting
remarks by Leonardo Bruni illustrate this rather clearly. In the
1420s and 1430s Bruni was concerned to justify his attacks on the
old translation of Aristotle's *Ethics* his own was intended to
replace. In excusing the vehemence of these attacks he uses an
image: when he saw the quality of Aristotle's work travestied, he
says, by these old translations, it was as if he was seeing a great

<hr/>

[66] 'Comentum sive recollectae sub Guarino super artem novam M[arci] T[ullii]
C[iceronis]', Biblioteca Riccardiana, Florence, MS. 681, fol. 108^{r-v}: '*Cares*, fuit pictor egregius,
qui fuerat discipulus Lisippi pictoris egregii, in quo quidem exemplo confirmat ad hoc rem
suam, quae non ab aliis exempla summantur. *Non isto modo*, scilicet quemadmodum qui ali-
orum exempla summunt, ut Lisippus ostenderet caput Mironis, qui fuit egregius pictor. Non
enim docebat Lisippus Carem, dicens Miro facit pulcrum caput ymaginibus, et dicebat
Prasiteles pictor egregius facit pulcra brachia ymaginibus, nec dicebat Policretus facit pul-
crum pectus, sed ipsemet dat exempla, et non aliunde summebant. *Coram*, id est in conspec-
tu, ut hic. At vox id significat quod vulgariter dicitur abocca. *Magistrum facientem omnia*, per
se scilicet et non aliorum exempla summentem. *Ceterum*, scilicet pictorum: poterat postea
ipsemet considerare exempla aliorum, licet suus preceptor non precipiet.' There are several
versions of this commentary, the most generally complete being Biblioteca Marciana,
Venice, MS. XII: 84; but at this point it happens to be less full than the Riccardiana MS.

painting being defaced by somebody. He seems to have liked the image for he used it on two separate óccasions, in the undated treatise *De interpretatione recta*, and then in a letter to his friend Francesco Piccolpassi, Archbishop of Milan. The treatise was a relatively formal work written, as we have seen, in an expansively periodic vein, and here the analogy appears in the following form:

Ego autem fateor me paulo vehementiorem in reprehendendo fuisse, sed accidit indignatione animi, quod, cum viderem eos libros in Graeco plenos elegantiae, plenos suavitatis, plenos inaestimabilis cuiusdam decoris, dolebam profecto mecum ipse atque angebar tanta traductionis faece coinquinatos ac deturpatos eosdem libros in Latino videre. Ut enim, si pictura quadam ornatissima et amoenissima delectarer, ceu Protogenis aut Apellis aut Aglaophontis, deturpari illam graviter ferrem ac pati non possem et in deturpatorem ipsum voce manuque insurgerem, ita hos Aristotelis libros, qui omni pictura nitidiores ornatioresque sunt, coinquinari cernens cruciabar animo ac vehementius commovebar.[67]

I confess that I was rather too violent in my censure, but it was with indignation of mind that, when I saw those books to be in Greek full of elegance, full of sweetness, full of an immeasurable grace, I was truly grieved and distressed to see the same books in Latin defiled and disfigured by such filth of translation. For as, if I were to take delight in some most excellent and pleasant painting by Protogenes, perhaps, or by Apelles or Aglaophon, I should strongly resist its being defaced and would not be able to tolerate such a thing, and would rise up with voice and hand against him who defaced it, so too in the case of these books of Aristotle, which are more handsome and excellent than any picture, I was grieved in my mind and violently aroused at seeing them defiled.

The letter to Piccolpassi written between 1435 and 1437 is familiar and casual in style; here Bruni is defending himself particularly against the widely noticed criticisms of Alonso de Cartagena, Bishop of Burgos.

Dixi libros illos inepte traductos: quis negare potest? Dixi graeca verba ob ignorationem latinae linguae ab eo relicta, pro quibus latina vel optima haberemus, nec dixi modo, sed probavi, et verba ipsa ostendi. Cetera quoque errata, nec ea pauca, nec levia redargui. Aut igitur ista defendat si potest, aut me pupugisse illum non moleste ferat.

[67] *Leonardo Bruni Aretino, Humanistisch-Philosophische Schriften*, ed. H. Baron, Leipzig–Berlin, 1928, pp. 82–3.

Equidem si in picturam Jocti quis faecem projiceret, pati non possem. Quid ergo existimas michi accidere, cum Aristotelis libros omni pictura elegantiores tanta traductionis faece coinquinari videam? An non commoveri? an non turbari? Maledictis tamen abstinui, sed rem ipsam redargui, ac palam feci.[68]

I said the books were clumsily translated: who could deny it? I said that Greek words had been left in through ignorance of the Latin language, words for which we had quite excellent words in Latin, and I not only said it but proved it, and cited the actual words. I showed up the other mistakes too, and they are neither few nor slight. Then let him either defend these, if he can, or not take ill my having attacked the translator. For my part, if someone were throwing filth at a painting of Giotto's, I could not tolerate it. So what do you expect me to feel when I see Aristotle's books, finer than any painting, being defiled with such filth of translation? Should I not be roused? Or disturbed? Yet after all I kept back my curses and argued the case itself, and did so openly.

'. . . ceu Protogenes aut Apelles aut Aglaophon' is grand and goes with broad periodic rhythms and an elevated vocabulary; *Joctus* is inescapably low and suits the simple words and short sentences of the familiar style. One throws dirt at a Giotto, but an excellent painting by Protogenes or Apelles or Aglaophon is something one presumes to deface. It is a matter of decorum.

In 1396 the Paduan humanist Pier Paolo Vergerio wrote a letter in which he opposes Seneca's recommendation about forming one's style on the model of the best aspects of many authors: instead one should imitate Cicero alone. Vergerio—arguing against eclecticism, in a familiar letter, from Padua—uses an argument *a simili*:

Et quanquam Anneus neminem velit unum sequendum, sed ex diversis novum quoddam dicendi genus conficiendum, michi tamen non ita videtur, sed unum aliquem eundemque optimum habendum esse, quem precipuum imitemur, propterea quod tanto fit quisque deterior quanto inferiorem secutus a superiore defecit. Faciendum est igitur quod etatis nostre pictores, qui, cum ceterorum claras imagines sedulo spectent, solius tamen Ioti exemplaria sequuntur.

Though Seneca considers one should not follow a single model but form a new style out of various models, I do not think this is so; rather, one should have a single writer—and him the best—whom one

[68] Bruni, *Epistolarum Libri VIII*, ed. L. Mehus, ii, Florence, 1741, 90 (VII. iv). For Alonso de Cartagena's criticism and the controversy that followed, A. Birkenmajer, *Vermischte Untersuchungen zur Geschichte der mittelalterlichen Philosophie*, Münster i. W., 1922, pp. 129–210.

imitates before all others, because the more one follows an inferior model and departs from the best, the worse one becomes. *So one should do what the painters of our own age do, who though they may look with attention at famous paintings by other artists, yet follow the models of Giotto alone.*[69]

On the face of it, the remark could seem evidence for two or three things that might interest an art historian: that, so far as a humanist was likely to know, it was customary in Padua to form a style not eclectically but by taking models from a single painter; that this painter was not necessarily the man one was apprenticed to; and that Giotto was in 1396 still the painter most conspicuously esteemed by other painters in Padua. Alternatively, taking a stand on the fact of Vergerio's humanist dispositions, one might argue it shows only that when a Paduan humanist with Florentine connections had to think in 1396 of a famous artist it was still Giotto's name that came to his mind: *mutatis mutandis* the rest followed from the *Rhetorica ad Herennium*. Neither point of view would be very satisfying.

5. THE LATIN POINT OF VIEW

Any language, not only humanist Latin, is a conspiracy against experience in the sense of being a collective attempt to simplify and arrange experience into manageable parcels. The language has a limited number of categories, grouping phenomena in its own way, and a very limited number of conventions for setting these categories in relation to each other. So as to communicate with other people we keep more or less to the rules; we contract to call this section of the spectrum *orange* and that other section *yellow*, and to use these categories only in certain acceptable relationships, such as nominal and adjectival, to others. In our normal speech we struggle to compromise between the complexity and variety of experience on the one hand, and the relatively limited, regular, and simple system of our language on the other. Because a degree of regularity and simplicity is necessary if we are to be understood, and because also the language itself has been deeply involved in our acquiring ways of discriminating at all, the system of the language is always pressing us to conform with it. Yet, from the other side, we continually

[69] *Epistolario di Pier Paolo Vergerio*, ed. L. Smith, Rome, 1934, p. 177. The passage is remarked on by E. Panofsky, *Renaissance and Renascences in Western Art*, Stockholm, 1960, p. 13.

resist the formal pressure of this system by testing it against experience. So that our speech may keep a usefully close relation to experience we insist on irregularities and awkwardness, resist the system's pull toward simplicity, force modifications and qualifications on its categories, rebuff its invitations to tidiness and pattern.

This is true at least of normal speech, in the sense of the language we use in everyday dealings with people. But humanists' remarks about painting are an extravagantly abnormal use of speech, both because they are humanists' remarks and because they are remarks about painting. Either circumstance would be enough to disturb any normal balance between the system of language on one side and undescribed experience on the other.

Art criticism, making remarks about paintings, is usually epideictic rhetoric: that is, it discusses art in terms of value, praise or dispraise, and demonstrates the speaker's skill. Its language is florid, not grand nor plain. One man disposes pigments on a ground, and another man seeing this tries to match words with the interest of the thing. To do this much beyond the point of saying 'good' or 'bad' is difficult and eccentric, and does not often happen except in a culture which, like neo-classical cultures, sets this activity up as an institution and rewards it, as the phrase is, with approval. It therefore very quickly develops a style and a domestic history within which the critic is expected to exercise his skill. But terms used of the interest of painting tend not to be sharply delimited or readily checked against experience: 'beauty' is a less verifiable category than 'wealth'. Further, there are in any case not many terms specific or proper to the interest of paintings, and above the level of 'big', 'smooth', 'yellow', 'square' our discourse must quickly become oblique. In the case of representational arts like Renaissance painting, one can cheat by talking about the represented things as if they were real; one can also talk about how real or not they seem, though this only has a limited usefulness.

Other approaches have to be found: we may characterize the quality of the painting by comparing it with something else, either by straight comparison or more commonly by metaphor, transferring to painting a word that has been defined by use in some other area; or we may characterize quality by imputing to it causes or effects: we may refer to the process or intention we

suppose went to produce it, or to the response we claim it stimulated in us. These are only the simplest of the linguistic tricks a critic must use. At any time very little is said about paintings in direct descriptive terms. It is a sort of linguistic activity specially exposed to pressure from the forms of the language in which the remarks are made.

The ascendancy of language over experience inevitable in any critical discourse was compounded by the humanists' attitude to language in general. We have seen that humanists shared a preoccupation with imitating the structures of classical Latin prose, itself a very elaborately patterned language; they were sufficiently linguistic determinists themselves to believe they must yield to the forms of the classical language before they could enter into the true classical consciousness and culture. So, for more respectable reasons than one might think, the humanists were passive and compliant in their relationship to the forms of literary Latin; they let *verba* influence *res* to an extraordinary degree, and the forms of the Ciceronian period had an authority for them of a kind they could not have had for Cicero, however much better he did it. The humanists decently disposed matter—matter naturally not in conflict with general experience—within the grand and delicately balanced forms of classical language; often, like Leonardo Bruni, they let themselves fill out the forms by generating inoffensive matter along classical lines from rather small kernels of sense. Relatively little of their energy need be spent on brutalizing the beautiful patterns of language to make a workable fit with experience, relatively more could be spent on playing on these patterns correctly and stylishly, *accurate et eleganter*.

This was only possible because Latin had so restricted a role. It was a supplementary language, used in relatively playful contexts, since, though much of a humanist's more prized intellectual activity happened in Latin words and syntax, he borrowed money or instructed his cook in Italian; it was along with the categories of Italian that he had learnt as an infant to articulate his experience and form concepts, and it was along with Italian syntax that he learned to set these in relation to each other. None of the humanists in this book learnt Latin in their early infancy; they learnt it in a formal and technical way, with conscious effort and the application of rules, that dissociated it from the Italian they

had previously absorbed informally. It was not a true bilingual situation; Latin was not a language co-ordinate with Italian but a secondary language of great prestige, particularly in certain situations, and this distance of their Latin from the more insistent fundamentals of life let them indulge their linguistic neo-classicism fully. For in humanist discourse the part of non-verbal controls and stimulations was reduced to a level that can have very few parallels. Taken on its own terms this freedom—a lurch in the direction of some almost abstract constructive activity with language—is most exciting. It would be wrong to call humanist discourse unreal, but it was able to exercise with a quite unusual independence of verification against un-literary experience. Even more than is usual in any language, a humanist remark is shielded from reality by a series of other interlocking remarks composed of the same categories and constructions. To say this is not to condemn humanist discourse, since it was never intended as a breathless statement of fresh perceptions of the world: lyric responses to fifteenth-century reality would have disrupted the neo-classical texture of their performance very seriously.

But however detached a humanist's remark about painting may be from any urgent convictions about painting, it is still a fact about the climate in which the painter worked. This is so, not because it is the true registration of somebody's feelings about painting, but because the terms in which the remark appears, *pro* and *contra* quite regardless, tell us something about the sort of attention he was in a position to bring to painting specifically as a humanist.

To exercise a language regularly on some area of activity or experience, however odd one's motives may be, overlays the field after a time with a certain structure; the structure is that implied by the categories, the lexical and grammatical components of the language. For what we can and do conveniently name is more available to us than what we cannot. People who have separate words for the colours *orange* and *yellow* recognize and remember these two colours more efficiently than people who have one name covering both.[70] And here the fact of Latin being a supplementary language formally learned is not decisive. If

70 E. H. Lenneberg and J. M. Roberts, *The language of experience: a case study*, Indiana University Publications in Anthropology and Linguistics, Memoir 13, 1956, especially pp. 20-1.

a group of people is taught even temporary numerical names for each of a set of nine shades of grey, they will discriminate among these shades more efficiently than another group of people who have not been taught the numbers.[71] It is intuitively obvious enough that learning a label for any class of phenomenon directs our attention to the quality by which the class is delimited. Any name becomes a selective sharpener of attention. Quite how far this will be important for the way someone attends to a painting will depend on his purpose and interest both in using the words and in seeing the pictures.

Latin categorization of experience was important for humanist attention only to things they talked about in Latin and which were more elaborately differentiated in Latin than Italian. We have seen that painting was a subject of this kind. The existence in Latin of names for various categories of visual interest—let us say, *decor* and *decus*—drew attention to the existence of these categories, and when a humanist had to learn to use these words in an acceptable neo-classical way he necessarily also learnt to distinguish the kinds of interest or stimulus they corresponded to. The effect of Latin on him was to make him notice, as he would otherwise not have occasion to notice, the distinguishing qualities of various kinds of interest and organization. So what will interest us in a humanist's remark is less that the man has praised a painting for *decor* than that *decor* is a category of visual interest he has had to learn to use.

Having learned a particular language has, however minutely, re-organized the attention he can bring to works of art. To take a collective case, it is interesting that several humanists speak approvingly of paintings with the quality of *ordo* not because this shows humanists were as a matter of fact urgently devoted to *ordo* in paintings, which is not certainly true, but because it shows that humanism, which was the learning of neo-classical Latin, involved acquiring *ordo* as one way of exercising attention on visual configurations. People who have trained themselves in the labels *decor* and *decus* will approach a painting by Giotto with a predisposition to look for, distinguish, and recall qualities different from someone equipped with the terms *maniera*, *misura*, and *aria*. A person given to categories like *supersplendere* or *deiformitas*, of course, will attend differently again.

[71] A. Lehmann, 'Über Wiedererkennen', *Philosophische Studien*, v, 1889, 96–156.

There was therefore a very distinct humanist point of view on painting, but it is not usefully identified with some consensus of humanists' opinions about paintings. It was not in the first place a matter of common taste for a certain kind of painting but rather the common possession, from a common experience of the same language, of a system of concepts through which attention might be focused. Vergerio's account of the Paduan painters' attitude to Giotto and to models may or may not be accurate; what it does certainly tell us is that Vergerio's humanism had given him an angle, so to speak, on the situation. He came to it more equipped to discriminate about the painters' interrelationships because he had a stock of humanist patterns against which to try them: not just the type case of Lysippus, but the resonant and well-connected notion of *exemplarium*, the refined nuance of qualification permitted by *cum*+subjunctive, and so on. Further, the occasion for making an observation about painters at all was a humanist occasion, an analogy sanctioned by inductive invention and a symmetrical sentence pattern. All these things were components of the humanist point of view—an approved set of categories, a repertory of favoured syntactic frameworks for them, and some matter-suggesting rhetorical drills.

How far and how importantly this differed from the vernacular point of view is not something one can measure at all; there are no controls. But the two versions of Alberti's treatise on painting, even though *Della pittura* is a translation of *De pictura* rather than an independent Italian performance, point to each language having pressed different kinds of remark even on him. Certainly Alberti does not say in Italian what he had said in Latin:

Bene conscriptam, optime coloratam compositionem esse velim.

(I should wish the composition to be well designed, *very* well coloured.)

Vorrei io un buon disegnio ad una buona conpositione bene essere colorato.

(I should wish a good design for a good composition to be well coloured.)

Nam ea quidem coniugatio colorum, et venustatem a varietate, et pulchritudinem a comparatione illustriorem referet.

(For that combination of the colours renders more distinct both the *venustas* by virtue of variety and the *pulchritudo* by virtue of contrast.)

Sarà questa comparatione, ivi la bellezza de' colori più chiara et più leggiadra . . .

(If there is this contrast, then the beauty of the colours will be more *chiaro* and more *leggiadro* . . .)[72]

These are moderate examples—and one finds such cases in every other sentence of the treatise—but it still seems like two minds thinking along similar lines.

Chapter II will try to isolate some characteristic parts of the pattern three generations of humanist Latin discourse came to impose on painting and sculpture. Anyone used to the more evolved kinds of criticism will find much of the material primitive; it is worth remembering, perhaps, that the humanists were re-establishing the institution of art criticism as they went along. Alberti differed from the other humanists because his purpose in speaking of painting was much more serious; out of the litter of humanist cliché and habit he made something with very long-term consequences for European attitudes to painting. He was both a good humanist and a practical student of painting, and Chapter III will discuss one of the fruits of this freakish conjunction, the notion of 'composition'.

[72] 'De pictura', Vatican Library, MS. Ottob. lat. 1424, fols. 20ᵛ and 22ᵛ; *Della pittura*, ed. L. Mallè, Florence, 1950, pp. 99 and 101.

II

The Humanists on Painting

I. PETRARCH: PAINTING AS THE MODEL OF ART

In his Italian sonnets Petrarch praised the painting of Simone Martini, whom he seems to have known personally, in terms developed quite strictly out of the classical anthology commonplaces *cedat Apelles* (let Apelles yield place) and *vultus viventes* (faces that live). In a Latin letter he neatly varied *vultus viventes* in favour of the bronze horses of St. Mark in Venice: 'ex alto pene vivi adhinnientes ac pedibus obstrepentes'. In his longest remark about a particular work of art, a twelfth-century polychrome stucco relief of St. Ambrose he saw on a wall of Sant'Ambrogio near his lodgings in Milan, he expands the related formulas of *signa spirantia* (statues that breathe) and *vox sola deest* (only the voice is lacking):

... it almost lives and breathes in the stone, and I often look up at it with reverence. It is no small reward for my coming here. I cannot say how much power there is in its expression, how much grandeur in the brow and serenity in the eyes; only the lack of a voice prevents one seeing the living Ambrose.

Giotto's frescoes at Naples are praised for skill-and-talent (*manus et ingenium*), and so are the Dioscuri (Plate 4) on Montecavallo at Rome (*ingenium et ars*).[1] Petrarch's remarks about particular works of art are constrained; the anthology formulas he used were perhaps a little less threadbare than they had become a hundred years later, but there is not in practice much profit in trying to

[1] For Simone Martini, Sonnets xlix, l, and lxxxvi; the horses of St. Mark, *Sen.* iv. 3; Giotto at Naples, *Itinerarium Syriacum* in *Opera Omnia*, Basel, 1581, p. 560; the Dioscuri, *Fam.* vi. 2; St. Ambrose, *Fam.* xvi. 11: 'Iocundissimum tamen ex omnibus spectaculum dixerim quod aram, quam non ut de Africano loquens Seneca, "sepulcrum tanti viri fuisse suspicor", sed scio, imaginemque eius summis parietibus extantem, quam illi viro simillimam fama fert, sepe venerabundus in saxo pene vivam spirantemque suspicio. Id michi non leve precium adventus; dici enim non potest quanta frontis autoritas, quanta maiestas supercilii, quanta tranquillitas oculorum; vox sola defuerit vivum ut cernas Ambrosium.' For the relief and Petrarch's remark, see A. Ratti, 'Il più antico ritratto di S. Ambrogio', in *Ambrosiana*, Milan, 1897, Sect. XIV, pp. 61–4, and E. H. Wilkins, *Petrarch's Eight Years in Milan*, Cambridge, Mass., 1958, pp. 16–17.

squeeze critical attitudes out of them. We may say Petrarch pub-
licly admired paintings and statues conspicuous in his time, and
that he was content to say so inside a narrow range of common-
places, none of them unknown to the Middle Ages.

This is very disappointing because Petrarch may well have
been as actively interested in painting as any important humanist
before Alberti: Simone Martini illuminated a book for him, he
owned a painting by Giotto, and there are even small drawings
in the margins of his books ascribed to Petrarch himself.[2] But the
conventionality of his praise is characteristic of humanist dis-
course; the commonplaces are epideictic grace-notes, a florid and
semi-classical way of saying that a work of art was good. The
grip of these formulas on statements of approval was very firm
in the Renaissance. The most bathetic example is in a famous
letter from Giovanni Dondi of Padua, a friend of Petrarch and
a meticulous collector of antique inscriptions. Dondi tells of an
unnamed sculptor enraptured by the fragments of classical sculp-
ture in Rome; what this sculptor finally said was—so Dondi was
informed by someone present at the time—'to use the man's own
words, if only the statues did not lack breath, they would be
better than the living'.[3] The sculptor, or Dondi, or Dondi's
informant, was falling back on eloquence. It might be argued

[2] Petrarch's relationship to painting has been much discussed: particularly by [V.
Masséna,] Prince d'Essling, and E. Muentz, *Pétrarque: ses études d'art, son influence sur les
artistes, ses portraits et ceux de Laure, l'illustration de ses écrits,* Paris, 1902, Chapter I; L.
Venturi, 'La critica d'arte e F. Petrarca', *L'Arte,* xxv, 1922, 238–44; Lucia Chiovenda, 'Die
Zeichnungen Petrarcas', *Archivum Romanicum,* xvii, 1933, 1–61; T. E. Mommsen, 'Petrarch
and the Decoration of the Sala Virorum Illustrium in Padua', *Art Bulletin,* xxxiv, 1952,
95–116; E. H. Wilkins, 'On Petrarch's Appreciation of Art', *Speculum,* xxxvi, 1961, 299–
301; E. Panofsky, *Renaissance and Renascences in Western Art,* Stockholm, 1960, Chapter I.

[3] Prince d'Essling and E. Muentz, op. cit., p. 45, n. 3: 'De artificiis ingeniorum veterum
quamquam pauca supersint si que tamen manent alicubi ab his qui ea in re sentiunt cupide
queruntur et videntur magnique penduntur. Et si illis hodierna contuleris non latebit
auctores eorum fuisse ex natura ingenio potiores et Artis magisterio doctiores. Edificia dico
vetera et statuas sculpturasque cum aliis modi hujus quorum quedam cum diligenter obser-
vant hujus temporis artifices obstupescunt. Novi ego marmorarium quemdam famosum
illius facultatis artificem inter eos quos tum haberet Ytalia, presertim in artifitio figurarum,
hunc pluries audivi statuas atque sculpturas quas Rome prospexerat tanta cum admiratione
atque veneratione morantem, ut id referens poni quodammodo extra se ex rei miraculo
videretur. Aiebant enim se quinque cum sociis transeuntem inde ubi alique hujusmodi
cernerentur ymagines intuendo fuisse detentum stupore. Artificii et societatis oblitum
substitisse tam diu donec comites per quingentos passus et amplius preterirent, et cum
multa de illarum figurarum bonitate narraret et auctores laudaret ultraque modum comen-
daret ingenia ad extremum hoc solebat addicere ut verbo utar suo, nisi illis ymaginibus
spiritus vite deesset, meliores illas esse quam vivas ac si diceret a tantorum artificum ingeniis
non modo imitatam fuisse naturam verum etiam superatam.' For this passage see also E.
Panofsky, op. cit., pp. 208–9.

1. Pliny, *Natural History*, xxxv, 79-91 with Petrarch's annotations. Paris, Bibliothèque Nationale, MS. lat. 6802, fol. 256 verso.

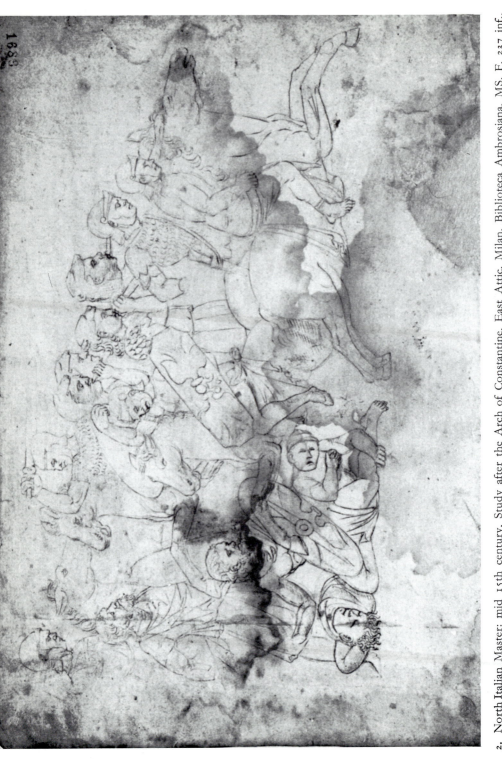

2. North Italian Master: mid 15th century, Study after the Arch of Constantine, East Attic. Milan, Biblioteca Ambrosiana, MS. F. 237 inf, fol. 1687. Pen and silverpoint.

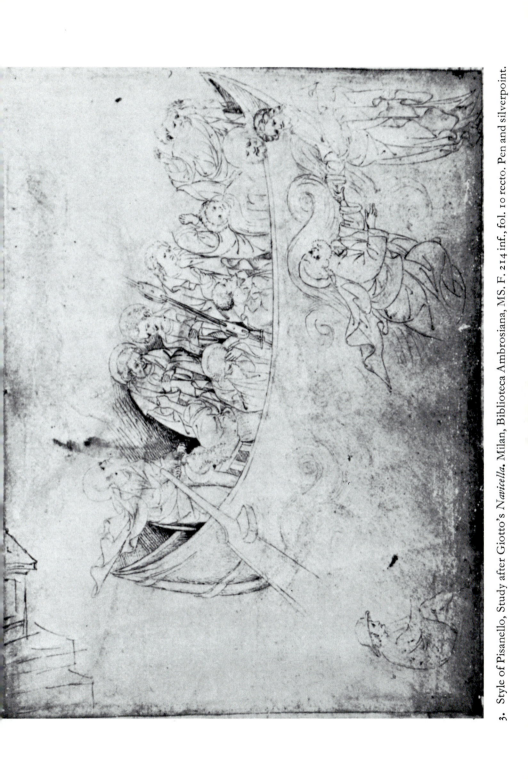

3. Style of Pisanello, Study after Giotto's *Navicella*. Milan, Biblioteca Ambrosiana, MS. F. 214 inf., fol. 10 recto. Pen and silverpoint.

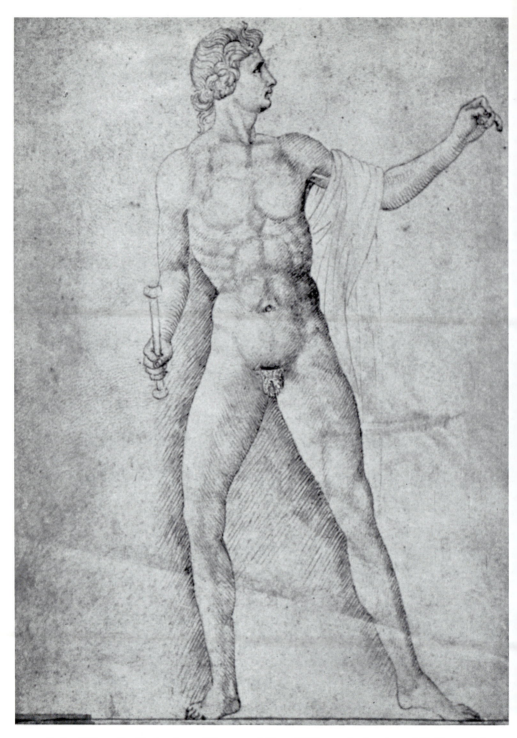

4. Style of Pisanello, Study after a Dioscuros. Milan, Biblioteca Ambrosiana, MS. F. 214 inf., fol. 10 verso. Pen and silverpoint.

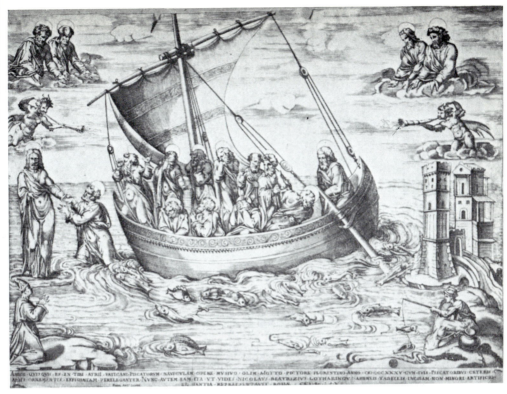

5(a). Nicolas Beatrizet, Engraving after Giotto's *Navicella*.

OPVS FIDIAE

OPVS·PRAXITELIS

5(b). Antonio Lafreri, The *Dioscuri* on Montecavallo. Engraving.

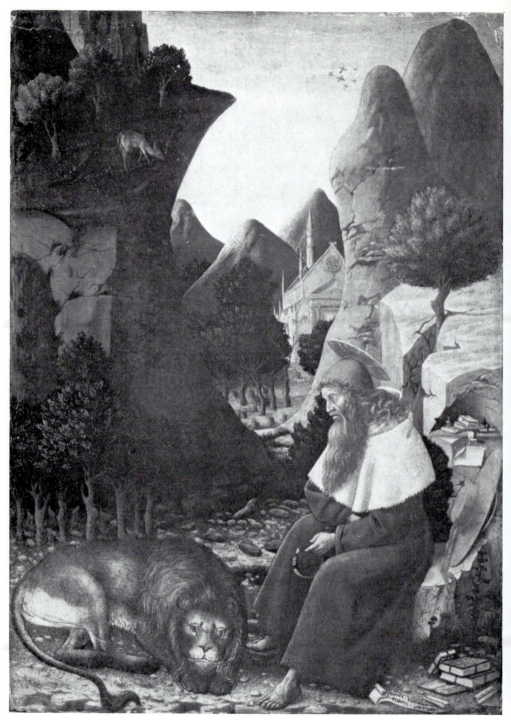

8. Bono da Ferrara, *St. Jerome*. London, National Gallery. Tempera on panel.

that these formulas are at least more consistent with interest in an art directed to imitation of nature than to, say, *splendor* or *symmetria*, and so far as it goes this is clearly true.

Petrarch is important in humanist art criticism, not for his characterless particular judgements, but because he re-established for humanism a characteristic sort of generalized reference to painting and sculpture. A peculiarity of this sort of discourse is that it turns on and round a few very clear and more or less interconnected concepts. These appear at their clearest in the chapters on painting and sculpture in *De remediis utriusque fortunae*, Petrarch's longest statement about art and indeed the longest discussion of art one has from the humanist Trecento. On account of its great ambivalence *De remediis utriusque fortunae* is nowadays one of the most enjoyable of Petrarch's Latin books to read. It was written between 1354 and 1366, a development of a type offered by Seneca's *De remediis fortuitorum*, but Petrarch takes the form further than Seneca. In the section with chapters on painting and sculpture the form is a rather one-sided dialogue between *Gaudium* and *Ratio*: *Gaudium* repeatedly states joy in some material aspect of good fortune—such as the possession of works of art— and *Ratio* states a series of reasons for inhibiting one's enjoyment of it. The fact that painting and sculpture are, like health, chess, friendship, books, and many other things, matters of good fortune is therefore not in question. What the dialogue is concerned with is how to keep a proper moderation and poise in one's approach to this good fortune, and part of the game lies in finding better ideas to use against some joys than against others. Petrarch's arguments against the enjoyment of painting are relatively thin or double-edged. Here are the chapters on painting and sculpture from *De remediis utriusque fortunae* in Thomas Twyne's translation of 1579,[4] which comes nearer to Petrarch's Latin than modern English can:

Of Pictures and painted Tables. The XL. Dialogue

Ioy. I am delighted with pictures, and painted tables.

[4] *Phisicke against Fortune, as well prosperous, as adverse, conteyned in two Books* . . . Written in Latine by Frauncis Petrarch . . . Englished by Thomas Twyne, London, 1579, pp. 57a–60a. Twyne made a few mistakes in his translation; these are corrected here, between square brackets. There is one deliberate misrepresentation: the sentence 'To take delight also in [sacred images . . .]' (p. 58) was apparently too Romish for Twyne, who substituted 'To take delight also in the images and statues of godly and vertuous men, the beholding of which may stirre us up to have remembrance of their manners and lives is reasonable, and may profite us in imitating yᵉ same.'

Reason. A vaine delight, and no lesse folly then hath raigned some-tyme in great personages, and no deale more tollerable then it hath ben in olde tyme. For every evyl example is then worst, when as eyther the weight of auctoritie, or of yeeres is ioyned unto it. The force of cus-tome [increases with age] from whence soever it tooke beginning, and age as it advaunceth good thinges to better, so doth it cast downe evyl thinges to woorse. But O, I would God, that ye that do far surpasse your auncetours in vaine things, would matche them in earnest matters, and with them would esteeme of glory and vertue, with whom ye stand fondly gazing at Pictures without ende.

Ioy. Truely I am woonderfully delighted with painted tables.

Reason. O woonderfull madnesse of mans minde, which woondreth at evry thing, saving it selfe, [than which] there is nothing not only among all the woorkes of art, but also of nature, more woonderful.

Ioy. Painted tables delight me.

Reason. What mine opinion is herein, thou mayest perceive in that which I have sayde before. All earthly delyghtes, if they were governed by discretion, would styre men up to the heavenly love, and put them in minde of their first original. For, I pray thee, who ever loved a river, and hated the head thereof? But you weltring heavily upon the ground, stouping, and as it were fastened to the earth, dare not look upwardes to wardes heaven, and forgettyng the chiefe woorkeman [of the Sunne and Moone], with marvellous pleasure ye beholde [their] slender pic-tures, and where the passage is to the highest places, [you look down, and] there ye ende the boundes of your understanding.

Ioy. I am specially delyghted with painted tables, and Pictures.

Reason. Thou conceivest delight in the pencill and colours, wherein the price, and cunning, and varietie, and curious dispersing, doth please thine eye: even so likewyse the lively gestures of lyvelesse pic-tures, and the [motions of unmovable images], and countenaunces comming out of poastes, and lively portraitures of faces, doo bryng thee into woondring, insomuch as thou wilt almost thynke they would speak unto thee: and this is the onely danger in this behalfe, in that many great wittes have been [those most] overtaken by these meanes. So that, whereas the clowne and unskylfull person will with small woondryng pass them over: the wyser wyll repose hym selfe with sighing and woondring. A cunning matter truly, howbeit it is not possible from the beginning to unfold the fyrst originall and encrease of this art, and the wonderfulnesse of the woorkes, and the industrie of the woorkmen, the madnesse of princes, and the unreasonable prices wherewith these have been bought and brought from beyonde the seas, and placed at Rome, eyther in the Temples of the Goddes, or in

the bed chambers of the Emperours, or in the common streetes, or publique porches and galleries. Neyther was this sufficient, but that they must also apply their owne right handes,[5] which of duety ought to have been busied about greater affayres, unto the exercise of this art, which the most noble Philosophers of all *Greece* had doone before: Whereby it came to passe, that among you the art of paintyng was esteemed above all handie craftes, as a thyng more neere to the woorke of nature: And among the *Grecians*, yf ye wyll beleeve *Plinie*, it was accompted [a first step in] the Liberal Artes.[6] But I let passe these thinges, for that they are in a maner contrary to mine entended brevitie, and present purpose: and may seeme rather to minister infected humours to the sicknesse, whose cure I promised to undertake, and by the excellencie of the thinges, to excuse the madnesse of the woonderers at them. How beit I sayde yer whyle, that the greatnesse of them that dyd erre, made not the errour the lesse: but I touched that poynt the rather to this intent, that it myght appeare how great the force of that folly was, with whiche so many and so great wittes have conspired, unto which also the prince of errour the common multitude, and long continuance, whiche is the engenderer of customes, and auctoritie, whiche is a great heape of all mischiefes, are ioyned: so that the pleasure and admiration thereof, is able privily to remoove and withdrawe the minde from contemplation of higher matters. But yf these thynges that are counterfeited and shadowed with vayne colours doo so muche delyght thee, cast up thyne eyes uppon him that hath adorned mans face with senses, his minde with understandyng, the heaven with starres, the earth with flowres, and so shalt thou contemne those woorkemen whom thou woondredst at.

Of Statues and Images. The XLI. Dialogue

Ioy. But I take great pleasure in Images.

Reason. These be sundrie artes, but the madnesse is one, and there is but one beginning of them both, and one ende, but divers matter.

Ioy. I delight in statues.

Reason. These come in shew more neere unto nature, then pictures: For they doo but appeare only, but these are felt to be sounde and substantiall, and there theyr bodyes are more durable: Whiche is the cause that there remayne to this day in no place any pictures of men of auncient times, but statues innumerable: Whereby this age in this point, as in many thynges els erronious, woulde seeme to have been the fyrst inventer of pictures: [or—what is next to its invention—to have

5 Pliny, *N.H.* xxxv. 19-20.
6 Pliny, *N.H.* xxxv. 77: 'reciperetur ... in primum gradum liberalium'.

perfected and finished the art,] and dare boldly and impudently affirme, though falsely, that it is not inferiour to any, in graving and carving all sortes of seales and statues: seeing in very deede they be almost al one art, or if they be divers, they sprang both from one fountayne, to wit, the art of drawing, and doubtlesse are of one antiquitie, and flourished at one tyme. For why, *Apelles*, and *Pyrgoteles*, and *Lysippus*, lyved at one tyme, whiche may by this meanes be prooved, in that the great pride of *Alexander* of *Macedonie*, chose these three together above the rest, whereof the one should paint him, the other engrave him, and the thyrde carve him:[7] strayghtly forbiddyng all other, uppon whatsoever cunnyng or assuraunce of skyll presumyng, to meddle with expressyng the kynges face any maner of way: and yet was not this madnesse lesse then the residue. But everry disease is so much the more daungerous, howe muche more stable and fixed the matter is whereof it proceedeth.

Ioy. But I am delyghted in Images.

Reason. Thynke not that thou errest alone, or that thou hast no fellowes but the common people: For in tymes past howe great the dignitie hath been of statues and images, and howe fervent the studie and desire of men was reposed in suche pleasures, the most diligent enquirie of *Augustus* and *Vaspasian*,[8] and other Emperours, and Kynges, of whom it were impertinent and too long to intreate, and also of other noble personages of the second degree, and industrious keepyng of them when they had founde them, and theyr sundrie dedicatyng and bestowing them, may sufficiently declare. Hereunto also may be added, the great fame of the woorkemen, not rashly spread abroade by the common people, or reported upon dumbe workes, but celebrated in the soundyng of learned and approved writers: whiche beyng so great, seemeth in no wyse to be able to spryng from a smal roote. A great name commeth not of nothing, it must be great in deede, or seeme to be so, whereof great men do seriously intreate. But all these thinges I have answered before, and tende to this purpose, that thou mayest understande with what force so auncient and stout an errour must be resisted.

Ioy. I conceyve pleasure in sundry statues and images.

Reason. There is one of these artes, whiche by the handy woorke doth imitate nature, men commonly call it framyng and fashioning. This art woorketh with waxe, playster of Paris, and cleaving claye, whiche although among all the other artes that have affinitie with it, it be more freendly, and come neerest to vertue, or is lesse enimie to modestie and thriftinesse, whiche two vertues doo more allowe of images and statues of Goddes and men to be made of earth, and suche lyke matter,

[7] Pliny, *N.H.* vii. 125. [8] Pliny, *N.H.* xxxvi. 27-8.

then of golde and precious stone:[9] Yet what delyght there is to be conceyved in looking uppon faces made of waxe or earth, I doo not understand.

Ioy. I take delyght in noble statues and images.

Reason. I know the meanyng of covetousnesse: it is the price, as I suppose, and not the art that pleaseth thee. I am sure thou doest in minde esteeme one image of golde of meane woorkemanshyp, above many made of brasse, and marble, and specially of clay or other cast stuffe, and not unwysely, as the present valuation of thinges nowe adayes requireth: and this is as muche as to say, as to love the golde, and not the statue, whiche as it may be made noble of a vile matter, so may it be made rude of pure golde. How much wouldest thou esteeme of an image, whether it were the kinges of *Assyria*, whiche was made of golde threescore cubites long, which it was death not to adore,[10] although there be many at this day that would adore it to have it of their owne, or whether it were made of a great Topace of foure cubites long, of which thou readest that the Queene of *Egypts* image was made:[11] a strange think to be spoken, I suppose thou wouldest not very muche enquire after the woorkeman that made it, but rather after the matter it is made of.

Ioy. Images and statues cunningly wrought, delight mine eyes.

Reason. Images and statues somtime were the tokens of vertues but now they be the enticementes of the eyes. They were erected in the honour and remembraunce of suche as had atchived woorthy deedes, or voluntarily yeelded them selves up unto death [for] their common wealth: Suche as were decreed to be set up in honour of the Embassadours that were slayne by the king of the [*Fidenates*]:[12] such as were erected in the honour of *Scipio Africane*, the deliverer of *Italye*, whiche his most valiant courage, and woorthy modestie woulde not receive, but whiche after his death he coulde not refuse.[13] They were erected in the honour of wise and learned men, the lyke whereof we reade was erected unto *Victorinus*:[14] and now adayes they are erected unto ryche Merchantes, wrought of outlandish Marble, of great value.

Ioy. Statues artificially wrought doo muche delight mee.

Reason. Every kinde of stuffe almost wyl admit cunning woorkmanship: but I perceyve how this thy delight is ful of wisdome, and ioyned with the most noble matter. Howbeit I can not perceyve how there shoulde be any pleasure in the golde, no although it were wrought by *Phidias*, or what worthinesse there shoulde be in it, being but a drosse of

[9] Pliny, *N.H.* xxxv. 157–8.
[10] Daniel 3: 1–6.
[11] Pliny, *N.H.* xxxvii. 108.
[12] Cicero, *Philipp.* IX. ii. 4.
[13] Livy, xxxviii. 56.
[14] Augustine, *Conf.* viii. 2.

y^e earth, although it be yelow, but by meanes of the Andvil, hammers, tongues, coales, invention, handy labour. What thing may be wrought that is to be wished of a man, or hath in deede any magnificence in it, consider with thee selfe.

Ioy. I can not chose but take great pleasure in images.

Reason. To take pleasure in the wittie devises of men, so it be modestly done, is tollerable, and specially of such as excel in wit: For unlesse malice be an hinderaunce, every man doeth willingly reverence that in another, which he loveth in him selfe. To take delight also in [sacred images, which may remind the beholder of the grace of heaven, is often a devout thing and useful in arousing our minds.] Prophane images also, although sometime they move the minde, and styre it up to vertue, whilst lukewarme mindes doo waxe hot with the remembraunce of noble deedes, yet ought they not to be loved or esteemed of above reason and duetie, lest they become eyther witnesses of our follie, or ministers of our covetousnesse, or rebellious to our fayth and true religion, and that most excellent commaundement of the Apostle, *Keepe your selves from Images.*[15] But truly, if thou beholde him in thy contemplation, who created the fixed earth, the moveable sea, and turnyng heaven, who also hath replenished the earth, not with feigned and counterfeite, but with true and living men and beastes, the sea with fishes, the heaven with foules, I suppose that thou wylt as lytle esteeme of *Polycletus* and *Phidias*, as of *Protegenes* and *Apelles.* (I)

Clearly there is very little point in trying to extract statements of opinion from a text of this kind. What can be derived from it are concepts, the counters with which the game is being played. Typically, these work in contrasting pairs; important distinctions operate here, for instance, (1) between then (namely classical antiquity) and now; (2) between the informed beholder and the uninformed; (3) between sensuous delight and a more discriminating useful pleasure; (4) between matter and form or, in another aspect, (5) between matter and skill; and (6) between nature and art, as a minor aspect of a greater distinction between God and man. None of these concepts or distinctions was new, they would have been familiar to schoolmen, but it was Petrarch who more than anyone established them as the basis for humanist discussion of painting and sculpture. As so often, what distinguishes the humanist from the medieval is a new sort of emphasis rather than a new set of ideas.

[15] 1 John 5: 21.

In most cases these distinctions were transferred directly from the discussion of verbal style, the humanists' own art. Their whole intellectual position rested, for instance, on a sharp distinction between then and now: reference back to antiquity was natural to them in any discussion of their culture, and the simple act of reference back inevitably became comparative and in some degree goal-setting. But the humanists' knowledge of classical art rested on a different basis from their much more direct knowledge of classical literature. Petrarch's interest in the ruins of Rome is well known and very impressive.[16] He knew these and he also knew a number of classical accounts of art, particularly Pliny and probably Vitruvius.[17] It was very difficult for the early humanists, who knew no classical paintings and relatively few and late classical sculptures, to harmonize the fragments they could see with the literary accounts they could read. It is not surprising that they talked of the latter in some dissociation from immediate visual experience.

Much the same is true of the division into informed and uninformed publics. St. Augustine had notoriously preferred to be condemned by the grammarians rather than not to be understood by the vulgar. The humanists consciously reversed this attitude; they were committed to a neo-classical literary élite whose activity must necessarily pass over most people's heads. Whenever the more subtle qualities of a painting or statue were referred to, it was easy for a similar pattern of subtle and un-subtle classes of beholder to appear, and for this pattern to be seen in close relationship with the possession of some sort of knowledge about painting or sculpture. Besides, in classical anecdotes like Pliny's about Apelles and the cobbler, happily referred to by Petrarch to make a point about literature, the point had already been made:

Movent profecto animum scribentis aliena iuditia, quibus maxime, neque adulationis neque odii sit adiuncta suspitio, ideoque veri Poetae, ut ait Cicero, suum quisque opus, a vulgo considerari voluit, ut siquid reprehensum sit a pluribus corrigatur. Addo ergo si quid laudatum a scientibus in pretio habeatur, dicit idem. Et pictores facere solitos, et sculptores, quod specialiter de Apelle pictorum principe scriptum est.[18]

[16] See especially *Africa* viii. 862–951; *Fam.* vi. 2; *Ep. Metr.* ii. 5.

[17] See Lucia Ciapponi, 'Il "De Architectura" di Vitruvio nel primo Umanesimo', *Italia medioevale e umanistica*, iii, 1960, 59–99.

[18] Petrarch, *Sen.* xv. 3; in Pliny the story appears in *N.H.* xxxv. 184–5.

It was a thoroughly classical point of view. By the early 1350s
Boccaccio had used the motif for Giotto:

E per ciò, avendo egli quella arte ritornata in luce, che molti secoli sotto
gli error d'alcuni, che piú a dilettar gli occhi degl'ignoranti che a com-
piacere allo 'ntelletto de' savi dipigneano, era stata sepulta . . .[19]

In 1370, in his will, Petrarch drew on the distinction to recom-
mend to Francesco da Carrara the panel by Giotto of a Virgin
and Child he himself owned, 'cuius pulchritudinem ignorantes
non intelligunt, magistri autem artis stupent'.[20] An implication
of these categories was that, in theory, some knowledge of paint-
ing was an acceptable part of the humanist's equipment; we shall
see later that this licence became important.

It was, *De remediis utriusque fortunae* implies, the informed be-
holder who was in a position to distinguish between crude
sensuous pleasure and some more complex and intellectual enjoy-
ment offered by a painting or statue. Petrarch and the humanists
are naturally more explicit about the crude qualities one is not to
revel in than the subtler qualities worth a thinking man's atten-
tion: roughly speaking the latter seem to be connected, first, with
recognition of the craftsman's skill and, second, with a certain
moral advantage gained from the contemplation of edifying sub-
jects. Qualms of an iconoclast colour are never a real issue in the
humanists' discussion of art. Coluccio Salutati, Petrarch's Floren-
tine admirer, speaks for most:

I think Caecilius Balbus' feelings about the Romans' religious images
were no different from what we in the full rectitude of our faith feel
about the painted or carved memorials of our Saints and Martyrs. For
we perceive these not as Saints and as Gods but rather as images of God
and the Saints. It may indeed be that the ignorant vulgar think more
and otherwise of them than they should. But, since one enters into
understanding and knowledge of spiritual things through the medium
of sensible things, if pagan people made an image of Fortune with
a cornucopia and a rudder—as distributing wealth and controlling
human affairs—they did not deviate very much from the truth. So too,

[19] *Decamerone* vi. 5.

[20] T. E. Mommsen, *Petrarch's Testament*, Ithaca, 1957, pp. 78–80: 'Et predicto igitur
domino meo Paduano, quia et ipse per Dei gratiam non eget et ego nihil aliud habeo
dignum se, dimitto tabulam meam sive iconam beate Virginis Marie, operis Iotti pictoris
egregii, que mihi ab amico meo Michaele Vannis de Florentia missa est, cuius pulchri-
tudinem ignorantes non intelligunt, magistri autem artis stupent; hanc iconam ipsi domino
meo lego, ut ipsa virgo benedicta sibi sit propitia apud filium suum Iesum Christum.'

when our own artists represent Fortune as a queen turning with her hands a revolving wheel very fast, so long as we apprehend that picture as something made by a man's hand, not something itself divine but a similitude of divine providence, direction, and order—and representing indeed not its essential character but rather the winding and turning of mundane affairs—who can reasonably complain?[21]

If Petrarch himself in ascetic contexts stated doubts about the value of sacred images, these doubts too related to the possibility of abuse by uninformed and undiscriminating beholders.

The distinction between matter and skill overlapped in the humanist mind with the distinction between matter and form. Matter—it may be marble or pigments—is the medium of the artist. To a certain extent it may determine form, but for Petrarch, as later for Alberti, the common art of design underlay the work of both painter and sculptor: 'they be almost all one art, or if they be divers, they sprang both from one fountayne, to wit, the art of drawing . . .' On the other hand, from artists of similar skill one will not expect identical forms even in the same sort of matter: 'ex eadem massa Phydias aliam cudebat imaginem, aliam Praxiteles, aliam Lisyppus, aliam Polycletus.'[22] The point had been made by Cicero: 'the skill or method of painting is one, and yet the painters Zeuxis, Aglaophon, and Apelles are very unlike each other; and the skill of none of these three can be said to be lacking in any particular.'[23] *Ingenium* intervenes. To this extent the distinction between matter and art is a specialized case of the distinction between matter and form, and borrows its

[21] 'Qui [Caecilius Balbus] michi videtur de simulacris suis non aliter autumasse quam et nos ipsi de memoriis pictis vel sculptis sanctorum martyrorumque nostrorum in fidei nostre rectitudine faciamus. Vt hec non sanctos, non deos, sed dei sanctorumque simulacra sentiamus. Licet vulgus indoctum plus de ipsis forte et aliter quam oporteat opinetur. Quoniam autem per sensibilia ventum est in spiritualium rationem atque noticiam, si gentiles finxerunt fortune simulacrum cum copia et gubernaculo tamquam opes tribuat, et humanarum rerum obtineat regimen, non multum a vero discesserunt. Sic etiam cum nostri figurant ab effectibus quos videmus fortunam quasi reginam aliquam manibus rotam mira vertigine provolventem, dummodo picturam illam manu factam non divinum aliquid sentiamus sed divine providentie dispositionis et ordinis similitudinem, non etiam eius essentiam sed mundanarum rerum sinuosa volumina representamus, quis rationabiliter reprehendat?' (Coluccio Salutati, 'De fato et fortuna', Vatican Library, MS. Vat. lat. 2928, fols. 68ᵛ–69ʳ). For Caecilius Balbus, see *Caecilii Balbi De nugis philosophorum*, ed. E. Woelfflin, Basel, 1855, i. 1–3, p. 3.

[22] Petrarch, *Sen.* ii. 3.

[23] 'Una fingendi est ars, in qua praestantes fuerunt Myro, Polyclitus, Lysippus; qui omnes inter se dissimiles fuerunt, sed ita tamen, ut neminem sui velis esse dissimilem. Una est ars ratioque picturae, dissimillimique tamen inter se Zeuxis, Aglaophon, Apelles; neque eorum quisquam est cui quicquam in arte sua deesse videatur' (*De oratore* iii. 26).

prestige. It is here that the humanists consistently take their stand on the question of what sort of pleasure is properly taken in works of art: resisting the charms of matter, one is to enjoy the subtlety of form and skill bestowed on it, and the capacity to do this is in turn characteristic of the informed, as opposed to the uninformed, beholder. Even in the most casual references to painting and sculpture the Petrarchan humanists commonly mobilized the distinctions in harness. For example, Giovanni da Ravenna makes a humanist point about true nobility:

Nobility dazzles us with rays of virtue, not with wealth and ancestral portraits. When a painting is exhibited, the knowledgeable beholder expresses approval not so much of the purity and exquisite quality of the colours as about the arrangement and the proportion of its parts, and it is the ignorant man who is attracted simply by the colour: men are judged in a similar way . . . But if someone admires the proportionality of parts in fine paintings, they are still bound to be worthy of more admiration when beauty of colour is added to this proportionality. The same is true of nobility, family property being added to finished virtue . . .[24]

The remark turns neatly on our distinctions: the informed beholder and the uninformed, immediate sensuous response and discrimination, matter and form, matter and art. Unexciting as they may seem, implicit acceptance of these distinctions was the underpinning for most humanist reference to painting and sculpture.

It was Petrarch too who left the first clear indication of the neo-Ciceronian inductive habit, the running analogy between writing and painting, of which we have already seen examples. It is an intimate witness, his own copy of Pliny's *Natural History*; like many of the manuscripts from Petrarch's library it was intermittently annotated by him in the margin, and Books xxxiv–xxxvi, the books on art, are one of the sections bearing many such *postillae*. One relatively heavily annotated page (Plate 1) from this

[24] 'His [i.e. virtutis] quibusdam quasi radiis splendor nobilitatis emicat non ut diximus diviciis et avorum imaginibus ut si pictura quepiam oblata fuerit non tam colorum puritatem ac eleganciam quam ordinem proporcionemque membrorum peritus probet inspector colore duntaxat capiatur indoctus sic de hominibus eximias (*sic*) vulgus racionem vite sapiens quidam qui membrorum proporcionem admirabitur exquisitis imaginibus si pigmentorum pulcritudo accesserit admiracionis commendacio necessario geminetur. Itidem in nobilitate si ad virtutis perfectionem substantiam quoque adiecisse maiorum videatur . . .' ('Historia Ragusii', Venice, Biblioteca Querini-Stampalia, MS. IX. 11, fol. 80ᵛ).

part of the manuscript can show the kind of interests Petrarch's notes imply; it is from Pliny's account of Apelles.[25] The first note on this page is a gloss on Pliny's Greek word *charis*, grace—a quality special to Apelles. Petrarch was often intrigued by Greek terms: a few pages earlier he had marked *symmetria*: 'Simmetria latinum non est nomen.'[26] Next, against Apelles' criticism of Protogenes for not knowing when to stop work on a piece—when 'manum de tabula scire tollere'—Petrarch puts one of his characteristic *maniculi*, small hands drawn with a pointing finger, and urges himself: '[At]. f. dum [sc]ribis' (Watch out for this, Francesco, when you are writing). Petrarch now notes two axioms with the marginal comment *proverbium*: the first is Apelles' rule never to let a day pass without having drawn at least one line for practice; the second is Apelles' retort to the over-zealously critical cobbler, that he should 'stick to his last'. Then, against Pliny's account of Apelles' charm of manner and ability to converse on equal terms with Alexander the Great, Petrarch attributes the same sort of personal quality to Simone Martini: 'Hec fuit et Symoni nostro Senensi nuper iocundissima.' Finally, after some textual emendations, Petrarch comes to the pictures of dying people (*exspirantium imagines*) Apelles had painted. He notes that he himself owns a painting of this kind: 'Qualem nos hic unam habemus preclarissimi artificis.' Various Christian subjects fit the description.

Two main interests seem to lie behind annotations like these: a very restricted element of comparison with painting as Petrarch knew it in his own time, and the acquisition of axioms and precepts that can be applied to general, not just pictorial, artistic practice. The second of these is the more important, because Petrarch's references to contemporary art are few and usually as superficial as his reference here to Simone Martini; he did sometimes try to apply Pliny to what he saw around him—against Pliny's account of encaustic painting, *parietes fornacei*, he noted: 'Tales sunt in sancto Miniato et cet.',[27] but the notes imply no developed habit of applying Pliny to the Trecento situation. On the other hand, the axiomatic and preceptive value of Pliny's history is very immediate. 'Attende, Francisce, dum scribis'—

[25] Bibliothèque Nationale, Paris, MS. lat. 6802, fol. 256ᵛ. The page corresponds to Pliny, *N.H.* xxxv. 79–91. P. de Nolhac, *Pétrarque et l'humanisme*, 2nd edition, Paris, 1907, ii. 74, drew attention to the annotations in Petrarch's Pliny.

[26] MS. cit., fol. 249ʳ, a reference to *N.H.* xxiv. 65. [27] MS. cit., fol. 260ʳ.

the phrase sums up most of Petrarch's approach to Pliny and his account of the ancient painters and sculptors. From critical axioms like Apelles' criticism of Protogenes the humanist could draw lessons for his own verbal art. Thus again, when Pliny tells of the sculptor Pasiteles, who always made sketches before he started on a finished work—'nihil unquam fecit antequam finxit' —Petrarch addresses himself in the margin: 'N[ota], tu.'[28]

There were advantages even beyond being Ciceronian in using the standard accounts of ancient art as a reservoir of analogies. Paintings and sculptures were concrete and visualizable things, and these were virtues of comparison recommended by every handbook on rhetoric. When Petrarch claimed that faults were as visible in writing as in painting even—'non minus enim rhetorica quam pictura vitia in aperto habet'[29]—he was implicitly admitting this. Besides, the history of ancient art is a personalized and gossipy affair, with many more edged anecdotes than the history of literary rhetoric. Pliny in particular offered a sort of mythology of skill, a guide to the difficulties of being an artist of any kind, that Petrarch and the humanists could always draw on, vividly but sometimes with a little distortion. Pliny prefaces his own book with a disclaimer of completeness:

. . . I should like to be accepted on the same basis as those founders of the arts of painting and sculpture who, as you will find in my book, inscribed their completed works, even those we never tire of admiring, with a sort of provisional signature—*Apelles faciebat*, for instance, or *Polyclitus faciebat*: 'Apelles has been at work on this'—as if art was something always in progress and incomplete; so that in the face of any criticisms the artist could still fall back on our forbearance as having intended to improve anything a work might leave to be desired, if only he had not been interrupted. There is a wealth of diffidence in their inscribing all their works as if these were just at their latest stage, and as if fate had torn them away from work on each one. Not more than three works of art, I believe, are recorded as being inscribed as actually finished: *fecit*.[30]

In Petrarch's memory this ironic and poised passage became an *exemplum* of artistic low cunning:

I think a very similar kind of shrewdness, though in a very different medium, was shown by a certain artist who never admitted that he had

[28] MS. cit., fol. 259ʳ. [29] MS. cit., fol. 195ʳ. [30] N.H., Praef. 26.

given the final touch to any of his marvellously finished works; in this way he left himself free to make additions or alterations at any time, and since the beholders' judgement was suspended, both the artist and the work were presented to their minds as the more magnificent and perfect.[31]

Perhaps the distortion is an index of vitality.

What was to Petrarch at least sometimes a means of illumination about his art became in many of his followers just one more trope. Gasparino Barzizza, discussing how a boy should be taught to write a good style, advises against excessive cramming:

The course you describe—and which in the case of our Giovanni's progress you have pursued rather more rapidly than may be appropriate for him, or indeed than I myself would consider proper—should not be taken to the point where his studies are such a great discomfort to him. For myself, I would have done what good painters practise towards those who are learning from them; when the apprentices are to be instructed by their masters before having achieved a thorough grasp of the method of painting, the painters follow the practice of giving them a number of fine drawings and pictures as models (*exemplaria*) of the art, and through these they can be brought to make a certain amount of progress even by themselves. So too in our own art of literature . . . I would have given Giovanni some famous letters as models . . .[32]

Antonio da Rho, a distinguished Milanese humanist, speaks of the importance of good teaching for eloquence:

Neither by nature nor through art will we at once attain what we are seeking. Without some brilliant and excellent man whose footsteps we may follow in our diction, we shall not be able to be impressive in the thoughts we state or elegant in the refinement and brilliance of our language: in this not unlike many painters who, though they may consider themselves powerfully equipped by nature and art, and may strive to represent the forms and images of all things like an Apelles or an

[31] *Rerum memorandarum libri*, ed. G. Billanovich, Florence, 1943, pp. 115–16.

[32] 'Si fieri potuisset, quam maxime vellem de consiliis vestris aliquid praescivisse. Res enim ista, quam aliquanto celerius agitastis super motu Joannis nostri, quam vel sibi conveniret, vel ego putarem, non esset eo perducta, ut studiis suis tanto esset incommodo. Fecissem enim, quod solent boni pictores observare in his, qui ab eis addiscunt; ubi enim a magistro discendum est, antequam plane rationem pingendi teneant, illi solent eis tradere quasdam egregias figuras, atque imagines, velut quaedam artis exemplaria, quibus admoniti possint vel per se ipsos aliquid proficere. Ita ego sibi in ea arte, in qua satis proficiebat; sed nondum pervenerat quo volebam; exempla aliquarum illustrium epistolarum tradidissem . . .' (*Gasparini Barzizii Bergomatis et Guiniforti Filii Opera*, ed. J. Furiettus, i, Rome, 1723, 180).

Aglaophon, yet because they have learned ill since boyhood, cannot reach perfection, being quite uncultivated and devoid of refinement....[33]

But the point to be made again here is that the lack of critical effort in so many of these remarks did not prevent them from having an accumulative critical effect; in three generations they became a background of assumption about art from which real and immediate criticism of a new kind could grow. There were, besides, always some minds restless enough to make an analogy occasion for a real statement about art, a careful formulation of a commonplace, perhaps, or the injection of a potentially profitable idea. So Boccaccio, for example, was stimulated to give a classic definition of what so much early Renaissance art conventionally intends:

. . . secondo che ne bastano le forze dello 'ngegno, c'ingegnamo nelle cose, le quali il naturale esemplo ricevono, fare ogni cosa simile alla natura, intendendo, per questo, che esse abbiano quegli medesimi effetti che hanno le cose prodotte dalla natura, e, se non quegli, almeno, in quanto si può, simili a quegli, sí come noi possiam vedere in alquanti esercizi meccanici. Sforzasi il dipintore che la figura dipinta da sé, la quale non è altro che un poco di colore con certo artificio posto sopra una tavola, sia tanto simile, in quello atto ch'egli la fa, a quella la quale la natura ha prodotta e naturalmente in quello atto si dispone, che essa possa gli occhi de' riguardanti o in parte o in tutto ingannare, facendo di sé credere che ella sia quello che ella non è . . .[34]

2. FILIPPO VILLANI AND THE PATTERN OF PROGRESS

A humanist sometimes fell into moods or modes of revulsion from the world of affairs. Petrarch wrote a *De otio religioso*, which contains some quite negative reflections about sculpture, and his admirer Coluccio Salutati wrote a *De seculo et religione* recom-

[33] 'Sed neque natura neque arte simul id quod quaerimus adipiscemur. deficiente etenim splendido et ornato viro, quem per vestigia in dicendo passim insequamur, neque graves in sententiis neque elegantes sermonis in cultu splendoreque verborum esse poterimus, non dissimiles recte plerisque pictoribus, qui, cum natura et arte sese pollere arbitrentur rerumque omnium formas et imagines quasi Apelles et Aglaophon effingere contendant, non tamen res ipsas, cum a pueris prave didicerint, expolire poterunt, rudes omnino et ab omni cultu abhorrentes. nunc iam tandem quid imitatio, in qua omnes multum adiumenti esse fateantur, polliceatur et praestet percunctemur licebit' ('Oratio fratris Antonii Raudensis theologi ad scolares', in K. Müllner, *Reden und Briefe italienischer Humanisten*, Vienna, 1899, pp. 167–73).
[34] Boccaccio, *Il Comento alla Divina Comedia*, ed. D. Guerri, iii, Bari, 1918, 82 (*Inferno* xi. 101–5).

mending monastic withdrawal from the active life. This includes an unusual view of the great buildings of Florence:

Let us climb the hill dedicated to the holy blood of the Blessed Miniato on the left bank of the Arno, or the two-peaked mountain of ancient Fiesole, or any of the surrounding ridges from which every cranny of our city of Florence can be fully seen. Let us climb up, pray, and look down on the city walls jutting upward to the heavens, on the splendid towers, on the vast churches, and the splendid palaces. It is difficult to believe these could have been completed even at public expense, let alone built out of private men's wealth, as is the case. But then let us bring our eyes or minds back to each individual structure, and consider what deterioration each one of them has sustained. The Palazzo del Popolo has been admired by all and is, it must be admitted, a superb work; yet through its own weight it is collapsing on itself and is falling apart with gaping cracks both within and without. It already seems to be foretelling its own eventual, gradual ruin. Our Cathedral, a wonderful work with which—if it were ever completed—one would believe no building made by human beings could be compared, was undertaken with great expense and exertion and has now been taken as far as the fourth storey, which the fine campanile reaches too. Nothing could be decorated with marble more beautifully, nothing could be painted or designed more attractively. But the Cathedral has developed a fissure and seems about to end in a state of hideous ruin: soon it will be in need of restoring quite as much as completing. (III)

Salutati wrote his book in 1381 and it was much admired by his friend Filippo Villani, who praised it as 'utilis ad detestationem negotiosae vitae' and lost no time in writing a depressed and recessive book of his own, the *De origine civitatis Florentiae et eiusdem famosis civibus* of 1381–2; this includes brief lives of many Florentine notables and is important to us for its chapter on painters.[35] The theme of Villani's book is that the present age is debased, and that Florence needs reminding of the virtues of such earlier citizens as Dante and his generation: 'sane eo nunc scelerum atque ignaviae perventum est, ubi necesse sit in saeculi praesentis ignominiam antiquorum virtutes memoria renovare.'[36]

[35] Villani's chapter on painters has been very much discussed; see particularly: C. Frey, *Il codice Magliabecchiano*, Berlin, 1892, pp. xxxii–xxxvii; J. v. Schlosser, 'Lorenzo Ghiberti's Denkwürdigkeiten', *Jahrbuch der K. K. Zentral-Kommission*, iv, 1910, 127–33; L. Venturi, 'La critica d'arte alla fine del Trecento (Filippo Villani e Cennino Cennini)', *L'Arte*, xxviii, 1925, 233–44; M. Meiss, *Painting in Florence and Siena after the Black Death*, Princeton, 1951, p. 69; E. Panofsky, *Renaissance and Renascences in Western Art*, Stockholm, 1960, pp. 14–19.

[36] *Philippi Villani Liber de civitatis Florentiae famosis civibus*, ed. G. C. Galletti, Florence, 1847, p. 5. The work is cited here as *De origine*.

He therefore fills his own *vita solitaria* by providing a memorial of these; formally his book is not a paean to present glories.

Villani was under the impression that the impersonal verb *decet* took a dative of person. He wrote of Giotto: 'fuit etiam ut viro decuit prudentissimus fame potius quam lucri cupidus' ('he was also, as was proper to a man, very prudent of his reputation, rather than anxious for monetary gain'). When he had finished, Filippo passed a copy of his book to Salutati, the arbiter of humanist performance in late Trecento Florence, who went through it, correcting errors in its Latin. Salutati, of course, saw *viro decuit* as a solecism. He put disapproving dots under *viro* and *prudentissimus* and indicated in the margin that the phrase should read: *virum decuit prudentissimum*.[37] In doing this Salutati was going rather beyond simple correction of the dative to an accusative; he was also attaching the adjective *prudentissimus* to the noun *vir*. The sentence now read: 'he was also, as was proper to a most prudent man, anxious for fame rather than gain.' The incident goes some way towards defining a relationship between Filippo Villani and literary humanism. First, Filippo's latinity was insecure; he did not really know how to use *decet* in a Ciceronian way. Second, in some circumstances this insecurity involved an independence from patterns that were verbal conventions, certainly, but also conventions of thought. The effect of Salutati's distaste for a clumsy chiasmus (*prudentissimus fame . . . lucri cupidus*) was to generalize the purchase of the word *prudens*. In this sort of context it rang a particular bell for Salutati; his emendation overlays Giotto with a more humanist character, the *prudens vir* of considered virtue. For Filippo, Giotto had been 'careful of his reputation', as a decent man is; Salutati's emendation makes him more expansively and diffusely 'desirous of Fama', as a *prudens vir* should be. Giotto had been coaxed into a humanist category.

A last point to notice about this trivial matter is that Filippo accepted Salutati's emendation; he wanted to be classical. He was one of the group of Florentines led by Salutati who began the process of assimilation between Petrarchan humanism on the one hand and the republican intellectual tradition of Florence on the

[37] Biblioteca Laurenziana, Florence, MS. Ashburnham 942, fol. 36ᵛ. For the roles of Villani and Salutati in the manuscript as a whole, see especially B. L. Ullman, 'Filippo Villani's Copy of his History of Florence', in his *Studies in the Italian Renaissance*, Rome, 1955, p. 241.

other;[38] Filippo and his book *De origine* belong to an early stage in this development. The book was written very shortly after Filippo had completed a fairly successful period of five years as Chancellor of the Republic of Perugia. His background was a family of Florentine chroniclers and politicians committed to the values of the mercantile middle class in Florence. He is apologetic about his father and uncle because they had written their chronicles in Italian:

Ioannes mihi patruus, Matthaeus pater conati sunt quae tempora secum attulerunt memoratu digna vulgaribus litteris demandare. Rem sane non confecere bellissimam: id fecere, ut reor, ne gesta perirent iis qui ingenio meliori meliora portenderent, et ut scribendi politius materiam praepararent.[39]

But in many ways he was of their kind. He may, under the influence of Salutati's *De seculo et religione*, speak airily of the withdrawn life, but the personal context of this kind of remark is, again as with Salutati, active engagement in affairs. How far it may have been a literary pose, and how far it was real disenchantment after some unpleasantness about his conduct of accounts at Perugia, it is not possible to know. But it is always clear in the *De origine* that here speaks a man drawing strength from many sides of Florentine culture: a jurist and student of the Church Fathers, a negotiator abroad for the great Arte di Calimala, a future lecturer on Dante at the university of Florence. It is perhaps fair to use an un-Ciceronian prefix he himself was fond of and describe Filippo, with no intention at all to belittle, as a semi-humanist.

The *De origine* has two parts; the first deals with the legends of the foundation of Fiesole and later of Florence, the second with its distinguished citizens. The classes of citizens are Poets, Theologians, Jurists, Physicians, Orators, Semipoets, Astrologers, Musicians, Painters, Buffoons, and Captains, and there are separate sections on Niccolò Acciaiuoli, Grand Seneschal of Naples, and on Giovanni and Matteo Villani. The chapter on painters follows that on musicians:[40]

[38] For Villani in general, G. Calò, *Filippo Villani*, Rocca S. Casciano, 1904, and, for his relationship to the humanism of Salutati, also H. Baron, *The Crisis of the Early Italian Renaissance*, 2nd edition, Princeton, 1966, pp. 317–20.

[39] *De origine*, ed. cit., p. 40.

[40] The text used here is not the customary Ashburnham 942, supplemented from Gaddianus 89 inf. 23, both from the Biblioteca Laurenziana; this is generally accessible in,

The ancients, who wrote admirable records of events, included in their
books the best painters and sculptors of images and statues along with
other famous men. The ancient poets too, marvelling at the talent and
diligence of Prometheus, represented him in their tales as making men
from the mud of the earth.[41] These most wise men thought, so I infer,
that imitators of nature who endeavoured to fashion likenesses of men
from stone and bronze could not be unendowed with noble talent and
exceptional memory, and with much delightful skill of hand. For this
reason, along with the other distinguished men in their annals they put
Zeuxis . . . Phidias, Praxiteles, Myron, Apelles of Cos . . .[42] and others
distinguished in this sort of skill. So let it be proper for me, with the
mockers' leave, to introduce here the excellent Florentine painters,
men who have rekindled an art that was pale and almost extinguished.

First among whom John, whose surname was Cimabue,[43] sum-
moned back with skill and talent the decayed art of painting, wantonly
straying far from the likeness of nature as this was, since for many
centuries previously Greek and Latin painting had been subject to the
ministrations of but clumsy skills, as the figures and images we see
decorating the churches of the Saints, both on panels and on walls,
plainly show.

After John, the road to new things now lying open, Giotto—who is
not only by virtue of his great fame to be compared with the ancient
painters, but is even to be preferred to them for skill and talent—
restored painting to its former worth and great reputation. For images
formed by his brush agree so well with the lineaments of nature as to
seem to the beholder to live and breathe; and his pictures appear to
perform actions and movements so exactly as to seem from a little way
off actually speaking, weeping, rejoicing, and doing other things, not
without pleasure for him who beholds and praises the talent and skill
of the artist. Many people judge—and not foolishly indeed—that
painters are of a talent no lower than those whom the liberal arts have
rendered *magistri*, since these latter may learn by means of study and
instruction written rules of their arts while the painters derive such

inter alia, C. Frey, *Il libro di Antonio Billi*, Berlin, 1892, pp. 73–5, who established the stan-
dard text by filling the lacunae of the authentic Ashb. 942 from the inferior Gadd. 89 inf. 23.
For a number of reasons, including that of increasing options, I have preferred the Vatican
MS. Barb. lat. 2610, not printed before. This is a revised version of the book from about
1395. In the section on painters there are only three significant variations of fact from the
supplemented Ashb. 942. These are pointed out on p. 71, nn. 45, 47 and 49. For the
Vatican manuscript and its date, see A. Massèra, 'Le più antiche biografie del Boccaccio',
Zeitschrift für romanische Philologie, xxvii, 1903, 299–301.

[41] Lactantius, *Divinarum Institutionum* II. x. 12.

[42] The list of ancient artists is evidently corrupt in Barb. lat. 2610; in Ashburnham 942
it reads: 'ceusim policretum phydiam prasitelem mironem appellem conon . . .'

[43] For Villani's classical model in stating the relationship between Cimabue and Giotto,
see p. 77.

rules as they find in their art only from a profound natural talent and a tenacious memory.[44] Yet Giotto was a man of great understanding even apart from the art of painting, and one who had experience in many things. Besides having a full knowledge of history, he showed himself so far a rival of poetry that keen judges consider he painted what most poets represent in words. He was also, as was proper to a most prudent man, anxious for fame rather than gain. Thus, with the desire of making his name widely known, he painted something in prominent places in almost every famous city of Italy, and at Rome particularly in the atrium of the Basilica of St. Peter, where he represented most skilfully in mosaic the Apostles in peril in the boat [Plate 3], so as to make a public demonstration of his skill and power to the whole world that flocks to the city. He also painted with the help of mirrors himself and his coeval the poet Dante Alighieri on a wall of the chapel of the Palazzo del Podestà.[45]

As from a most copious and pure spring glittering brooklets of painting flowed from this admirable man and brought about an art of painting that was once more a zealous imitator of nature, splendid and pleasing. Among whom Maso,[46] the most delightful of all, painted with wonderful and unbelievable beauty. Stefano,[47] nature's ape, imitated nature so effectively that in human bodies represented by him the arteries, veins, sinews, and every most minute lineament are accurately disposed as by physicians: so much so that, as Giotto himself said, his pictures seem only to lack breath and respiration. Taddeo[48] painted buildings and places[49] with such skill as to seem a second Dynocrates or Vitruvius (a man who wrote a treatise of architecture). And to count

[44] *Ingenium . . . artes . . . praecepta . . .; . . . ingenium . . . memoria . . . ars.* Cf. Isidore, *Etymologiae* I. i. 2: 'ars vero dicta est quod artis *praeceptis* regulisque consistat'; and see pp. 15–16.

[45] MS. Ashb. 942 reads *in tabula altaris*; Vat. Barb. lat. 2610 reads *in pariete*—that is, a fresco, not a hypothetical lost altar painting. For a full bibliography of the long discussion about this portrait, G. Previtali, *Giotto e la sua bottega*, Milan, 1967, p. 336.

[46] Maso di Banco, documented in Florence between 1341 and 1346. There are no surviving documented works but, ever since Ghiberti, the frescoes of the life of Saint Sylvester in the Bardi di Vernio chapel of S. Croce have been attributed to him.

[47] For the problem of Stefano, R. Longhi, 'Stefano Fiorentino', *Paragone*, ii. xiii, 1951, 18–40. For the phrase *simia naturae*, H. W. Janson, *Apes and Ape Lore in the Middle Ages and the Renaissance*, London, 1952, pp. 287–94, and E. R. Curtius, *European Literature and the Latin Middle Ages*, New York, 1953, p. 538, who cites in this connection Dante, *Inferno*, xxix. 139: 'Com'io fui di natura buona scimia . . .' For the rest, see Pliny on the bronze sculptor Pythagoras, *N.H.* xxxiv. 59 ('. . . primus nervos et venas expressit . . .'). The ascription of the final remark about Stefano to Giotto occurs only in Vat. Barb. lat. 2610, not in Ashb. 942.

[48] d. 1366. There are documented Madonnas in Berlin, Staatliche Museen, 1334; Pistoia, S. Giovanni Fuorcivitas, 1353; and Florence, Uffizi, 1355. Among the attributed works are the frescoes in the Baroncelli chapel, S. Croce; cf. P. Donati, *Taddeo Gaddi*, Florence, 1966.

[49] Gaddianus 89 inf. 23, supplementing the lacuna in Ashburnham 942, omits 'et loca', a valuable addition only in Vat. Barb. lat. 2610.

the countless men who, following these, made the art renowned would
need more time than I have and draw the subject out too lengthily; so,
content to have spoken on this matter concerning these men, I pass on
to other things. (V)

The chapter on painters is followed by that on *buffoni*.

Filippo's primitive humanist ornaments are quite regularly
quoted out of context as dashing new opinions about painting;
but to adduce as 'bold' Filippo's remark that, say, Giotto is to be
preferred to the ancient painters, or even his reference to the
ancient painters' respectability as justification for a section on
modern painters, is to move directly against the evidence. This is
not just because both these remarks have the form of notorious
commonplaces, but because the measure of remarks of this sort
is provided within the rest of Filippo's book. So, it is true that
Filippo says Giotto is to be preferred to the ancient artists; we
cannot however really claim that this represents a considered
opinion, not just because 'better than the ancients' was a humanist
formula of praise, but because a few pages earlier Filippo has said
that Pagolo de' Dagomari surpassed all ancient and modern
astronomers.[50] Again, it is true that Filippo mentions the antique
antecedents of the modern artists as a reason for including them
in his book. But we cannot very well take this as a new conviction
of the painter's intellectual respectability, because in an exactly
similar way Filippo cites Roscius as the antecedent and justifica-
tion of Gonnella and the *buffoni*:

Dicet quis fortasse ridiculum, si de facetissimis histrionibus Florentinis,
qui acumine ingenii quam multa iocosa confecerint ludicra, amoenitatis
tantae, ut in proverbium pene decurrerint, pauca narravero. Sed Roscius
famosus et emendatissimus ioculator, sine quo magnus Pompeius iucun-
dam diem Romae fere non egerit, excusationem faciat, de quo re-
tulerunt plerique scriptores impraemeditatum nunquam dixisse aliquid
vel egisse: idque ipsum placiditate tanta arteque tanta, ut etiam nobilis-
sima ingenia cogeret pro suis adinventionibus admirationi, librumque
pulcherrimum ferunt de arte histrionica confecisse.[51]

Filippo's stock of humanist formulas was limited, but those he
had he worked hard: as Roscius stood to buffoons, Zeuxis did to
painters.

[50] *De origine*, ed. cit., p. 53. For the commonplace of contemporaries outdoing the
ancients, see E. R. Curtius, op. cit., pp. 162–6.
[51] Op. cit., p. 36.

In any case, Filippo was explicit about the point of his book: he is, so he says, extending into other fields of Florentine activity a conception of cultural revival modelled on Dante. He had begun by writing about Dante only; it then occurred to him to treat other classes of people in the same way:

While I tried arguing this out with myself, a desire for a larger undertaking somehow came upon me. For while I was diligently dealing with what our Poet had done, many most learned and famous fellow citizens of his came into my mind, the very recollection of whom could stimulate the capacities of the living to emulate their excellence. For, as you know, a mind of good innate quality, reminded of illustrious men who have spread far and wide the name of their native town, is incited and inflamed with a desire of equalling such men, so as to increase the glory of the city. Indeed, such a pitch of criminality and wickedness has nowadays been reached that it is necessary to renew again in our memory the excellence of our forefathers amidst the ignominy of this present age . . . In commemorating these poets and others, I have not kept them in order of time, but shall join together those whom the same arts and disciplines made colleagues; so that splendour added to splendour, its rays multiplied and enlarged, shall shine the more strongly and wonderfully in the eyes of the beholder.[52]

It followed that the sort of attention here given to great Florentines of the fourteenth century was to a very large extent predetermined. It was to focus on glories revived by the Florentines, and the model for this revival was to be Dante. To speak of Giotto in terms of revival was not a new thing. Exactly the same image as Filippo used to describe Dante himself—'revocavit poesin in lucem'—Boccaccio had already used of Giotto—'avendo egli quella arte di pittura ritornata in luce'.[53] The parallel was built into the circuits of humanist discourse, and Filippo's chapter is an expansion and a particularization.

[52] 'Haec dum mecum concionando tentarem, quo pacto nescio, majoris occupationis ardor incessit. Nam dum nostri Poetae quae facta sunt diligentius agitarem, Concives multi doctissimi et famosi per meum animum incesserunt, quorum vel sola recordatio viventium possit ingenia excitare aemulatione virtutum. Nam, ut cernis, bonae indolis animus, illustribus viris ad memoriam revocatis, qui patriae suae nomen longius propagassent, irritatur, incenditur studio viros huiusmodi coaequandi, ut inde possit civitatis suae gloria augeri. Et sane eo nunc scelerum atque ignaviae perventum est, ubi necesse sit in saeculi praesentis ignominiam antiquorum virtutes memoria renovare . . . Ceterum in horum aliorumque commemorationem, serie temporum et ordine non servato, quos eaedem artes atque doctrinae fecere consortes, simul jugabo, ut splendori superadditus splendor, multiplicatis ampliatisque radiis, in contuentium oculos fortius ac mirabilius elucescat' (op. cit., p. 5).

[53] *Decamerone* vi. 5.

It is the manner of the particularization that matters. A number of humanist critical categories are present, at least by invocation though they are never very exactly brought to bear. Much the most prominent is the couple *ars* and *ingenium*, but Filippo holds it firmly in tandem as a compound quality for praise, without playing on the distinction. Behind *ars* and *ingenium* is the couple *exemplaria* and *natura* (model patterns: nature). Filippo limits himself to *natura*. In the Florentine tradition of discussing Giotto there was not much part for *exemplaria*: the Giotto talked about was always the

> Giotto, al qual la bella
> Natura parte di sè somigliante
> non occultò nell'atto in che suggella.[54]

Even Filippo's uncle Giovanni had characterized him as 'quegli che più trasse ogni figura e atti al naturale'.[55] The most influential formulation of all had probably been Boccaccio's:

... l'altro, il cui nome fu Giotto, ebbe uno ingegno di tanta eccellenza, che niuna cosa dá la natura, madre di tutte le cose ed operatrice col continuo girar de' cieli, che egli con lo stile e con la penna e col pennello non dipignesse sí simile a quella, che non simile, anzi piú tosto dessa paresse, in tanto che molte volte nelle cose da lui fatte si truova che il visivo senso degli uomini vi prese errore, quello credendo esser vero che era dipinto. E per ciò, avendo egli quella arte ritornata in luce, che molti secoli sotto gli error d'alcuni che piú a dilettar gli occhi degl'ignoranti che a compiacere allo 'ntelletto de' savi dipignendo era stata sepulta, meritamente una delle luci della fiorentina gloria dirsi puote; e tanto piú, quanto con maggiore umiltá, maestro degli altri in ciò vivendo, quella acquistò, sempre rifiutando d'esser chiamato maestro; il qual titolo rifiutato da lui tanto piú in lui risplendeva, quanto con maggior disidèro da quegli che men sapevan di lui o da' suoi discepoli era cupidamente usurpato.[56]

But within the habit of Filippo's own book a distinction is in fact made between the interest offered by Giotto's painting and the interest offered by, say, humanist literature. The painter Stefano is for Filippo *simia naturae*; his own friend Coluccio Salutati is *simia Ciceronis*.[57] The *natura–exemplaria* distinction was within Filippo's range, but only *natura* was to the point in praising

[54] Boccaccio, *Amorosa visione* iv. 16–18.
[55] Giovanni Villani, *Cronica*, ed. F. G. Dragomanni, iii, Florence, 1845, 232 (XI. xii).
[56] *Decamerone* vi. 5. [57] *De origine*, ed. cit., p. 19.

painters. There is no great degree of organization in Filippo's possession of these very generally accessible binary categories: there is for instance no suggestion at all of interest in their overlap, in the relationships between *ars* and *exemplaria, ingenium* and *natura*.

His potentiality for humanist art-criticism lay more in the pattern of his description of the Trecento situation. Roughly speaking, the sequence he describes is this: Cimabue first began to recall painting from its decadence, and Giotto, who represented things better than he but yet was following a road already opened up by him, completed the revival; from Giotto sprang a number of other painters—including Maso, Stefano, and Taddeo —who were different among themselves. The potentiality of this sequence is that, latent in a very concise linear pattern— (C:)G–m/s/t . . ., so to speak—there are several distinct kinds of differentiation between one artist and another. The form, prophet-saviour–apostles, seems simple but is here charged with a developed style of discrimination. In the relationship stated between Giotto and Cimabue two standards are in play. There is, first, a scale of chronological priority: it was Cimabue, not Giotto, who opened up the road. Playing against this is a standard of absolute achievement in the representation of nature: Giotto's work is in this respect better, absolutely, than Cimabue's, and being more impressive is more fully described. Yet on the question of absolute stature there is a tactful vagueness; it is not, given the artists' relative circumstances, a matter on which judgement could usefully be pressed. With the relationship between Giotto and his followers, it was however proper to do so. As they were secondary to Giotto both chronologically and in the quality of their achievement, they were therefore also secondary to him in stature. But these secondary artists, contemporary with each other, also differ among themselves. This is a difference neither of priority, nor of actual achievement, nor of stature; it is a difference of kind. Maso (*delicatissimus omnium*) offers this sort of interest, Stefano (*imitatio . . . in figuratis corporibus*) that, and Taddeo (*edificia et loca tanta arte*) that other. And the fact that they are described in terms of such specialist quality is in turn one means of implying stature secondary to the general representative force of Giotto. One could think that, given half a dozen painters and two pages to mention them, implications

of value analogous with Filippo's are inevitable, but this is not
so; a glance at Michele Savonarola's later account at similar
length of a similar number of painters active in Padua[58] is a quick
way of seeing that it is not. There is no fourteenth- or fifteenth-
century parallel outside Florence for the delicacy and firmness
with which Filippo's artists are placed and his valuations implied,
or for the nimbleness with which he trims his standards.

To a certain extent this was a humanist achievement. Filippo's
focus on his subjects projected on to a number of other arts and
sciences a particular view of Dante's position in the history of
literature; it was therefore a semi-humanist focus on the revival
of these arts and sciences. In some of its appearances the pre-
occupation with a revival of culture was one of the critical
strengths of the humanists, since it compelled a degree of thought
and statement about the part of individuals in this revival. It is
true this sharp edge on their contemplation of men and their
works was soon blunted; the act of coming to terms with one's
predecessors easily deteriorated into standard judgements uttered
in conventional formulations. All the same, it is in the humanists'
discussions about the relative importance of individuals in the
revival of letters[59]—for instance, the disagreements about whether
Dante or Petrarch was the true beginning of the rebirth of letters
—that their operative values are most clearly exposed. What
compounds the humanism of Villani's view of painting, how-
ever, is that he goes on to project upon Giotto not only the
historical position of Dante but also the historical position of
Zeuxis, as this is formulated by Pliny. The fact of there having
been Cimabue before Giotto was enshrined in Dante himself:

> Credette Cimabue ne la pintura
> tener lo campo, e ora ha Giotto il grido,
> sí che la fama di colui è scura.[60]

But this does not say very much about their respective contri-
butions to the art, and the Trecento commentaries on Dante
really do not expand on the artistic relationship between the

[58] Michele Savonarola, *Libellus de magnificis ornamentis regie civitatis Padue*, ed. A. Segarizzi
in Muratori, *Rerum Italicarum Scriptores*, xxiv, 1902, 44–5.

[59] Especially 'Leonardo Aretini ad Petrum Paulum Istrum dialogus', in T. Klette,
Beiträge zur Geschichte und Litteratur der italienischen Gelehrtenrenaissance, ii, Greifswald, 1889;
or in *Prosatori latini del Quattrocento*, ed. E. Garin, Milan, 1952. pp. 44–99.

[60] *Purgatorio* xi. 94–6.

two. Villani's main source for ancient painting was Pliny's *Natural History*, and Pliny's account of the relation between Apollodorus and Zeuxis[61] became his model for saying how Cimabue stood to Giotto. It was Apollodorus who first gave his figures the appearance of reality ('hic primus species exprimere instituit'), just as it was Cimabue who first began to recall painting to the likeness of nature. It was through 'gates opened' by Apollodorus that Zeuxis entered ('ab hoc artis fores apertas'), and so along a 'road opened' by Cimabue that Giotto restored painting ('strata iam in novis via'). It was Zeuxis, however, who gave the painter's aspiring brush its full glory ('audentemque iam aliquid penicillum . . . ad magnam gloriam perduxit'), as it was later Giotto who restored painting to its former greatest glory ('in pristinam dignitatem nomenque maximum picturam restituit').

At the same time what Villani passed through this humanist focus came out of a vulgar sense of history in such matters. An awareness of the sequence of the city's painters seems highly developed in Florence, naturally most of all among painters themselves; Cennino Cennini describes his artistic ancestry:

fui informato nella detta arte xii anni da Angnolo di Taddeo da Firenze mio maestro; il quale inparo la detta arte da Taddeo suo padre; il quale suo padre fu battezato da Giotto, e fu suo discepolo anni xxiiii°; il quale Giotto rimuto l'arte del dipingnere di grecho in latino, e ridusse al moderno; e ebe l'arte piu compiute ch'avessi mai piu nessuno.[62]

Further, making remarks about how good people were at the things they did was very much part of the texture of Florentine discussion.

. . . furono già certi dipintori e altri maestri, li quali essendo a un luogo fuori della città, che si chiama San Miniato a Monte, per alcuna dipintura e lavorìo, che alla chiesa si dovea fare; quando ebbono desinato con l'Abate, e ben pasciuti e bene avvinazzati, cominciorono a questionare; e fra l'altre questione mosse uno, che avea nome l'Orcagna, il quale fu capo maestro dell'oratorio nobile di Nostra Donna d'Orto San Michele:

— Qual fu il maggior maestro di dipignere, che altro, che sia stato da Giotto in fuori? — Chi dicea che fu Cimabue, chi Stefano, chi Bernardo,

[61] *Nat. Hist.* xxxv. 60–1.
[62] *Il Libro dell'Arte*, ed. D. V. Thompson, i, New Haven, 1932, 2.

e chi Buffalmacco, e chi uno e chi un altro. Taddeo Gaddi, che era nella brigata, disse:

— Per certo assai valentri dipintori sono stati, e che hanno dipinto per forma, ch'è impossibile a natura umana poterlo fare; — ma questa arte è venuta e viene mancando tutto dì. —[63]

In Boccaccio's account of Giotto, as we have seen, Filippo could have found formulations of Giotto's relationship to the Middle Ages, to nature, and to his pupils, but it is questionable whether he needed to go that far. Such formulations probably lay to hand in Florentine small talk. Beyond a certain point it seems tactless to look for literary sources for Filippo's remarks, and this is his strength.

Villani's semi-humanist account of early fourteenth-century painting is compelling enough for the history of art not yet to have outgrown it. The pattern in our handbooks is still substantially his adaptation of Pliny's account of Apollodorus, Zeuxis, and his followers to the Trecento situation: Cimabue, Giotto, and Giotteschi. It is an attractive pattern; it articulates very boldly an awkward chapter in the history of painting, and it is inherently satisfying because it embodies so compactly such varied differentiations—priority, quality, stature, kind. Its self-contained character set a problem for fifteenth-century humanists, who quite failed to find any such clearly structured pattern to follow it into their own time.[64]

3. MANUEL CHRYSOLORAS, GUARINO, AND THE DESCRIPTION OF PISANELLO

So far this chapter has been concerned with a humanism based mainly on Latin literature and such Greek literature as was accessible in Latin translations, especially Aristotle and the Greek Fathers. From about 1400 this basis was much broadened and humanists began to read many more Greek authors, either in new translations or, in increasing numbers, in Greek. The balance of their Greek reading seems by our standards a little off-centre, for

[63] Franco Sacchetti, *Il Trecentonovelle*, Novella CXXXVI. The passage is discussed by M. Meiss, *Painting in Florence and Siena after the Black Death*, Princeton, 1951, pp. 3–5.

[64] The earlier 15th-century remarks about the revival of painting have been much discussed: see, for example, W. K. Ferguson, *The Renaissance in Historical Thought*, Cambridge, 1948, pp. 18–28, and E. Panofsky, *Renaissance and Renascences in Western Art*, Stockholm, 1960, Ch. I. The most interesting statement seems that of Matteo Palmieri, *Della vita civile*, ed. F. Battaglia, Bologna, 1944, p. 36, written in 1439.

it leaned more than ours to the later Greek sophistic literature. In this respect the Italian humanists were reflecting the taste and values of the Byzantines from whom they learned their Greek. Still, the literary sources of humanism were very much more varied in 1425 than they had been in 1400, and this had its effect on their ways of speaking about painting and sculpture.

The principal agent in this spread of Greek studies was Manuel Chrysoloras,[65] the Byzantine humanist and diplomat, who came to Italy from Constantinople in about 1395. There had been other teachers of Greek even in northern Italy before him, but the impression made on Italian humanism by Manuel was of a quite different order. He taught Greek, particularly in Florence and Lombardy, and wrote a Greek grammar, the *Erotemata*, which was a standard handbook in western Europe well into the sixteenth century; he also inspired a handful of the Italians to make their way to Constantinople and study at the source. Yet Manuel is a curiously uncertain quantity. One difficulty is that there is no substantial body of writings; apart from the *Erotemata*, there are only a dozen letters, a couple of translations and one pious treatise. It is therefore hard to be sure what precisely was the quality of Manuel's influence and what aspects of the Byzantine tradition he would have displayed most clearly, and it is correspondingly difficult to distinguish between different degrees of indoctrination by him. A man who just attended Manuel's lectures in Florence is obviously different from one like Guarino of Verona, who followed him to Constantinople and spent years in that city, but finer distinctions are almost impossible to draw. What is not in doubt is that Manuel left a deep impression on an astonishingly large number of the more talented Italian humanists, and if that impression may sometimes have been not much more than the elements of Greek grammar and an admiration for Manuel's Levantine urbanity it was none the less real for that. It was a main source and stimulus for the curiosity about Greek things that became the most expansive element in Quattrocento humanism.

So, with the general lack of evidence about the colour of his teaching, it is fortunate that Manuel left clear indications of

[65] For Chrysoloras, G. Cammelli, *Manuele Crisolora*, Florence, 1941. For a survey of previous Greek teaching in Italy, A. Pertusi, *Leonzio Pilato fra Petrarca e Boccaccio*, Venice, 1965, Ch. VII, especially its bibliography.

a literary attitude towards painting and sculpture. In 1411 he was induced by the new Pope, John XXIII, to go to Rome, on the chance of negotiating military help for the beleaguered Constantinople, and he was kept waiting for two years in Rome before he realized that nothing was seriously intended. During this period of frustration Manuel, who seems to have been a reluctant writer, composed three formal letters on topics suggested to him by his surroundings. The first and very much the longest is the *Comparison of Old and New Rome*,[66] addressed to John VIII Palaeologue. It is a very ample and highly evolved rhetorical construction indeed, an extended comparison of Rome with Constantinople. The conclusion is based on standards of pleasure and utility: Constantinople, the maritime city, is the finer mainly because its foundation followed from a rational choice, in a free choice situation, of a site adapted to the full functions of world government; and yet, as Manuel blandly suggests, is not the superior beauty of the Daughter to the Mother's credit? However, the successive characterizations of the cities, Rome and then Constantinople, admit various kinds of descriptive discourse. Rome is submitted to a meditation on ruins in the tradition of the Emperor Theodore Lascaris's thirteenth-century letter on Pergamon,[67] with reflections on the greatness of ancient inhabitants and the transitoriness of men's works. In the course of this Manuel gives clearer evidence than any Italian humanist of having looked closely at the relief sculpture on the Arch of Constantine (Plate 2) and others:

... triumphal arches erected in commemoration of their triumphs and solemn processions: on these are carved in relief their battles and captives and spoils, fortresses taken by storm; and also sacrifices and victims, altars and offerings. As well as these there are battles of ships, of horse and foot, and every shape of war-engine and arms; and conquered kings of the Medes, it may be, or Persians or Iberians or Celts

[66] In *Patrologia graeca*, ed. J.-P. Migne, Paris, 1857–60, clvi, cols. 23–53; also in Georgius Codinus, *Excerpta de antiquitatibus Constantinopolitanis*, ed. P. Lambecius, Paris, 1655, pp. 107–30 and Venice, 1729, pp. 81–96, all with Latin paraphrases. Part of the letter is effectively used by Gibbon in *The Decline and Fall of the Roman Empire*, Ch. LXVII.

[67] *Theodori Ducae Lascaris Epistulae CCXVII*, ed. N. Festa, Florence, 1898, pp. 107–8. See too S. Antoniadis, 'Sur une lettre de Théodore II Lascaris', in *L'hellénisme contemporain*, viii, 1954, 356 ff. and C. Mango, 'Antique Statuary and the Byzantine Beholder', *Dumbarton Oaks Papers*, xvii, 1963, 69; for the role of descriptive passages in Byzantine letters, see particularly G. Karlsson, *Idéologie et cérémonial dans l'épistolographie byzantine*, 2nd edition, Uppsala, 1962, pp. 112–36.

or Assyrians, each in their own costume; and subject races with the
generals triumphing over them, and the chariot and the *quadrigae* and
the charioteers and bodyguards, and the captains following after and
the booty carried before them—one can see all this in these figures as if
really alive, and know what each is through the inscriptions there. So
that it is possible to see clearly what arms and what costume people
used in ancient times, what insignia magistrates had, how an army was
arrayed, a battle fought, a city besieged, or a camp laid out; what
ornaments and garments people used, whether on campaign or at home
or in the temples or the council-chamber or the market-place, on land
or sea, wayfaring or sailing in ships, labouring, exercising or watching
the games, at festivals or in workshops—and all these with the dif-
ferences between the various races. Herodotus and some other writers
of history are thought to have done something of great value when
they describe these things; but in these sculptures one can *see* all that
existed in those days among the different races, so that it is a complete
and accurate history—or rather not a history so much as an exhibition,
so to speak, and manifestation of everything that existed anywhere at
that time. Truly the skill of these representations equals and rivals
Nature herself, so that one seems to see a real man, horse, city, or army,
breastplate, sword, or armour, and real people captured or fleeing,
laughing, weeping, excited or angry. (VI)

This mode of description, a sort of generalized enumeration,
became rather important in humanist art criticism. When he had
written the letter Manuel sent a copy to his Italian pupil Guarino
of Verona and through Guarino it entered the humanists' reading.[68]

But it was another of Manuel's Roman letters, this time
addressed to Demetrius Chrysoloras, that provided the most
important additions to the humanists' repertory of general notions
apt for mentioning in relation to painting or sculpture:

Can you believe of me that I am wandering about this city of Rome,
swivelling my eyes this way and that like some boorish gallant,
clambering up palace walls, even up to their windows, on the chance of
seeing something of the beauties inside? I never used to do this sort of
thing when I was young, as you know, and had a poor opinion of those
who did. Yet here I am, getting on in years, and I scarcely know how
I have been brought to this point. Am I reading you a riddle? Hear,
then, its answer.

I am doing all this in the hope of finding in these places beauty not in
living bodies but in stones, marbles, and images. You might say that

[68] Guarino's letter of thanks is in *Epistolario di Guarino Veronese*, ed.. R. Sabbadini,
Venice, 1915–19, i. 19–21.

this is even more ridiculous than the other. And it has often occurred to me to wonder about this: how it is that when we see an ordinary living horse or dog or lion we are not moved to admiration, do not take them for something so very beautiful or reckon seeing them as something of very much importance. The same is true of trees, fish, and fowl, and also of human beings, a fair number of whom indeed we actively dislike. Yet when we see a representation of a horse, or ox, plant, bird, human being, or even, if you like, of a fly, worm, mosquito, or other such disagreeable things, we are much impressed and, when we see their representations, make much of them. Though they are not, I suppose, any more meticulously formed than the living objects, the representations are praised in proportion to the degree in which they seem to resemble their originals. While we neglect the latter and their beauties when they are present in the life, we admire their representations. We do not concern ourselves with whether the beak of a live bird or the hoof of a live horse is properly curved or not, but we do with whether the mane of a bronze lion spreads beautifully, whether the individual fibres or vessels are visible on the leaves of a stone tree or whether the sinews and veins are shown in the stone leg of a statue. These are the things that men take pleasure in. Many people would willingly have given many living and faultless horses to have one stone horse by Phidias or Praxiteles, even if this happened to be broken or mutilated. And the beauties of statues and paintings are not an unworthy thing to behold; rather do they indicate a certain nobility in the intellect (διάνοια) that admires them. It is looking at the beauties of women that is licentious and base.

What is the reason for this? It is that we admire not so much the beauties of the bodies in statues and paintings as the beauty of the mind (νοῦς) of their maker. This, like well-moulded wax, has reproduced in the stone, wood, bronze, or pigments an image which it grasped through the eyes to the soul's imagination (τὸ φανταστικὸν τῆς ψυχῆς): and just as the soul of each man disposes his body, which has no few areas of softness, so that its own disposition—distress or joy or anger— is seen in the body, so too the artist disposes the outward form of the stone, stubborn and hard though this may be, or of the bronze or pigments, disparate and alien to him though these are, so that through portrayal and skill the passions of the soul can be seen in them. The artist's mind, though it is not itself disposed particularly to laughter or pleasure, anger or sorrow—and may indeed be disposed to their contraries—yet impresses these passions on the materials. This is what we admire in these representations. (VIII)

What Manuel provides here is a general statement in more or less Aristotelian terms of certain very clear values: detailed lifelike-

ness, variety, and an intensity of emotional expressiveness. The question he proposes—How is it that visual representations of things, even of disagreeable things, are as such pleasurable?—is Aristotle's.[69] Aristotle had located the first source of pleasure in the beholder's act of recognition; Manuel does the same, spelling the point out with examples. But then he turns to justify the interest in expressiveness, and to be Aristotelian in doing this was less easy. Aristotle had been reserved about the capacity of the visual arts to stimulate emotion in the beholder: a painting must show the body of a man, and the body of a man can show only symptoms and traces of passion, and these are not passion.[70] But Manuel turns this difficulty by now directing our attention to the efficient cause, the artist. He borrows and expands Aristotle's description of the malleable, euplastic poet[71] and applies it to the visual artist. Again the odd mechanics of this expressive creativeness are spelled out in terms of Aristotelian faculties—*nous*, *psyche*, *phantasia*—and an Aristotelian physiology. So the distinction of the artist's performance lies specially in a capacity to represent in his figures emotional and moral conditions, and it is the recognition of these that is pleasurable. Our admiration is invited particularly for two aspects of this virtuosity: first, the faculty of extending into alien and rigid or inert matter the mechanism by which we externalize the movements of the soul in our own flesh; second, the faculty of assuming and sustaining for the purpose of this act an emotion independent of the personal life. The artist is a kind of gymnast of the sentiments.

This letter was very important indeed to the Italians. For the Venetian humanist Leonardo Giustiniani, Manuel's avowal of rational pleasure in works of art was one good argument for letting oneself enjoy them; for Guarino's son Battista, Manuel had even displaced Aristotle as the authority for the principle of pleasurable recognition.[72] The letter was so much more nimble than anything yet written about art by an Italian humanist that this deep impression is understandable, even apart from Manuel's general prestige. Yet he in turn was writing out of a certain culture, and though his ideas have little except Aristotelian

[69] *Poetics* 1448b. [70] *Politics* 1340a. [71] *Poetics* 1455a.

[72] Giustiniani, see p. 98; Battista Guarino—'... Chrysoloram nostrum sic dicere solitum accepimus scorpios et serpentes quos fugimus, si pictos vera quadam imitatione viderimus, magno opere delectamur ...' (*De ordine docendi et discendi*, in *Il pensiero pedagogico dello Umanesimo*, ed. E. Garin, Florence, 1958, p. 464).

categories in common with the aesthetics of Byzantine Iconodules, and are very difficult to harmonize with the Byzantine art even of his own time,[73] they are closely connected with the rhetorical interests of the Byzantine humanists.

Even at the time people seem to have been agreed that the literary culture of Constantinople was not at one of its peaks at the beginning of the fifteenth century. Filelfo, who was a pupil and eventually a son-in-law of Manuel's nephew John Chrysoloras, spoke contemptuously of academic standards there:

... What is taught publicly by the teachers at the school is all full of nonsense. There is nothing either complete or exact to be got from their teaching about the grammatical construction of discourse, or about the quantities of syllables, or of accents. For the Aeolian tongue, which both Homer and Callimachus most followed in their works, is quite unknown there. What I learned about this sort of thing I learned through my own study and diligence, although I would not deny at all that I got some help from my father-in-law John Chrysoloras. I reached my goal, so far as it could be done, by my own exertions.[74]

Filelfo was an ungenerous man, but such a native scholar as George Scholarios was as critical of the condition of learning in the city as Filelfo was, and it appears from many sources that Byzantine scholarship and education were at this moment in decline.[75] All the same, an Italian humanist in Constantinople touched a Greek culture with a direct pedigree from the ancient world. Guarino spoke of the excitement of hearing demotic Greek spoken in the streets of the city; he was not worried by the rather distant relation of the vernacular with the classical tongue. It was the continuity rather than the decadence that impressed the Italians, and it is easy to understand why this should

[73] The difficulty of squaring Byzantine art with Byzantine literary responses to art is discussed by C. Mango, op. cit., 65–7. The Iconodules are discussed by G. Mathew, *Byzantine Aesthetics*, London, 1963, pp. 117–21.

[74] *Epistolae familiares*, Venice, 1502, pp. 30b–31a: 'Cum istic [i.e. at Constantinople] essem, diu multumque studui quaesivique diligenter comparare aliquid mihi, ex Apollonii Erodianique iis operibus, quae ab illis, de arte grammatica, copiose fuerant, et accurate scripta. Nihil usquam potui odorari. Nam a magistris ludi, quae publicae docentur, plena sunt nugarum omnia. Itaque neque de constructione grammaticae orationis, neque de syllabarum quantitate neque de accentu quicquam, aut perfecti, aut certi, ex istorum praeceptis, haberi potest. Nam lingua aeolica, quam et Homerus, et Callimacus, in suis operibus, potissimum sunt secuti, ignoratur istic prorsus. Quae autem nos de huiusmodi rationibus dídicimus, studio nostro, diligentiaque, didicimus, quamvis minime negarim nos, ex Chrysolora socero, adiumenta nonnulla accepisse. Sed nostro, ut ita dixerim, marte, ad calcem, quoad eius fieri potuit, pervenimus.'

[75] For a number of contemporary criticisms, F. Fuchs, *Die höheren Schulen von Konstantinopel im Mittelalter*, Leipzig–Berlin, 1926, pp. 65–73.

be so, when Latin humanism presented itself as a revival, cut off from its sources by dark centuries of ignorance. And in a sense the very atrophy of Byzantine literary culture guaranteed the survival of what the humanists were looking for. The old Greek rhetoric had been embalmed in the schools of Constantinople for a thousand years; it had shrivelled but not crumbled. In 1400 boys were still being taken through the rhetorical exercises codified by Hermogenes of Tarsus in the second century, the *Progymnasmata*. Literary amateurs were still imitating the sophistic exhibitions of Lucian and Libanius.[76] As we have already seen, the *Progymnasmata* were well known in the west in the Middle Ages through Priscian's *Praeexercitamenta*; what distinguished the Byzantine humanists was that they made the means an end. On the model of late Greek sophistic writers they practised many of the single exercises as independent genres, essays performed for their own sake with great virtuosity and elaboration. In 1400 Byzantine literary people, from the Emperor Manuel II downwards, were writing and circulating exercises in these forms as works of art in their own right. There is no real parallel in the west for the grip the *Progymnasmata* had on Byzantine literary performance.

One of the most advanced of the *Progymnasmata* had been *ekphrasis* or description, the tenth of Hermogenes' twelve exercises:

Ekphrasis is an account with detail; it is visible, so to speak, and brings before the eyes that which is to be shown. Ekphrases are of people, actions, times, places, seasons, and many other things . . . The special virtues of ekphrasis are clarity and visibility; the style must contrive to bring about seeing through hearing. However, it is equally important that expression should fit the subject: if the subject is florid, let the style be florid too, and if the subject is dry, let the style be the same.[77]

Bravura ekphrasis was an important genre for the Byzantine humanist, sometimes as detached essays, sometimes incorporated into letters or other forms, often also metrical.[78] From the beginning works of art had been a favoured subject for ekphrasis—the

[76] On this aspect of Byzantine *belles lettres*, K. Krumbacher, *Geschichte der byzantinischen Literatur*, 2nd edition, Munich, 1897, pp. 1–31, and R. Jenkins, 'The Hellenistic Origins of Byzantine Literature', *Dumbarton Oaks Papers*, xvii, 1963, 43–6.

[77] Hermogenes, *Opera*, ed. H. Rabe, Leipzig, 1913, pp. 22–3.

[78] For ekphrasis in general, K. Krumbacher, op. cit., pp. 454–6; P. Friedländer, *Johannes von Gaza und Paulus Silentiarius*, Leipzig, 1912, pp. 83–103; G. Downey, s.v. 'Ekphrasis' in *Reallexikon für Antike und Christentum*, iv, Stuttgart, 1959, 921–44, with its bibliography.

Imagines of Philostratus had been of this kind—and this was a practice the Byzantines maintained.[79] Many Byzantine ekphrases, particularly metrical ekphrases of images of saints, had moved a long way from antique practice, but the great sophistic models, particularly those of Libanius of Antioch, were still copied quite closely. One especially poignant example is an ekphrasis written by Manuel II Palaeologue[80] on a tapestry he saw in Paris during his trip through western Europe in 1399–1402:

It is the spring season; the flowers proclaim it, and the clear air flowing gently among them. In this breeze the leaves whisper sweetly, and the meadow seems almost to surge in welcoming the wind that lightly moves it with its friendly sallies. This is delightful to see. The rivers are now coming to terms with their banks and their full spate is checked; what was hidden before by flood-water now emerges and men's hands may grasp their fruits. One of them already has been caught by this boy there: he is holding himself steady with his left hand, bending forward and stooped to the point of just not dipping his nose in the stream, and he puts his bare right hand noiselessly into the water, searching under the rush of the torrent, groping with his fingers about the hollows for anything that may be hiding there out of fear of the splashing, for the water has been disturbed by the boy's feet.

The partridges are rejoicing, already regaining the strength they lost through the excesses of things naturally distressful to them, for the bright sunlight, not burdensome with immoderate heat, restores it to them again. So they dwell with good heart in the fields and lead their chicks to dinner, first pecking off food themselves and by this action pointing to the victuals. Yet the song-birds sitting in the trees do not often touch the fruit; they use most of their time for singing. I think their voices wish to proclaim that better things are at hand, since the queen of seasons is come; that from now on it is clear weather instead of murk, calm instead of storm and, in sum, pleasant things instead of distressing things. Everything is busily giving tongue, even the meanest beings—gnats, bees, cicadas, and all kinds of such creatures. Some have emerged from their burrows, but others have been generated by the symmetry of the season—or, if you like, from the action of a degree

[79] Some accessible examples: the metrical ekphrasis of a mosaic of the goddess Earth by Manuel Melissenos in *Manuelis Philae Carmina*, ed. E. Miller, ii, Paris, 1857, 267–8, which also includes many ekphrases by Philes; ekphrases by John Eugenikos in F. Boissonade, *Anecdota nova*, Paris, 1844, pp. 340–6, and one of an image of St. John Chrysostom in *Catalogus codicum graecorum bibliothecae Mediceae Laurentianae*, ii, Florence, 1768, 31.

[80] K. Krumbacher, op. cit., 489–92; J. v. Schlosser, 'Die höfische Kunst des Abendlandes in byzantinischer Beleuchtung', in *Präludien*, Berlin, 1927, pp. 68–81, who draws attention both to Manuel's ekphrasis and those of John Eugenikos.

of heat on a proportionate degree of humidity—and they are humming round the human beings, fluttering in front of the wayfarer and singing together most harmoniously with every other songster. Some wrestle, some fight, and others are just squatting on the flowers.

It is all a delightful spectacle. Children playing in the meadow are trying very ingenuously and yet also charmingly to hunt the insects. One has stripped his hood from his head and is using it as a hunting net, and because he mostly misses them he makes his playmates laugh. Another, holding his hands close to him, throws his whole body at an insect: when he tries to hunt like this, how can one not be delighted and amused? Do you see that fine boy there? At last and with much effort he has caught one of those insects some call *Ptilota*. He seems frantic with joy and, in lifting the bottom edge of his tunic to stow away his catch and be able to go off and hunt another, he does not notice he has exposed parts of his person which should really be covered. But that younger boy over there is even prettier. For with a very fine thread he has bound two of the mites and, I take it, is letting them fly. Reining in the threads with his finger tips from a distance, he checks the direction of their flight; and he laughs and rejoices and dances, holding these childish occupations as something of importance. In every way the skill of the weavers feasts the eye and brings delight to the beholder. Yet the cause is Spring, that deliverer from dejection or, if you will, emissary of happiness. (VI)

In detail this looks back to a famous ekphrasis of Spring by Libanius;[81] it is unlikely to be a very accurate account of a tapestry. And there is an obvious symmetry between the values implied in descriptive modes like this and Chrysoloras's general critical propositions. The ekphrases describe qualities of detailed lifelikeness, of physiognomic expressiveness, of variety, and they describe these in an affirmative form, for ekphrasis is a device of epideictic, the rhetoric of praise or blame: there are no neutral ekphrases. This combination—Manuel's critical propositions and the ekphrastic range of descriptive modes—influenced the Italians' way of speaking of painting and sculpture.

Of Manuel's Italian pupils, the closest to him was Guarino of Verona.[82] Guarino had followed him back to Constantinople

[81] *Opera*, viii, *Progymnasmata*, ed. R. Forster, Leipzig, 1915, pp. 479–82.

[82] Guarino was born in 1374 in Verona. Soon after 1390 he took to humanist studies in Padua, from 1392 with Giovanni da Ravenna, and after qualifying as a notary taught grammar at Venice till 1403. In 1403 he followed Manuel Chrysoloras to Constantinople and remained there till 1408, in close touch with Manuel and his nephew John; by 1409 he had returned via Rhodes and Chios to Italy. The rest of his life was spent in teaching: 1410–14 in Florence; 1414–19 in Venice, where his pupils included Francesco Barbaro and

in 1403 and stayed in the East for five or six years, and during part of this time Manuel himself was in western Europe. Guarino's Hellenism was very Byzantine in its bias towards sophistic litera- ture and progymnasmatic postures. Petrarch and Boccaccio had wanted to know Greek in order to read Homer; Guarino, who did know Greek well, read Lucian and Arrian. In an admittedly withered version, Guarino transmitted to Italy the ekphrastic values of Byzantium, both in the original form of a mode of description and through the generalized formulations of Manuel. This is ironic, since there is no reason at all to suppose Guarino was very much interested in painting. On the contrary, he more than anyone else was responsible for popularizing a number of debating points that praised literature at the expense of painting and sculpture. Guarino's three main points against painting—that it shows appearance, not moral quality; that it draws attention to the artist's skill at the expense of the subject; that a paint- ing is less durable than a book[83]—are not very interesting, but they are the immediate source of the long account of the limita- tions of painting and sculpture put into the mouth of Leonello d'Este in Angelo Decembrio's dialogue De politia litteraria. Both Leonello and Angelo were pupils of Guarino.

However there were many pressures on Guarino which, whether he was personally responsive to painting and sculpture or not, demanded reference to them of a less purely negative kind. He was a humanist and so disposed to remarks in the Petrarchan manner:

At this point I begin adding such embellishment and rhetorical orna- ment as the poverty of my literary workshop allows. For so far I have been proceeding in the manner of the sculptor, who first chisels at the marble so as to reveal, as yet only in form, the figure of a horse or lion or man without yet having added the lustre and embellishment that completes the work. In the same way I too have collected and joined together a number of topics so that a structure and form are in exis- tence, but the individual parts have yet to be given, through such talent as I have, their final polish.[84]

Leonardo Giustiniani and, for the elements of Greek, Barzizza and Vittorino da Feltre; 1419–29 in Verona, his pupils including Bartolomeo Fazio; 1429 till his death in 1460 at Ferrara, initially as tutor to Leonello d'Este. The best account of Guarino's life is still that of Sabbadini, La scuola e gli studi di Guarino Guarini Veronese, Catania, 1896.

[83] Epistolario di Guarino Veronese, ed. R. Sabbadini, Venice, 1915–19, 589–91.

[84] Epistolario, ed. cit., ii. 71: 'Dehinc eos addam colores et ornamenta quae pro meae officinae inopia potero. Hactenus enim more sculptorum feci, qui principio ita marmora

Again, at Ferrara he was the most authoritative humanist at a court very active as a patron of artists, and was in no position to dissociate himself entirely from these activities. Indeed he is the author of an early example of that much-posited thing, a humanist programme for a cycle of paintings. It was addressed in 1447 to Leonello d'Este and refers to the series of Muses done by Angelo da Siena and Cosimo Tura for Leonello's *studio* at Belfiore, destroyed in 1483:

One is to understand that the Muses are conceptions so to speak and intelligences which through human endeavour and by industry have contrived various activities and arts. They are so called because they seek after all things or because they are sought after by all men, desire for knowledge being innate in man. For μῶσθαι means *seek* in Greek, so that Μοῦσαι means *seekers*.

Clio is the discoverer of history and things that pertain to fame and antiquity; for this reason let her hold a trumpet in one hand and a book in the other; varied colours and patterns will be woven into her garments, in the manner of silken drapery in the ancient style.

Thalia discovered one part of agriculture, that which concerns planting the land, as indeed her name shows, coming as it does from θάλλειν, to bloom; so let her hold various seedlings in her hands and let her drapery be decorated with flowers and leaves.

Erato attends to the bonds of marriage and true love; let her hold a boy and a girl one to each side of her, setting rings on their fingers and joining their hands.

Euterpe, discoverer of the pipes, should display the gesture of a teacher to a musician carrying musical instruments; her face should be particularly cheerful, as the origin of her name makes clear.

Melpomene devised song and vocal melody; therefore she must have a book in her hands with musical notation on it.

Terpsichore set forth the rules of dancing and the foot movements often used in sacrifices to the gods; let her therefore have boys and girls dancing round her and herself show a directing gesture.

Polymnia discovered the cultivation of fields; let her be girt up and dispose hoes and vases of seed, bearing in her hand ears of corn and bunches of grapes (Plate 16).

Let Urania hold an astrolabe and gaze at a starry heaven above her head, for she found out its system, namely Astrology.

erudiunt, ut equi aut leonis aut hominis adhuc in forma detegant imaginem, nondum splendor adiectus extremusque color sit. Sic et ipse locos quosdam assumptos in unum ita coegi, ut corpus et forma compareat, necdum autem expolita membra pro mei ingenioli facultate sunt.' Cf. Cicero, *Brutus* xxxiii. 126.

Calliope, the seeker out of learning and guardian of the art of poetry, also provides a voice for the other arts; let her carry a laurel crown and have three faces composed together, since she has set forth the nature of men, heroes, and gods. (XIII)[85]

Situated as Guarino was, an intellectual of great authority in an *ambiente* where the current of patronage was strong but a little undirected, even his negative attitudes might be given positive interpretations. He complains that, unlike literature, paintings and statues—'quas princeps ingenii litterarum et virtutis Manuel Chrysoloras mutas laudes, hoc est ἄφωνα ἐγκώμϊα, vocare solebat'[86] —are poor vehicles for transmitting personal fame, first, because they are *sine litteris*, unlabelled, and second, because they are not conveniently portable. It is difficult not to see these objections, cited in a letter of 1447 to Alfonso V of Naples,[87] turning into demands, and the demands into part of the context to Pisanello's revival of the portrait medal, a visual vehicle of fame which Guarino at least acquiesced in (Plate 9b). His other negative points tend to reappear with a positive aspect, even in his own remarks; his Aristotelian insistence on the inability of the painter to show moral quality was quickly converted into a conceit— praise for particular paintings which did show moral qualities and so achieved the impossible.

In Guarino's references to painting and sculpture his Byzantine experience played a large part, not so much a visual experience of monuments as a literary experience of late Greek sophistic literature:

I laughed a great deal over the charming type you described, so well that I seemed to see him—lean and bleached with chagrin . . . Heavens! Apelles drew Envy just so in his picture of Calumny. If you want to see this more plainly, look out the essay by Lucian I once sent you.[88]

It was Guarino who, while he was still living in Constantinople, translated into Latin Lucian's *Calumny* with its ekphrasis of Apelles' painting (X), and Alberti's account of it in *De pictura*

[85] For some discussion of paintings related to this programme, see Baxandall, 'Guarino, Pisanello and Manuel Chrysoloras', *Journal of the Warburg and Courtauld Institutes*, xxviii, 1965, 187–9. Francesco Cossa's painting (Plate 16), presently known as *Autumn*, is not a painting from the studio at Belfiore, but is illustrated as an example of a picture following Guarino's scheme.

[86] 'Guarini Veronensis in Rhetoricam novam Ciceronis inchoandam', in Biblioteca Laurenziana, Florence, Misc. MS. Ashburnham 272, fol. 118ᵛ.

[87] *Epistolario*, ed. cit., ii. 492. [88] Ibid. i. 126.

is taken from Guarino's translation.[89] It is therefore not surprising to find that Guarino himself could handle the ekphrasis form with great confidence:

Not to speak of almost countless other things, how could I find words and style worthy of the ink-stand you sent me? Though certainly its form is most beautiful, elegant, and apt, this is overshadowed by the truly Phidian skill and workmanship I feast my eyes on. If I fix my gaze on the leaves and little branches and look at them attentively, shall I think that I am looking at real leaves and real branches and that they could be safely bent this way and that? So does the diligence of Art seem to rival the ease of Nature. Often I cannot have enough of the pleasure I find in examining the little figures and the living faces in the clay. What has not been represented to the life here by imitation of Nature the creator? Nails, fingers, and hair, soft even though earthen, take me in when I behold them. When I look at an open mouth I expect a voice to come from the dumb; when I see the putti hanging from the tree I forget that they are made of earth and fear they may fall and injure their small bodies, and I call out in pity. As childhood and changeable souls make for varied feelings of the soul, so here you see varied expressions on their faces: one is grinning, another is a little sad, this one is carefree, that one meditative, and here too are postures immodest through the wantonness of childhood, for parts of the body which should in natural prudence be hidden are here impudently exposed to view. (XII)

It is characteristic that this description of an ink-stand should be a more poised and elaborate performance than any contemporary humanist account of a painting; but it was round Pisanello that the main ekphrastic activity of Guarino and his pupils soon centred.

It is one of the more disconcerting facts of Quattrocento art history that more praise was addressed by humanists to Pisanello than to any artist of the first half of the century; in this sense— and it seems a reasonably substantial one—Pisanello, not Masaccio, is the 'humanist' artist. The most famous of the various poems to Pisanello was by Guarino himself;[90] it is not the best

[89] R. Förster, 'Die Verläumdung des Apelles in der Renaissance', *Jahrbuch der Königlich Preussischen Kunstsammlungen*, viii, 1887, 29–56 and 89–113, especially 33–4; and R. Altrocchi, 'The Calumny of Apelles in the Literature of the Quattrocento', *Proceedings of the Modern Language Association*, xxxvi, 1921, 454–91.

[90] The poem is mentioned by Flavio Biondo in the middle of the 15th century: 'Pictoriae artis peritum Verona superiori seculo habuit Alticherium. Sed unus superest, qui fama caeteros nostri seculi faciliter antecessit, Pisanus nomine, de quo Guarini carmen extat, qui Guarini Pisanus inscribitur' (*Opera*, I, Basel, 1559, 377). Vasari refers to it, after Biondo, and

either of Guarino's poems or of the humanist poems to Pisanello, but it does appear to have set the precedent. Guarino relies heavily on the devices we have seen as characteristic of Byzantine ekphrases of paintings, insistence on the physiognomic sugges- tiveness of figures and insistence on the rich variety of com- ponents. Lifelike expressiveness is seen by Guarino in a painting of St. Jerome, a favourite humanist object (Plate 8):[91]

Why list your accomplishments one by one? Here as I write is their pattern: the noble gift you have sent me, a picture of my beloved Jerome, offers a wonderful example of your power and skill. The noble whiteness of his beard, the stern brows of his saintly countenance— simply to behold these is to have one's mind drawn to higher things. He is present with us and yet seems also absent, he is both here and some- where else: the grotto may hold his body, but his soul has the freedom of Heaven. However plainly the picture declares itself to be a painted thing in spite of the living figures it displays, I scarcely dare open my mouth, and whisper close-lipped rather than let my voice break loutishly in on one who contemplates God and the Kingdom of Heaven. (XI)

This last conceit is a favourite of Byzantine ekphrasis:

> Σὺ γοῦν σιγῶν θαύμαζε τὴν τεχνουργίαν
> Μήπως ταραγμὸν ἐμβάλῃς ταῖς εἰκόσι[92]

> (Admire the art silently lest you
> disturb with noise the figures . . .).

but the whole would have had a familiarity to Italian humanists as an extension of the *vultus viventes* and *signa spirantia* of the Latin tradition; it differs only in details from Petrarch's St. Ambrose.

More exotic and evidently more intoxicating was Guarino's way of speaking about the variety of Pisanello's painting:

. . . you equal Nature's works, whether you are depicting birds or beasts, perilous straits and calm seas; we would swear we saw the spray

to Tito Vespasiano Strozzi's poem, with the comment: 'E questi sono i frutti che dal viver virtuosamente si traggono' (*Le vite*, ed. G. Milanesi, iii, Florence, 1878, 12–13). The best modern discussions are in Vasari, *Le vite*, I, *Gentile da Fabriano e il Pisanello*, ed. A. Venturi, Florence, 1896, pp. 39–41; G. F. Hill, *Pisanello*, London, 1905, pp. 113–18; and especially the notes of the *Epistolario di Guarino Veronese*, ed. R. Sabbadini, Venice, 1915–19, i. 554–7 and iii. 209–10.

[91] No St. Jerome by Pisanello survives; the nearest equivalent is the illustrated (Plate 8) panel in the National Gallery by Bono da Ferrara, who signs himself *Bonus Ferrariensis Pisanj Disipulus* and may well be reproducing one of Pisanello's types.

[92] Manuel Melissenos, ekphrasis of a mosaic of Earth, in *Manuelis Philae Carmina*, ed. E. Miller, ii, Paris, 1857, 268.

gleaming and heard the breakers roar. I put out a hand to wipe the sweat from the brow of the labouring peasant; we seem to hear the whinny of a war horse and tremble at the blare of trumpets. When you paint a nocturnal scene you make the night-birds flit about and not one of the birds of the day is to be seen; you pick out the stars, the moon's sphere, the sunless darkness. If you paint a winter scene everything bristles with frost and the leafless trees grate in the wind. If you set the action in spring, varied flowers smile in the green meadows, the old brilliance returns to the trees, and the hills bloom; here the air quivers with the songs of birds. (XI)

This mode was imitated in other poems to Pisanello. Tito Vespasiano Strozzi, a pupil of Guarino:

How shall I tell of the living birds or gliding rivers, the seas with their shores? I seem to hear the roaring waves there, and the scaly tribe cleave the blue water. Prating frogs croak beneath the muddy runnel; you make boars lurk in the valley and bears on the mountain. You wrap soft verges round the clear springs, and green grass mingles with fragrant flowers. We see two nymphs wandering in the shady woods, one with a hunting-net on her shoulder, the other bearing spears, and in another part baying dogs flushing she-goats from their dens and snapping their savage jaws. Yonder the swift hound is intent on the hare's destruction; here the rearing horse neighs and champs at its bit. (XIV)[93]

There is a similar section in the poem to Pisanello by Basinio of Parma,[94] and long after Guarino's death his pupils were still using the same mode to praise other and lesser artists. Roberto Orsi praises the book illuminator Giovanni da Fano.[95]

You would run away from the angry lion in the pine-wood, and tremble at the shaggy boars on the painted mountains. You would swear the beasts quiver with life and that the stags are running, that the buildings stand there solid, and that the meadows are blooming with varied grasses; that you do indeed hear the baying dogs and the silent words of men, or that the waters of a shady spring are indeed gushing

[93] For this poem, see Vasari, *Le vite*, I, *Gentile da Fabriano e il Pisanello*, ed. A. Venturi, Florence, 1896, pp. 52–5, with its bibliography.

[94] *Le poesie liriche di Basinio*, ed. F. Ferri, Turin, 1925, pp. 103–5; or the less satisfactory text in Vasari, *Le vite*, I, *Gentile da Fabriano e il Pisanello*, ed. A. Venturi, Florence, 1896, p. 57.

[95] Cf. G. Castellani, 'Un miniatore del secolo XV', *La Bibliofilia*, i, 1899, 169–70. For Roberto Orsi, *Roberti Ursi De Obsidione Tiphernatum Liber*, ed. G. M. Graziani in Muratori, *Rerum Italicarum Scriptores*, xxvii. iii, Bologna, 1922, pp. xxvi–xxxii. For Giovanni da Fano, O. Pächt, 'Giovanni da Fano's Illustrations for Basinio's Epos *Hesperis*', in Società di Studi Romagnoli, *Studi Malatestiani*, Faenza, 1952, pp. 91–111.

forth. So skilled a hand has Giovanni, one would never say these things were mere representations on narrow pages.[96]

This kind of diction appears to have been Guarino's most personal addition to the humanists' ways of speaking about painting. Its sources are clearly mixed: much of the vocabulary is Virgilian and most of the items catalogued in these passages could come straight out of the epic *locus amoenus* of medieval Latin poetry.[97] The mode is not ekphrasis proper, since it describes not so much one particular work as the distinctive quality and range of the painter's general performance. For this Guarino's starting-point seems to be the sort of ekphrasis used by Manuel for the triumphal arches of Rome, but it is much enriched by decorative development along the lines of the more evolved ekphrases of animated landscape. In any event, it is clear that this is a tendentious form; it depends for its existence on pictorial variety, it cannot operate without a fair number and diversity of items to list. Further, the bias of the form was reinforced by the easy accessibility of general formulations for the notion of pictorial variety. *Varietas* was a rhetorical value and, like most rhetorical values, was open to definition by visual metaphor. For instance, George of Trebizond in 1429:

So much for sentences: now I shall discuss the sort of skill we need in such discourse in order to make it brilliant and to have the greatest variety. For it is evident that variety is exceedingly useful and pleasant not just in painters or poets or play-actors, but in everything—so long,

[96] *De Iano Fanestri pictore*
Bythinii digitis opus hoc memorabile Iani
 Ingenio veteres vincit et arte novos.
Candida compositis delubra coloribus ornat
 Patricios tantum Caesareosque lares.
Effingit veris quecunque simillima rebus,
 Et rerum arcanos explicat ipse modos.
Iratum fugies inter pineta leonem,
 Hirsutos timeas per iuga picta sues.
Iurabis trepidare feras, et currere cervos,
 Stare domos, variis prata virere comis.
Latrantesque canes, et surda audire virorum
 Verba, vel umbrosi surgere fontis aquas.
Quin te te in parvis modo dixeris esse tabellis,
 Usque adeo doctas possidet ille manus.
Inclyta piceno quesita est gloria Fano,
 Unde genus noster nobile Ianus habet.

(Robertus Ursus, 'Poemata', Florence, Biblioteca Nazionale, MS. Magl. VII, 1200, fol. 82ᵛ).
[97] For which see especially E. R. Curtius, *European Literature and the Latin Middle Ages*, New York, 1953, pp. 192–202.

that is, as it is fitting—and yet above all in our rhetorical faculty; it both strengthens one's case and gives delight to the spectator. Hence an architect builds his most beautiful buildings by using now arches, now plain wall, and now bricks, now dressed stone—these being applied, of course, with art. Hence too, in our needful use of clothing, varied colours are contrived for dyeing. Hence too God, that glorious Craftsman of all things, decorates the meadows with white, violet, dark, or multi-coloured flowers and red roses. This teaches us that, if we want to speak well and attractively, we should studiously, diligently, and carefully seek for *variety* of discourse.[98]

The combination of rhetorical *varietas* and its transferable prestige, of ekphrasis and its tendentious attractions, and of the critical notions of Chrysoloras, was a powerful one.

Pisanello was the exemplar, and it is not difficult to project the broad lines of an ekphrastic response in Guarino's manner to a particular painting—say, *St. George and the Princess of Trebizond* (Plate 7). In itemizing its variety there is much to be made of the varied animals and landscape, and also of physiognomies. There are also fair possibilities in the fresco for a number of proved decorative conceits; the dead men on the scaffold in the background, for which there is a fine pen and chalk study (Plate 6), and the reptiles in the left-hand extension of the painting call for Aristotle: 'things which in themselves we view with distress, we yet enjoy contemplating when they are depicted with extreme accuracy—the forms of the lowest animals, for example, and also of dead bodies'. Again, the epic nature of the occasion suggests that St. George, who may have been less poker-faced in the fifteenth century than now, should be observed as expressing in his face and his bearing a striking nobility: the nature of this nobility and its effect on our own feelings might well be particularized. Again, Pisanello has sharply foreshortened the horses

[98] 'Sed de sententiis hactenus, nunc de artificio disseremus, quod hoc in genere eiusmodi esse debet, ut et claram orationem faciat, et varietatem habeat maximam. Nam varietas non modo pictoribus, aut poetis, aut istrionibus, sed etiam cum omni in re dum apte fiat, tum maxime in oratoria facultate, et utilitatis et suavitatis videtur habere plurimum, quippe que nam et rem muniat, et delectationes videntibus afferat. Hinc architectus modo fornicibus recto modo pariete, et lapidibus nunc coctis, modo nam confectis, arte accomodatis domos edificat multo pulcherrimas. Hinc vestium necessarius usus, tingendi colores invenit varios. Hinc denique nam omnium mirabilis rerum artifex, albis violis nigris variis, ac rubeis, prata rosis ornatissima reddidit. Hec ergo nos etiam admonent, si bene iocundeque dicere volumus, ut varietatem orationis studio, diligentia curaque consequamur' (George of Trebizond, *De suavitate dicendi ad Hieronymum Bragadenum*, in Venice, Biblioteca Marciana, MS. XI. 34 (4354), fol. 3^{r-v} (31. viii. 1429).

and dogs in his foreground, a supreme and assertive example of a common late Gothic trick. It would be strange if we did not apprehend these animals as lifelike to the point of hearing them bay or neigh or snap their jaws, and in the context of our discourse this would not be misunderstood as extravagance. By this time the number of items mentioned will have made our point about the variety of the artist's virtuosity, but even so we may feel it in place to make an explicit reference to this towards the end of the piece, and the introduction here of one abstract noun, *varietas* or some equivalent, may suggest the addition of some others in a small accumulation: here words like *ratio*, *ars*, *artificium*, *scientia* in combination with words like *forma*, *color*, *lux*, *lineamenta* will have a part. In the face of all this Apelles must surely yield place.

To say that description in the manner of Guarino and his pupils is very conventional is certainly not to imply that it is negligible either as a skill or, more particularly, as an account of Pisanello; the ekphrastic response seems to answer very well to the qualities of the painting. For whether he was aware of it or not, Pisanello's work sometimes has the character of contriving a series of cues for standard humanist responses—Mongols and birds for variety, whole menageries for decorative itemizing, flashy foreshortenings for *ars*, snakes and gibbets for the principle of pleasurable recognition. There is a genuine conformity between Pisanello's narrative style and the kind of narrative relevance assumed by the humanist descriptions. Strozzi's description is of painting without a subject; it looks forward to the modal art of Venetian pastoral and landscape. Similarly, narrative decorum in Pisanello is a matter of some internal concinnity between represented objects rather than single-minded reference of every represented object to one narrative end: thus *St. George and the Princess of Trebizond* is an anthology from Pisanello's repertoire of visually interesting objects, none of them inconsistent with the epic tone of the story. Guarino's ekphrastic discourse is one of rather few proper ways of speaking about such painting. When Alberti tried to formulate in *De pictura* a new and more rigorous idea of pictorial composition, this nexus—Chrysoloras's propositions, the ekphrastic values, and the art of Pisanello—was the nearest humanism had come to a body of articulate taste in such matters, and it set Alberti great problems.

4. BARTOLOMEO FAZIO AND LORENZO VALLA: THE LIMITS OF HUMANIST CRITICISM

Three main strands have now emerged in the developing art criticism of the humanists. The first was the Ciceronian–Petrarchan tradition, a running analogy between painting and writing on the basis of a limited system of neo-classical categories and distinctions. This was the staple element in the humanists' discussion of painting. The second and more local strand was a view of modern art history as a series of artists of individual capacity and interest. This primitively Pliniesque point of view produced a very firmly structured account of Florentine art of the early fourteenth century, but it was not sustained into the fifteenth. The third was an approach through the ekphrastic modes and values of Guarino and his school.

By the second quarter of the fifteenth century very many humanists were in the way of making remarks about art with a terrible ease and unparticularity. To give some scale to the better humanist criticism one example of this conventional humanist discourse is necessary and enough. Leonardo Giustiniani, a Venetian pupil of Guarino, recommends to the Queen of Cyprus[99] his gift of a painting or painted box:

I know well with how much interest, honour, and respect the art of painting has been cherished by kings, peoples, and nations, inasmuch as it has—not just through art, practice, and imitation, but also through force of mind and a truly divine talent[100]—so nearly rivalled the parent of all things, Nature herself, that, if one only added a voice to some of the figures fashioned by its art, it would easily vie with Nature herself—nay, would even have surpassed it in some respects, I would say. Lest anyone be astonished at my saying this, let me observe that the force and power of Nature is limited in various respects; so that, while Nature produces flowers only in spring and fruits only in autumn, the art of painting may produce snow even under a blazing sun, and abundant violets, roses, apples, and olives even in winter tempests. It is for this reason that there have, I hear, been some most authoritative and learned men who have associated Poetry with Painting as, in most respects, a kind of sister art. How have they defined painting,

[99] The letter, noted by B. Fenigstein, *Leonardo Giustiniani*, Halle, 1909, p. 20, is not dated, nor is it clear which Queen of Cyprus is addressed. Giustiniani died in 1446.

[100] The elements of the rhetorician's *facultas*: *ars . . . usus . . . imitatio . . . ingenium*; cf. Quintilian, *Inst. Orat.* III. v. 1, for example: *natura . . . ars . . . exercitatio . . . imitatio*.

if not as 'a silent poem'?[101] And we can corroborate this with testimony from the poets themselves: 'Painters and poets have always had equal powers of venturing',[102] and indeed they are like each other in being aroused and directed by a keenness of the mind and a certain divine inspiration.

There are many examples of the great honour in which painting has been held by men. Alexander the Great desired to be painted by Apelles, the most excellent painter of his age, above all others.[103] Why was this? It was because he realized that his fame—something of which he was most careful—would receive no small addition through the art of Apelles . . .[104] Demetrius Poliorcetes beheld the works of the famous painter Protogenes with the utmost admiration and was taken with such great pleasure in them that when, in the siege of Rhodes, to whose inhabitants he was most inimical, he had got the paintings of Protogenes into his power, he held them in the highest honour and for the sake of the noble painter, now dead, lifted the siege and spared the city.[105] But why should I go on enumerating Phidias, Zeuxis, Cimon, Aristides, Nicomachus, and all the famous painters on whom honour was bestowed by many foreign kings and peoples, all through this art of which I am speaking? Among the Romans too the greatest praises fell to this art—so that some most distinguished families took their surname from it: Fabius, Lepidus, Cornelius, Actius, Priscus (sic) were all surnamed Pictor[106]—just as much as the publishing of books brought great fame and reputation to the authors.

That learned philosopher and excellent man Manuel Chrysoloras, ornament of both Greek and Latin nations, though he was only very rarely entertained by pleasures, particularly the sort of pleasure one seeks outside oneself, enjoyed paintings to an extraordinary degree.[107] What he gave his attention to was not so much the actual brushstrokes, the shadings and outlines, but rather the talent of the artist and the admirable powers of the artist's mind, by which limbs might be represented as alive and countenances fashioned as if living. I am persuaded that there can be no liberal and vigorous and noble talent that is not overcome and attracted and consoled by the delightfulness and charm and pleasure of this craft. (XV)

Like Giustiniani, Bartolomeo Fazio[108] was a pupil of Guarino,

[101] Simonides, quoted by Plutarch, *Moralia* 346F.

[102] Horace, *Ars poetica* 9–10. [103] Valerius Maximus VIII. xi. 2.

[104] The story of Apelles and Pancaspe (Pliny, *Nat. Hist.* xxxv. 86) follows.

[105] Aulus Gellius, *Noct. Att.* xv. 31.

[106] For Fabius, Pliny, *Nat. Hist.* xxxv. 19; for Cornelius and Attius Priscus presumably xxxv. 120 and xxxv. 37. I cannot identify Lepidus. [107] Cf. pp. 81–2.

[108] 1420–6, a pupil of Guarino in Verona; 1426–9, tutor to the sons of Doge Francesco Foscari in Venice; 1429, in Florence; from 1434 to at least 1435, notary in Lucca; by 1441 in

but like Filippo Villani's his discussion of painting is part of a classified collection of brief lives, and this favoured more particular detail than a letter to the Queen of Cyprus. Fazio, who was historian and secretary to Alfonso V of Naples, wrote his short book *De viris illustribus*[109] in 1456. In this book he chose, apparently against his original intention, to associate with more usual classes of distinguished men—Poets, Orators, Lawyers, Physicians, Private Citizens, Captains, Princes—the class of Painters and Sculptors. In the chapter 'De pictoribus' a short introductory passage on painting in general is followed by notices of four painters whom he considers the best of his time: Gentile da Fabriano, Jan van Eyck, Pisanello, and Rogier van der Weyden. Fazio seems to have been fairly consistently resident in Naples since 1444 and this may have involved a certain cultural isolation from northern and central Italy; it must certainly have involved strong social pressures towards conformity with Aragonese taste. On the other hand, before 1440 Fazio's knowledge of Tuscany and Venice was first-hand and of long standing, and his reference to Alberti, who was uneasily classed among the Orators, suggests he knew at least of the existence of *De pictura*:

Picturae studiosus ac doctus, de artis ipsius principiis librum unum edidit.[110]

He is a keen and learned student of painting, and has published a book on the principles of this art.

The court of Alfonso V, rather a flirt in his relations with writers, was a very competitive environment for humanists; among other things it had seen in the 1440s the great vendetta between Lorenzo Valla and Antonio Panormita, to whose faction Fazio belonged. This atmosphere, wary and hypercritical of detail, had an institutional form in the *ora del libro*, the regular literary seance at which Alfonso gathered his courtiers for an

Genoa again; 1444 to Naples. For Fazio see P. O. Kristeller, 'The Humanist Bartolomeo Facio and his Unknown Correspondence', in *From the Renaissance to the Counter-Reformation: Essays in Honor of Garrett Mattingly*, ed. C. S. Carter, New York, 1965, pp. 56–74.

[109] The only printed edition is *Bartholomaei Facii de viris illustribus liber*, ed. L. Mehus, Florence, 1745, which appears to have followed an inaccurate copy. There are two complete 15th-century manuscripts: Vatican Library, Vat. lat. 13650 and Biblioteca Nazionale, Rome, Vittorio Emmanuele 854. The text of the chapter 'De pictoribus' used here collates these two manuscripts; see Text XVI.

[110] Cod. Vat. lat. 13650, fol. 9[r].

evening of reading and discussion.[111] From the accounts of those most centrally involved it is clear that for the humanists the meetings were public performances of a most testing kind. A text, most often from a historian, was read aloud, and later the reader replied to questions and disputed interpretations. Fazio's *Invectivae in Vallam* and Valla's *Recriminationes in Facium*, written in the form of dialogues at these meetings, record a bitter competitiveness among the participating scholars. On a literary level the atmosphere coincides with a distinctive kind of scholarly showmanship; perhaps an elaborate allusiveness, an exasperated form of something always present in Quattrocento humanism, was the most solid defence against the special kind of close reading with which any author could expect to be faced at Naples. What is at present important is that in a literary culture of this kind any text may well be partly shorthand, a series of cues for exposition, and that an argument can consist not only in what is said but also in the sequence of what is referred to. Fazio's introduction to his chapter 'De pictoribus' is of this kind.

He starts from two generalized commonplaces about the kinship between painting and poetry: 'There is, as you know, a certain great affinity between painters and poets; a painting is indeed nothing else but a wordless poem.' Both of these derive from Greek authors, and both are from contexts closely associated with what is to emerge as his general position. The *quaedam affinitas* of the first is the ξυγγένειά τις of the Prooemium to the *Imagines* of the younger Philostratus;[112] Facius will presently return to the plea by Philostratus for expressiveness of which the phrase is part. The *pictura poema tacitum* of the second is the proverb of Simonides recorded by Plutarch. Its context in Plutarch is a discussion of the best way of writing history, something of practical interest to Alfonso's historian and also to Alfonso himself, whose concern with history was important for the Neapolitan literature of his time. Plutarch is comparing the vividness, the γραφική ἐνάργεια indeed, of Thucydides with Euphranor's painting of the battle of Mantineia:

Simonides calls painting wordless poetry and poetry verbal painting: for the actions which painters portray as taking place in the present,

[111] Valla's *Recriminationes in Facium* (in *Opera Omnia*, Basel, 1540, pp. 460–632) are an interesting reflection of such discussions. For their atmosphere and range see also G. Mancini, *Vita di Lorenzo Valla*, Florence, 1891, pp. 194–7.

[112] *Imagines*, Prooemium, 6.

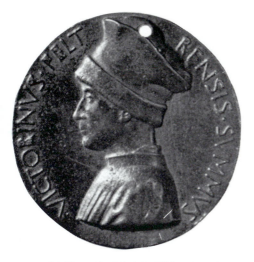

9(*a*) Pisanello, Medal of Vittorino da Feltre. Kress Collection, National Gallery of Art, Washington. Bronze.

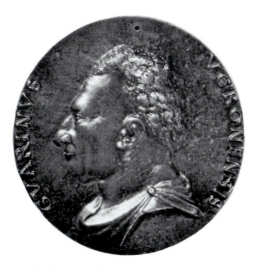

9(*b*) Matteo de' Pasti, Medal of Guarino da Verona. Kress Collection, National Gallery of Art, Washington. Bronze.

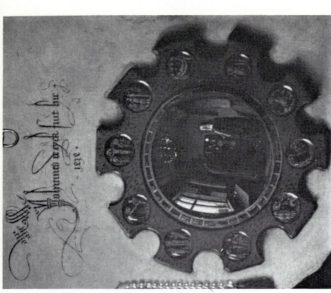

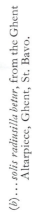

(c) ...*posteriores corporis partes in speculo*, from *Giovanni Arnolfini and Jeanne Cenami*, London, National Gallery.

(b) ...*solis radiusilla betur*, from the Ghent Altarpiece, Ghent, St. Bavo.

(a) ...*biblioteca videtur introrsus recedere*, from *St. Jerome*, Detroit, Institute of Arts.

10. Jan van Eyck. Details suggesting pictorial devices admired by Bartolomeo Fazio.

11. Rogier van der Weyden, *Descent from the Cross*. Madrid, Prado Museum.

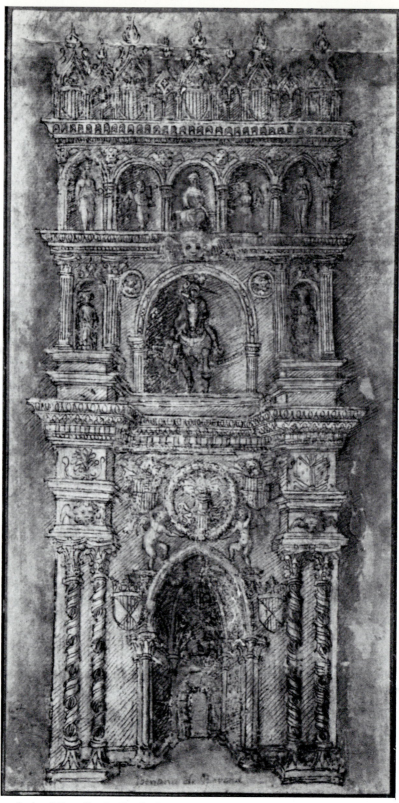

12. Style of Pisanello, Study of a decorated archway. Rotterdam, Boymans Museum.
Drawing in ink and wash.

13. Pisanello, Study for a fresco decoration at Mantua. Paris, Louvre. Pen drawing.

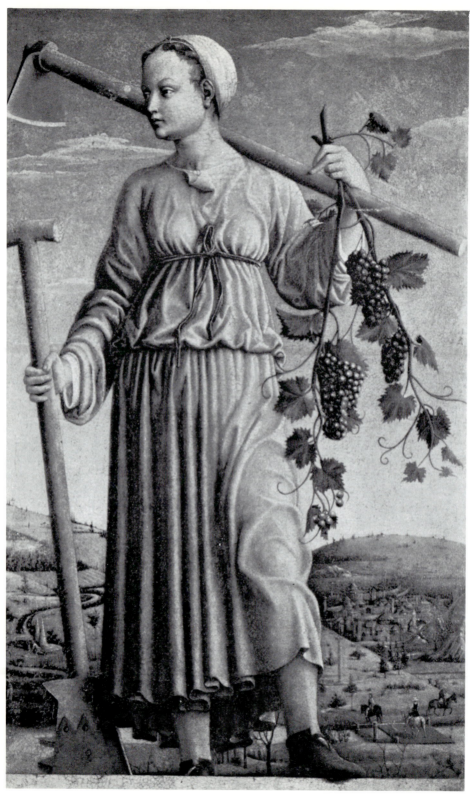

16. Francesco Cossa, *Polymnia, Muse of Agriculture*. Berlin-Dahlem, Staatliche Museen.
Tempera on panel.

literature narrates and records as having taken place in the past. And if artists with colours and lines, and writers with words and phrases, represent the same subjects, yet they differ in the material and manner of their imitation; but the underlying aim of both is the same, and the successful historian is the one who makes his narrative like a painting by representing vividly emotion and character.[113]

The immediate reference of both phrases, then, is to *ethopoeia*,[114] the expression of character and emotion.

But in Fazio the references are suspended for the moment; before pursuing the subject he obliquely sets its limits by borrowing a division from the art of literature. Both painting and poetry, he says, involve *inventio* and *dispositio*. These, of course, are the first two of the three principal parts of rhetoric—*inventio*, *dispositio*, and *elocutio*. By implication Fazio has committed himself to offering some equivalent for the third and least transferable of the three parts, *elocutio*; and by easing *ethopoeia* into the vacancy he can regularize his emphasis on it and also suggest the extent of its purchase.

This, Fazio's third part of painting, we may call *expressio*: he himself repeatedly used the verb *exprimere* in this context, and there is precedent for the noun in some of the shadier Latin rhetorical theory.[115] For its further definition he mobilizes, in the form of a close paraphrase, the first of his suspended references, the Prooemium to the *Imagines*.

Fazio:

No painter is accounted excellent who has not distinguished himself in representing the properties of his subjects as they exist in reality. For it is one thing to paint an arrogant man, but quite another to paint a mean, or fawning, or improvident one, and so forth. It is as much the painter's task as the poet's to represent these properties of their subject,

[113] *Moralia* 346F–347A: Πλὴν ὁ Σιμωνίδης τὴν μὲν ζωγραφίαν ποίησιν σιωπῶσαν προσαγορεύει, τὴν δὲ ποίησιν ζωγραφίαν λαλοῦσαν. ἃς γὰρ οἱ ζωγράφοι πράξεις ὡς γιγνομένας δεικνύουσι, ταύτας οἱ λόγοι γεγενημένας διηγοῦνται καὶ συγγράφουσιν. εἰ δ' οἱ μὲν χρώμασι καὶ σχήμασιν, οἱ δ' ὀνόμασι καὶ λέξεσι ταὐτὰ δηλοῦσιν, ὕλῃ καὶ τρόποις μιμήσεως διαφέρουσι, τέλος δ' ἀμφοτέροις ἓν ὑπόκειται, καὶ τῶν ἱστορικῶν κράτιστος ὁ τὴν διήγησιν ὥσπερ γραφὴν πάθεσι καὶ προσώποις εἰδωλοποιήσας.

[114] Cf. Isidore, *Etym.* II. xiv. 1: 'ethopoeiam vero illam vocamus, in qua hominis personam fingimus pro exprimendis affectibus aetatis, studii, fortunae, laetitiae, sexus, maeroris, audaciae.'

[115] Cf., for instance, Pseudo-Rufinianus, *De schematis dianoeas* 13: 'ἠθοποιΐα est aliorum affectuum qualiumlibet dictorumque imitatio non sine reprehensione; latine dicitur figuratio vel expressio.'

and it is in that very thing that the talent and capability of each is most recognized.

Philostratus:

If the painter is skilful in these things he will grasp every characteristic and his hand will interpret successfully the individual drama of each person—that a man is mad, perhaps, or angry, or thoughtful, or happy, or reckless, or in love—and in short, he will paint in every case the appropriate characteristics.[116]

And after a short gloss on the sense in which painting and poetry have this function in common[117] he returns to the same source.

Fazio:

And certainly the esteem in which painting has been held has always been great, and not undeserved; for it is an art of great talent and skill. There is hardly one of the other handicrafts that needs greater discretion, seeing that it requires the representation not only of the face or countenance and the lineaments of the whole body, but also, and far more, of its interior feelings and emotions . . .

Philostratus:

The art of painting is most excellent and rests on no slight foundation. For to master the art properly one must understand human nature well, and be able to distinguish, even when they are silent, the signs of men's character, what is revealed in the state of their cheeks, in the expression of their eyes, in the character of their eyebrows and, in short, whatever has to do with the mind.[118]

The presence of Philostratus at this point is important not just as a source; it offers one possible reason for the abruptness with which Fazio switches to speaking about the insufficiency of beauty: 'Otherwise it would be like the sort of poem that is beautiful, indeed, and tasteful, but languid and unaffecting.' For

[116] Prooemium 3: Τούτων δὲ ἱκανῶς ἔχων ξυναιρήσει πάντα καὶ ἄριστα ὑποκρινεῖται ἡ χεὶρ τὸ οἰκεῖον ἑκάστου δρᾶμα, μεμηνότα εἰ τύχοι ἢ ὀργιζόμενον ἢ ἔννουν ἢ χαίροντα ἢ ὁρμητὴν ἢ ἐρῶντα, καὶ καθάπαξ τὸ ἁρμόδιον ἐφ' ἑκάστῳ γράψει.

[117] Suggested by Quintilian *Inst. Orat.* VIII. vi. 8 and other accounts of rhetorical metaphor.

[118] Prooemium 3: Ζωγραφίας ἄριστον καὶ οὐκ ἐπὶ σμικροῖς τὸ ἐπιτήδευμα· χρὴ γὰρ τὸν ὀρθῶς προστατεύσοντα τῆς τέχνης φύσιν τε ἀνθρωπείαν εὖ διεσκέφθαι καὶ ἱκανὸν εἶναι γνωματεῦσαι ἠθῶν ξύμβολα καὶ σιωπώντων καὶ τί μὲν ἐν παρειῶν καταστάσει, τί δὲ ἐν ὀφθαλμῶν κράσει, τί δὲ ἐν ὀφρύων ἤθει κεῖται καὶ ξυνελόντι εἰπεῖν ὁπόσα ἐς γνώμην τείνει.

in the Prooemium the passage which he has just been using is followed by Philostratus's own statement of a similar point:

Wise men of ancient times have, I believe, written much about symmetry in painting, making rules, as it were, about the relationships of each of the limbs, as though it was not possible to succeed in expressing the movements of the mind without the harmony of the body conforming to the measurements laid down by nature; for they insist that if it is abnormal and goes beyond these measurements it cannot express the emotions of a properly constituted being. When one examines this matter, however, one finds that the art has a certain affinity with poetry, and that a certain element of imagination is common to both.[119]

Fazio's transition, if it is made with the Prooemium in mind, is balder and soon leaves Philostratus. He invokes Horace's recommendation that poetry should move the hearer's heart, and prepares for his most elegant stroke, signposted with an *ut ita loquar*, the word *figuratus*. The extraordinary critical resonance of this word was noticed in the first chapter.[120]

After clinching his argument in this way, Fazio ends his introduction; he remarks on the primacy of painting over the other visual arts and then goes on to consider his four painters.

OF PAINTERS

Now let us come to the Painters, though it might perhaps have been more appropriate to put the Painters after the Poets. For there is, as you know, a certain great affinity[121] between painters and poets; a painting is indeed nothing else but a wordless poem.[122] For truly almost equal attention is given by both to the invention and the arrangement[123] of their work. No painter[124] is accounted excellent who has not distinguished himself in representing the properties of his subjects as they exist in reality. For it is one thing to paint a proud man, but quite another to paint a mean, or fawning, or improvident one, and so forth. It is as much the painter's task as the poet's to represent these properties of their subjects, and it is in that very thing that the talent and capability of each is most recognized. For if one who wishes to portray a mean

[119] Prooemium 5–6: Δοκοῦσι δέ μοι παλαιοί τε καὶ σοφοὶ ἄνδρες πολλὰ ὑπὲρ ξυμμετρίας τῆς ἐν γραφικῇ γράψαι, οἷον νόμους τιθέντες τῆς ἑκάστου τῶν μελῶν ἀναλογίας ὡς οὐκ ἐνὸν τῆς κατ᾽ ἔννοιαν κινήσεως ἐπιτυχεῖν ἄριστα μὴ εἴσω τοῦ ἐκ φύσεως μέτρου τῆς ἁρμονίας ἡκούσης· τὸ γὰρ ἔκφυλον καὶ ἔξω μέτρου οὐκ ἀποδέχεσθαι φύσεως ὀρθῶς ἐχούσης κίνησιν. σκοποῦντι δὲ καὶ ξυγγένειάν τινα πρὸς ποιητικὴν ἔχειν ἡ τέχνη εὑρίσκεται καὶ κοινή τις ἀμφοῖν εἶναι φαντασία.

[120] See pp. 18–19. [121] See above, p. 100. [122] See above, p. 100.
[123] See above, p. 101. [124] See above, p. 101.

man has likened him to a lion or eagle, or a generous man to a wolf or kite, he would certainly, whether poet or painter, seem to be proceeding foolishly; the nature of things thus likened to each other should be similar. And certainly[125] the esteem in which painting has been held has always been great, and not undeserved; for it is an art of great talent and skill. There is hardly one of the other handicrafts that needs greater discretion, seeing that it requires the representation not only of the face or countenance and the lineaments of the whole body, but also, and far more, of its interior feelings and emotions, so that the picture may seem to be alive and sentient and somehow move and have action. Otherwise it would be like the sort of poem that is beautiful, indeed, and tasteful, but languid and unmoving. Truly, as Horace says,[126] 'it is not enough for poetry to be beautiful, it must also be pleasing—such as to move the hearts and feelings of men in whatever direction it wishes'; and in the same way it is proper that painting should not only be embellished by a variety of colours but, far more, that it should be, so to speak, enlivened[127] by a certain vigour. And, let it be said, what is true of painting is also true of carved and cast sculpture and of architecture, all of which crafts have their origin in painting; for no craftsman can be excellent in these branches of art if the science of painting is unknown to him.[128] However, let us pass on without further discussion to write of those few painters and sculptors who have distinguished themselves in our time; and, out of the infinite number of their works, we shall mention only those of which we have acquired some distinct knowledge.

GENTILE DA FABRIANO

Gentile da Fabriano possessed a talent apt and suited to all kinds of painting, but his art and industry are recognized most fully in his decoration of buildings. His is that celebrated picture in the church of Santa Trinita in Florence (Plate 14),[129] in which are admired the

[125] See above, p. 102.

[126] *Ars poetica* 99–103:

> Non satis est pulchra esse poemata; dulcia sunto
> et quocumque volent animum auditoris agunto.
> ut ridentibus arrident, ita flentibus adsunt
> humani voltus: si vis me flere, dolendum est
> primum ipsi tibi.

[127] For the reference of *figuratus*, see p. 18.

[128] Cf. Cennino Cennini, *Il libro dell'arte*, ed. D. V. Thompson, New York, 1932, p. 3; and Alberti, 'De pictura', Vatican Library, MS. Ottob. lat. 1424, fol. 11ᵛ: 'Pictoris enim regula et arte lapicida, sculptor omnesque fabrorum officine, omnesque fabriles artes diriguntur; denique nulla pene ars non penitus abiectissima reperietur, que picturam non spectet, ut in rebus quicquid assit decoris, id a pictura sumptum audeam dicere.'

[129] The panel, now in the Uffizi, was painted for Palla Strozzi in 1423 and was formerly in the sacristy of S. Trinita (Richa, *Notizie delle chiese fiorentine*, iii, Florence, 1755, 156).

Virgin Mary with the infant Christ in her arms and the three Magi adoring Christ and offering gifts. His is a work in the Piazza at Siena, again the Mother Mary holding the Christ Child in her lap as if she would wrap him round with fine linen;[130] John the Baptist, the Apostles Peter and Paul, and Christopher carrying Christ on his shoulder are here done with art so admirable that it seems to be reproducing also even the motion and action of the body. His is a work in the Duomo at Orvieto, again the Virgin with the infant Christ smiling in her arms;[131] and to this it seems nothing could be added. At Brescia he decorated, for a handsome fee, a chapel for Pandolfo Malatesta.[132] At Venice he painted in the Palace the land battle that the Venetians undertook on the Pope's behalf and fought against the son of the Emperor Frederick; but through damage to the wall this has almost entirely disappeared.[133] In the same city he also painted a whirlwind uprooting trees and the like,[134] and its appearance is such as to strike even the beholder with horror and fear. His also is a work in the church of San Giovanni in Laterano in Rome, a scene from the life of St. John, and above it four prophets represented in such a way as to appear not painted, but portrayed in marble.[135] In this work he is considered to have surpassed himself, as if foreseeing his death. Overtaken by death indeed, he left certain things in this work only in outline and incomplete. His also is a second painting in which Pope Martin and ten cardinals[136] are so represented that they seem to rival Nature herself and to differ in no respect from the living. It is said of Gentile that when the famous painter Rogier of Gaul, of whom we shall speak afterwards, had visited in the Jubilee year this same church of John the Baptist and had looked at this picture, he was taken with admiration and inquired after its author, and heaping praise on him preferred him to the other Italian

130 The panel formerly on the Ufficio de' Banchetti in Siena, a Pietà with Saints and Angels, done between 1424 and 1426. Documentation in Vasari, *Le vite*, I, *Gentile da Fabriano e il Pisanello*, ed. A. Venturi, i, Florence, 1896, 14–15. Lost.

131 Fresco painted late in 1425 (L. Fiumi, *Il duomo d'Orvieto e i suoi restauri*, Rome, 1891, pp. 292–3). A figure of St. Catherine was added in the 17th century.

132 A chapel in the former Broletto, painted between 1414 and 1419 and destroyed at the beginning of the 19th century. Documentation in Vasari, ed. cit. i. 9.

133 Fresco in the Sala del Maggior Consiglio. Sansovino (*Venetia*, Venice, 1581, p. 124a) reports its repainting in the 1470s.

134 Unidentified.

135 Payments were made in 1426 and 1427; Gentile died in 1428 and the work was continued by Pisanello. One Prophet and the general arrangement are recorded in a drawing by Borromini published by K. Cassirer, 'Zu Borrominis Umbau der Lateransbasilika', in *Jahrbuch der Preussischen Kunstsammlungen*, xlii, 1921, 62–4. The figures are described by Vasari as 'figure, di terretta tra le finestre in chiaro, et scuro' (Vasari, ed. cit., i. 1). Two drawings associated with Pisanello—British Museum, 1947–10–11–20 and Louvre 420ʳ— appear to be copies after Gentile's frescoes (cf. B. Degenhart and A. Schmitt, 'Gentile da Fabriano in Rom und die Anfänge des Antikenstudiums', in *Münchner Jahrbuch der bildenden Kunst*, 3. Folge, xi, 1960, 59).

136 Unidentified.

painters.[137] There are fine paintings in various places ascribed to him, of which I have not written because I have not obtained sufficient information about them.

JAN OF GAUL

Jan of Gaul has been judged the leading painter of our time. He was not unlettered, particularly in geometry and such arts as contribute to the enrichment of painting, and he is thought for this reason to have discovered many things about the properties of colours recorded by the ancients and learned by him from reading Pliny and other authors.[138] His is a remarkable picture in the private apartments of King Alfonso,[139] in which there is a Virgin Mary notable for its grace and modesty, with an Angel Gabriel, of exceptional beauty and with hair surpassing reality, announcing that the Son of God will be born of her; and a John the Baptist that declares the wonderful sanctity and austerity of his life, and Jerome like a living being in a library done with rare art: for if you move away from it a little it seems that it recedes inwards and that it has complete books laid open in it, while if you go near, it is evident that just their main features are there (Plate 10a).[140] On the outer side of the same picture is painted Battista Lomellini, whose picture it was—you would judge he lacked only a voice—and the woman whom he loved, of outstanding beauty; and she too is portrayed exactly as she was. Between them, as if through a chink in the wall, falls a ray of sun that you would take to be real sunlight (Plate 10b). His is a circular

[137] The Jubilee of 1450. This remark is the only direct evidence for Rogier having visited Italy. The probability of this has been examined by E. Kantorowicz ('The Este portrait by Rogier van der Weyden', in *Journal of the Warburg and Courtauld Institutes*, iii, 1939–40, 179–80), who is against, and E. Panofsky (*Early Netherlandish Painting*, i, Princeton, 1953, 272–3), who is for.

[138] Cf. Alberti, 'De pictura', Vatican Library, MS. Ottob. lat. 1424, fol. 23ᵛ: 'Doctum vero pictorem esse opto quoad eius fieri possit omnibus in artibus liberalibus. Sed in eo presertim geometrie peritiam desidero.' Fazio's insistence on van Eyck's researches into colour is the first statement of a theme recurrent in early critics: especially Vasari, *Le vite*, ed. G. Milanesi, ii, Florence, 1878, 565–7. Panofsky (op. cit., p. 24, n. 1) refers both this and the general emphasis on learning to Pliny's account of Apelles (*N.H.* xxxv. 79 ff.).

[139] Lost. R. Weiss ('Jan van Eyck and the Italians', in *Italian Studies*, xi, 1956, 2–3 and 9–10) has identified the Baptista Lomelinus portrayed on the outer sides of the wings as Battista di Giorgio Lomellini (d. 1463), a member of a Genoese family trading with Bruges and a friend of Fazio. Lomellini was, like Fazio, with the Genoese embassy to Naples in 1444, and perhaps Alfonso acquired Fazio and the Lomellini triptych at the same time. For the influence of this painting in Naples, see Vasari, ed. cit. ii. 568 (on Antonello) and F. Nicolini, *L'arte napoletana del Rinascimento*, Naples, 1925, pp. 221–30 (on Colantonio).

[140] The crux of this sentence is the word *capita*. This is translated by Panofsky, op. cit. 3, as 'their upper edges'; and by Elizabeth Holt (*A Documentary History of Art*, i, 1957, 200), on the suggestion of E. H. Gombrich, as 'their main divisions'. The translation here, '*main features*', is by analogy with the classical use in this sense in, for example, Cicero, *Brut.* xliv. 164: '. . . non est oratio, sed quasi capita rerum et orationis commentarium paullo plenius.' For the general idea of the sentence cf. Horace, *A.P.* 361–2: 'Ut pictura poesis; erit quae, si propius stes, / te capiat magis, et quaedam, si longius abstes.' Panofsky (op. cit., p. 190) has suggested comparison with the small panel by van Eyck in Detroit.

representation of the world, which he painted for Philip, Prince of the Belgians, and it is thought that no work has been done more perfectly in our time; you may distinguish in it not only places and the lie of continents but also, by measurement, the distances between places.[141] There are also fine paintings of his in the possession of that distinguished man, Ottaviano della Carda:[142] women of uncommon beauty emerging from the bath, the more intimate parts of the body being with excellent modesty veiled in fine linen, and of one of them he has shown only the face and breast but has then represented the hind parts of her body in a mirror painted on the wall opposite, so that you may see her back as well as her breast. In the same picture there is a lantern in the bath chamber, just like one lit, and an old woman seemingly sweating, a puppy lapping up water, and also horses, minute figures of men, mountains, groves, hamlets, and castles, carried out with such skill you would believe one was fifty miles distant from another. But almost nothing is more wonderful in this work than the mirror painted in the picture, in which you see whatever is represented as in a real mirror (Plate 10c). He is said to have done many other works, but of these I have been able to obtain no complete knowledge.

PISANO OF VERONA

To Pisano of Verona has been ascribed almost a poet's talent for painting the forms of things and representing feelings. But in painting horses and other animals he has in the opinion of experts surpassed all others. In Mantua he painted a chapel and some highly praised pictures (Plate 13).[143] In the Palace at Venice he painted Frederick Barbarossa, the Roman Emperor, and his son as a suppliant,[144] and in the same place a great throng of courtiers with German costume and German cast of feature, a priest distorting his face with his fingers, and some boys laughing at this, done so agreeably as to arouse good humour in those who look at it. And in the Church of S. Giovanni in Laterano he painted what Gentile had left unfinished in the story of St. John the Baptist;[145] but, as I heard from him, this work was afterwards almost

[141] Lost.

[142] Lost. Ottaviano Ubaldini della Carda (d. 1499) was nephew and counsellor to Federigo da Montefeltro of Urbino: Vasari (ed. cit. i, Florence, 1878, 184) states that Jan sent 'al duca d'Urbino Federico II, la stufa sua'.

[143] For the lost and dispersed work done by Pisanello in Mantua between 1441 and 1443, see Maria Fossi Todorow, I disegni del Pisanello, Florence, 1966, pp. 32–7 and 83–8.

[144] Lost. The paintings represented the Emperor's son Otto, whose capture had been painted by Gentile, set free by the Republic to plead its cause with his father. Sansovino (op. cit., p. 124a) reports its repainting by Luigi Vivarini in the 1470s. It was probably painted around the second decade of the century; for a summary of current opinions see Todorow, op. cit., p. 6, n. 7.

[145] Lost. Gentile died in 1428; Pisanello was employed in the Lateran till 1432 (Todorow, op. cit., pp. 8–9, n. 22, and, for drawings related to the frescoes, 47–8).

obliterated by the moisture from the wall. Other examples of his talent
and art are a number of pictures on panels and parchment in which
there is Jerome adoring the Crucified Christ and arousing veneration
through his bearing and facial grandeur;[146] and also a wilderness in
which are many animals of different kinds that you would think were
alive. To painting he added the art of sculpture: works of his in lead
and bronze are King Alfonso of Aragon, Prince Filippo of Milan,[147]
and very many other princes of Italy, by whom he was much esteemed
for the excellence of his art.

ROGIER OF GAUL

Rogier of Gaul, a pupil and fellow countryman of Jan, has produced
many matchless monuments of his art. His is a most notable painting
in Genoa[148] in which there is a woman sweating in her bath, with
a puppy near her and two youths on the other side secretly peering in at
her through a chink, remarkable for their grins. His is another painting
in the private apartments of the Prince of Ferrara:[149] on one wing Adam
and Eve with naked bodies, expelled from the earthly paradise by an
angel, in which there are no deficiencies from the highest beauty; on the
other wing, a certain prince as suppliant; and on the centre panel,
Christ brought down from the Cross, Mary His Mother, Mary Mag-
dalen, and Joseph, their grief and tears so represented, you would not
think them other than real. His also are the famous tapestry pictures
in the possession of King Alfonso,[150] again the Mother of God, dis-
mayed at hearing of the capture of her son yet, even with flowing tears,
maintaining her dignity, a most perfect work. Likewise the abuse and
pain that Christ Our Lord patiently suffered from the Jews, and in this
you may easily distinguish a variety of feelings and passions in keeping

[146] Fazio is speaking of a type. Cf. p. 92 and Plate 8.

[147] For Alfonso V, see G. F. Hill, *Italian Medals of the Renaissance*, i, London, 1930, 18,
nos. 41–3; for Filippo Maria Visconti, Duke of Milan, p. 12, no. 21.

[148] Lost.

[149] Lost. In 1449 the picture was seen and described by Ciriaco d'Ancona: 'cuiusce
nobilissimi artificis manu apud Ferrariam VIII Iduum quintilium N.V.P.A. III [8 July
1449] Lionellus hestensis princeps illustris eximii operis tabellam nobis ostendit primorum
quoque parentum ac e supplicio humanati Jovis depositi pientissimo agalmate circum et
plerumque virum imaginibus mirabili quidem et potius divina quam humana arte depictam.
Nam vivos aspirare vultus videres, quos viventes voluit ostentare, mortuique similem defun-
ctum, et utique velamina tanta, plurigenumque colorum paludamenta, elaboratas eximie
ostro atque auro vestes, virentiaque prata, flores, arbores et frondigeros atque umbrosos
colles nec non exornatas porticus et propylea auro auri simile margaritis gemmas, et coetera
omnia non artificio manu hominis quin et ab ipsa omniparente natura inibi genita diceres'
(printed in G. Colucci, *Delle Antichità Picene*, Vol. XV, Fermo, 1792, p. 143).

[150] Lost. Not pictures on canvas, as Panofsky (op. cit., p. 2, n. 7) reads it, but
tapestries. Alfonso's tapestries from Rogier's designs were later described by Pietro
Summonte (F. Nicolini, *L'arte napoletana del Rinascimento*, 1925, pp. 162–3 and 233–6). Cf.
Plate 11. for a painting representative of these virtues.

with the variety of the action.[151] At Brussels, a city in Gaul, he painted a sacred chapel[152] with the most perfect workmanship.

OF SCULPTORS

LORENZO OF FLORENCE

Out of the multitude of sculptors few are famous, though there are at present some who we believe will one day be renowned. But first I shall say something of Lorenzo of Florence. He is considered an admirable artist in bronze. On the doors of the church of John the Baptist in Florence he modelled in bronze first the New Testament and then the Old, most copious and varied, of indescribable workmanship.[153] His also in Florence are the bronze tomb of St. Zenobius in the church of the Reparata,[154] and the John the Baptist and St. Stephen Protomartyr on Or San Michele,[155] work of as much talent as skill.

VITTORE

His son Vittore is thought nothing inferior to him. His hand and art are seen in the fashioning of those same doors of the church of John the Baptist. For the work of each is so compatible with that of the other that they seem to have been done by one and the same hand.

DONATELLO OF FLORENCE

Donatello, likewise a Florentine, will also distinguish himself by the excellence of his talent and art. He is much noted for work not only in bronze but also in marble: he seems to 'form faces that live',[156] and to be approaching very near to the glory of the ancients. His in Padua are the St. Antony and other excellent images of saints on the same altar.[157] Also his in the same city is the famous general Gattamelata,[158] bronze and mounted on a horse, of marvellous workmanship. (XVI)

[151] Panofsky (op. cit., p. 249, n. 1) refers Fazio's praise of Rogier's expressiveness to Pliny's of Aristeides (*N.H.* xxxv. 98): 'is omnium primus animum pinxit et sensus hominis expressit, quare vocant Graeci ethe, item perturbationes . . .' A generalized version of Fazio's judgement became standard: cf. Carel van Mander, *Het Schilder-Boek*, Haarlem, 1604, p. 206b.

[152] Unidentified.

[153] Hung in 1424 and 1452 respectively. For Fazio the doors—'tam diffusa, tam varia'— seem to fulfil Leonardo Bruni's hope of the second door that it should be not only 'significante' but also 'illustre' — 'ben pascere l'occhio con varietà di disegno': see pp. 19–20.

[154] Completed by 1442.

[155] Set up in 1416 and 1429 respectively. Fazio omits the third of Ghiberti's figures for Or San Michele, the St. Matthew of 1422 (cf. R. Krautheimer, *Lorenzo Ghiberti*, Princeton, 1956, p. 87).

[156] Virgil, *Aeneid* vi. 848.

[157] Provisionally set up in June 1448. The manuscripts read *Antoninus* for *Antonius*.

[158] Set up in September 1453. Fazio mentions no work in Tuscany, nor the relief Assumption of the Virgin on the tomb of Cardinal Brancacci in S. Angelo a Nilo at Naples (1427–8).

What is especially impressive about Fazio's piece is the lack of strain between the principles he states in his preface and the particular criticisms he makes in the individual notices. The paintings he discusses are approached as things existing in their own right; they are not reduced to simple *exempla* of individual pictorial qualities. But the tact with which Fazio handles the paintings is also an index of real consistency between principles and cases, and it is difficult to think of any other critic before Vasari of whom one can say the same. The Apelles motif, for example, the insistence on the painter being learned, is clarified in the figure of van Eyck. Here Fazio goes beyond a simple attribution of geometrical knowledge to an instance of what, in Jerome's study (Plate 10a), it makes possible. Again, the principle of variety that runs through the introduction is established so clearly in the case of Rogier van der Weyden's tapestries that, when Fazio comes to Ghiberti's doors, the term stands firmly by itself. Most clearly of all *expressio*, the primary value, is given its final definition in descriptions of paintings by all four painters. The character which van Eyck expresses in John the Baptist or Pisanello in Jerome arouses veneration both directly and by sympathy; we feel both with and towards them. How complex the expression may be even in a single figure we see in Rogier's figure of the Mourning Virgin in whom a passion, grief, and an ethos, spiritual dignity, are both conveyed. We discover in Rogier's tapestry of the Mocking of Christ that expression appears in its highest form when it exists in a context and can interact with a complex of variously balanced feelings: 'a variety of feelings and passions in keeping with the variety of the action'. This might have been written by Alberti.

Fazio's 'De pictoribus' is the last and most perfect blossom of the early humanist criticism of painting. All the attitudes and approaches we have met are present here to a greater or lesser degree, and with a congruity found nowhere else. At the same time, however, it looks forward. A number of the central points of sixteenth- and seventeenth-century criticism of the academic kind usually called humanistic[159] are already stated or implied in Fazio: the two basic processes of the artist, Imitation and Invention, given meaning by their deployment as means to Expression;

[159] For which see R. W. Lee, '*Ut pictura poesis*: the Humanistic Theory of Painting', *Art Bulletin*, xxii, 1940, 197–269.

the uneasily related aims of Instruction and Delight; the Decorum that is both a practical condition of Imitation and a moral obligation; the Learned Painter necessary for activity on this level. It is true that where Fazio implies or touches on a point, Lomazzo and the sixteenth-century critics will hammer it heavily home; but the notions are in Fazio and had been maturing in humanist discourse for four generations.

Fazio exploited quite fully the critical potentialities of the humanist tradition of criticism; what is doubtful is how far the humanist tradition of criticism fully exploited the critical potentialities of humanism itself. The great authority of Ciceronian and ekphrastic conventions let humanists discourse in acceptable neo-classical ways about painting and sculpture, but perhaps the same authority diverted humanists from doing more interesting things. Our own disappointment with the humanists' remarks about art, our sense of their inadequacy as a contemporary account of Giotto and Masaccio, is of course unhistorical; it is not difficult to regain perspective by reminding oneself of the function of humanist discourse and also of the fact that the humanists were, after all, re-inventing the art of art criticism as they went along. Every critic before Baudelaire owed much to these first stiff steps. But there is a legitimate historical question to be asked about the quality of humanist criticism, and one will want to phrase it like this: Are there observable in humanist literature an important number of skills and notions about visual experience, relevant to the discussion of painting and sculpture but not brought to bear on them? The answer must be that there were indeed many such skills and notions; one can see how much humanist art criticism was missing by looking at the work of a man like Lorenzo Valla, Fazio's contemporary and antagonist at Naples.

Valla was by birth a Roman,[160] with a first-hand experience of

[160] Valla was born in 1407 at Rome and died there in 1457. After humanist studies in Rome he became in 1427 professor of rhetoric at Pavia; he left in 1433 after unpleasantness connected with his *De voluptate* (1431–2) and *Epistola de insigniis et armis*, an attack on the Trecento jurist Bartolo da Sassoferrato. After short stays in Milan and Florence he settled in Naples in 1437 as a secretary of Alfonso of Aragon, and stayed there till 1448. This was his most fertile period, in spite of involvement in a number of polemics; his books included the *Elegantiarum latinae linguae libri VI* (1435–44), *De libero arbitrio, Dialecticae libri III* (1439), *De Constantini donatione Declamatio* (1440). In 1448 he was brought back to Rome by Nicolas V. For Valla, see still G. Mancini, *Vita di Lorenzo Valla*, Florence, 1891, and L. Barozzi and R. Sabbadini, *Studi sul Panormita e sul Valla*, Florence, 1891.

classical art that does occasionally show itself in an aside.[161] He
was moreover a humanist at cultivated courts, demonstrably in
touch with the working out of pictorial schemes; here he de-
scribes a minor skirmish in his long, sterile feud at Naples with
Antonio Panormita:

Giovanni Carafa, vigorous *Decurio* of Naples, arranged for a portrait
of the King in armour and on horseback to be painted on the Castel
Capuano, and about him four Virtues—Justice, Charity or Liberality,
Prudence, and Temperance or possibly Fortitude (the painting could
be either) [Plate 12].[162] He was anxious for me to compose verses for
them, one verse for each figure, to be inscribed on scrolls held in their
hands. And he said that at least two of them should be done within
a couple of days since they were to go on the two higher figures,
already nearly finished. He had misunderstood the painter, really, who
did not intend to paint on these verses before starting on the lower
figures . . . Now I had a fever coming on at the time, but still I under-
took to do them and more than kept my promise. On that same day
I sent three verses to the man—for Justice, Liberality, and Temperance.
When the painter was about to paint them up and people were eagerly
reading them—it is the most frequented place in the city—Antonio
somehow heard about it and, of course, came along to run them down
as much as he could; in the end he made the man nervous about painting
such 'crude' verses (as Antonio put it) on his splendid painting, and
on a site specially chosen for the painter's as well as the King's glory.
He told him only to wait a day or two and he, Antonio, would produce
verses truly worthy of the house of Carafa and the Castel Capuano and
the portrait of a King. Eight days later he did hand some verses over.
I still had not heard anything about it, on account of being unwell.
Giovanni sent the verses to me; by this time I was feeling a little better
but had not yet ventured outdoors, and he told me about the whole
affair. I then finished my verses in a day, Antonio his in a week, more
or less; each of us started showing them round, each defended his own
verses and criticized the other's; both of us gathered supporters. 'The

[161] 'Plurima videmus dearum ac foeminarum simulacra non solum capite nudato, sed
etiam altero lacerto, altera papilla, altero crure, ut uniuscuiusque corporeae pulchritudinis
pars aliqua appareret. Multa etiam nullo velata integumento, et quidem melius me hercule
et gratius, ut in monte Celio simulacrum Dianae in fonte se lavantis cum caetero nym-
pharum comitatu, qualem Actaeon deprehendit' (*De voluptate* i. xxii, in *Opera*, Basel, 1540,
p. 915).
[162] The drawing is usually associated with the arch of the Castelnuovo at Naples (L.
Planiscig, 'Ein Entwurf für den Triumphbogen am Castelnuovo zu Neapel', *Jahrbuch der
Preussischen Kunstsammlungen*, liv, 1933, 16–28): its relation to the Castel Capuano gateway
described by Valla is therefore a speculation. For the drawing and the problem of its
function, see G. L. Hersey, 'The Arch of Alfonso in Naples and its Pisanellesque "Design"',
Master Drawings, vii, 1969, 16–24.

giddy Vulgar, as their Fancies guide, / With Noise say nothing, and in parts divide', as Virgil says.

In any event, Giovanni, by now not knowing what to do, sent us both to King Alfonso for him to settle the matter, as judge and referee. But the King did not want to appear as condemning anyone either, and left it open: he said both sets of verses seemed very nice. (Even so, he admitted privately—two of his secretaries told me—that mine had more bite). The outcome was that neither set was painted up . . . Antonio made his verses such that the speaker must be either the beholder— which is absurd—or the Virtues themselves; and yet if it *is* the Virtues speaking for themselves, they are not speaking about themselves. I, on the other hand, made the verses such that the Virtues are plainly speaking each one about itself, and also such that they can be put in the same order as the painter wants to put the figures. Antonio's cannot begin—as they should—with Prudence. Here are his:

> Iustitia.
> Te bone rex sequitur victas Astraea per urbes.
>
> Charitas.
> Te pietas et amor reddunt per secula notum.
>
> Prudentia.
> Agnoscit sociatque suum prudentia gnatum.
>
> Fortitudo.
> Te dignum coelo virtus invicta fatetur.

These flatteries seem to me simply banal, to say no more; and the verse he gives to any one figure could just as well be given to any of the others. As for mine, they are certainly not what Antonio said, 'a nothing', beside his. I put them in the natural order I mentioned, with Prudence first:

> Prudentia.
> Prima ego virtutum, peragunt mea iussa sorores.
>
> Iustitia.
> Per me stat regis thronus et concordia plebis.
>
> Charitas, or Largitas.
> Celsius est dare nostra, suum quam reddere cuique.
>
> Temperantia.
> Corporis illecebras plus est, quam vincere bella.
>
> Fortitudo.
> In gemmis Adamas, in moribus ipsa triumpho.

On this occasion the King did not openly give judgement for me, but on others he did so . . . (XIX)

Valla has all the marks of a critic *manqué*; more than most humanists he had the philological equipment to master the classical critical vocabulary. Many humanists who did talk about painting were not in control of this, particularly of its metaphorical weight, but in Valla's *Elegantiae* there are hints of what a humanist analysis of it would properly have been:

Mollis homo: molle opus

One speaks of a *mollis* man and also of a *molle* work of art; the latter in praise, the former in censure. So Virgil:

> India mittit ebur, molles sua tura Sabaei.

Again:

> Excudent alii spirantia mollius aera:
> Credo equidem vivos ducent de marmore vultus.[163]

This is reasonable. A man who is not austere, steadfast, and constant, not able to support hard times or withstand either good or bad fortune, such a man is *mollis*, like wax or a delicate plant . . . In this sense *mollis* is understood as a fault. But it is used in praise of anything for which hardness (*durum*) is a fault—hard fare, hard bed, hard ground, and also hard *ingenium*, as for a horse hard to break, an *ingenium* hard to teach: also, one might say, of carving, which is spoken of as being *molle* on the same grounds—because it is not hard and is therefore to be praised. Quintilian, speaking of images, says that one man's are *duriora*, another's *molliora*.[164]

By images (*signa*) is meant carved or cast works of art or any other such things made in the likeness of living beings: for instance, panel paintings. Note that the ancients did their paintings on panels, not on walls. In such cases as these *mollis* refers to the things that are made rather than to the *ingenium* that makes them. (XVIII (*d*))

Again, in the course of a savage attack on the Trecento academic lawyer Bartolo da Sassoferrato,[165] Valla lays about the late medieval hierarchy and symbolism of colours—traces of which are still very clear in Alberti[166]—mainly by appealing to common experience.

[163] Virgil, *Georgics* i. 57 and *Aeneid* vi. 848–9.
[164] *Inst. Orat.* XII. x. 7.
[165] The *Tractatus de insigniis et armis* (ed. F. Hauptmann, Bonn, 1883) of Bartolo da Sassoferrato (1314–57). Valla's attack on Bartolo was written in Pavia and was a cause of his leaving there in 1433: for the circumstances, see L. Barozzi and R. Sabbadini, *Studi sul Panormita e sul Valla*, Florence, 1891, pp. 182–5.
[166] For which see now S. Y. Edgerton, Jr., 'Alberti's colour theory: a medieval bottle without Renaissance wine', *Journal of the Warburg and Courtauld Institutes*, xxxii, 1969, 109–34.

THE HUMANISTS ON PAINTING

Now let us look at Bartolo's theories of colour . . . The colour gold
(*aureus*) is the most noble of colours, he says, because light is repre-
sented by it; if someone wished to represent the rays of the sun, the
most luminous of bodies, he could not do it more properly than by rays
of gold; and it is agreed that there is nothing more noble than light.
If by gold we mean of a tawny (*fulvus*) or reddish-yellow (*rutilus*) or
yellowish (*croceus*) colour, who was ever so blind or sottish as to call the
sun *yellowish*? Raise your eyes, you ass Bartolo . . . and see whether it is
not rather of a silvery white colour (*argenteus*). It is for this reason that
a white gem can be called *heliotrope* after the sun. We speak of white-
blazing (*candens*) torches, and when someone is moved and, so to speak,
inflamed by anger or indignation we say he is blazing (*excandescens*);
flame which has nothing of moisture or earth in it is white (*candidus*) and
like the sun.

Which colour does he put next? . . . Blue, he says, comes next—
though the word he barbarously uses to denote 'blue' is the effeminate
azurus rather than *sapphireus*. Air, he says, is represented by this colour.
But surely this suggests he is now following the order of the elements?
It does. But why did he leave the moon out . . .? If you put the sun
first, then you ought to make the moon second, and if you call the one
golden you should call the other silver and next after the sun, just as
silver comes second after gold . . . And if you want to put Phoebe next
to her brother Phoebus, reality and hierarchy really do demand that
silver, a white colour, should have the place after gold—all the more
so, in that you later place this colour first or second (I do not know
how) on the ground that it most nearly approaches light . . . so
you put sapphire-colour in second place, seduced away from the
hierarchy of Heavenly Bodies by the hierarchy of the Elements.
Of course you do not think it right to take your examples from
metals, stones, grasses, and flowers; they would have been more
appropriate, but you saw them as humble and abject things, you
that are constituted of sun and of air alone. For, if we are following
the order of elements, you have mentioned two but left two more out;
and we, waiting for the grand and lofty progression to continue, feel let
down. If the first colour is of fire and the second of air, the third will
be of water and the fourth of earth . . .

But let us pass on. A little later the man says white is the noblest
colour and black the lowest; and as for the other colours, they are good
to the extent that they approach white and inferior as they approach
blackness. There are a number of things to complain about in this.
Has he forgotten now what he said about gold, as if anticipating my
objections? Does he put white at the top now, and black at the bottom?
And surely the nonsense he talks about the other colours is anyway

darker in meaning than an oracle of Apollo?... Who ever thought the colour of roses inferior to *rose bianche*? Who ever preferred pearl or crystal to emerald, sapphire, or topaz? Why do we dye silk purple or white linen red, unless we find red more attractive than white? For while white is indeed the plainest and purest colour, it is not invariably the best ...

And what shall I say of black? Indeed I find it is not considered of inferior excellence to white: the raven and swan are both holy to Apollo ... In my view Ethiopians are more beautiful than Indians for the very reason that they are blacker. Why appeal to human authority when it is made puny by the heavenly? Did God the Father and Maker of all things err, who put black in the middle of our eye, and white—not red or yellow or sapphire-colour—round it...? What more apt or powerful argument than that the eye, which is the only judge of colours (*qui unus est colorum arbiter*), is formed by God of black or near-black: I am speaking of the pupil ... If the Maker of all things saw no difference of value in colours, why should we little men do so? Do we know more than God, and shame to follow him? In Jesus' name, even if Bartolo did not consider stones and grasses and flowers and so many other things in his pronouncement on dress and ornament, how can he have overlooked the birds' dress—the cock, peacock, woodpecker, magpie, pheasant, and all the rest ... Come then, hearken to this man at odds with God and men; and let us impose a law on our Pavia girls, now spring is coming, not to presume to weave garlands except as Bartolo prescribes ... But enough of this. It is stupid to lay down any law about the dignity of colours. (XVII)

This, more than any humanist criticism of painting, seems to be carrying out the liberating role of humanism. At an even more basic level too, in his slightly philistine critique of scholastic logic, *Dialecticarum disputationes*, Valla puts forward a theory of sense perception which, for all its logical primitivism, would be a lively companion to Quattrocento painting.[167]

[167] See especially I. xii–xv. Valla reduces Aristotle's ten categories to three (*substantia, qualitas, actio*), for instance, thus: 'visus obiectum (ut dixi) est color, et ex consequenti figura, quantitas, motus, quies, quarum figura est qualitas: de reliquis postea disseremus: eadem quatuor etiam tactus sentit: duo posteriora, nonnihil auditus. Quid splendor? estne color? an alia quaedam qualitas? Aristoteles vult eum esse, non dico candorem, sed candidum: si candidus: quaenam erit eius substantia? quem cum faciat candidum, miror cur dicat solem et ignes rutilos: unde enim suum candorem splendor habeat, nisi a sole, quem Homerus candidum facit, aut ab igne, aut si quid simile est? Nusquam etiam splendor est, nisi in his aut ab his, nec video quare ignis aut sol si rutilus esset, non posset habere splendorem rutilum: ergo splendor seu fulgor, est vigor ille, illa vivacitas ignei coloris. Nam qualitas in qualitate est, et aliquando in actione: ut pulchritudo formae corporis, suavitas coloris, dulcedo vocis, tarditas ambulationis. Quo fit ut omnem, quem nanciscitur colorem splendor et fulgor illustret, vehementioremque reddat: in aere vero qui colore vacat,

In one central area Valla did leave an entirely mature statement which could—if only anybody had taken it up—have filled one of the most obvious gaps in fifteenth-century criticism. This gap was the absence of any sufficiently evolved model on which to describe the complicated interrelationships of Quattrocento artists, to follow the old prophet–saviour–apostles pattern of the Trecento. A new, less rigid and less single-line pattern was needed for the situation in, say, Florence during the first half of the century; in its absence fifteenth-century humanists fell back on either a feeble continuation of the Trecento model, or half-hearted direct reference to Pliny, or avoided structural remarks altogether. We still suffer from the lack of a contemporary account of the Quattrocento. Valla brought in his model in the course of discussing the role of the revived Latin language. There is a well-known reference in the Preface of his *Elegantiae* to the improvement of painting and sculpture and their kinship, in some sense, with the liberal arts :[168]

Now for many centuries nobody even read Latin with real understanding, let alone spoke it. So, as a rule, students of philosophy did not and indeed still do not comprehend the ancient philosophers, nor advocates the ancient orators, nor law-mongers the ancient lawyers, nor any other readers any of the ancients' books. It was as if, once the Roman dominion was lost, it would be improper either to speak or to know the Roman tongue, and people let the splendour of the pure Latin language decay with the mould and rust of disuse. There are many different views put forward by wise men as to why this happened; speaking for myself, I neither reject nor accept any of these views, and certainly I have not ventured to express an opinion of my own. No more do I know why those arts that most closely resemble the liberal arts—painting, carving, modelling, architecture—became so degenerate for so long and were along with literature nearly dead, or why at the present time they are raised up and come to life again: so great a growth now springs up both of good craftsmen and of good writers. But certainly, the more wretched those earlier ages, with not one learned man to be found in them, the more we should rejoice in our own age in

nullum representat colorem: etsi Aristoteles aeri dat colorem album quasi si colorem haberet, non cerneremus, uti solem quem album proprie et argentum nonnunquam alia de causa aureum cernimus. Ego qui diceret se vidisse aerem praeter Aristotelem inveni neminem. Nam nisi vidisset nunquam album esse dixisset' (*Dialecticarum disputationes* 1. xiv, in *Opera*, Basle, 1540, p. 675).

[168] See especially W. K. Ferguson, *The Renaissance in Historical Thought*, Cambridge, Mass., 1948, p. 28, and E. Panofsky, *Renaissance and Renascences in Western Art*, Stockholm, 1960, p. 16.

which, if only we strive a little more, I am sure the Roman tongue will soon flourish more vigorously than the city of Rome itself, and that along with it all the sciences will be on the way to renewal. (XVIII (*a*))

The sentence about visual artists and writers must be read in context. Valla is thinking of Quintilian's extended parallel between the development of oratory and of painting and sculpture; he is careful to acknowledge his indebtedness by echoing some of Quintilian's turns of phrase—for instance, *efflorescere* (*oratorum* or *artificum*) *proventus*.[169] What Valla is talking about is the Latin language; the point of his reference to the visual arts is made clear in the sentence that follows: 'along with it [the Roman language] all the sciences will be on the way to renewal.' In the *Elegantiae* Valla was not prepared to be more positive than this; but later, in a more mature work, he restates his point in terms that amount almost to a theory of culture, and again he makes a point of placing the visual arts. The passage comes in the splendid *Oratio in principio sui studii*, delivered as an introduction to a rhetoric course in his own city of Rome on 18 October 1455, less than two years before his death:

. . . in my opinion the cause of all the sciences being so increased in ancient Italy was the greatness of the Romans' dominion. For it is ordained by Nature that nothing should be able to progress or grow very much that is not being built up, elaborated, and refined by many individual men, particularly men who are in competition with each other and vying with each other for public esteem. What sculptor or painter or other such artist would ever have been excellent or of any distinction in his craft if he had been the only practitioner of that craft? Each invents something different, and what each individual regards as excellent in the work of another he tries to imitate and rival and surpass. In this way an eagerness for study is kindled, progress is made, the arts grow up and reach the heights, and this happens the better and quicker the more individuals there are applying themselves to them; just as the construction of a town reaches completion more quickly and better if the hands of many rather than few are applied to it—as in Virgil's lines:

> The Prince, with Wonder, sees the stately Tow'rs,
> Which late were Huts, and Shepherds homely Bow'rs;
> The Gates and Streets; and hears, from ev'ry part,
> The Noise, and buisy Concourse of the Mart.

[169] *Inst. Orat.* XII. X. 11.

The toiling *Tyrians* on each other call,
To ply their Labour: Some extend the Wall,
Some build the Citadel; the brawny Throng,
Or dig, or push unweildy Stones along.
Some for their Dwellings chuse a Spot of Ground
Which, first design'd, with Ditches they surround.
Some Laws ordain, and some attend the Choice
Of holy Senates, and elect by Voice.
Here some design a Mole, while others there
Lay deep Foundations for a Theatre:
From Marble Quarries mighty Columns hew,
For Ornaments of Scenes, and future view.[170]

Now any of the arts is quite as difficult to perfect as a city is. Therefore just as no city, so also no art can be established by a single man, nor indeed by a few men; it needs many, very many men, and these men must not be unknown to each other—how otherwise could they vie with each other and contend for glory? But above all else they must be known and related to each other by virtue of communication in the same language. I have already taken a simile from the building of a city: do we not also learn from the Bible that the men who built the great tower of Babel stopped building it precisely because they did not fully understand each other's speech?[171] And if it is necessary for community of language to exist within these crafts that are achieved by hand, how much more must this be so in those which actually consist of language, that is in the liberal arts and sciences. Thus the sciences and arts were meagre and almost nothing as long as each nation used its own peculiar language. But when the power of the Romans spread and the nations were brought within its law and fortified by lasting peace, it came about that very many peoples used the Latin language and so had intercourse with each other . . . (XX)

In other words, progress in the arts is a function of social interaction. It appears in two phases: first, the individual man innovates; second, his innovation is made accessible to his fellows, and he in turn has access to the sum of their innovation. The impetus to movement within this framework is human competitiveness. A necessary condition is completeness of communication: particularly, much of the dialogue will take place in the medium of language—to a greater degree in the verbal arts, to a lesser but still real degree in the case of such manual arts as painting and sculpture. The factor which regulates the rate of

[170] Virgil, *Aeneid* i. 421-9. The translation is Dryden's. [171] Genesis 11: 1-9.

progress, finally, is the size of the community within which the dialogue can take place. Such a model is clearly relevant to any description of mid-fifteenth-century painting and sculpture; here, in fact, was a system into which most of their main characters— as we ourselves see them—were built: the vital element of competitiveness, the artists' new theoretical interests and attempts to verbalize about their art, the pattern of big centres and satellite small centres, the intricate network of relationship and interchange between individual craftsmen. These things were not discussed until the Second Part of Vasari's *Lives*.

If we speak, therefore, of a failure of humanist criticism, this is not because humanist criticism is often such poor stuff; it is rather because its conventions so quickly became of a kind to exclude so much that was available in humanism itself. In short, the trouble with humanist art criticism from our point of view is that its conventions were not of a kind to encourage a Lorenzo Valla—or, in a different sense, an Alberti—to operate within them.

III

Alberti and the Humanists: Composition

In Leonis Baptistae libellum de pictura elegantissimum
Pingere seu discas, seu dicere multa latine,
 Baptistae ingenio, lector, utrumque potes.
Auribus atque oculis fecit satis, et studiosis
 Omnibus, hinc lingua profuit, inde manu.
Scilicet, his quoniam discuntur sensibus artes,
 Doctrinam ut discat sedula turba suam.

 PIETRO BAROZZI[1]

To Battista's Elegant Book 'De pictura'
Battista's talents, Reader, lead you to facility
In painting and in Latin volubility.
He satisfies our ears and eyes:
For every hand and tongue a guide supplies.
See! what a throng will swarm to school
When both these senses study art and rule!

ALBERTI wrote his treatise *De pictura* twenty years before
Fazio wrote *De viris illustribus*; it does not belong with the sorts
of discourse looked at in the last chapter. The difference is
mainly one of seriousness; Alberti's book is not just much larger
and better than anything else a humanist wrote on painting, it is
written from a position of personal contact with the art and from
an interest in developing method, and so becomes something of
a different order. Alberti was a completely equipped humanist,
but when he writes about painting he no longer belongs entirely
with the humanists; he is instead a painter, perhaps of a rather
eccentric kind, with access to humanist resources. What interests
us here is the part these humanist resources may have played in
his account of painting, and if it is to be a genuinely interesting
part, it will be more than a matter of the classical commonplaces

[1] Biblioteca Ambrosiana, Milan, MS. O. 58 sup., fol. 64ᵛ. The poem is printed in
Giovanni Battista Contarini, *Anecdota Veneta*, Venice, 1757, p. 262, without variation. For
Pietro Barozzi (1441–1507), Bishop of Belluno (1471) and then of Padua (1487), see the
article by F. Gaeta in *Dizionario Biografico degli Italiani*, vi, Rome, 1964, 510–12.

and artists' names scattered over the text. This chapter will try to suggest that *De pictura* is a humanist book in less obvious and more substantial ways. Four not unconnected points will recur in it. First, *De pictura* is a humanist book in the quite material sense of having been written in humanist Latin. Secondly, *De pictura* is written under humanist licence: that is to say, a treatise on painting was something acceptable within the humanists' general view of a liberal education. Thirdly, it was written in terms of skills specific to an identifiable kind of humanist reader. And fourthly, an important part of the book and its conception of painting grows directly out of the system and situation of rhetorical humanism in 1435.

For people so much given to analogy between painters and writers, the humanists were rather unspeculative about any general theoretical relationship of painting, as an intellectual activity, with their own *studia humanitatis*. Whether or not painting was a liberal art is mercifully not an important theme of the early humanists, but neither were other kinds of conjecture about its status. Behind this silence there are presumably a number of more or less Aristotelian assumptions about the actions of the mind, of a sort explained in a famous letter from Leonardo Bruni to a Venetian correspondent, Lauro Quirini.[2] Quirini had asked him whether a man might possess isolated *virtutes* or whether *virtutes* were interdependent and indivisible. Bruni's reply depended on two distinctions. The first is between moral virtues and intellectual virtues: moral virtues being irrational and of the affections, intellectual virtues being rational and concerned with truth and falsehood. The second distinction was between natural virtues or dispositions and virtues proper, which are established by practice:

... every virtue is a habitual condition, but every habitual condition is acquired by exercise and practice. From this it seems clear that virtues proceed from practice and exercise. However, we have a certain natural disposition to virtues, for we clearly see that some people are more fitted for some virtues, and others more for other virtues . . . Such dispositions being innate in men, whether to liberality or courage or

[2] *Epistolarum Libri VIII* . . ., ed. L. Mehus, ii, Florence, 1741, 134–44. The letter is dated to 1441 by H. Baron, *Leonardo Bruni Aretino, Humanistisch-Philosophische Schriften*, Leipzig–Berlin, 1928, p. 215.

justice, are not virtues proper. For a virtue proper is that which has produced a habitual condition through practice and exercise. As a craftsman becomes effective by exercising his craft and a lutenist by playing his lute, so does the just man by doing just things and the brave man by doing brave things.[3]

Painting and writing are arts, and art is an intellectual virtue established by practice.

. . . prudence unites all moral virtues and lets none be separate from the rest, and whoever has one virtue has all. As for the intellectual virtues, here I do not see why separation should be impossible. For an artist who has reached perfection in his own art, like Apelles in painting or Praxiteles in sculpture, need not be expert in the *scientia* of warfare or of government, or in *cognitio* of natural philosophy. Indeed, as Socrates says in the *Apology*,[4] a common fault among artists is that, as each excels in his own art, so he deceives himself into thinking he knows about other skills too, which he does not. So art is separate from the other intellectual virtues; and one may well say the same of both *scientia* and prudence too . . .[5]

[3] 'Tertia quaestio tua est de virtutibus, de quibus dubitare videris, utrum a natura sint, vel ab usu. In quo illud simpliciter respondeo, virtutem omnem esse habitum, habitus autem omnis per exercitationem et usum fieri. Ex quo palam est ab usu, et exercitatione virtutes existere. Est tamen nobis quaedam naturalis dispositio ad virtutes: videmus enim manifeste nasci alios ad alias virtutes aptiores. Nempe alii natura intrepidi adversus pericula existunt, alii meticulosi, quidam mites natura, et verecundi, quidam effrenes natura et impudentes, alii cupidi natura, et rapaces, alii liberales, et abstinentes. Hujuscemodi ergo dispositiones hominibus innatae vel ad liberalitatem, vel ad fortitudinem, vel ad justiciam, non sunt virtutes propriae. Nam propria virtus est, quae habitum jam per usum, exercita-tionemque contraxit. Ut enim fabricando fabri, et citharam pulsando citharoedi, sic justa agendo justi, et fortia fortes efficiunt. Ex his patet, neque natura, neque praeter naturam inesse nobis virtutes, sed sumus nos quidem ad illas recipiendas natura apti, perficimur autem per exercitationem, et assuetudinem' (op. cit., pp. 142–3).

[4] Plato, *Apology* 23 d.

[5] 'Moralium autem virtutum omnium catenatio quaedam esse videtur, nec alteram ab altera separari posse. Sunt enim habitus cum ratione circa affectus animi, ratio autem in hujusmodi virtutibus a prudentia est, prudentia vero in omnibus affectibus eadem est. Non enim unum curat, alium negligit. Ex quo fit, ut prudentia omnes virtutes morales simul liget, nec ullam separatim patiatur, et qui unam habet virtutem, omnes habet. Restant virtutes intellectivae, in quibus non video, cur separatio fieri non possit. Artifex enim quandam perfectionem, et habitum in arte sua consecutus, ut Apelles in pictura, Praxiteles in statuis, non necesse habet rei militaris, aut gubernandae Reipublicae scientiam habere, aut naturae rerum cognitionem. Immo, ut Socrates in Apologia docet, hoc est commune vicium in artificibus, quod ut quisque in arte sua excellit, ita se se decipit putans in aliis quoque facultatibus se scire, quae nescit. Ars igitur ab aliis virtutibus intellectivis separatur. Idem forsan de scientia, et prudentia dicendum est. Prudens enim cum in agendo versetur, non videtur requirere scientiam naturae, cujus finis est non actio, sed cognitio. Itaque ut naturales virtutes, sic etiam intellectivae videntur separationem recipere' (op. cit., pp. 143–4). This passage is referred to by R. Krautheimer (*Lorenzo Ghiberti*, Princeton, 1956, p. 302), who however sees it as reflecting a disposition to look down on the artist as *vilis mechanicus*: 'artists, he says, neither need to be possessed of theoretical knowledge (*scientia*), nor steeped in the natural sciences (*materiae rerum cognitio*)'. This seems a misunderstanding.

Unlike moral virtues proper, then, art is a separate virtue and is not transferable from one faculty to another.

This raised a problem. Everyone agreed that only an informed beholder could draw real satisfaction from paintings, as indeed from literature; but 'informed' in what sense? Petrarch and Poggio Bracciolini appealed to the judgement of the professionals ('Donatellus vidit et summe laudavit')[6] but such humility was rare, unclassical and often rhetorically out of place; no humanist could be anxious to point out that he himself, not being a practising painter, was unable to judge. Instead he might take refuge in the ambiguity of a word like *doctus*, which may be *doctus* absolutely, as he could well consider himself, or *doctus* as to the particular art. More respectably, in his *De interpretatione recta* Leonardo Bruni was prompt with another helpful distinction, between understanding an art and having executive ability in it. A man can read Aristotle intelligently without having the specialized verbal skill to make a good translation of him; similarly, so Bruni asserted, one could appreciate painting or music without being oneself a good painter or singer:

Multi ad intelligendum idonei, ad explicandum tamen non idonei sunt. Quemadmodum de pictura multi recte iudicant, qui ipsi pingere non valent, et musicam artem multi intelligunt, qui ipsi sunt ad canendum inepti.[7]

No doubt it was this distinction that licensed Bruni himself to advise on Ghiberti's bronze doors.

The question that next offers itself is about what the training of this informed but non-executive beholder might consist in, and particularly whether a person of humanist culture should have any practical experience of, as opposed to real accomplishment in, drawing or painting. Probably this question was not often asked, but in any case there was an answer in Aristotle:

Children may similarly be taught drawing—not to prevent them making mistakes in their own purchases of objects of art, nor in order that they may not be imposed on when they are buying or selling them, but perhaps rather because it makes them judges of the beauty of the human form. Always to be running after the strictly useful is not becoming to free and exalted souls.[8]

[6] For Poggio and Donatello's opinion of his antique sculpture, E. Walser, *Poggius Florentinus*, Leipzig–Berlin, 1914, p. 147, note 4; for Petrarch, see p. 60, above.

[7] *Humanistisch-Philosophische Schriften*, ed. H. Baron, Leipzig–Berlin, 1928, p. 84.

[8] *Politics* 1338a–b.

In 1404, Pier Paolo Vergerio expanded and rather coarsened this in the most influential of all the humanist treatises on education, *De ingenuis moribus*:

There were four things the Greeks used to teach their boys: letters, wrestling, music, and drawing (*designativa*), which some call portrayal (*protractiva*) . . . Nowadays drawing does not in practice pass as a liberal study except so far as it relates to the writing of characters—writing being the same thing as portraying and drawing—for it has otherwise remained in practice the province of painters. But as Aristotle says, among the Greeks activity of this kind was not only advantageous but also highly respected. When buying vases, paintings, and statues, things in which the Greeks took much pleasure, it was an aid against being cheated over the price; and it also contributed much to comprehending the beauty and grace of objects, both natural and artificial. These are things it is proper for men of distinction to be able to discuss with each other and appreciate.[9]

This is only prescription and there is no reason to think that a humanist education generally included painting lessons in any important way. The point to be made is simply that there was in principle some licence for humanists who might wish to practise drawing or even to have it taught in a school. And to a humanist an art was by definition something taught through precepts: a humanist book on the subject was not urgently needed or demanded, but if someone wanted to write one, there was at least a niche for it in their system. It was this niche Alberti's *De pictura* filled, more expansively than any humanist except Alberti himself could have had in mind. Book I is the earliest account of the optics and geometry of representing three-dimensional objects on plane surfaces, pictorial perspective. Book II is the first account of pictorial composition. Book III, the least substantial, is still the first extended discussion of how painters stand to other artists, particularly writers. Book II is systematic and

<hr/>

[9] *Petri Pauli Vergerii De ingenuis moribus et liberalibus studiis adulescentiae etc.*, ed. A. Gnesotto, 1918, pp. 122–3: 'Erant autem quattuor, quae pueros suos Graeci docere consueverunt: litteras, luctativam, musicam, et designativam, quam protractivam quidam appellant . . . Designativa vero nunc in usu non est pro liberali, nisi quantum forsitan ad scripturam attinet (scribere namque et ipsum est protrahere atque designare), quoad reliqua vero penes pictores resedit. Erat autem non solum utile, sed et honestum quoque hujusmodi negotium apud eos, ut Aristoteles inquit. Nam et in emptionibus vasorum tabularumque ac statuarum, quibus Graecia maxime delectata est, succurrebat, ne facile decipi pretio possent, et plurimum conferebat ad deprehendendam rerum, quae natura constant aut arte, pulchritudinem ac venustatem; quibus de rebus pertinet ad magnos viros et loqui inter se, et judicare posse.'

divides painting into three parts: circumscription (or delinea-
tion), composition, reception of light (or tone and hue).[10]

De pictura therefore becomes a book for people with three
necessary skills. It is, first, for people able to read neo-classical
Latin quite freely: that is, humanists.[11] Secondly, *De pictura* is
a book for people with some grasp of Euclid's *Elements*, since to
follow the series of demonstrations through which Alberti ex-
plains his perspective construction in Book I is strenuous geo-
metrical optics. Not every historian is at ease with it now, and
those who are seem to disagree with each other about what
Alberti is saying; it is unlikely Florentine mechanicals or indeed
humanists found it much easier. Alberti himself remarked on its
difficulty: 'huiusmodi est ut verear ne ob materie novitatem
obque hanc commentandi brevitatem parvum a legentibus intel-

[10] For a general bibliography on studies of Alberti, see *Encyclopedia of World Art*, i, New
York, 1959, s.v. 'Alberti', pp. 188–216, and the article on Alberti by Cecil Grayson in
Dizionario Biografico degli Italiani, i, Rome, 1960, 702–9. Creighton Gilbert ('Antique
Frameworks for Renaissance Art Theory: Alberti and Pino', *Marsyas*, iii, 1943–5, 87–106)
has pointed out that the three books follow the classical form of the isagogic treatise:
(1) elements, (2) the art, (3) the artist.

[11] For various reasons the Italian version, *Della pittura*, is now more often read: it is
available in modern printed editions, it is very interesting for the history of Italian technical
prose, it has a preface addressed to Brunelleschi. It seems nevertheless a rather perfunctory
translation from *De pictura*, sometimes off-hand to the point of being incomprehensible and
—so the tally of manuscripts suggests—much less widely current in the 15th century than
the Latin was. By the end of the 15th century the existence of *Della pittura* seems to have
been forgotten; the 16th century made its own new translations into Italian direct from the
Latin. Alberti's copy of Cicero's *Brutus* (Biblioteca Marciana, Venice, Cod. lat. 67. cl. xi)
carries an autograph note on its last page: Die veneris ora xx¾ quae fuit dies 26 augusti 1435
complevi opus de Pictura Florentiae (G. Mancini, *Vita di L. B. Alberti*, Florence, 1882,
p. 141); but this does not necessarily refer to the Latin rather than the Italian version. The
best MS. of the Italian version (Biblioteca Nazionale, Florence, MS. II. IV. 38) ends with
the note: Pittura: Finis laus deo die xvii mensis iulii MCCCC36; but this could refer to the
manuscript, not to the Italian version as such. An opinion about the precedence of one
version over the other therefore depends mainly on the internal quality of the texts them-
selves. Much the best discussion of the editions of the treatise is in two articles by Cecil
Grayson. 'Studi su Leon Battista Alberti, II, Appunti sul testo della *Pittura*' (*Rinascimento*,
iv, 1953, 54–62), distinguishes and illustrates the kinds of variation between Latin and
Italian that point to the priority of the Latin. 'The text of Alberti's *De pictura*' (*Italian
Studies*, xxiii, 1968, 71–92) lists 3 manuscripts of the Italian, two of them very poor, and
no less than 19 of the Latin, 10 of these being of the 15th century; and, distinguishing two
major groups among the Latin manuscripts, argues persuasively for a sequence of: (1) MSS.
reflecting a first Latin edition of 1435, (2) the Italian translation of perhaps 1436, (3) MSS.
reflecting a somewhat revised Latin version, perhaps associated with the dedication to
Gianfrancesco Gonzaga. The text used in this book, Vatican Ottob. lat. 1424, would
belong to the second, revised group of Latin manuscripts. A text of the Latin version has
been twice printed (Basle, 1540; Amsterdam, 1649) but it differs in detail from the text of
most manuscripts. There are a number of modern editions of the Italian version: the most
recent is L. B. Alberti, *Della pittura*, ed. L. Mallé, Florence, 1950. An English translation is
L. B. Alberti, *On painting*, translated by J. R. Spencer, London, 1956.

ligatur.'[12] Thirdly, the treatise is for a reader who draws or paints at least potentially or notionally, since much of it is addressed to someone who may perform the operations that are described.

The designed reader is therefore a humanist practised in Euclid and himself disposed to draw or to paint. This is not the typical humanist; to a certain extent, perhaps, it was all an ideal in Alberti's own image. But a group equipped with the skills presupposed by *De pictura* did exist in the pupils of Vittorino da Feltre of Mantua, and in a sense the book seems obliquely directed to this school. Alberti dedicated *De pictura* not to Brunelleschi but to Gianfrancesco Gonzaga, Marquis of Mantua.[13] Gianfrancesco was a condottiere, not a humanist, and could hardly have read the book himself; but his librarian, the reader and eager distributor of his books, was Vittorino da Feltre. For Vittorino in turn the library was an activity secondary to the school he ran in Mantua with Gianfrancesco's support and protection. The school, the Casa Giocosa, was maintained by Gianfrancesco at first as an amenity for his own children, perhaps later also for its own sake, and under Vittorino's direction it was the most progressive and, with Guarino's, the most celebrated of all early humanist schools.[14] But Vittorino himself was not a humanist of the more exclusively literary kind. Pisanello's portrait-medal of Vittorino (Plate 9a) has on its reverse the inscription: MATHEMATICUS ET OMNIS HUMANITATIS PATER, and this is an exact description of his main interests. He was a distinguished enough literary humanist to be appointed to the chair of rhetoric at Padua when Gasparino Barzizza left for Milan in 1421; but he was also a mathematician, and this is more singular in a humanist. All the contemporary accounts of Vittorino make much of his mathematics, especially his geometry, and of his association at Padua with the great geometrician Biagio Pellicano of Parma. It was an association that attracted picturesque detail: Vittorino,

[12] MS. Ottob. lat. 1424, fol. 10ᵛ.

[13] The dedication was published by H. Janitschek in his edition of Alberti, *Kleinere Kunsttheoretische Schriften*, Vienna, 1877, pp. 254–5.

[14] Most of the contemporary accounts of Vittorino and his school are conveniently collected in *Il pensiero pedagogico dello umanesimo*, ed. E. Garin, Florence, 1958, pp. 504–718. For a modern bibliography of studies of Vittorino, E. Faccioli, *Mantova: Le lettere*, ii, Mantua, 1962, 44–6. A standard account in English is W. H. Woodward, *Vittorino da Feltre and other Humanist Educators*, Cambridge, 1921, pp. 1–92.

oppressed by Pellicano's avarice, was said to have worked as a *famulus* in his house to pay off tutorial fees.[15] But the fact of the association was certainly real and is important, since Pellicano was the author of *Quaestiones perspectivae* and is now considered the immediate source of the early-fifteenth-century developers of linear perspective.[16] Not to labour the point, Vittorino·was one humanist very well able to take the Euclidean technicalities of *De pictura* I in his stride.

But Vittorino projected his own interests into his school, where mathematics played an unusually important part; here the contrast with the severely philological bias of his friend Guarino at Ferrara is marked. The details of Vittorino's syllabus are admittedly not very clear; fifteenth-century accounts were more interested in the humane moral tone of the Casa Giocosa than in quite what was taught there. But it seems that Vittorino believed in teaching mathematics in the first place through play; he contrived mathematical games.[17] It is clear that some pupils reached a high standard. In July 1435, two months before Alberti finished his treatise, the Florentine humanist Ambrogio Traversari visited the school and afterwards remarked on the quality of work by the third and most talented of the Gonzaga sons, Gianlucido, then aged fifteen years. The work he had seen included 'propositiones duas in Geometria Euclidis a se additas cum figuris suis':[18] two Euclidean propositions with figures. Like Vittorino, Gianlucido could have read *De pictura* I with some understanding. Geometry, as was more usual in a fifteenth-century commercial education, was taught in conjunction with surveying—the calculation of the areas and volumes of fields and barrels—but also together with drawing.[19] And it seems that some sort of professional instruction in drawing was available too. Francesco Prendilacqua, a pupil, gives a list of miscellaneous

15 Francesco da Castiglione, *Vita Victorini Feltrensis*, in E. Garin, op. cit., p. 536.

16 See particularly P. Sanpaolesi, 'Ipotesi sulle conoscenze matematiche statiche e meccaniche del Brunelleschi', *Belle Arti*, ii, 1951, 37, and A. Parronchi, *Studi su la dolce prospettiva*, Milan, 1964, pp. 239–43. For the *Quaestiones* see G. Federici Vescovini, 'Le Questioni di "Perspectiva" di Biagio Pelacani da Parma', *Rinascimento*, 11. ser., i, 1961, 163–250.

17 '... morem illum eruditissimorum Aegyptiorum magnopere probans, qui liberos suos in numeris per ludum exercebant'. Sassuolo da Prato, *De Victorini Feltrensis Vita*, in E. Garin, op. cit., p. 530.

18 *Latinae Epistolae*, ed. L. Mehus, Florence, 1759, (VII. 3) p. 332.

19 W. H. Woodward, op. cit., p. 42; but I have failed to find Woodward's source for this statement.

specialist teachers employed by Vittorino, and in this list, along with people like grammarians and dancing-masters, are *pictores*:

Neque deerant grammatici peritissimi, dialectici, arithmetici, musici, librarii graeci latinique, pictores, saltatores, cantores, citharaedi, equitatores, quorum singuli cupientibus discipulis praesto erant sine ullo praemio, ad hoc ipsum munus a Victorino conducti ne qua discipulorum ingenia desererentur.[20]

These *pictores* are unlikely to be the sort of painter who painted frescoes or altarpieces; they come in the list after *librarii* and are presumably book-illuminators. Yet it is difficult to see what they could have taught anyone if not drawing or painting, and it seems likely that in some degree, probably quite limited, Vittorino was sponsoring the humanist licence to draw. On the whole, his school seems the *ambiente* most able to make something of Alberti's book.[21]

De pictura, then, appears a handbook in the active appreciation of painting for an unusual kind of informed humanist amateur. Book I, its geometry and perspective, is only humanist in this special sense and is not something open to the general run of humanist. Book II, on the other hand, is a thoroughly humanist affair because it depends from Vittorino's other interest, the literary rhetoric central to humanism. As Book I with its perspective is written in terms of geometrical skills locally available in Mantuan humanism, the medium of Book II and its account of composition is the language and categories of rhetoric; and so it concerns us here as Book I does not. Book I sees painting through a Euclidean, Book II through a Ciceronian screen.

The central subject of Book II is pictorial composition, the way in which a painting can be organized so that each plane surface and each object plays its part in the effect of the whole. Here Alberti seems to be calling Italian painting back to some standard of narrative relevance, decorum, and economy. The standard may well be largely Giottesque, as it appeared in Giotto himself

[20] Francesco Prendilacqua, *Dialogus*, in E. Garin, op. cit., p. 660.

[21] Alberti dedicated his later book *De statua* directly to a pupil of Vittorino da Feltre, Giovandrea de' Bussi (1417–75), Bishop of Aleria, with the remark: 'Mea tibi placuisse opuscula, id quod de pictura et id quod de elementis picturae inscribitur, vehementer gaudeo.' The dedication is printed in Alberti, *Kleinere Kunsttheoretische Schriften*, ed. H. Janitschek, Vienna, 1877, p. 167.

—whose *Navicella* (Plate 3) is the only actual composition praised by Alberti—and less certainly in such neo-Giottesque painters as the obscure and recently deceased Masaccio. On the other hand, the standard is not classical: 'Vix enim ullam antiquorum historiam apte compositam, neque pictam, neque fictam, neque sculptam reperies.'[22] Alberti urged high standards of relevance and organization in a climate of public taste, particularly humanist taste, that often favoured painting less rigorous in this respect. In Mantua, as in so many other Italian courts, the Marquis had employed Pisanello since 1425 (Plate 13);[23] even in Florence Palla Strozzi, the pioneer Greek humanist, had set a standard and tone for humanist patronage by commissioning Gentile da Fabriano's *Adoration of the Magi* (Plate 14) of 1423. For humanists the ekphrastic virtues of painters like Gentile and Pisanello were the most accessible and convenient to talk about.

Alberti's weapon in this situation was his specialized concept of 'composition'. *Compositio* was not altogether a new word to use about works of art in the general sense of the way things are put together. Vitruvius had used it of buildings and Cicero of human bodies;[24] it is not uncommon, either, in medieval aesthetics. All these uses were certainly part of the background to Alberti's use of the word, but he himself used it in a new and exact sense. By *compositio* he means a four-level hierarchy of forms within the framework of which one assesses the role of each element in the total effect of a picture; planes go to make up members, members go to make up bodies, bodies go to make up the coherent scene of the narrative paintings:

Compositio is that method of painting which composes the parts into the work of art ... The parts of the *historia* are bodies, the parts of the body are members, the parts of the member are plane surfaces.[25]

Alberti was providing a concept of total interdependence of forms that was quite new, rather unclassical and, in the long run, much the most influential of the ideas in *De pictura*.

[22] MS. Ottob. lat. 1424, fol. 10ᵛ.

[23] For a bibliography of studies on the problem of Pisanello's activity in Mantua, see Maria Fossi Todorow, *I disegni del Pisanello*, Florence, 1966, pp. 32–5.

[24] Cicero, *De officiis* I. xxviii. 98; Vitruvius III. i. 1.

[25] MS. cit., fol. 15ᵛ: 'Est autem compositio ea pingendi ratio qua partes in opus picture componuntur. Amplissimum pictoris opus non colossus, sed historie. Maior enim est ingenii laus in historia quam in colosso. Historie partes corpora, corporis pars membrum est. Membri pars est superficies. Prime igitur operis partes superficies, quod ex his membra, ex membris corpora, ex illis historia.'

Yet it is precisely at this point that Alberti is most the humanist writing for humanists, and dependent on this fact to communicate with his reader, for the notion of *compositio* is a very precise metaphor transferring to painting a model of organization derived from rhetoric itself. *Compositio* was a technical concept every schoolboy in a humanist school had been taught to apply to language. It did not mean what we mean by literary composition, but rather the putting together of the single evolved sentence or period, this being done within the framework of a four-level hierarchy of elements: words go to make up phrases, phrases to make clauses, clauses to make sentences: 'fit autem ex coniunctione verborum comma, ex commate colon, ex colo periodos.'[26] The correspondence is this:

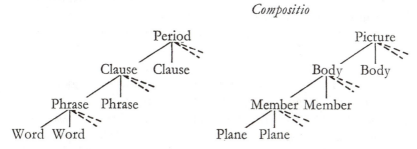

Compositio

Alberti is treating the art of Giotto as if it were a periodic sentence by Cicero or Leonardo Bruni, and with his powerful new model he could put painting through an astonishingly firm functional analysis. In *De pictura* II he works up through his hierarchy: first he discusses the quality of planes within the members whose surface they make up, then the proper relation of members to the single body, lastly the function and the relevance of bodies within the total narrative *historia*.

Such a concept could only be a useful tool as long as it was tactfully applied; to approach painting from such a very rhetorical point of view had great dangers, and for one moment it seems Alberti may fall into them. The moment comes immediately after his statement of the hierarchy of forms involved in *compositio*, as he begins to describe composition of planes. For what

[26] Isidore, *Etymologiae* ii. 18 (after Aquila, *De figuris sententiarum et elocutionis* 18): 'componitur autem instruiturque omnis oratio verbis, comma et colo et periodo: comma particula est sententiae, colon membrum, periodos ambitus vel circuitus; fit autem ex coniunctione verborum comma, ex commate colon, ex colo periodos.'

we first find is a transfer to painting of the rhetorical notion *structura aspera*. The *structura aspera* was the disagreeable conjunction of two 'rough' consonants between the end of one word and the beginning of the next, as in the phrase *ars studiorum*,[27] something which the rhetorician avoided. Alberti, displacing *verbum* by its equivalent *superficies* or plane, produced:

In qua vero facie ita iuncte aderunt superficies, ut amena lumina in umbras suaves defluant nulleque angulorum asperitates extent, hanc merito formosam et venustam faciem dicemus.[28]

In a *facies* where the planes are so joined that pleasant lights flow into agreeable shades and there are no *asperitates* of angles, this we will rightly call a beautiful and graceful *facies*.

Facies, which can be either a person's face or any surface form, is ambiguous here; previously Alberti has been speaking of *vultus*. In either sense it is an uncharacteristic remark, and not easy to reconcile with experience. Alberti, seeming to sense this, quickly retreats by recommending nature as the guide; he ends his short treatment of *compositio superficierum*, something on which he has very little to say and which perhaps had been forced on him by his model, and proceeds to his next level, *compositio membrorum*. By the time he had moved on to *compositio corporum* he was confident enough to make mild humanist jokes about his model. Discussions of the periodic sentence generally include some recommendation about the number of clauses the sentence should not exceed, the number varying: 'medius numerus videtur quattuor, sed recipit frequenter et plura.'[29] Alberti transfers this preoccupation from *cola* to *corpora*.

Meo quidem iudicio nulla erit usque adeo tanta rerum varietate referta historia, quam ix. aut x. homines non possint indigne agere; ut illud Varronis huc pertinere arbitror, qui in convivio tumultum evitans non plusquam novem accubantes admittebat.[30]

In my view there will be no painted narrative so filled with so great a variety of events that nine or ten persons will not be capable of

[27] Quintilian, *Inst. Orat.* ix. iv. 37; see also Cicero, *De oratore* iii. xliii. 171: 'collocationis est componere et struere verba sic ut neve asper eorum concursus neve hiulcus sit, sed quodam modo coagmentatus et laevis.' A good Renaissance account of *asperitas* is in Gasparino Barzizza's *De compositione*, in *Gasparini Barzizii . . . Opera*, ed. J. Furiettus, i, Rome, 1723, 8–9.

[28] MS. cit., fol. 16ʳ. [29] Quintilian, *Inst. Orat.* ix. iv. 125.

[30] MS. cit., fol. 18ʳ. For Varro, Aulus Gellius, *Noctes Atticae* xiii. xi. 1–3.

acting them out quite fittingly; I feel that much to the point here is an opinion of Varro's, who, to avoid having a crush at parties, admitted not more than nine people to his table.

Alberti left the passage with this half-serious precept out of his Italian translation; the mechanicals, who knew about neither period nor *triclinium*, could not be expected to see the joke.

Indeed, if one looks for an immediate influence from Alberti's book and his idea of composition, one is likely to find traces not so much among the Florentine painters[31] as in the policy of a certain sort of humanist patron: an obvious example would be Federigo da Montefeltro of Urbino, who was a pupil at Vittorino's school at Mantua from 1434 to 1437. There was not much reason why the general run of Quattrocento painters should be directly influenced by any text; they learned from visual things, from models, tricks, formulas, groupings. There are only two important mid-Quattrocento painters one could describe as more than occasionally Albertian: Piero della Francesca and Mantegna. Both are slightly special cases in that they both had, though in different ways, a demonstrably academic bent; probably both of them were also in contact with Alberti.[32] Of the two it was Mantegna who produced the visual models of Alberti's *compositio*, models in the strict sense of engravings able to carry patterns of the Albertian narrative style into the painters' workshops. And with Mantegna one returns yet again to the Padua–Mantuan axis. Lodovico Gonzaga, Vittorino da Feltre's pupil, had succeeded his father Gianfrancesco in 1444, and by the end of the 1450s both Mantegna and Alberti himself were working for him at Mantua. Out of this conjunction of humanist prince, scholarly painter and Alberti came the classic *exemplaria* of composition as Alberti understood it. One of them is the *Lamentation over the Dead Christ* (Plate 15): the maximum ten figures are disposed on a *pavimentum* tactfully traced out in lines of pebbles. Planes of drapery are lucidly composed, without *asperitas*, into members. Members are harmonized into bodies, with the figures

[31] One exception to this seems to be Filarete in Milan, who copied *De pictura* extensively in the early 1460s for Books XXII–XXIV of his *Trattato di Architettura* (ed. J. R. Spencer, New Haven, 1965, ii, Facsimile, fols. 173ᵛ–185ᵛ). Moreover he was using the Latin version, as is pointed out by Spencer, op. cit., i. 313, n. 6.

[32] The consistency between Alberti and Mantegna is discussed by M. Muraro, 'Mantegna e Alberti', *Atti del VI Convegno internazionale di studi sul Rinascimento*, Florence, 1966, pp. 103–32.

bearing the body of Christ (itself an exercise in Alberti's *mortuus languidus*) as a specialized model of the counterbalancing, weight-carrying *corpora* Alberti had explained: 'alia tota pars ad coequandum pondus contra sistatur.'[33] Ten diverse *corpora* are composed into the coherent group of the *historia*, *ornatus* not by crass *copia*—quite inappropriate to this solemn event—but by a structural *varietas*; this *varietas* is both formal, in the varied direction of movement—'aut sursum versus; aut deorsum, aut in dexteram, aut in sinistram'[34]—and narrative; for each *corpus* is an expressive variation on the common theme of lamentation, variation as Alberti had described it in Giotto's *Navicella*: 'quisquam suum turbati animi inditium vultu et toto corpore preferens, ut in singulis singuli affectionum motus appareant'.[35] The foreground figure of St. John has the special role of a choric figure cueing the beholder to his response, a subtle adaptation of Alberti's figure which 'ut una adrideas aut ut simul deplores suis te gestibus invitet'.[36] And in one case the engraving contrives a more composed solution of a problem than *De pictura*. Alberti required drapery blowing in the wind so as to reveal the figure, but each piece of drapery must blow in the same direction: 'illud caveatur, ne ulli pannorum motus contra ventum surgant'. Mantegna is meticulous in this. But as a rational basis for this movement of drapery Alberti recommended a head of Auster or Zephyr blowing from the clouds: 'pulchre idcirco in pictura zephiri aut haustri facies perflans inter nubes ad hystorie angulum ponetur, qua panni omnes adversi pellantur.'[37] Perhaps this idea came from Giotto's *Navicella*; it would have been eccentric in Mantegna's time, at least in a painting of such a solemn event. Mantegna improves on it with the vastly more *compositus* weather-cock of the *cumulus humilis* cloudlets insistently pointing to the right. His engravings are the proper visual appendix to *De pictura* II, and penetrated to the painters—the *Lamentation* even to Raphael and Rembrandt—as a book never could.

In *De pictura* II and its system of total pictorial composition humanist art-criticism bore fruit, since the notion is a humanist achievement, a non-classical thing made out of neo-classical components along neo-classical lines. It depended on the com-

33 MS. cit., fol. 21r. 34 MS. cit., fol. 19v.
35 MS. cit., fol. 19r. 36 MS. cit., fol. 19r.
37 MS. cit., fols. 21v and 20r.

plex of humanist elements and dispositions, unadventurous in themselves, described in the earlier part of this book: the habit of analogy between writing and painting, the habit of critical metaphor, the availability of a stock of terms apt for such metaphor in the system of rhetoric, the assumption that an art is by definition systematic and teachable through rules, the view that we do need some analytical skills if we are to appreciate an art like painting properly, the passion for the periodic sentence. With characteristically serious wit Alberti pulls these threads together into something the humanists had never had in mind and which was not particularly in tune with what we can sense of their own tastes. He takes them up on their imagery, reverses the analogy from painting to writing into an analogy from writing to painting, and has the effrontery to claim for painting a structure like that of the balanced periodic sentences in which they had so continually stated that analogy. He must have enjoyed the neatness of his moves very much, and they are not entirely without malice.

We have seen that the most articulate body of humanist opinion by the 1430s lay in the Pisanello lobby and the ekphrastic modes of Guarino and his school, with their interest in abundant diversity. Neither in Pisanello nor in humanist descriptions of his paintings was there much emphasis on the strict narrative relevance of each represented object or figure; Guarino and Strozzi ranged over his repertory informally, picking out attractive and striking items in a very free way. If there was a sense of narrative decorum, then this was a matter of internal consistency within the limits of a season or an epic mode, not the single-minded reference of all represented things to one narrative end. It was not a naïve, but a very urbane nexus of assumptions and interests: as the abundance of Pisanello offered facilities for a pleasant descriptive *oratio soluta*, so humanists reciprocated with epideictic praise. Since all this was so opposed to the rigour he himself was urging, it was something Alberti must, as tactfully as possible, state an attitude towards; it was one of the things that made the invention of *compositio* necessary at all. He addressed this problem in his long section on *compositio corporum*, though naturally without naming names. The beginning of the passage must be looked at more closely here, both as an instance of Alberti's general method

in *De pictura* II and for its own special implications. Perhaps it will be helpful to leave the more important puns in Latin:

The *historia* you might justly praise and admire will be of a kind to show itself so pleasant and *ornata* with allurements that it long holds the eyes of the *doctus* and *indoctus* beholder with a certain *voluptas* and *animi motus*. For the first thing to bring *voluptas* in a *historia* is precisely *copia* and *varietas* of things. As in the case of food and music the new and the abundant always delight—along with other factors, perhaps, but yet certainly for this reason—because they differ from the old and ordinary: so too in all things the mind is much delighted by *varietas* and *copia*. In painting, therefore, *varietas* both of bodies (*corpora*) and of colours is pleasant. I will declare that the *historia* is most *copiosa* in which there are mingled together in their places old men and men in their prime, youths, boys, mature women and maidens, young children, pet animals and puppy-dogs, small birds, horses, cattle, buildings and stretches of country; and I will praise all *copia* provided that it is appropriate (*conveniens*) to the event that is being represented there. For it is usually the case that, when the beholder lingers over his examination, then the *copia* of the painter gains favour. But I should wish this *copia* to be *ornata* with a degree of *varietas*, and also *gravis* and *moderata* with *dignitas* and *verecundia*. I certainly condemn those painters who, because they wish to seem *copiosi* or because they wish nothing left empty, on that account pursue no *compositio*. But indeed they scatter everything round in a confused and *dissolutus* way, on which account the *historia* seems not to enact but rather to disorder its matter . . .[38]

The key terms here are *copia*, *varietas*, and *dissolutus*. Alberti begins by driving a wedge into the vague ekphrastic sense of varied abundance, splitting it into *copia* and *varietas*. Both were rhetorical terms, *copia* being used of a profusion of words or

[38] 'Historia vero quam merito possis et laudare et admirari eiusmodi erit, que illecebris quibusdam sese ita amenam et ornatam exhibeat, ut oculos docti atque indocti spectatoris diutius quadam cum voluptate et animi motu detineat. Primum enim quod in historia voluptatem afferat est ipsa copia et varietas rerum. Ut enim in cibis atque in musica semper nova et exuberantia, cum caeteras fortassis ob causas, tum nimirum eam ob causam delectant, quod ab vetustis et consuetis differant: sic in omni re animus varietate et copia admodum delectatur. Idcirco in pictura et corporum et colorum varietas amena est. Dicam historiam esse copiosissimam illam in qua suis locis permixti aderunt senes, viri, adolescentes, pueri, matrone, virgines, infantes, cicures, catelli, avicule, equi, pecudes, edificia provincieque, omnemque copiam laudabo modo ea ad rem de qua illic agitur conveniat. Fit enim ut, cum spectantes lustrandis rebus morentur, tunc pictoris copia gratiam assequatur. Sed hanc copiam velim cum varietate quadam esse ornatam, tum dignitate et verecundia gravem atque moderatam. Improbo quidem eos pictores qui, quo [MS. qui qui] videri copiosi, quove nihil vacuum relictum volunt, eo nullam sequuntur compositionem. Sed confuse et dissolute omnia disseminant, ex quo non rem agere sed tumultuare historia videtur' (MS. cit., fols. 17ᵛ–18ʳ).

matter, *varietas* of a diversity of words or matter. Relative to *copia*, *varietas* tends to be an articulating factor working in larger units: 'verborum sumenda copia est et varietas figurarum et componendi ratio...'[39] Both induce *voluptas*, and Alberti decorates his statement by analogies with food and music borrowed from the discussion of similar matters in *De oratore*, in which Cicero is pointing out that unrelieved *voluptas* in any case becomes tedious.[40] From this point on Alberti detaches *varietas* from *copia*, and handles them as quite separate categories of interest. *Varietas*, both in the *corpora* and in the *colores* of a painting, is presented as an absolute value, and indeed most of the rest of Book II is given up to explaining how a diversity of figures, attitudes, and colours can be functionally effective in one's narrative. *Copia*, on the other hand, is very far from an unqualified value. Alberti is specific about what sort of pictorial objects correspond to rhetorical language or matter in respect of *copia*: old men, young men, and the rest. He then starts on a series of qualifications about the desirability of the thing. First, *copia* is praiseworthy only when it is proper (*conveniens*) to the event represented; this is a straightforward use of the notion of decorum between style and matter. Secondly, *copia* must be *ornata* with *varietas*, this being the vital distinction which he had prepared for by driving his first wedge into abundance: *ornatus* is variation from the ordinary and commonplace, not embroidery. Thirdly, *copia* must be *gravis* and moderated by a sense of *dignitas* and modesty. Both *gravis* and *dignitas* are complex words carrying a mass of connotations from rhetoric, even to the point of circularity: '*dignitas* est quae reddit *ornatam* orationem *varietate* distinguens.'[41] *Gravis* was commonly used as a contrary of the florid or *iucundus*. Both imply a degree of restraint. Fourthly, *copia* must be subordinated to *compositio*, because its exclusive pursuit leads to the *dissolutus*. *Dissolutus*, in rhetoric the contrary of *compositus*, was 'disconnected' both in a neutral, general sense and in a very precise and loaded sense of a *vitium orationis*; *dissolutus* is what the middle or florid style fell into if not disciplined:

μέσῳ quod est contrarium? tepidum ac dissolutum et velut enerve.[42]

[39] Quintilian, *Inst. Orat.* x. ii. 1.

[40] *De oratore* iii. xxv. 98–100: 'voluptatibus maximis fastidium finitimum est.'

[41] *Rhet. ad. Her.* iv. xiii. 18. [42] Fortunatianus, *Ars rhetorica* iii. 9.

Sed et copia habeat modum . . . Sic erunt magna non nimia, sublimia non abrupta, fortia non temeraria, severa non tristia, gravia non tarda, laeta non luxuriosa, iucunda non dissoluta . . .[43]

What Alberti has politely said is that certain painters may be practitioners of the florid style who have fallen into the vice of *dissolutio*, in which *copia* has been unrelieved and unchastened by *varietas* or *compositio*, to a point indeed where even *voluptas* may stale.

A humanist reading this passage would have been aware of slightly scandalous resonances. If one had asked him for a case of *dissolutus* prose style, the name which would have come into his mind was that of Guarino himself; not as a fact, but as a current critical issue. By 1435, the year when Alberti wrote his treatise on painting, George of Trebizond had published his *De rhetorica libri V*. It was the first comprehensive humanist treatise on rhetoric: previously humanists had relied mainly on the classical Latin rhetorics of Cicero and Quintilian. George of Trebizond was an Italianized Cretan and a Greek scholar, and between 1430 and 1432 he was Greek tutor at Vittorino's Casa Giocosa in Mantua; his new treatise injected into the old Latin rhetoric a mass of formulations and notions from Greek rhetoric, mainly from Aristotle, Dionysius of Halicarnassus, and Hermogenes. However in one respect the book was outrageous. George compulsively bit any hand that fed him, and one of the Italian humanists who had taught him Latin was Guarino, in Venice around 1418; George singles out Guarino as his example of a bad, disjointed, and unperiodic sentence structure, using Guarino's panegyric of Count Francesco of Carmagnola, a famous oration of 1428, as his text.[44] This appears to him disjointed and weak: 'compositione nihil fere viriliter colligatur, ac ideo supina quaedam, et futilis oratio sit.' He rewrites parts of Guarino's *absurde composita* oration so that short sentences are combined into long ones. For example, Guarino had written:

Ingens et incredibile illud occurrit, quod urbs ipsa non semel, sed toties vincenda fuit, quot arces habuit, castellaque et loco et arte munitissima. cum ne minimus quidem angulus in potestatem redigi,

[43] Quintilian, *Inst. Orat.* XII. x. 79–80.

[44] *Georgii Trapezuntii Rhetoricorum libri V etc.*, Venice, 1523, pp. 68a and b. For this episode and the reaction of Guarino's admirers, R. Sabbadini, 'Giorgio da Trebisonda', *Giornale storico della letteratura italiana*, xviii, 1891, 230–41; this is still the best account of George's early career.

nisi ferro, machinamentis, et obsidionis viribus, impugnatus expugnatusque potuerit. geminas tam longe lateque fossas sub hostium oculis, inter infesta illorum tela, sub ardentissimo sole, circumducens omnem subsidiorum spem, et occasionem ademisti.

George composes these three sentences into one large construction:

Ingens et illud et incredibile nobis occurrit, quod urbs ipsa et loco et arte munitissima, quae non semel, sed toties vincenda fuit, quot arces habuit, atque castella, cuius ne minimus quidem angulus in potestatem redigi possit, nisi obsidionis viribus, ferro, machinamentis, impugnatus expugnatus esset, geminis tam longe lateque fossis sub hostium oculis, sub ardentissimo sole, inter infesta tela, brevi tempore circumducta omnem subsidiorum et occasionum spem amisit.

In the terms of 1435—in terms, that is, of *compositio*—we can make out a polarization of styles common to both painting and writing. On the one hand there is the painting of artists like Pisanello as Alberti saw it, and the writing of Guarino as George of Trebizond saw it; on the other, there is painting of the more or less neo-Giottesque kind recommended by Alberti, and the more elaborately periodic writing recommended by George. *Composita* are opposed to *dissoluta*. Guarino, practitioner of *dissolutus* language, had praised the *dissolutus* painting of Pisanello. So, as George of Trebizond urged *compositus* language, Alberti urged *compositus* painting. This is not to make a critical point— to us Giotto's *Navicella* and a humanist period, or Guarino's prose and Pisanello's paintings, are probably not apprehended as cognate styles of organization—but a historical point: in 1435 these things *did* appear as similar, in humanist terms. The humanist terms, *compositio*, *dissolutus*, *copia*, *varietas*, and all the rest, were the humanist point of view, and the attention directed through them to painting was quite differently articulated from ours. Seen through *compositio* the replacement of a Pisanello by a Mantegna, or indeed of the triptych form by the form of the Sacra Conversazione, is part of the same movement as the replacement of Guarino's prose by that of the generation of George of Trebizond: the *dissolutum* was becoming *compositum*.

IV

Texts

I. PETRARCH

DE TABULIS PICTIS. DIAL. XL

GAU[DIUM]. Pictis tabulis delector. R[ATIO]. Inanis delectatio, nec minor vanitas, quam magnorum hominum saepe fuit, nec tollerabilior, quam antiqua. Siquidem omne malum exemplum, tunc fit pessimum, quando illi vel auctorum pondus adiungitur, vel annorum. Undecunque ortae consuetudinis robur ingens consenuerit, et ut bona in melius, sic mala in peius aetas provehit. Sed o utinam, qui maiores vestros vanis in rebus facile vincitis, eosdem in seriis aequaretis, virtutemque illis, et gloriam miraremini cum quibus pictas tabulas sine fine miramini. G. Vide, utique pictas tabulas miror. R. O mirus humani furor animi, omnia mirantis, nisi se, quo inter cuncta non solum artis, sed naturae opera, nullum mirabilius. G. Pictae delectant tabulae. R. Quid de hoc sentiam, ex iam dictis intelligere potuisti, omnis quidem terrena delectatio, si consilio regeretur, ad amorem coelestis erigeret, et originis admoneret. Nam quis unquam quaeso rivi appetens, fontem odit? at vos graves, humi accliues, affixique coelum suspicere non audetis, et obliti opificem illum solis ac lunae, tanta cum voluptate tenuissimas picturas aspicitis, atque unde transitus erat ad alta despicitis illic metam figitis intellectus. G. Pictis tabulis delector unice. R. Pennicello, et coloribus delectaris, in quibus et pretium, et ars placet, ac varietas, et curiosa disparsio. Sic exanguium vivi gestus, atque immobilium motus imaginum, et postibus erumpentes effigies, ac vultuum spirantium liniamenta suspendunt, ut hinc erupturas paulo minus praestoleris voces, et est hac in re periculum, quod iis magna maxime capiuntur ingenia: itaque ubi agrestis laeto, et brevi stupore praetereat, illic ingeniosus suspirans, ac venerandus inhaereat. Operosum sane, neque tamen huius est operis, ab initio artis originem, atque incrementa retexere, et miracula operum, et artificum industrias, et principum insanias, et enormia pretia,

quibus haec trans maria mercati, Romae in templis Deorum, aut Caesarum in thalamis, inque publicis plateis, ac porticibus consecrarunt. Neque id satis, nisi ipsi huic arti dextras, atque animos maiori exercitio debitos, applicarent, quod iam ante nobilissimi Philosophorum Graeciae fecerant. Unde effectum, ut pictura diu quidem apud vos, ut naturae coniunctior, ante omnes mechanicas in pretio esset, apud Graios vero, siquid Plinio creditis, in primo gradu liberalium haberetur. Mitto haec quoniam, et intentae brevitati, et praesenti proposito quodammodo sunt adversa: videri enim possunt morbum ipsum, cuius remedium pollicebar, alere, et rerum claritas stupentis amentiam excusare. Sed iam dixi, nihil errori detrahit errantium magnitudo, imo haec quidem, ideo attigerim, ut liqueret mali huius quanta vis esset, ad quam tot, tantisque sit ingeniis conspiratum, cui et vulgus errorum princeps, et consuetudinum genitrix, longa dies, cumulusque ingens omnium malorum semper auctoritas accesserint, ut voluptas, stuporque animos ab altiore furtim contemplatione dimoveat, distrahatque. Tu autem si haec ficta, et adumbrata, fucis inanibus usque adeo delectant, attolle oculos ad illum, qui os humanum sensibus, animam intellectu, coelum astris, floribus terram pinxit, spernes quos mirabaris artifices.

DE STATVIS. DIAL. XLI

GAU. At delector statuis. R. Artes variae, furor idem, ipsarumque fons unus artium, unus finis, diversa materia. G. Delectant statuae. R. Accedunt haec quidem ad naturam propius quam picturae, illae enim videntur tantum, hae autem et tanguntur, integrumque ac solidum, eoque perennius corpus habent, quam ob causam picturae veterum nulla usquam, cum adhuc innumerabiles supersint statuae. Unde haec aetas in multis erronea, picturae inventrix vult videri, siue quod inventioni proximum, elegantissima consumatrix, limatrixque, cum in genere quolibet sculpturae, cumque in omnibus signis, ac statuis longe imparem se negare temeraria, impudensque non audeat. Cum praeterea pene ars una, vel si plures, unus (ut diximus) fons artium graphidem dico, atque ipse proculdubio sint coaevae, pariterque floruerint (siquidem una aetas et Appellem, et Pyrgotelem, et Lysippum habuit) quod hinc patet, quia hos simul ex omnibus, Alexandri Magni tumor maximus delegit, quorum primus cum pingeret, secundus sculperet, tertius fingeret, atque in statuam excuderet,

edicto vetitis universis, qualibet ingenii, artisque fiducia, faciem regis attingere. Nec minor hic ideo furor quam reliqui, imo vero omnis morbus eo funestior, quo stabiliore materia subnixus. G. At me statuae delectant. R. Non te solum, aut plebeis comitibus errantem putes, quanta olim dignitas statuarum, quantumve apud antiquos, clarissimosque hominum studium, desideriumque rei huius fuerit, et Augusti, et Vespasiani, ac reliquorum, de quibus nunc dicere longum esset, et impertinens, Caesarum ac Regum, virorumque secundi ordinis illustrium, solers inquisitio, et repertarum cultus, et custodia, et consecratio iudicio sunt. Accedit artificum fama ingens, non vulgo, aut mutis duntaxat operibus, sed late sonantibus, scriptorum literis celebrata, quae tam magna, utique parva de radice nasci posse non videtur. Non fit de nihilo magnum, esse vel videri oportet, de quo serio magni tractant. Sed his omnibus supra responsum est, eo autem spectant, ut intelligas quanto nisu obstandum tam vetusto, et tam valido sit errori. G. Variis delector statuis. R. Harum quippe artium, manu naturam imitantium una est, quam plasticen dixere. Haec gypso, et ceris operatur, ac tenaci argilla, quae cognatis licet artibus, cunctis amicitior sit, virtuti, aut certe minus inimica modestiae in primis et frugalitati, quae magis fictiles, quam aureas Deorum, atque hominum formas probant, quid hic tamen delectabile, quid quo cereos, aut terreos vultus ames, non intelligo. G. Nobilibus statuis delector. R. Avaritiae consilium agnosco, pretium ut auguror, non ars placet. Unam tu auream artificii mediocris, multis aeneis atque marmoreis, multoque maxime plasticis praeferendam duxeris, haud insulse quidem, ut se habet aestimatio rerum praesens, hoc est, autem aurum amare non statuam: quae ut ex vili materia nobilis, sic puro rudis, ex auro fieri potest. Quanti vero tu statuam extimares, sive illam regis Assyrii ex auro sexaginta cubitorum, quam non adorasse capitale fuit, quamque hodie multo ultro suam ut facerent adorarent, sive illam cubitorum quatuor, quam ex ingenti topazio, mirum dictu, reginae Aegyptiae factam legis, puto non anxie quaereres, cuius esset artificis, contentus de materia quaesivisse. G. Artificiosae oculos delectant statuae. R. Fuere aliquando statuae insignia virtutum, nunc sunt illecebrae oculorum, ponebantur his qui magna gessissent, aut mortem pro Repub. obiissent, quales decretae sunt legatis, a rege Fidenatium interfectis, quales liberatori Italiae Africano, quas illius magnitudo animi, ac spectata modestia non recepit,

quasque post obitum recusare non potuit. Ponebantur ingeniosis, ac doctis viris, qualem positam legimus Victorino, nunc ponuntur divitibus, magno pretio marmora peregrina mercantibus. G. Artificiosae placent statuae. R. Artificium fere omnis recipit materia: sentio autem, ut tua delectatio plena sit ingenii, materiaeque nobilitas iuncta perficiet: neque hic tamen aurum, quamvis Phydiasque convenerit, vera delectatio nulla est, aut vera nobilitas, fex terrae licet rutila, incus, mallei, forcipes, carbones, ingenium, laborque mechanici, quid hinc viro optabile, vereque magnificum fieri possit cogita. G. Non delectari statuis non possum. R. Delectari hominum ingeniis, si modeste fiat tollerabile, his praesertim, qui ingenio excellunt, nisi enim obstet livor, facile quisque, quod in se amat in alio veneratur. Delectari quoque sacris imaginibus, quae spectantes beneficii coelestis admoneant, pium saepe, excitandisque animis utile: prophanae autem, etsi interdum moveant, atque erigant ad virtutem, dum tepentes animi rerum nobilium memoria recalescunt: amandae tamen aut colendae aequo amplius non sunt, ne aut stultitiae testes, aut avaritiae ministrae, aut fidei sint rebelles, ac religioni verae, et praecepto illi famosissimo: Custodite vos a simulacris. Profecto autem si hic quoque illum aspicis, qui solidam terram, fretum mobile, volubile coelum fecit, quique non fictos, sed veros, vivosque homines, et quadrupedes terrae, pisces mari, coelo volucres dedit, puto ut Protogenem, atque Apellem, sic etiam Polycletum spernes, et Phydiam.

De remediis utriusque fortunae, 1. xl–xli, in *Opera*, Basle, 1581 pp. 39–40. (pp. 53–8)

II. PETRARCH

Proinde si Cristo non creditur, cui credetur? an saxis? an ebori? an ligno muto et exanimi os habenti nec loquenti, manus nec palpanti, pedes nec ambulanti, aures nec audienti, nares nec odoranti, oculos nec videnti? Cui ergo similem fecistis Deum, inquit Ysaias [40: 18–20], aut quam imaginem ponetis ei? Nunquid sculptile conflabit faber, aut aurifex auro figurabit illud et laminis argenteis argentarius? Forte lignum et imputribile elegit; artifex sapiens querit quomodo statuat simulacrum quod non moveatur. De hoc non imputribili ligno sed trunco et inutili diu olim et irrisorie ait Flaccus [*Sat.* i. 8. 2–3]: Faber incertus

scamnum faceret ne Priapum maluit esse deum, magis ad avium furumque formidinem quam ad religionem cultumque fidelium, et ut potius talem custodem ortus, quam ut talem deum humana mens habeat. An forte securius preciosiori materie, argento atque auro, credere? quia scilicet simulacra gentium argentum et aurum opera manuum hominum [Ps. 113: 4 and 9], quibus similes illis fiant qui faciunt ea et omnes qui confidunt in eis [Ps. 134: 15 and 18]. Nostra tamen etate tam multos eis credere cernimus etiam ex nostris, ut pudor et stupor occupet cogitantem aureos et argenteos deos, quos prisci reges sanctorum pontificum verbis instructi propter Cristi reverentiam delevere, ad Cristi iniuriam certatim a nostris hodie regibus ac pontificibus renovari. Si bene est quoniam argentum et aurum non ut deos colunt et, ut premordaciter ait ille [Juvenal i. 113–14], funesta pecunia, celo nondum habitas, nullas nummorum ereximus aras, colitur tamen argentum et aurum tanto cultu quanto nec Cristus ipse colitur et sepe vivus Deus inanimati metalli desiderio atque admiratione contemnitur: non tamen adhuc argentum aut aurum deus esse creditur.

De otio religioso, ed. G. Rotondi, Vatican City, 1958, pp. 21–2
(p. 66)

III. COLUCCIO SALUTATI

Ascendamus consecratum pio cruore beati Miniatis ab Arni sinistra ripa colliculum aut antiquarum Fesularum bicipitem montem vel aliquod ex circumstantibus promuntoriis unde per sinus omnes completius videri possit nostra Florentia. Ascendamus, precor, et intueamur minantia menia celo, sidereas turres, immania templa, et immensa palatia, que non, ut sunt, privatorum opibus structa, sed impensa publica vix est credibile potuisse compleri, et demum vel mente vel oculis ad singula redeuntes consideremus quanta in se detrimenta susceperint. Palatium quidem populi admirabile cunctis et, quod fateri oportet, superbissimum opus, iam mole sua in se ipso resedit et tam intus quam extra rimarum fatiscens hyatibus lentam, licet seram, tamen iam videtur nuntiare ruinam. Basilica vero nostra, stupendum opus, cui, si unquam ad exitum venerit, nullum credatur inter mortales edificium posse conferri, tanto sumptu tantaque diligentia inceptum et usque ad quartum iam fornicem consummatum, qua

speciosissimo campanili coniungitur, quo quidem nedum pulcrius ornari marmoribus sed nec pingi aut cogitari formosius queat, rimam egit, que videatur in deformitatem ruine finaliter evasura, ut post modicum temporis resarciendi non minus futura sit indiga quam complendi.

De seculo et religione, ed. B. L. Ullman, Florence, 1957, pp. 60–1 (i. xxvii, 'Quod mundus sit speculum vanitatum'). (p. 67)

IV. COLUCCIO SALUTATI

Et ut rem hanc figuraliter videamus, fingamus tres pictores unius et eiusdem diei spacio opus faciendi unius hominis vel alterius rei effigiem certis iuxta sui operis merita premiis promisisse et diem illam sic cuilibet sufficere, quod si vel modicum temporis amiserit, nequeat quod promiserit observare. Nunc autem incipiat unus et arte graphica iaciat picture quam promiserit fundamenta; moxque facta delens aliud cogitet et intendat, quod, cum auspicatus fuerit, incumbere spongie faciens aliud initium meditetur. Nonne sibi tempus eripit, ut licet ex magna parte tandem proficiat, implere tamen non valeat quod promisit? Sin autem alter, rebus aliis vacans, cum advesperascere ceperit, pingendi propositum assumet, quantum ad observationem promissionis pictureque perfectionem pertinet, nichil agit. Tertius vero de satisfaciendo non cogitans, nisi prius sibi sol occubuerit quam inceperit, nonne totum quod debebat omisit? Nullus horum quod promisit effecit; prior tamen aliquid operatus est, incipiens multotiens quod debebat, precipue tamen de inconstantia reprehendendus. Secundum autem sic incipientem, quod perficere nequeat, quis non irrideat ut insanum? Tertium vero quid infidelitatis et negligentie non accuset? Ut si volueris attendere, magna pars operis culpabiliter elapsa sit illi, qui eripiens sibi tempus, tandiu circa principium laboravit; culpabilius autem et maximam operis partem amiserit ille, cui tantum diei subductum est, quod quodam modo nichil acturus, quod perficere nequeat frustra, hoc est nichil agens, sero nimium inchoavit: tota vero dies cum omni plenitudine culpe lapsa fuerit occasum ante quam inceperit expectanti.

'Insigni viro magistro Antonio de Scarperia physico tractatus ex epistola ad Lucilium prima . . .' [6 February 1398?], *Epistolario di Coluccio Salutati*, ed. F. Novati, iii, Rome, 1896, 256–7. (p. 34)

[. . . expositio sumpta a similitudine pictorum non satis apte potest stare. Vult quidem eum qui tarde venit ad pingendum nihil egisse, cum tamen concedat eum qui tempestive venit et totiens delevit incepta aliquid egisse. Peccat igitur in eo quod falsum presupponit in exemplo hoc. Si enim actio refertur ad suam perfectionem aut nihil egerit ille oportet, qui opus non perfecerit, aut si ponentem multa principia concedimus aliquid egisse, necesse est ut nonnihil egerit, qui unum tantum principium posuit. Ex quo male supposito impugnatur sententia ab eo posita, cum dixit illum qui incepit vivere, cum esset desinendum, nihil egisse et sic maximam partem vite amisisse; concedens tamen eum aliquid agere, qui semper incipit vivere; quare eius sententia iudicio meo in hac similitudine et expositione non est approbanda.

[Gasparino Barzizza], *Comentum super epistulas Senecae*, Cremona Biblioteca Governativa Cod. 128, fol. 113^{r-v}, cit. F. Novati, *Epistolario di Coluccio Salutati*, iii, Rome, 1896, p. 258. (p. 34)]

V. FILIPPO VILLANI

Vetustissimi, qui res gestas conspicue descripsere, pictores optimos atque imaginum statuarumque sculptores cum aliis famosis viris (fol. 71v) in suis voluminibus miscuerunt. Poete insuper prisci Promethei ingenium diligentiamque mirati, ex limo terre eum fecisse hominem fabulando finxerunt. Extimaverunt enim, ut coniector, prudentissimi viri nature imitatores, qui conarentur ex ere atque lapidibus hominum effigies fabricare, non sine nobilissimi ingenii singularisque memorie bono atque delicate manus docilitate tanta potuisse. Igitur inter illustres viros eorum annalibus Zeusim, Peharotum [?], Chalcym [?], Fydiam, Prasittellem, Myrronem, Appellem, Couon, Volarium [?] et alios huiuscemodi artis insignis indiderunt. Michi quoque eorum exemplo fas sit hoc loco, irridentium pace dixerim, egregios pictores florentinos inserere, qui artem exanguem et pene extinctam suscitaverunt. Inter quos primus Johannes, cui cognomento Cimabue dictus est, antiquatam picturam et a nature similitudine quasi lascivam et vagantem longius arte et ingenio revocavit. Siquidem ante istum grecam latinamque picturam per multa secula sub

crasso peritie ministerio iacuisset, ut plane ostendunt figure et imagines que in tabellis parietibusque cernuntur sanctorum ecclesias adornare. Post hunc, strata iam in novis via [*MS*. nivibus], Giottus, non solum illustris fame decore antiquis pictoribus comparandus, sed arte et ingenio preferendus, in pristinam dignitatem nomenque maximum picturam restituit. Huius enim figurate radio imagines ita liniamentis nature conveniunt, ut vivere et aerem spirare contuentibus videantur, exemplares etiam actus gestusque conficere adeo proprie, ut loqui, flere, letari et alia agere, non sine delectatione contuentis et laudantis ingenium manumque artificis prospectentur: extimantibus multis, nec stulte quidem, pictores non inferioris ingenii his, quos liberales artes fecere magistros, cum illi artium precepta scripturis demandata studio atque doctrina percipiant, hii solum ab alto ingenio tenacique memoria, que in arte sentiant, exigant. Fuit sane Giottus, arte picture seposita, magni vir consilii et qui multarum usum habuerit. Historiarum insuper notitiam plenam habens, ita poesis extitit emulator, ut ipse pingere que illi fingere subtiliter considerantibus perpendatur. Fuit etiam, ut virum decuit prudentissimum, fame potius quam lucri cupidus. Unde ampliandi nominis amore per omnes ferme Italie civitates famosas spectabilibus locis aliquid pinxerit, Romeque presertim arce pre basilica sancti Petri ex musivo periclitantes navi apostolos artificiosissime figuravit, ut orbi terrarum ad urbem conflue ntiarte vique [*MS*. urbeque] sua spectaculum faceret. Pinxit insuper speculorum suffragio semet ipsum eique contemporaneum Dantem Allagherii poetam in pariete capelle palatii potestatis. Ab hoc laudabili valde viro, velut a fonte sincero (fol. 72r) abundantissimoque, rivuli picture nitidissimi defluxerunt, qui novatam emulatricem nacture picturam preciosam placidamque conficerent. Inter quos Masius omnium delicatissimus pinxit mirabili et incredibili venustate. Stephanus, nature simia, tanta eius imitatione valuit, ut etiam figuratis a physicis in figuratis per eum corporibus humanis arterie, vene, nervi et queque minutissima liniamenta proprie colligantur et ita, ut imaginibus suis, Giotto teste, sola aeris attractio atque respiratio deficere videantur. Taddeus insuper edificia et loca tanta arte depinxit, ut alter Dynocrates seu Victaurius, qui architecture artem scripserit, videretur. Numerare fere innumeros, qui eos secuti artem ipsam Florentie nobilitaverunt, otiantis latius foret officium et materiam longius

protrahentis. Igitur in hac re de his dixisse contentus ad reliquos veniamus.

De origine civitatis Florentie, et de eiusdem famosis civibus . . ., Vatican Library, MS. Barb. lat. 2610, fols. 71ʳ–72ʳ. (pp. 70–2)

VI. MANUEL II PALAEOLOGUE

ΕΑΡΟΣ ΕΙΚΩΝ ΕΝ ΥΦΑΝΤῼ ΠΑΡΑΠΕΤΑΣΜΑΤΙ ΡΗΓΙΚῼ

Ἦρος ὥρα, καὶ δηλοῖ τὰ ἄνθη, καὶ λευκὸς οὗτος ἀὴρ διακεχυμένος ἐπ᾽ αὐτὰ μάλα ἡμέρως. Διὰ τοῦτο ψιθυρίζει ἡδὺ τὰ φύλλα, καὶ δοκεῖ κυμαίνεσθαί πως ἡ πόα, αὔραν δή τινα δεχομένη, φιλίαις ταύτην ὑποκινοῦσα ἐπιφοραῖς. Χάριεν ἰδεῖν. Ποταμοὶ δὲ ἤδη ταῖς ὄχθαις σπένδονται, καὶ ὁ πολὺς ἐπέχεται ῥοῦς, καὶ τὰ πρὶν πλημμύραις ἀφανιζόμενα τῶν ὑδάτων ὑπερφαίνεται, καὶ παρέχει χερσὶ θηρᾶσθαι τὰ παρ᾽ ἑαυτοῖς ἀγαθά. Τούτων ἕν τὸ χειρωθὲν ἤδη τῷ νεανίσκῳ· ὃ κατέχων τῇ λαιᾷ, κεκυφὼς ἠρέμα, καὶ συγκαθίσας, ὅσον μὴ τῷ ῥείθρῳ τοὺς μυκτῆρας βαπτίσαι, τὴν δεξιὰν ἀποφητὶ γυμνὴν τοῖς ὕδασιν ἐμβαλών, τὰς ὑπὸ τὸ ῥόθιον χαράδρας διερευνᾶται, ψηλαφῶν καὶ τοῖς δακτύλοις τὰς τρώγλας, μή τι τῶν ὑδάτων ταρασσομένων τοῖς ποσὶ τοῦ νεανίσκου, φόβῳ τῶν πατάγων ἐγκέκρυπται. Οἱ δὲ δὴ πέρδικες χαίρουσι, τὴν ἀποβληθεῖσαν αὐτοῖς ἰσχὺν ὑπερβολαῖς τῶν πεφυκότων λυπεῖν, ἀπολαμβάνοντες ἤδη, ἀκτῖνος ταύτην αὐτοῖς ἐπανασωζούσης, μηδὲν λυπούσης δι᾽ ἀμετρίαν. Ὅθεν δὴ σὺν εὐθυμίᾳ τοῖς ἀγροῖς ἐνδιαιτῶνται, καὶ τὰ νοσσία πρὸς τροφὴν ἄγοντες, πρῶτοι ταύτης ἅπτονται, ἔργῳ δεικνύντες τὴν τράπεζαν. Ὠδικοὶ δὲ ὄρνιθες τοῖς δένδρεσιν ἐγκαθήμενοι, ὀλίγον μὲν ἅπτονται τῶν καρπῶν, τὸ πολὺ δὲ τούτοις τοῦ χρόνου εἰς τὸ ᾄδειν ἀναλίσκεται. Κηρύττειν οἶμαι βούλεσθαι τουτοισὶ τὴν φωνήν, τὰ κρείττω παραγίνεσθαι, τῆς τῶν ὡρῶν βασιλίσσης ἐπιλαμψάσης, καὶ λοιπὸν εἶναι αἰθρίαν μὲν ἀντὶ τῆς νεφέλης, γαλήνην δὲ ἀντὶ τρικυμίας, καὶ ὅλως ἀντὶ τῶν λυπούντων τὰ τερπνά. Πάντα παρρησιάζεται, καὶ αὐτὰ τῶν ζωϋφίων τὰ φαῦλα, ἐμπίδες, μέλιτται, τέττιγες, γένη τῶν τοιούτων παντοδαπά· ὧν τὰ μὲν τῶν σίμβλων ἐξορμηθέντα, τὰ δὲ τὴν γένεσιν ἐσχηκότα τῇ συμμετρίᾳ τῆς ὥρας, εἰ δὲ βούλει, τῇ τῆς θέρμης εἰσβολῇ πρὸς ἀνάλογον ὑγρότητα, περιβομβεῖ τὸν ἄνθρωπον, καὶ ὁδοιπόρου προΐπταται, καὶ ᾄδοντί που τούτῳ συνᾴδει τὰ μουσικώτερα. Ἔνια μὲν ἁμιλλᾶται, ἔνια δὲ μάχεται, τὰ δ᾽ ἐφιζάνει τοῖς ἄνθεσι.

Πάντα δὲ ἡδὺ θεαθῆναι. Τὰ δὲ παιδία παρὰ τὸν κῆπον ἀθύροντα, ἐκεῖνα θηρεύειν ἐπιχειρεῖ μάλα ἀκεραίως ἅμα καὶ χαριέντως. Τὸ μὲν γὰρ ἤδη τῶν παιδίων γυμνῶσαν τὴν αὐτοῦ κεφαλὴν τοῦ καλύμματος,

ἀντ' ἄλλου τινὸς θηράτρου τούτῳ κατακέχρηται, καὶ διαμαρτάνον ὡς
ταπολλά, γίνεται τοῖς ἥλιξι γέλως· ἄλλο δὲ τὼ χεῖρε ἔχον παρ' ἑαυτῷ,
ὅλον ἐπιρρίπτον τὸ σῶμα τῷ ζωϋφίῳ, καὶ θηράσαι τοῦτο ταύτῃ
βουλόμενον, πῶς οὐχὶ ἡδὺ καὶ γελοῖον; ὁρᾷς τὸ ὑπερφέρον τῷ σώματι;
ὀψὲ γὰρ δὴ καὶ μόγις τινὸς λαβόμενον τῶν, ἃ καλοῦσιν ἔνιοι πτιλωτά.
Βακχεύοντι ἔοικεν, ὑπὸ τῆς χαρᾶς, καὶ τὰ κράσπεδα ἀνελόμενον τοῦ
τελευταίου χιτῶνος, ὡς ἐλίσσον τούτοις τὸ θηραθέν, πορεύεσθαι ζητεῖν
ἕτερον, οὐκ αἰσθάνεται γυμνοῦν ἃ δέον κρύπτειν τοῦ σώματος. Ἐκεῖνο
μέντοι γε ἀστειότερον, τὸ τὴν ἡλικίαν βραχύτερον. Νήματι γὰρ πάνυ
λεπτῷ πεδῆσαν δύο τῶν ζωϋφίων, ἐᾷ δῆθεν πέτεσθαι. Κατέχον
δ' ἄκροις δακτύλοις ἐκ διαστήματος τὴν ἡτράν, εἴργει τὴν πτῆσιν,
κατὰ τρόπον τουτοισὶ γίγνεσθαι, καὶ γελᾷ, καὶ γέγηθε, καὶ ὀρχεῖται,
σπουδαῖόν γέ τι νομίζον τὴν παιδιάν. Ὅλως δὲ ἡ τέχνη τῶν
ὑφασμένων ἑστιᾷ τὸν ὀφθαλμόν, τρυφὴ γιγνόμενα θεαταῖς. Αἴτιον
δὲ τὸ ἔαρ, κατηφείας λύσις, εἰ δὲ βούλει, φαιδρότητος πρόξενον.

Patrologiae cursus completus, ed. J.-P. Migne, Series Graeca
vol. xlvi, Paris, 1866, cols. 577–80. (pp. 86–7)

VII. MANUEL CHRYSOLORAS

Οὐ γὰρ μόνον ἀγωγοὺς ὑδάτων ἀερίους ἔξεστιν ὁρᾶν πόρρωθεν ἐρχο-
μένων, καὶ τειχῶν ὄγκον, καὶ στοῶν, καὶ βασιλείων, καὶ βουλευτηρίων,
ἔτι δὲ ἀγορῶν, καὶ βαλανείων, καὶ θεάτρων πλῆθός τε, καὶ μέγεθος,
καὶ κάλλος, ἀλλὰ καὶ νεὼς περιφανεῖς πολλοὺς καὶ συνεχεῖς, ἄλλους ἀπ'
ἄλλης προσηγορίας ὠνομασμένους, καὶ ἱερά, καὶ ἀγάλματα, καὶ ἀνδρι-
άντας, καὶ τεμένη, καὶ στήλας τῶν παλαιῶν ἐκείνων καὶ περιφανῶν
ἀνδρῶν, εἴ τις ὑπὲρ τῆς πόλεώς τι εἴργασται, ἐκείνοις παρὰ τοῦ δημοσίου
γενομένας, καὶ ἀριστεῖα, καὶ γεφύρας θριαμβικάς, εἰς ὑπόμνημα τῶν
θριάμβων ἐκείνων καὶ τῶν πομπῶν πεποιημένας, αὐτῶν τῶν πολέμων,
καὶ τῶν αἰχμαλώτων, καὶ τῶν λαφύρων, καὶ τῶν τειχομαχιῶν ἐγκεκο-
λαμμένων, ἔτι δὲ ἱερείων ἐν αὐταῖς καὶ θυσιῶν καὶ βωμῶν γλυφὰς καὶ
ἀναθημάτων. Πρὸς δὲ τούτοις ναυμαχίας, καὶ πεζομαχίας, καὶ ἱππομα-
χίας, καὶ πᾶν εἶδος, ὡς εἰπεῖν, μάχης, καὶ μηχανημάτων τε καὶ ὅπλων,
καὶ τοὺς ὑπηγμένους δυνάστας Μήδους τυχόν, ἢ Πέρσας, ἢ Ἴβηρας, ἢ
Κελτούς, ἢ Ἀσσυρίους, κατὰ τὴν αὐτῶν στολὴν ἑκάστους καὶ τὰ
δεδουλωμένα γένη, καὶ τοὺς θριαμβεύοντας ἐπὶ τούτοις στρατηγούς,
καὶ τὸ ἅρμα, καὶ τὰ τέθριππα, καὶ τοὺς ἡνιόχους καὶ τοὺς δορυφόρους,
καὶ τοὺς ἑπομένους λοχαγούς, καὶ τὰ προϊόντα σκῦλα, ἅπαντα ὡσανεὶ
ζῶντα ἐπὶ τῶν εἰκόνων ἔστιν ἰδεῖν, καὶ συνεῖναι τί ἕκαστον ἦν διὰ τῶν

ἐν αὐτοῖς γραμμάτων· ὥστε δύνασθαι σαφῶς ὁρᾶν τίσι μὲν ὅπλοις, τίσι
δὲ στολαῖς ἐχρῶντο τὸ παλαιόν, τίσι δὲ ἐπισήμοις τῶν ἀρχῶν, ὁποίαις
δὲ παρατάξεσι, καὶ μάχαις, καὶ πολιορκίαις, καὶ στρατοπέδοις· τίσι δὲ
ἄρα ἢ θέσεσιν, ἢ περιβολαῖς, εἴτε ἐπὶ στρατείας, εἴτε οἴκοι, εἴτε ἐν
ἐκκλησίαις, εἴτε ἐν βουλευτηρίῳ, εἴτε κατ' ἀγοράν, εἴτε ἐν γῇ, εἴτε ἐν
θαλάττῃ, εἴτε ὁδοιποροῦντες, εἴτε πλέοντες, εἴτε πονοῦντες, εἴτε ἀσκοῦν-
τες, εἴτε θεώμενοι, εἴτε ἐν πανηγύρεσιν, εἴτε ἐν ἐργαστηρίοις, καὶ ταῦτα
καὶ τὰς τῶν ἐθνῶν διαφοράς. Ὧν ἕνεκα ἐκθεὶς Ἡρόδοτος καὶ ἄλλοι τινὲς
τῶν ἱστορίας συγγραψαμένων δοκοῦσί τι προὔργου πεποιηκέναι. Ἀλλ'
ἐν τούτοις, ὥσπερ κατ' ἐκείνους τοὺς χρόνους ὄντα, καὶ ἐν διαφόροις
ἔθνεσι γινόμενα πάντα ὁρᾶν ἔξεστιν· ὥστε ἱστορίαν τινὰ πάντα ἁπλῶς
ἀκριβοῦσαν εἶναι· μᾶλλον δὲ οὐχ ἱστορίαν, ἀλλ' ἵν' οὕτως εἴπω,
αὐτοψίαν τῶν τότε ἁπλῶς ἁπανταχοῦ γενομένων πάντων, καὶ παρου-
σίαν. Ἥ γε μὴν τέχνη τῶν μιμημάτων ἀληθῶς ἐρίζει καὶ ἁμιλλᾶται πρὸς
τὴν τῶν πραγμάτων φύσιν, ὥστε δοκεῖν ἄνθρωπον, ἢ ἵππον, ἢ πόλιν, ἢ
στρατὸν ὅλον ὁρᾶν, ἢ θώρακα, ἢ ξίφος, ἢ πανοπλίαν, καὶ ἢ ἁλισκο-
μένους, ἢ φεύγοντας, ἢ γελῶντας, ἢ κλαίοντας, ἢ κινουμένους, ἢ ὀργιζο-
μένους. Ἐπὶ πᾶσι δὲ τούτοις γράμματα μεγάλα λέγοντα, Ἡ βουλὴ τῶν
Ῥωμαίων καὶ ὁ δῆμος, Ἰουλίῳ εἰ τύχοι Καίσαρι, ἢ Τίτῳ, ἢ Οὐεσπα-
σιάνῳ ἀρετῆς καὶ ἀνδραγαθίας ἕνεκεν, νικήσαντι ἀπὸ τῶν δεινῶν,
ἢ φυλάξαντι τὴν πατρίδα, ἢ ἐλάσαντι τοὺς βαρβάρους, ἤ τι τοιοῦτον
ἕτερον τῶν ἐπαινουμένων. Τί δὲ τοὺς παλαιοὺς ἐκείνους, Μελεάγρους,
καὶ Ἀμφίονας, καὶ Τριπτολέμους, εἰ δὲ βούλει, Πέλοπας, καὶ Ἀμφιάρεως,
καὶ Ταντάλους, καὶ εἴ τι τοιοῦτον ἕτερον ἐπὶ τῆς μυθικῆς καὶ ἀρχαίας
ἐκείνης τῆς Ἑλληνικῆς ἱστορίας λέγεται; Μεσταὶ μὲν τούτων ὁδοί,
μεστὰ δὲ μνήματα καὶ τάφοι παλαιῶν, μεστοὶ δὲ οἰκιῶν τοῖχοι· πάντα
τῆς ἀρίστης καὶ τελεωτάτης τέχνης, Φειδίου τινός, ἢ Λυσίππου, ἢ
Πραξιτέλους, ἢ τῶν ὁμοίων ἔργα. Ὥστε ἀνάγκη διὰ τῆς πόλεως ἰόντι
ποτὲ μὲν πρὸς τοῦτο, ποτὲ δὲ πρὸς ἐκεῖνο ἕλκεσθαι τῷ ὀφθαλμῷ· ὅπερ
συμβαίνει τοῖς ἐρωτικοῖς τούτοις, καὶ τὰ ζῶντα κάλλη θαυμάζουσι, καὶ
περιέργως θεωμένοις.

Letter to John Palaeologue (Σύγκρισις τῆς παλαιᾶς καὶ νέας
Ῥώμης), *Patrologiae cursus completus*, ed. J.-P. Migne, Series
Graeca, vol. xlvi, Paris, 1866, cols. 28–9. (pp. 80–1)

VIII. MANUEL CHRYSOLORAS

Μανουὴλ Χρυσολωρᾶς Δημητρίῳ Χρυσολωρᾷ, ἀνδρῶν ἀρίστῳ καὶ
περιφανεστάτῳ, χαίρειν. Ἄρα δύνασαι πιστεῦσαι περὶ ἐμοῦ, ὡς ἐγὼ
τὴν πόλιν ταύτην περιϊών, κατὰ τοὺς ἐρωτολήπτους τούτους καὶ

κωμαστὰς τοὺς ὀφθαλμοὺς ὧδε κἀκεῖσε περιφέρω, καὶ τοὺς τῶν οἰκιῶν
τοίχους εἰς ὕψος, καὶ τὰς ἐν αὐταῖς θυρίδας περιεργάζομαι, εἴ τί που
τῶν καλῶν ἴδοιμι παρ' ἐκείναις; Τοῦτο γὰρ νέος μὲν ὤν, ὡς οἶσθα, οὐκ
ἐποίουν, καὶ τοῖς ποιοῦσιν ἐμεμφόμην. Νῦν δὲ ὠμογέρων ἤδη γενό-
μενος, οὐκ οἶδ' ὅπως εἰς τοῦτο ἐξηνέχθην. Αἴνιγμά σοι δοκῶ λέγειν·
ἄκουε δὲ τὴν λύσιν τοῦ αἰνίγματος καὶ τῆς ἀπορίας· ἐγὼ γὰρ οὐ
3ώντων σωμάτων κάλλη ἐν ἐκείνοις 3ητῶν τοῦτο ποιῶ, ἀλλὰ λίθων,
καὶ μαρμάρων, καὶ ὁμοιωμάτων. Φαίης ἂν ἴσως τοῦτο εἶναι ἀτοπώ-
τερον ἐκείνου, καὶ ἐμὲ δὲ πολλάκις τοῦτο λογίσασθαι ἐπῆλθε· τί δήποτε
ἵππον μὲν ἢ κύνα ἢ λέοντα καθημέραν 3ῶντα ὁρῶντες, οὐ πρὸς θαῦμα.
ἐγειρόμεθα, οὐδὲ τοσοῦτον αὐτὰ ἀγάμεθα τοῦ κάλλους, οὔτε μὴν τὴν
ὄψιν αὐτῶν περὶ πολλοῦ ποιούμεθα, οὐδὲ δένδρον, ἢ ἰχθύν, ἢ ἀλε-
κτρυόνα, ταυτὸ δὲ καὶ ἐπ' ἀνθρώπων, τινὰ δὲ αὐτῶν καὶ μυσαττόμεθα,
ἵππου δὲ εἰκόνα ὁρῶντες, ἢ βοός, ἢ φυτοῦ τινος, ἢ ὄρνιθος, ἢ ἀνθρώπου,
εἰ δὲ βούλει μυίας, ἢ σκώληκος, ἢ ἐμπίδος, ἢ τινὸς τῶν αἰσχρῶν τούτων,
σφόδρα διατιθέμεθα ὁρῶντες τούτων τὰς εἰκόνας, περὶ πολλοῦ ποιού-
μεθα; Καίτοι οὐ ταῦτα δήπου ἀκριβέστερα ἐκείνων, ἄγε παρὰ τοσοῦτον
ἐπαινεῖται, παρ' ὅσον ὁμοιότερα ἐκείνοις φαίνεται. Ἀλλ' ὅμως ταῦτα
μὲν καὶ τὰ τούτων κάλλη παρατρέχομεν παρόντα, ταῖς δὲ ἐκείνων
εἰκόσιν ἐκπληττόμεθα· καὶ τὸ μὲν τοῦ 3ῶντος ὄρνιθος ῥύγχος ὅπως
εὐφυῆς κέκαμπται, ἢ τὴν ὁπλὴν τοῦ 3ῶντος ἵππου οὐ πολυπραγ-
μονοῦμεν· τὴν δὲ χαίτην τοῦ χαλκοῦ λέοντος, εἰ καλῶς ἥπλωται, ἢ
τὰ φύλλα τοῦ λιθίνου δένδρου, εἰ τὰς ἶνας παρεμφαίνει, ἢ τὴν τοῦ
ἀνδριάντος κνήμην, εἰ τὰ νεῦρα καὶ τὰς φλέβας ὑποδείκνυσιν ἐπὶ τοῦ
λίθου, τοῦτο τοὺς ἀνθρώπους τέρπει, καὶ πολλοὶ πολλοὺς ἂν ἵππους
3ῶντας καὶ ἀκεραίους ἀσμένως ἔδωκαν, ὥστε ἕνα λίθινον τὸν Φειδίου
ἢ τὸν Πραξιτέλους, καὶ τοῦτον εἰ τύχοι διερρωγότα καὶ λελωβημένον
ἔχειν. Καὶ τὰ μὲν τῶν ἀγαλμάτων καὶ 3ωγραφιῶν κάλλη οὐκ αἰσχρὸν
θεᾶσθαι, μᾶλλον δὲ καὶ εὐγένειάν τινα τῆς θαυμαζούσης ταῦτα διανοίας
ὑποφαίνει· τὰ δὲ τῶν γυναικῶν κάλλη ἀκόλαστον καὶ αἰσχρόν. Τί δὴ
τούτου τὸ αἴτιον; Ὅτι οὐ σωμάτων κάλλη θαυμάζομεν ἐν τούτοις,
ἀλλὰ νοῦ κάλλος τοῦ πεποιηκότος. Ὅτι καθάπερ κηρὸς καλῶς δια-
πλασθεὶς ὃν ἔλαβε διὰ τῶν ὀμμάτων ἐπὶ τοῦ φανταστικοῦ τῆς ψυχῆς
τύπον ἀποδέδωκεν ἐπὶ τοῦ λίθου, ἢ τοῦ ξύλου, ἢ τοῦ χαλκοῦ, ἢ τῶν
χρωμάτων· καὶ ὥσπερ ἡ ἑκάστου ψυχὴ τὸ αὐτῆς σῶμα οὐκ ὀλίγας
μαλακότητας ἔχον διατίθησιν, ὥστε τὴν αὐτῆς διάθεσιν, λύπην, ἢ
χαράν, ἢ θυμὸν ἐν αὐτῷ ὁρᾶσθαι· οὕτω τὴν τοῦ λίθου φύσιν οὕτως
ἀντίτυπον καὶ σκληράν, ἢ τοῦ χαλκοῦ ἢ τῶν χρωμάτων τὴν τῶν
ἀλλοτρίων τε, καὶ ἔξω διὰ τῆς ὁμοιότητος καὶ τέχνης διατίθησιν, ὥστε
ἐν τούτοις τὰ πάθη τῆς ψυχῆς ὁρᾶσθαι. Καὶ ὃ πλέον οὐ γελῶν αὐτός,

ἀλλ᾽ οὐδὲ χαίρων ὅλως ἴσως, οὐδὲ ὀργιζόμενος, οὐδὲ πενθῶν, οὐδὲ διατιθέμενος, ἢ καὶ κατὰ τὰ ἐναντία τούτοις διατιθέμενος, ταῦτα ἐν ταῖς ὕλαις ἀπομάττει. Τοῦτό ἐστι τοίνυν, ὅπερ ἀγάμεθα ἐν τούτοις, ἐπεὶ καὶ ἐν ἐκείνοις τοῖς φυσικοῖς λέγω, εἴ τις τὸν διαπλάσαντα, καὶ καθημέραν διαπλάττοντα, καὶ αὐτὰ δὲ τὰ τῶν πραγμάτων εἴδη παραγαγόντα νοῦν, καὶ τὸ ἐκείνων κάλλος, ὅθεν τὰ τοιαῦτα κάλλη προήχθη, θεωροῖ, εἰς ὑπερβολὴν ἄγαται. Καὶ τοῦτο ἀληθῶς ἐστι τὸ φιλοσοφεῖν, καὶ ἡ τοιαύτη θεωρία, καὶ ὁ τοιοῦτος ἔρως, πρὸς τῷ σεμνὸς καὶ σώφρων εἶναι ἐπέκεινά ἐστι πάσης ἡδονῆς. Ἀναγκαζόμεθα δὲ ἀπὸ τῆς τούτων ὄψεως, καὶ ὥσπερ τῶν ὁμοιωμάτων τούτων, οὕτω πολλῷ μᾶλλον τῶν φυσικῶν, οὕτω καλῶν καὶ κατὰ λόγον ὄντων, νοῦν ἀποδιδόναι δημιουργόν. Καὶ εἰ ἐν τούτοις ἡ εὐγένεια τοῦ πεποιηκότος αὐτὰ φαίνεται, καὶ ταῦτα ἀλλοτρίοις παραδείγμασι, καὶ ἀλλοτρίᾳ, καὶ προϋπαρχούσῃ ὕλῃ κεχρημένου, πόσῳ μᾶλλον ἡ εὐγένεια τοῦ νοῦ ἐκείνου διαδείκνυται, οὐ καὶ αὐτὴν τὴν ὕλην καὶ τὰ εἴδη παράγοντος, καὶ αὐτὸν δὲ τὸν ἡμέτερον νοῦν, ὥστε τὰ τῶν πραγμάτων εἴδη ἀπομάττεσθαι, καὶ τὰ τοιαῦτα ποιεῖν ἔξω δύνασθαι πεποιηκότος; Ἀλλὰ ταῦτα τί ἂν πρὸς σὲ λέγοιμι, βέλτιον ἐμοῦ εἰδότα; Ὁ δὲ ἔλεγον, τὸ μὲν ἐν ἡμῖν θεωρητικὸν διὰ τοιούτων καὶ πολλῶν ἄλλων θειοτέρων ἡ πόλις αὕτη κινεῖν δύναται. Τὸ δέ γε ἠθικὸν ὁρῶσιν, ὅτι ἡ περὶ τὰ ἔξω ταῦτα τῶν ἀνδρῶν ἐκείνων σπουδὴ καὶ φιλοτιμία, εἰ ἐν οἰκοδομήμασιν, εἴτε ἐν πλούτῳ, εἴτε ἐν ἡγεμονίᾳ, εἴτε ἐν ἀρχαῖς, εἰς τοὔσχατον πάσης εὐδαιμονίας προελθοῦσαι, τέλος, ὥσπερ εἰ μηδὲ ἐγεγόνει τὴν ἀρχὴν εἰς τὸ μηδὲν ὄντως ἀπερρύη, ἐγείραντος διὰ τῆς πίστεως ἀπὸ τούτων ἄλλα τοῦ Θεοῦ ἅπερ ἔδοξεν ἂν τῷ πολλῷ καλλίῳ, καὶ ἃ δυνάμεθα νοῦν ἔχοντες μᾶλλον θαυμάζειν τε καὶ περὶ πλείονος ποιεῖσθαι. Ὑγίαινε.

Letter to Demetrius Chrysoloras, *Patrologiae cursus completus*, ed. J.-P. Migne, Series Graeca, vol. xlvi, Paris, 1866, cols. 57–60 (pp. 81–2)

IX. AMBROGIO TRAVERSARI

Veni Ravennam VII. Decembris, neque prius institutum opus peragere volui, quam templa vetustissima, et digna profecto miraculo cernerem, praecipueque maiorem Ecclesiam, ubi librorum aliquid delitescere, te quoque admonente, putabam. Ingressus Bibliothecam, dum singula studiosius explico, vix dignum te quidquam inveni. Solum Cypriani volumen antiquum reperi, in quo plures longe epistolas, quam unquam viderim, notavi.

Eas iam tunc transcribendas curare animus fuit. Studiose percontanti, an quidquam praeterea librorum lateret in scriniis, sive aliud antiquitatis monumentum, responsum a Custodibus est complura illic esse privilegia papyro exarata, atque inter cetera Caroli Magni unum cum aurea Bulla; locum quoque inesse, cui Carthulegio vocabulum est. Ea ego omnia dum mihi ostendi avide expeterem, intempestivum esse renuntiatum est. Magnum tamen, ac pervetustum codicem de Conciliis in conspectum dederunt, in quo Nicaeni Concilii fidem in membranis purpureis et aureis literis scriptam legi. Discessi tunc, inspecto prius templo dignissimo altarique argenteo, columnis argenteis quinque subfulto, cum ipso quoque ciborio argenteo; neque hac magnificentia contenta prominentia quoque circum altare capitella marmorea, quae ad ornatum templi sunt. Argento vestivit antiquitas, maximaque ex parte durant. Fateor, ne Romae quidem pulchriores sacras aedes vidi. Columnae ingentes ex marmore suo stant ordine. Interiora aedium maxime contegunt marmoris discoloris, et porphyritici lapidis tabulae. Musivum opus nusquam fere pulchrius vidi. Baptisterium iuxta maiorem Ecclesiam ornatissimum inspexi. Transivi ad spectandum mirificum, et magnificentissimum S. Vitalis Martyris Templum, rotundum id quidem, et omni genere superioris ornatus insigne musivo, columnis cingentibus ambitum fani, marmoreis crustis variis parietes interius vestientibus. Sed habet subspensum, columnisque subfultum peripatum, et aram ex alabastro tam lucidam, ut speculi instar imagines referat. Sacellum fano propinquum, Placidiae Augustae, et Valentiniani Senioris sepulcra magnifica servat ex marmore candido. Tantam illic musivi operis speciem offendi, ut adcedere nihil posse videatur. Contendi ad visendum S. Ioannis Evangelistae templum speciosissimum, et quod a memorata Placidia, et Theodosio Augustis conscriptum incisae marmore graecae literae testantur. Transivi ad contuendum Classense Monasterium nostrum tribus fere millibus ab urbe remotum: et flere uberrime ruinas ingentes coactus sum. Ecclesia tamen integra durat omni ornatu conspicua. Pinicam sylvam octo ferme millibus passuum se porrigentem iuris nostri, et visere et adequitare libuit; dum ad Monasterium, quod S. Mariae in Portu dicitur, et ipsum permagnificum, dignumque miraculo inveniremus; ubique libros desideravi. Vas in eo Monasterio porphyreticum pulchrum, et tornatile inveni, quod putarent simpliciores fratres unam ex hydriis esse, in quibus

aquam in vinum conversam Evangelista testatur. Plerasque in
hunc modum Basilicas haec civitas servat. Sed tanta luti vis est,
ut domo egredi vix, nisi equitibus liceat, ita, ut redire ad maiorem
Ecclesiam hactenus datum non sit. Sepulcra plurima ex marmore
ingentia quidem per omnes ferme Ecclesias videas, et ex his
pleraque squamatis operculis. Minus hic signorum, et statuarum,
quam Romae est, sed cetera ferme sunt paria; immo ausim
dicere, maiore hic cura servata.

Ambrogio Traversari, Latinae Epistolae, ed. Petrus Cannetus
Florence, 1739, pp. 419–22 (12 Oct. 1433, to Niccolò
Niccoli). (p. 14)

X. GUARINO

Vir unus a dextra sedet. Is ingentes admodum habet aures Midae
auriculis ferme compares. Ipsique calumniae procul adhuc ac-
cedenti manum extendit, quem circum duae mulieres adstant,
ignorantia, ut opinor, atque suspicio. Parte alia ipsa horsum
adventare calumnia cernitur. Ea muliercula est ad excessum
usque speciosa, non nihil succalescens et concita, ut pote quae
rabiem iracundiamque portendat. Haec dextra quidem facem
(fol. 5ʳ) tenet accensam. Altera vero caesarie trahit adolescen-
temmanus ad caelum porrigentem, ipsosque deos obtestantem.

Dux huius est vir quidam palore obsitus et informis, acriter
intuens quem eis iure comparavero, quos macie diuturnior con-
fecit aegritudo. Hunc ipsum merito esse livorem quis coniecta-
verit. Aliae quoque duae comites sunt mulieres calumniae
praeduces, quae illius ornamenta component. Harum altera erat
insidia, fraus altera, sicut mihi quidam eius tabellae demonstrator
explicuit.

Subinde quaedam lugubri vehementer apparatu obscura veste
seque dilanians assequitur, eaque esse penitentia ferebatur. Obor-
tis igitur lacrimis haec retrovertitur, ut propius accedentem veri-
tatem pudibunda suspiciat. Hoc pacto suum Apelles periculum
picta effigiavit in tabula.

Translation of Lucian, *Calumniae non temere credendum*, in Modena
Biblioteca Estense, MS. Est. lat. 20 (α, F 2, 52). fols. 4ᵛ–5ʳ
(pp. 90–1)

XI. GUARINO
PISANUS GUARINI

Si mihi par voto ingenium fandique facultas
Afforet et magnum redolerent pectora Phoebum
Labraque proluerent pleno cratere Camenae,
Versibus aggrederer dignas extollere laudes
Pro meritis, Pisane, tuas, ut vividus omne 5
Exuperes aevum, sic post tua fata superstes
Pubescas servesque novam per saecla iuventam,
Qualiter accenso post se iuvenescere fertur
Assyrium phoenica rogo et de morte renasci.
Quid faciam? Licet eximias in carmina vires 10
Mi natura neget, non saltem grata voluntas
Defuerit, nostrumque olim testetur amorem,
Quos animi veteri iungit concordia nexu.
Qualiacunque loquar, sat erit tua nomina servem
Haud decet ut, celsos ornans heroas honore, 15
Induperatorum faciem sagulumque vel arma
Nobilitans, cunctis ut sit clamare necesse
'Sic oculos, sic ille manus, sic ora gerebat',
Principibus vitam divina ex arte perennem
Magnanimis tribuens, iaceas neglectus ab omni 20
Eloquio exclusus. Sinat hoc impune Minerva?
Non sinat hoc, natale solum quod laude celebras.
 Principio cuncti patria laetamur eadem,
Quae nos ambo creat germanaque nomina praestat,
Cui decus et famam per longas porrigis oras, 25
Cum te multimodis pangas virtutibus atque
Ore virum volites. Prudens, gravis atque modestus,
Munificus propriis, alienis, fidus amicis,
Moribus ornatus pulchroque insignis amictu,
Maxima Veronae reddis praeconia nostrae. 30
Caelitus adde datum tantis cum dotibus ingens
Ingenium, artifices digitos doctosque colores,
Quis naturae opera, cunctis mirantibus, aequas.
Seu volucres seu quadrupedes, freta saeva quietaque
Aequora describis, spumas albere, sonare 35
Littora iuremus; sudorem tergere fronte
Tento laboranti; hinnitus audire videmur
Bellatoris equi, clangorem horrere tubarum.

Noctis opus pingens circum volitare volucres
Nocturnas facis et nusquam apparere diurnas: 40
Astra, globum lunae cernas, sine sole tenebras.
Si gesta hyberno fingis, glacialibus horrent
Omnia frigoribus, frendet sine frondibus arbor.
Seu factum ponis sub verni temporis horam,
Arrident varii per prata virentia flores, 45
Arboribus lux prisca redit collesque nitescunt,
Hinc mulcent avium praedulces aethera cantus.
 Singula quid refero? Praesens exemplar habetur.
Nobile Hieronymi munus quod mittis amandi,
Mirificum praefert specimen virtutis et artis. 50
Splendida canicies mento, frons ipsa severo
Sancta supercilio. Quae contemplatio mentem
Abstrahit in superos! Praesens quoque cernitur absens,
Hic et adest et abest: corpus spelunca retentat,
Caelo animus fruitur. Quod cum declaret imago, 55
Picta quidem sed signa tamen vivacia monstrans,
Hiscere vix ausim clausisque susurro labellis,
Ne contemplantem caelestia regna deumque
Vox interpellet, vociter quoque rusticus, asper.
Quae lucis ratio aut tenebrae! distantia qualis! 60
Symmetriae rerum! quanta est concordia membris!
Quisnam hunc artificem divinae mentis et artis
Non miratus amet, venerans canat, imus honoret?
 Germanam hanc sanctae genuit natura poesi:
Auribus haec subicit res, illa movebit ocellos, 65
Utraque corda iuvat aptos formando colores,
Immortale aevum spondent mortalibus ambae.
Hanc magnis cultam ingeniis procerumque ducumque
Et quorum studium est causas tentare latentes,
Quis nescit? clarum inprimis tractasse Platonem 70
Socraticasque manus varias pinxisse figuras?
Pinxerunt Fabius, Lucilius: ambo quirites
Patricii. Verona parens nostra inclyta quondam
Turpilium vidit, cum membra simillima vivis
Ederet: hic fuerat tum ex ordine natus equestri. 75
Canacus, Euphranor, Polycletus et acer Apelles,
Praxiteles et Myrro Polygnotusque, Timanthes,
Munificus Zeuxis pleno celebrabilis ore.

Hic ubi iam tabulas perfecerat arte magistra,
Omnibus expletas numeris, donare solebat: 80
Quis divina queat preciis mercarier ullis?
 Caesaribus multis ea nota peritia, multis
Regibus, haec artes inter petebatur honestas.
 His, Pisane, viris numerandum protulit aetas
Te nostra et tantus non indignabitur ordo, 85
Cui decus et laudem possis augere. Deorum
Mendaces illi effigies componere norant;
Tu Patrem aeternum, totum qui condidit orbem
Ex nihilo, sanctosque viros componis eos, qui
Religione viam ad superos docuere beatam. 90

Epistolario di Guarino Veronese, ed. R. Sabbadini, i, Venice, 1915
pp. 554–7. (pp. 92–3)

XII. GUARINO

Guarinus suo Stephano s.

Si ad [te] serius rescribo quam vel ego soleam vel tu expectes, ne incuriae succenseas oro; alia causa detineor, nam cum tuum in me studium, summam vigilantiam, observantiam animadverto, longam quidem cogitationem consum[m]o ut aliquem gratiarum agendarum modum excogitem, si non parem, non valde dissimilem. Id autem cum assequi cogitatione non possum, discrucior animi et vitam molestiorem ago ut, cum re ipsa et opere, quod difficilius est, non solum meis satis votis facias sed etiam vota superes, ego verbis grates dignas dicere non queam. Nam ut alia omittam, quae paene innumerabilia sunt, quibus ego verbis et orationis ornatu calamarium abs te mihi missum aequaverim, in quo cum forma perpulchra concinna et commodissima sit, formam ipsam opus vere Phidiacum superat et oculos pascens artificium? Si frondes ramusculosve contemplor et attentione intueor, num veras frondes veros ramos intueri et impune huc illuc posse flecti putem? adeo cum naturae facilitate certasse videtur artis industria. Subinde satiari delectatione non possum cum imagunculas inspecto et vivas in argilla facies: quid in eis pro parentis naturae imitatione non expressum est? ungues, digiti, molles e terra capilli visentem fallunt. Cum oris hiatum inspicio, emanaturam vocem stultus expecto; pendentes puellos dum cerno,

terreos esse immemor, ne proni cadant et corpuscula casus laedat reformido et misericordia commotus inclamo. Quam varias animorum affectiones puerilis affert aetas animorumque mobilitas, tam varios in ore vultus cernas: ridentem hunc, subtristem illum, securum alium, cogitabundum alterum, tum gestus per teneriorem aetatis lasciviam inverecundos: itaque corporis partes naturae providentia latere volentes, impudentius deteguntur. Quid igitur miramur pristinis saeculis, quae passim adspirantes habuisse deos creduntur, extitisse nonnullos qui efficatas e terra figuras animarint et vitales in sensus expresserint, cum hac aetate, quae deorum expers ferme est, hae creteae imagines cum veris certare videantur et sic certare ut in eis saepius et attentius contemplandis legendi scribendive fiam nonnunquam immemor?

Quas itaque tibi gratias agam, qui me tanta voluptate tua opera et cura delinias? eius impensam ut mihi denunties reliquum est, ut vel hac via tibi satisfaciam, cum reliquis non liceat. Vale dulcissime Stephane.

Ex Ferraria VII idus iulias [1430].

Epistolario, ed. R. Sabbadini, ii, Venice, 1916, pp. 111–12
(p. 91)

XIII. GUARINO

Guarinus Veronensis ill.^mo principi et domino singulari d. Leonello Estensi sal. pl. d.

Princeps illustrissime et domine singularis.

Cum praeclaram vereque magnificam in pingendis musis cogitationem tuam nuper ex litteris tuae dominationis intellexerim, laudanda erat merito ista principe digna inventio, non vanis aut lascivis referta figmentis; sed extendendus fuisset calamus et longius quam expectas volumen dilatandum; deque musarum numero ratio evolvenda, de qua multi varios fecere sermones. Sunt qui tres, sunt qui quatuor, sunt qui quinque, sunt qui novem esse contendant. Omissis reliquis sequamur hos extremos qui novem fuisse dicunt. De ipsis igitur summatim intelligendum est musas notiones quasdam et intelligentias esse, quae humanis studiis et industria varias actiones et opera excogitaverunt, sic dictas quia omnia inquirant vel quia ab omnibus inquirantur: cum

ingenita sit hominibus sciendi cupiditas. Μῶσθαι enim graece indagare dicitur; μοῦσαι igitur indagatrices dicantur.

Clio itaque historiarum rerumque ad famam et vetustatem pertinentium inventrix; quocirca altera manu tubam, altera librum teneat; vestis variis coloribus figurisque multimodis intexta, qualiter sericos videmus pannos consuetudine prisca. Thalia unam in agricultura partem repperit, quae de agro plantando est, ut et nomen indicat, a germinando veniens; idcirco arbusculas varias manibus gestet; vestis esto floribus foliisque distincta. Erato coniugalia curat vincula et amoris officia recti; haec adulescentulum et adulescentulam utrinque media teneat, utriusque manus, imposito anulo, copulans. Euterpe tibiarum repertrix chorago musica gestanti instrumenta gestum docentis ostendat; vultus hilaris adsit in primis, ut origo vocabuli probat. Melpomene cantum vocumque melodiam excogitavit; eapropter liber ei sit in manibus musicis annotatus signis. Terpsichore saltandi normas edidit motusque pedum in deorum sacrificiis frequenter usitatos; ea igitur circa se saltantes pueros ac puellas habeat, gestum imperantis ostendens. Polymnia culturam invenit agrorum; haec succincta ligones et seminis vasa disponat, manu spicas uvarumque racemos baiulans. Urania astrolabium tenens caelum supra caput stellatum contempletur, cuius rationes excogitavit idest astrologiam. Calliope doctrinarum indagatrix et poeticae antistes vocemque reliquis praebens artibus coronam ferat lauream, tribus compacta vultibus, cum hominum, semideorum ac deorum naturam edisserat.

Scio plerosque fore qui alia musarum signent officia, quibus Terentianum respondebo illud: quot capita, tot sententiae [*Ph.* ii. 4. 14]. Bene vale, princeps magnanime decusque musarum, et Manuelis filii negotium et labores commendatos ut habeas supplex oro.

E Ferraria V novembris 1447.

Clio. Historiis famamque et facta vetusta reservo.
Thalia. Plantandi leges per me novere coloni.
Erato. Connubia et rectos mortalibus addit amores.
Euterpe. Tibia concentus hac praemonstrante figurat.
Melpomene. Haec vivos cantus et dulcia carmina format.
Terpsichore. Ista choris aptat saltus ad sacra deorum.
Polymnia. Haec docuit segetes acuens mortalia corda.

Urania. Signa poli, varias naturas monstro viasque.
Calliope. Materiam vati et vocem concedo sonantem.

Epistolario, ed. R. Sabbadini, ii, Venice, 1916, pp. 498–500
(pp. 89–90)

XIV. TITO VESPASIANO STROZZI

Ad Pisanum pictorem praestantissimum

Quis Pisane tuum merito celebrabit honore
 Ingenium praestans, artificesque manus?
Nam neque par Zeu[xis, nec par tibi magnus Apelles,]
 Sive velis hominem pingere, sive feram.
Quid volucres vivas, aut quid labentia narrem 5
 Flumina, cumque suis aequora littoribus?
Illic et videor fluctus audire sonantis,
 Turbaque caeruleam squammea findit aquam.
Garrula limoso sub gurgite rana coaxat,
 Valle sues, ursos monte latere facis. 10
Tum liquidos molli circundas mar[g]ine fontes,
 Mixtaque odoratis floribus herba viret.
Umbrosis nymphas silvis errare videmus,
 Haec humero casses, altera tela gerit.
Parte alia capreas lustris exire videntur, 15
 Et fera latrantes ora movere canes.
Illic exitio leporis celer imminet [u]mber,
 Hic fremit insultans, frenaque mandit equus.
Quis non miretur gestusque et sancta virorum
 Corpora, quae penitus vivere nemo neget? 20
Quisve Iovis faciem pictam non pronus adoret,
 Effigiem veri numinis esse ratus?
Denique quicquid agis, naturae iura potentis
 Equas divini viribus ingenii.
Illustris nec te tantum pictura decorat, 25
 Nec titulos virtus haec dedit una tibi,
Sed Policleteas artes ac Mentora vincis,
 Cedit Lisippus, Phidiacusque labor.
Haec propter toto partum tibi nomen in orbe,
 Et meritas laudes candida fama canit. 30
Sis felix! longum Lachesis te servet in evum,
 Et nostram, si qua est, dilige Cal[l]iopem!

Modena, Biblioteca Estense, MS. Est. lat. 140 (α, T 6, 17), fol. 25^{r–v}. The manuscript carries corrections, and these are between square brackets here. The text of this poem and its variants presents difficulties: for discussion of these, see R. Albrecht, 'Zu Tito Vespasiano Strozza und Basinio Basini's lateinischen Lobgedichten auf Vittore Pisano', *Romanische Forschungen*, iv, 1891, and Vasari, *Le vite*, I, *Gentile da Fabriano e il Pisanello*, ed. A. Venturi, Florence, 1896, pp. 52–5. (p. 93)

XV. LEONARDO GIUSTINIANI

Epistola Leonardi Justiniani ad Cypri Reginam. Laus picturae. Mecum nuper cogitabam, quid facerem, quod et mei erga Majestatem tuam amoris, ac venerationis pignus redderet, et tuam in me constantem, et perpetuam recordationem servaret. Nihil enim est, quod non illi divino Principi, et pro eo tibi debeam, propter immortalia erga meos, ac me beneficia. Venit igitur in mentem, ut pictam hanc Tabulam tibi dono mittam, quae vel eo ipso amplissima res judicari poterit, quod tuo designata nomini sit apud Majores nostros, quorum in omni re plurimum viget auctoritas. Vasa, vestes, signa, caeteraque id generis vel idcirco maximi saepenumero facta video, quod Dianae, Minervae, aut tuae, ex Cypro creatae, Veneri dicata erant. In ea vero tuae Majestati demittenda eo promptior, laetior, ac animosior sum, quod principale, ac regium munus visum est. Haud ignoro quantae diligentiae, honoris, observantiae, penes Reges, Populos, Nationes habita fuerit Pictura, ut quae non solum arte, usu, imitatione, sed etiam mentis viribus, et divino proprie ingenio expressa, ipsam ferme rerum omnium parentem naturam aequaverit adeo, ut si quibusdam fictis arte Animantibus vocem addideris, facile cum natura ipsa contendant, quin etiam aliqua ex parte eam superasse dixerim. Quod ne cui mirum esse videatur, naturae vires, ac potestatem adeo in plerisque rebus circumscriptam esse animadvertimus, ut non nisi Vere flores, Autumno fructus pariat, pictura vero sole sub ardenti nives, et hiberna tempestate Violas, Rosas, Poma, Baccasque, et affatim quidem procreet. Proinde summos, ac eruditissimos quosdam fuisse homines audio, qui ei Poeticam maxima ex parte Sororem adiunxerint. Quid enim aliud picturam, nisi tacens Poema deffinierunt? Idque ipso Poetarum testimonio comprobari potest. Etenim

Pictoribus, atque Poetis quaelibet audendi semper fuit aequa potestas, utrumque certe mentis acumine, et divino quodam spiritu excitari, ac duci constat. Quanta ejus dignitas apud Mortales sit, multa extant exempla. Alexander ille Magnus ab Apelle aetatis suae lectissimo potissimum pingi voluit. Quid ita? quoniam ad ipsius gloriam, cujus studiosissimus erat, non parvam ex Apellis arte futuram accessionem intelligebat: cujus non solum animo, et voluntate, sed etiam nutui parere, obsequi, et obsecundare statuit; atque ita statuit, ut nihil tam arduum, tam difficile, tam molestum esse, quod non humile, facile, ac jocundum videretur, modo Apelli more gestum intelligeret. Idque proximo patet exemplo. Alexander pulcherrimam, et egregiam forma nactus Virginem, ob ejus singularem corporis admirationem, et muliebris staturae dignitatem, nudam ab Apelle pingi statuit, ut tam excellentem Feminae, sed mortalis pulchritudinem tacita in sese imago servaret, et artis auxilio immortalitatem contineret. Id cum pararet excellentissimus Artifex, se captum amore sensit. Alexander ei dono dedit gratiosam, formosam, et carissimam Puellam; Rex, et juvenis magnus alioquin, sed major imperio sui, nec minor hac munificentia, quam clarus victoria, quippe se, aliorum victorem, vicit, nec thorum tantum suum, sed etiam affectum donavit Artifici, quem propter pictoriae artis praestantiam honore colebat, et gratia. Demetrius ille cognomento Poliorcetes clarissimi Pictoris Protogenis opera, summa cum admiratione conspicatus, tanta captus est voluptate, ut cum in obsidione Rhodiorum, quibus erat infensissimus, Protogenis imagines in potestatem redegisset, summis habuerit honoribus, et Pictoris nobilissimi, jam mortui, gratia, oppugnationem omiserit, Civitatique pepercerit. Quid Phidiam, Xeusim, Cimonem, Aristidem, Nicomachum pictores illustrissimos numerem? quibus ex hac, de qua loquor, arte plurimis ab exteris Regibus, Populisque honos impertitus est. Nunc et apud Romanos huic arti summa laus contigit, adeo ut clarissimae Gentes cognomen ex ea traxerunt, Fabius, Lepidus, Cornelius, Actius, Priscus pictores cognominati. Quidquid a nonnullis etiam volumina edita magnum Auctoribus nomen, et gloriam attulerunt. Eruditissimus Philosophus Vir optimus Manuel Chrysoloras, graeci, et latini nominis decus, cum raris admodum mulceri voluptatibus soleret, iis praesertim, quae petuntur extrinsecus, hac ipsa mirum in modum oblectabatur. Nec enim tractus illos, umbras ac lineamenta, sed artificis ingenium, et

admirabiles mentis vires contemplabatur, quibus spirantia effingi membra, et vivos duci vultus liceret. Ego ita mihi persuasi, nullum generosum vegetum, vel nobile extare ingenium posse, quod non hujus artificii delectatione, illecebris, et amaenitate capiatur, trahatur, leniatur. Quorsum tam multa de tabula ista, atque pictura? Ut intelligas, Regina illustrissima, hoc potissimum ad tuam Majestatem munus pertinere, cum apud excellentissimos Reges, Principes, et Philosophos tantae dignitati, ac venerationi picturam fuisse animadvertas. Suscipe igitur munus meum, quod et mecum in tuam Majestatem amorem testatur, et constantem de me servet recordationem tuam, quotiens in eo margaritas, monilia, praetiosamque supellectilem disposueris, et collocaveris, vel, quod felix, faustumque sit, quotiens id in ipso puerperio tibi ante locari contigerit. Vale.

Joannes Baptista Maria Contarenus, *Anecdota Veneta*, i, Venice, 1757, pp. 78–9. (pp. 97–8)

XVI. BARTOLOMEO FAZIO

DE PICTORIBUS[1]

Nunc ad pictores veniamus, quamquam fortasse convenientius fuit, ut post poetas pictores locarentur. Est enim, ut scis,[2] inter pictores ac poetas magna quaedam affinitas. Neque enim est aliud pictura quam poema tacitum. Namque in inventione ac dispositione operis utrorumque cura propemodum par, nec pictor ullus praestans est habitus, nisi qui in rerum ipsarum proprietatibus effingendis excelluerit. Aliud enim est superbum pingere, aliud avarum, aliud ambitiosum, aliud prodigum et reliqua item huiusmodi. Atque in his proprietatibus rerum exprimendis tam pictori quam poetae elaborandum est, et in ea sane re utriusque ingenium ac facultas maxime agnoscitur. Nam si avarum fingere quis volens leoni aut aquilae illum comparaverit, aut si liberalem lupo aut milvo, is nimirum sive poeta sive pictor fuerit desipere videatur. Oportet enim comparatorum naturam similem esse. Et sane semper magnus honos nec immerito picturae fuit. Est enim

[1] MSS.: Rome, Biblioteca Nazionale, Cod. Vittorio Emmanuele 854, chart., saec. xv, fols. 22r–26v (N), knowledge of which I owe to Professor P. O. Kristeller, and Vatican Library, Vat. lat. 13650, membr., saec. xv, fols. 37v–44v (V). The printed edition (ed. L. Mehus, Florence, 1745) is not used. N omits all headings.

[2] *Om.* ut scis N.

ars magni ingenii ac solertiae, nec temere alia inter operosas[3]
maiorem prudentiam desiderat, ut pote quae non solum ut os ut
faciem ac totius corporis liniamenta, sed multo etiam magis
interiores sensus ac motus exprimantur postulat, ita ut vivere ac
sentire pictura illa et quodammodo moveri ac gestire videatur.
Alioquin similis fuerit poemati pulchro illi quidem et[4] eleganti,
sed languido ac nihil moventi. Verum, ut non satis est poemata
pulchra esse, quemadmodum ait Horatius, oportet enim dulcia
sint, ut quamcunque in partem velint animos hominum sensus-
que permoveant, ita et picturam non solum colorum varietate
exornatam, sed multo magis vivacitate quadam, ut ita loquar,
figuratam esse convenit. Et quemadmodum de pictura, ita et de
sculptura, fusura, architectura, quae omnes artes a pictura ortum
habent, dicendum est. Nec enim quisquam probatus in his generi-
bus artifex esse potest, cui pingendi ratio ignota sit. Coeterum,
praetermissa longiori disputatione, de iis paucis pictoribus atque
sculptoribus qui hac aetate nostra claruerunt[5] scribere pergamus,
ac de infinitis eorum operibus ea solum attingemus quorum
clara notitia ad nos pervenit.

GENTILIS FABRIANENSIS

Gentilis Fabrianensis ingenio ad omnia pingenda habili atque
accommodato fuit. Maxime vero in aedificiis pingendis eius ars
atque industria cognita est. Eius est Florentiae in Sanctae Trinita-
tis templo nobilis illa tabula in qua Maria Virgo, Christus infans
in manibus eius, ac tres Magi Christum adorantes muneraque
offerentes conspiciuntur. Eius est opus Senis in foro, eadem Maria
Mater Christum itidem puerum gremio tenens, tenui linteo illum
velare cupienti adsimilis, Iohannes Baptista, Petrus ac Paulus
Apostoli, et Christoforus Christum humero sustinens, mirabili
arte, ita ut ipsos quoque corporis motus ac gestus representare
videatur. Eius est opus apud Urbem Veterem in maiore templo,[6]
eadem Virgo et Christus infantulus in manibus ridens, cui nihil
addi posse videatur. Pinxit et Brixiae sacellum amplissima mer-
cede Pandulfo Malatestae. Pinxit et Venetiis in palatio terrestre
proelium contra Federici Imperatoris filium a Venetis pro summo
Pontifice susceptum gestumque, quod tamen parietis vitio pene
totum excidit. Pinxit item in eadem urbe turbinem arbores

[3] operosa N. [4] *Om.* et N. [5] clarueruntur N.
[6] maiore in templo N.

caeteraque id genus radicitus evertentem, cuius est ea facies, ut vel prospicientibus horrorem ac metum incutiat. Eiusdem est opus Romae in Iohannis Laterani templo, Iohannis ipsius historia, ac supra eam historiam Prophetae quinque[7] ita expressi, ut non picti, sed e marmore ficti esse videantur. Quo in opere, quasi mortem praesagiret, se ipse superasse putatus est. Quaedam etiam in eo opere adumbrata modo atque imperfecta morte praeventus reliquit. Eiusdem est altera tabula in qua Martinus Pontifex Maximus et cardinales decem ita expressi, ut naturam ipsam aequare et nulla re viventibus dissimiles videantur. De hoc viro ferunt, cum Rogerius Gallicus insignis pictor, de quo post dicemus, iobelei anno in ipsum Iohannis Baptistae templum accessisset eamque picturam contemplatus esset, admiratione operis captum, auctore requisito, eum multa laude cumulatum caeteris italicis pictoribus anteposuisse. Eiusdem etiam tabulae praeclarae in diversis locis esse perhibentur, de quibus non scripsi, quoniam de iis haud satis comperi.

IOHANNES GALLICUS

Iohannes Gallicus nostri saeculi pictorum princeps iudicatus est, litterarum nonnihil doctus, geometriae praesertim et earum artium quae ad picturae ornamentum accederent, putaturque ob eam rem multa de colorum proprietatibus invenisse, quae ab antiquis tradita ex Plinii et aliorum auctorum lectione didicerat. Eius est tabula insignis in penetralibus Alfonsi regis, in qua est Maria Virgo ipsa, venustate ac verecundia notabilis, Gabriel Angelus dei filium ex ea nasciturum annuntians excellenti pulchritudine capillis veros vincentibus, Iohannes Baptista vitae sanctitatem et austeritatem admirabilem prae se ferens, Hieronymus viventi persimilis, biblioteca mirae artis, quippe quae, si paulum ab ea discedas, videatur introrsus recedere et totos libros pandere, quorum capita modo appropinquanti appareant. In eiusdem tabulae exteriori parte pictus est Baptista Lomelinus cuius fuit ipsa tabula, cui solam vocem deesse iudices, et mulier quam amabat praestanti forma et ipsa qualis erat ad unguem expressa, inter quos solis radius veluti per rimam illabebatur, quem verum solem putes. Eius est mundi comprehensio orbiculari forma, quam Philippo Belgarum principi pinxit, quo nullum consumatius opus

nostra aetate factum putatur, in quo non solum loca situsque regionum, sed etiam locorum distantiam metiendo dignoscas. Sunt item picturae eius nobiles apud Octavianum Cardam, virum illustrem, eximia forma feminae e balneo exeuntes, occultiores corporis partes tenui linteo velatae notabili rubore, e quis unius os tantummodo pectusque demonstrans, posteriores corporis partes per speculum pictum lateri oppositum ita expressit, ut et[8] terga quemadmodum pectus videas. In eadem tabula est in balneo lucerna ardenti simillima, et anus quae sudare videatur, catulus aquam lambens, et item equi hominesque perbrevi statura, montes, nemora, pagi, castella tanto artificio elaborata, ut alia ab aliis quinquaginta milibus passuum distare credas. Sed nihil prope admirabilius in eodem opere quam speculum in eadem tabula depictum, in quo quaecunque inibi descripta sunt, tanquam in vero speculo prospicias. Alia complura opera fecisse dicitur, quorum plenam notitiam habere non potui.

PISANUS VERONENSIS

Pisanus Veronensis in pingendis rerum formis sensibusque exprimendis ingenio prope poetico putatus est. Sed in pingendis equis caeterisque animalibus peritorum iudicio caeteros antecessit. Mantuae aediculam pinxit et tabulas valde laudatas. Pinxit Venetiis in palatio Federicum Barbarussam Romanorum Imperatorem et eiusdem filium supplicem, magnumque ibidem comitum coetum germanico corporis cultu orisque habitu, sacerdotem digitis os distorquentem et ob id ridentes pueros, tanta suavitate, ut aspicientes ad hilaritatem excitent. Pinxit et Romae in Iohannis Laterani templo quae Gentilis divi[9] Iohannis Baptistae historia inchoata reliquerat, quod tamen opus postea, quantum ex eo audivi, parietis humectatione pene oblitteratum est. Sunt et eius ingenii atque artis exemplaria aliquot picturae in tabellis ac membranulis, in quis Hieronymus Christum cruci affixum adorans, ipso gestu atque oris maiestate venerabilis, et item[10] haeremus in qua multa diversi generis animalia, quae vivere existimes. Picturae adiecit fingendi artem. Eius opera in plumbo atque aere sunt Alfonsus rex Aragonum, Philippus Mediolanensium princeps, et alii plerique Italiae reguli, quibus propter artis praestantiam[11] carus fuit.

[8] *Om.* et N. [9] de N. [10] idem N.
[11] praestantium V.

ROGERIUS GALLICUS

Rogerius Gallicus, Iohannis discipulus[12] et conterraneus, multa artis suae monumenta singularia edidit. Eius est tabula praesignis Genuae, in qua mulier in balneo sudans iuxtaque eam catulus, ex adverso duo adolescentes illam clanculum per rimam prospectantes, ipso risu notabiles. Eius est altera tabula in penetralibus principis Ferrariae, in cuius alteris valvis Adam et Eva nudis corporibus e terrestri paradiso per angelum eiecti, quibus nihil desit ad summam pulchritudinem, in alteris regulus quidam supplex, in media tabula Christus e cruce demissus, Maria Mater, Maria Magdalena, Iosephus, ita expresso dolore ac lachrimis, ut a veris discrepare non existimes. Eiusdem sunt nobiles in linteis picturae apud Alfonsum regem, eadem mater Domini, renunciata Filii captivitate, consternata profluentibus lachrimis, servata dignitate, consumatissimum opus. Item contumeliae atque supplicia quae Christus Deus noster a Iudaeis perpessus est, in quibus pro rerum varietate sensuum atque animorum varietatem facile discernas. Brusellae, quae urbs in Gallia est, aedem sacram pinxit, absolutissimi operis.

DE SCULPTORIBUS

RENTIUS FLORENTINUS

Ex sculptoribus paucos in tanta multitudine claros habemus, quamquam aliqui hodie sunt, quos aliquando nobiles fore existimamus. Sed de Rentio Florentino prius verba faciam. Hic in aere admirabilis censetur. Testamentum novum prius, deinde vetus, tam diffusa, tam varia Florentiae in valvis templi Iohannis Baptistae inenarrabilis operis ex aere finxit. Eius item sunt Florentiae in aede Reparatae divi Zenobii sepulchrum ex aere, in ortis Michaelis[13] Archangeli Iohannes Baptista ac Stephanus Prothomartyr, opus utique magni ingenii artificiique.

VICTOR

Nec inferior putatur Victor eius filius, cuius manus atque ars in iisdem valvis Iohannis[14] Baptistae elaborandis cognita est. Ita enim inter se utriusque opera conveniunt, ut unius et eiusdem manu facta esse videantur.

[12] *Om.* discipulus . . . quamquam hodie sunt, quos V., one complete folio being missing.
[13] miraclis N. [14] iohanni V.

DONATELLUS FLORENTINUS

Donatellus et ipse Florentinus ingenii quoque et artis praestantia excellet, non aere tantum, sed etiam marmore notissimus, ut vivos vultus ducere et ad[15] antiquorum gloriam proxime accedere videatur. Eius est Padua divus Antonius[16] atque alia Sanctorum quorundam in eadem tabula praeclara simulacra. Eiusdem est in eadem urbe Gattamelata egregius copiarum dux ex aere, equo insidens, mirifici operis.

De viris illustribus, 'De Pictoribus', 'De Sculptoribus'. (pp. 103–9)

XVII. LORENZO VALLA

Intueamur nunc rationes tuas de coloribus, in quibus quasi in triariis omnem spem profligatae causae reposuisti. Audite Iurisconsultum mira quaedam philosophantem, novam quandam et inauditam affert disciplinam, quae universum orbem revocet ab errore: et si minus revocare potest, iandiu propter consuetudinem induratam, certe commonefaciat, ita fuisse faciendum. Color aureus est, inquit, nobilissimus colorum, quod per eum figuratur lux. Si quis enim vellet figurare radios solis, quod est corpus maxime luminosum, non posset commodius facere quam per radios aureos, constat autem luce nihil esse nobilius. Animadvertite stuporem hominis, stoliditatemque pecudis. Si aureum colorem accipit eum solum, qui ab auro figuratur, sol quidem non est aureus. Si aureum pro fulvo, rutilo, croceo, quis unquam ita caecus atque ebrius fuit, nisi similis ac par Bartolo, qui solem croceum dixerit? Sustolle paulisper oculos asine: solent enim aliquando asini, praesertim quum dentes nudant, ora tollere. Tu quoque quum loqueris, faciem subleva, nec te nimia auri cupiditas caecet, quod in terra non in coelo invenitur: et vide an sol est aureus vel argenteus. Unde inter lapillos candidos heliotropium a sole nomen accepit. Et nos candentes tedas, candentes rogos: et excandescere dicimus, si quis ira aut indignatione commotus est, et velut inflammatus: flamma enim, quae nihil habet humoris et terrei, candida est, et soli comparanda. Quid postea, quae proximo loco colorem ponit? quem putas eum qui non est, ut sit semper sibiipsi similis, ut non modo dicat quicquid in buccam venit, sed

[15] *Om.* ad N. [16] Antoninus *codd.*

tanquam studeat nihil dicere, quod verum sit, aut rectum? Sapphireus, inquit, est proximus, quem ipse, ut est barbarus, et quasi cum foeminis, et non cum viris loquatur, azurum vocat: per hunc colorem, ait significatur aer. Nonne tibi hic aliquid dicere videtur, qui ordinem sequitur elementorum? certe. Sed nescio quare lunam praetermisit, nisi quia tunc in coelo non erat aut eclipsi laborabat: quum solem primum feceris, lunam debueras facere secundam, quae et altior aere est, et magis suum quendam colorem habet quam aer, et quum illum dixeris aureum, hanc oportebat argenteam nominare et proximam a sole facere, ut argentum secundum est ab auro: nisi forte lunam quoque auream putes aureo vino madidus et distentus, aut eam hinc odio habes, quia sis ipse lunaticus. Sin volueris sororem fratri Phoeben Phoebo proximum ponere, profecto res ipsa et ordo postulabat, post aurum sequens locus esset argento, qui est color candidus: eo quidem magis quod postea hunc ipsum colorem, nescio quomodo, sive primum sive secundum facis, quod videlicet luci maxime propinquus sit: homo tibiipsi contrarius, et ubique veluti per somnum loquens. Sapphireum igitur secundo numeras loco, delectatus, ut dixi, ordine elementorum: a metallis enim, a lapidibus preciosis, ab herbis et floribus, non putasti tibi exempla sumenda: quae si propria magis et accommodata erant, tum humilia tibi et abiecta duxisti, tu qui ex sole tantum es factus et aere. Nam quum seriem elementorum prosequeris, de duobus dicis, de duobus alteris obmutescis, et nobis expectantibus tam altum venerandumque processum, quodam modo illudis. Si primus color est igneus, sequens aerius, tertius aquaticus erit: quartus terreus. Aut non adeunda tibi erat ista Bartole via, aut prorsus obeunda. Pergamus ad caetera. Paulo post ait album esse nobilissimum colorum, nigrum abiectissimum, alios vero ita quenquam optimum, ut est albo coniunctissimus, rursum ita quenquam deterrimum: ut est nigredini proximus. Horum quid primum reprehendam? an quod aurei coloris non meminit, quasi meam increpationem timuisset? an quod album omnibus praetulit? an quod nigro infimum locum dedit? an, quod stultissimum est, quod de aliis coloribus incertius loquutus est quam Apollo consuevit? ut nesciamus quod maxime explicari oportebat, praeter album et nigrum, quorum alterum, ut dixi, optimum, alterum deterrimum putat, nescio qua ratione, nisi oculos quoque ut iudicium depravatos, et corruptos habebat. Quis enim unquam

rosas deteriore colore existimavit, quam eos flores, qui vulgo albae rosae vocantur? quis Carbunculi colori, quis Smaragdi, Sapphiri, Topazii, multorumque aliorum anteponat margaritas, Chrystallum, et eum qui dicitur *? Aut cur serica fila murice tingerentur, lanae candidae rubricarentur, nisi rubeus color albo putaretur esse venustior? Nam si candor est simplicissimus et purissimus, non continuo est praestantissimus. Siquidem argento et simplici et puro et candido antecellit electrum, quod compositum est, tum venustate, tum dignitate. De nigro autem quid dicam? quem cum albo comparatum invenio, nec minoris praestantiae putatum, unde corvus et cygnus propter hanc ipsam causam dicuntur Apollini consecrati: et Horatius spectandum ait, qui sit nigris oculis, nigroque capillo [A.P. 37]. Tu uero Bartole oculos tuos, qui, ut opinor, erant simillimi asininis, pulchriores putas nigris Horatii oculis? aut pilum asini, pilo equi nigri: qualem ob decorem, praecipue Vergilius descripsit, Quem Thracius albis portat equus bicolor maculis [Aen. v. 565–6]. Et mea sententia Aethiopes Indis pulchriores, eo ipso quod nigriores sunt. Quid ergo autoritatem hominum affero, quos ille aethereus parvifacit? peccavit ille rerum parens atque opifex, ne longius exempla repetam, qui nigrum in medio oculi posuit, et in extremis non rubeum aut croceum aut sapphireum, sed album collocauit: et quod te palam coarguit, isti colori, quem tenebris, non illi quem luci comparasti, totius corporis tribuit lumen, propter quod oculi, et proprie, et usitate lumina appellantur. Et quid afferri ad hanc rem potest decentius ac validius, quam quod oculus, qui unus est colorum arbiter, non alibi aut alterius, sed nigri coloris, aut nigro proximi, de pupilla loquor, quae plerunque nigra est, ab ipso deo rerum conditore formatus est? Atque ut de aliis rebus loquar, quid enumerem, quod in rerum natura reperiuntur nigri coloris, quae summam tamen exhibent dignitatem? ut Vergilius, Et nigrae violae sunt, et vacinia nigra [Ecl. x. 39]: Alba ligustra cadunt, vacinia nigra leguntur [Ecl. ii. 18]. Et in horto meo nascuntur violae albae, quae cum nigris minime sunt comparandae, et mora, si fabulis credimus, ex albis nigra fiunt, et meliora et pulchriora. Quod si rerum conditor nullam in operibus suis putavit colorum differentiam, quid nos homunculi faciemus? an volemus plus deo sapere? aut eum imitari et sequi erubescemus? O bone et sancte Iesu, si non cogitavit de lapidibus et herbis, de floribus et multis aliis Bartolus quum de vestibus et

operimentis hominum loqueretur, poteratne oblivisci de avium, prope dixerim, vestibus, ut galli, pavonis, pici, picae, phasiani, et aliorum complurium? Et quo de ipsis hominum vestibus dicamus, ex quo stultitia Bartoli inscitiaque tenetur, vestes Aaron, quibus nihil cogitari queat perfectius, an illum Bartolinum colorum ordinem observant? Transeo, quod coelestis Hierusalem duodecim generibus lapidum constructa describitur. Quod si Bartolus legisset, profecto alio modo quam est loquutus fuisset. Eamus nunc et hominem audiamus, a divinis atque humanis rebus dissentientem: et puellis Ticinensibus, ver enim adventat, legem imponamus, ne serta, nisi quomodo Bartolus praescribit, texere audeant, neque ad suum cuiusque iudicium atque voluntatem facere permittamus. Nam, ut inquit Satyricus, Velle suum cuique est, nec voto vivitur uno [Persius v. 53]. Ut in illo qui nobis hanc libertatem eripere tentat, non secus ac si in servitutem nos vellet afferere, sit conflagrandum. Sed de hoc superius questi sumus. Nunc illud dixisse satis est. Stolidissimum esse aliquem de dignitate colorum legem introducere.

'Epistola ad Candidum Decembrem', in *Opera*, Basle, 1540, pp. 639–41. (pp. 115–16)

XVIII. LORENZO VALLA

(*a*)

Siquidem multis iam seculis non modo Latine nemo locutus est, sed ne Latina quidem legens intellexit: non philosophiae studiosi philosophos, non causidici oratores, non legulei Iureconsultos, non caeteri lectores veterum libros perceptos habuerunt, aut habent: quasi amisso Romano imperio, non deceat Romane aut loqui, aut sapere, fulgorem illum Latinitatis situ, ac rubigine passi obsolescere. Et multae quidem sunt prudentium hominum, variaeque sententiae, unde hoc rei acciderit, quarum ipse nullam nec improbo, nec probo, nihil sane pronunciare ausus: non magis quam cur illae artes, quae proxime ad liberales accedunt, pingendi, scalpendi, fingendi, architectandi, aut tandiu tantoque opere degeneraverint, ac pene cum literis ipsis demortuae fuerint, aut hoc tempore excitentur, ac reviviscant: tantusque tum bonorum opificum, tum bene literatorum proventus efflorescat. Verum enimvero quo magis superiora tempora infelicia fuere, quibus

homo nemo inventus est eruditus, eo plus his nostris gratulandum est, in quibus (si paulo amplius adnitamur) confido propediem linguam Romanam virere plus, quam urbem, et cum ea disciplinas omnes iri restitutum.

Elegantiarum Libri VI, i, Praef., in *Opera*, Basle, 1540, p. 4. (pp. 117–18)

(b) Facies, et Vultus

Facies magis ad corpus: Vultus magis ad animum refertur, atque voluntatem, unde descendit. Nam volo supinum habebat vultum: inde dicimus irato et moesto vultu potius quam facie: et contra lata aut longa facie, non vultu: a quo compositum est superficie, non sane discrepans a suo simplici: ut, facies maris, facies terrae, quasi superficies: et, facies hominis, quasi primum illud quod intuemur in homine. Est tamen aliquando ubi utroque uti liceat: ut, foedata facie, et foedato vultu: scissa facie, et scisso vultu: conversa facie, et converso vultu: quae exempla sunt plurima.

Op. cit. IV. xiii, p. 125. (p. 10)

(c) Decus, Decor et Dedecus

Decus est illa (ut sic dixerim) honorificentia ex bene gestis rebus, unde decora militiae, laudes, honores, honestamenta militi in bello comparata: cuius contrarium est dedecus, proprie ignominia quaedam, aut ignominiae genus et infamis turpitudo. Unde dedecoro. Cicero inquit de quodam: Magistratum ipsum dedecorabat, id est, turpificabat, et contumelia atque ignominia afficiebat. Transfertur etiam ad animum: quippe decus pro honesto, dedecus pro inhonesto accipitur, ut idem: Sequitur decus, atque honestum. Quintil. Satis dedecoris atque flagitii castra ceperunt. Decor est quasi pulchritudo quaedam ex decentia rerum personarumque, in locis, temporibus, sive in agendo, sive in loquendo. Transfertur quoque ad virtutes: appellaturque decorum, non tam ipsum honestum, quam quod hominibus et communi opinioni honestum videtur et pulchrum, et probabile. Unde verbum decôro media longa. Nam decoro media brevi a decus venit.

Op. cit. IV. xv, pp. 125–6. (p. 10)

(d) Mollis homo, Molle opus

Mollis homo dicitur, et molle opus, hoc in laudem, illud in vituperationem. Vergilius:

> India mittit ebur, molles sua tura Sabaei.

Idem:

> Excudent alii spirantia mollius aera:
> Credo equidem vivos ducent de marmore vultus.

Quod non sine ratione factum est. Nam qui non fuerit severus, fortis, et constans, et in morem rei durae patiens, resistensque fortunae vel adversae, vel blandae, hic mollis est, similis cerae, et tenellis plantis: quum praesertim qui mollicula membra habent, fere molli sint mente, ut pueri, foeminaeque. Contra autem milites, nautae, agricolae, ut corpore, ita animo indurati putantur: hoc igitur modo mollis accipitur in vitium. In laudem vero, quod ut vitio datur durum, ut durus cibus, durum cubile, durum solum, ita durum ingenium, veluti durus equus ad domandum, durum ingenium ad docendum, et (ut sic dicam) sculpendum, eadem ratione molle dicetur, quod non est durum, eritque laudabile. Quintilianus de signis loquens, inquit: Illius opera duriora, huius molliora. Dicuntur autem signa opera sculptilia, sive fusilia, sive caetera eiusmodi ad effigiem animalium fabricata: quemadmodum tabulae, opera pictorum. Siquidem in tabulis antiqui pingebant, non in parietibus. Haec talia magis dicentur mollia, quae fiunt, quam ingenium, quod facit.

<div align="center">Op. cit. IV. cxv, p. 159. (p. 114)</div>

(e) Fingo, et Effingo

Fingere proprie est figuli, qui formas ducit ex luto. Inde generale fit vocabulum ad caetera, quae ingenio, manuque hominis artificiose formantur, praesertim inusitate, et nove. Effingere est ad alterius formam fingere, et quodam modo fingendo repraesentare. Cicero secundo de Oratore: Tum accedat exhortatio, qua illum, quem delegerit, imitando effingat, atque exprimat. Quintil. lib. 10. cap. 1. Nam id quoque est docilis naturae, sic tamen, ut ea, quae discit, effingat. Et iterum: Nam mihi videtur M. Tullius, quum se totum ad imitationem Graecorum contulisset, effinxisse vim Demosthenis, copiam Platonis, iucunditatem Isocratis. Unde ductum est nomen effigies, figura ad vivam alterius

similitudinem, vel ad veritatis imaginem facta, tam in picturis, quam in sculpturis.

Op. cit. v. xliii, p. 178. (p. 10)

XIX. LORENZO VALLA

Ioannes Carrapha strenuus Decurio Neapolitanus, cum in arce, quae dicitur Capuana, imaginem regis armati, equoque insidentis pingendam curasset, et circum eam quatuor virtutes Iustitiam, Charitatemque, sive Largitatem, Prudentiam, ac Temperantiam, sive Fortitudinem (est enim ambigua pictura) a me contendit, ut versus totidem facerem, singulos in singularum libellis, quos manu tenebant, scribendos: addiditque, ut duos saltem eo biduo, qui superioribus imaginibus iam prope absolutis adscriberentur. A pictore enim se deceptum, qui non praemonuisset scribere superiores versus antequam ad inferiores pingendas descenderet imagines, ideoque tempus componendorum versuum spe sua brevius esse: alioqui non ita commode postea scribi. Ego etsi febrire incipiebam, tamen me facturum recepi, ac plus exolvi, quam promisi. Tres enim versus Iustitiae, Largitatis, Temperantiae, eodem die ad hominem misi, quos cum pictor esset descripturus, et plurimi homines lectitarent (est enim locus ille totius urbis celeberrimus), nescio quo pacto Antonius audivit, lectosque, mirum dictu, quantopere carpsit: denique hominem deterret ne versus impolitissimos egregie picturae, atque illi loco, quem ad suum et regis decus elegisset, inscriberet. Iubet biduo expectare, et familia Carrapha, et castello Capuano, et regia pictura dignos se daturum, itaque octavo ab his verbis die totidem suos tradit, nihildum me earum rerum per valetudinem resciscente. Eos versus Ioannes ad me mittit, et iam convalescebam, nondum tamen domo prodire ausus, remque omnem gestam exponit. Ego meos postridie absolvo, ille suos septem diebus ferius, utrique ostenduntur, utrique nostrorum suos defendere, alterius impugnare, sui cuique fautores adesse. Scinditur incertum studia in contraria vulgus, ut in eodem loco Vergilius. At Ioannes, ut incertus quid ageret, utrosque mittit ad regem, in expeditione agentem, velut iudicem atque arbitrum. Is quoque ne quem damnare videretur, rem in medio reliquit: tantum utrosque commodos esse respondit. Seorsum autem meos (ita duo mihi secretarij retulerunt) plus succi habere confessus est: ex quo factum est, ut neutri

scriberentur, quos hic ego caeteris iudicandos subieci. Et si quis
tales imagines alicubi pingere velit, ut habeat utros eligat. In suis
ille loquentes facit, aut lectores, quod et absurdum, et obscurum
est: aut virtutes, tanquam non de se, cum tamen de se loquantur.
Ego virtutes ipsas, non modo aperte loquens de se singulas, sed
etiam ita, ut versus in eum ordinem possint redigi, quo pictor
imagines pingere velit. Istius nequeant a prudentia incipere: qui
hi sunt:

Iustitia.

Te bone rex sequitur victas Astraea per urbes.

Charitas.

Te pietas et amor reddunt per secula notum.

Prudentia.

Agnoscit sociatque suum prudentia gnatum.

Fortitudo.

Te dignum coelo virtus invicta fatetur.

Hae laudes, ut caetera taceam, nisi fallor, nihil habent nisi
vulgare, et quod singulis virtutibus datur id omnibus dari potest.
Quid mei? certe non tales, ut (quod dicebat Antonius) ad suos
nihil sint: quos in illum naturalem, quem dixi ordinem, redigo
prudentia praeposita.

Prudentia.

Prima ego virtutum peragunt mea iussa sorores.

Iustitia.

Per me stat regis thronus et concordia plebis.

Charitas, seu Largitas.

Celsius est dare nostra, suum quam reddere cuique.

Temperantia.

Corporis illecebras plus est, quam vincere bella.

Fortitudo.

In gemmis Adamas, in moribus ipsa triumpho.

Sed ut in his rex non tulit aperte sententiam, sic in aliis pro me
pronuntiavit, cum pro alia, tum vero quia indecens sit loquentem
facere dormientem. Est enim signum quoddam marmoreum,
quod quidam Parthenopes virginis volebant esse iacentis habitu,
dormientisque: cui distichon epigramma iussi aliqui docti viri
facere sumus, aliorum tacebo. Antonii hoc fuit:

Parthenope, multos bello vexata per annos.

Nunc opera Alphonsi parta iam pace quiesco.

Meum hoc,

> Parthenope virgo diuturno exercita Marte,
> Martius Alphonsus dat, requiesce tibi.

Sumus etiam nunc de alio Carmine ad marmoream statuam
scribendo in controversia, de quo nondum attinet facere men-
tionem, denique ipsius versus nusquam videntur inscripti, cum
mei et pro Salamanchis Panhormi, et Gaietae pro antistite Nor-
manno, et Neapoli pro Caraciolo magno Senescallo apud augu-
stissima templa in marmore incisi visantur.

In Barptolemaeum Facium Ligurem invectivae seu recriminationes, iv, in
Opera, Basle, 1540, pp. 597–9. (pp. 112–13)

XX. LORENZO VALLA

Igitur quod ad primam attinet partem, scientiarum omnium
propagandarum apud nos, ut mea fert opinio, auctor extitit
magnitudo imperii illorum. Namque ita natura comparatum est,
ut nihil admodum proficere atque excrescere queat, quod non
a plurimis componitur, elaboratur, excolitur, praecipue aemu-
lantibus invicem et de laude certantibus. Quis enim faber statuarius,
pictor item et ceteri, in suo artificio perfectus aut etiam magnus
extitisset, si solus opifex eius artificii fuisset? Alius aliud invenit,
et quod quisque in altero egregium animadvertit, id ipse imitari,
aemulari, superare conatur. Ita studia incenduntur, profectus
fiunt, artes excrescunt et in summum evadunt, et eo quidem
melius eoque celerius, quo plures in eandem rem homines elabo-
rant: veluti in extruenda aliqua urbe et citius et melius ad
consummationem pervenitur, si plurimorum quam paucissi-
morum manus adhibeantur, ut apud Virgilium [*Aeneid* i. 420–9]:

> Miratur molem Aeneas, magalia quondam,
> Miratur portas strepitumque et strata viarum.
> Instant ardentes Tyrii: pars ducere muros
> Molirique arcem et manibus subvolvere saxa,
> Pars aptare locum tecto et concludere sulco.
> Iura magistratusque legunt sanctumque senatum.
> Hic portus alii effodiunt, hic alta theatri
> Fundamenta locant alii immanesque columnas
> Rupibus excidunt, scaenis decora alta futuris.

Neque enim minus operosum est artem aliquam omni ex parte consummari quam urbem. Itaque sicuti nulla urbs ab uno, immo nec a paucis condi potest, ita neque ars ulla, sed a multis atque a plurimis, neque his inter se ignotis—nam aliter quomodo aemulari possent et de laude contendere—sed notis et ante omnia eiusdem linguae commercio coniunctis. Quoniam ab urbe extruenda comparationem ac similitudinem sumpsi, nonne ita e sanctis libris accepimus, eos qui immanem illam turrim Babel extruebant, ideo ab extruendo cessasse, quod alius alium loquentem amplius non intelligebat? Quod si in iis artificiis, quae manu fiunt, necesse est communionem sermonis intercedere, quanto magis in iis, quae lingua constant, id est in artibus liberalibus atque scientiis. Ergo tamdiu scientiae et artes exiles ac prope nullae fuerunt, quamdiu nationes suis singulae linguis utebantur.

At romana potentia propagata, in suas leges nationibus redactis ac diuturna pace stabilitis, effecit, ut pleraeque gentes uterentur lingua latina et inter se consuetudinem haberent: tunc ab his omnibus ad omnes disciplinas latine scriptas tamquam ad optimam mercimoniam properatum est.

'Oratio in principio sui studii 1455', ed. J. Vahlen, in *Sitzungsberichte der Philosophisch-Historischen Classe der Kaiserlichen Akademie der Wissenschaften [in Wien]*, lxii, 1869, 94–5. (pp. 118–19)

SELECT BIBLIOGRAPHY

(*Note*: The list is selective, and the large bibliography on Alberti is not dealt with: for this latter see P. H. Michel, *La Pensée de L. B. Alberti*, Paris, 1930, pp. 11–39; Alberti, *Della pittura*, ed. L. Mallé, Florence, 1950, pp. 153–60; B. Zevi, in *Encyclopedia of World Art*, i, New York, 1959, pp. 207–8, s.v. 'Alberti'; C. H. Grayson, in *Dizionario biografico degli Italiani*, i, Rome, 1960, pp. 708–9, s.v. 'Alberti'.)

ANTAL, F., *Florentine painting and its social background*, London, 1947, Chapter I, 4.

ASSUNTO, R., *La critica d'arte nel pensiero medioevale*, Milan, 1961, pp. 285 ff.

BARON, H., *The crisis of the early Italian Renaissance*, 2nd edition, Princeton, 1966, pp. 103 f. and 499 ff.

BAXANDALL, M., 'A dialogue on art from the court of Leonello d'Este: Angelo Decembrio's *De politia literaria* Pars LXVIII', in *Journal of the Warburg and Courtauld Institutes*, xxvi, 1963, 304 ff.

BENKARD, E., *Das literarische Porträt des Giovanni Cimabue*, Munich, 1917, Chapter I.

BLUNT, A., *Artistic theory in Italy, 1450–1600*, Oxford, 1940, Chapters 1 and 4.

BORINSKI, K., *Die Antike in Poetik und Kunsttheorie*, i, Leipzig, 1914, Chapters I–II.

BOSKOVITS, M., ' "Quello ch'e dipintori oggi dicono prospettiva": Contributions to the theory of 15th century Italian art', in *Acta Historiae Artium Academiae Scientiarum Hungaricae*, viii, 1962, 241 ff., and ix, 1963, 139 ff.

CHASTEL, A., *Art et humanisme à Florence au temps de Laurent le Magnifique*, Paris, 1959.

CIAPPONI, L. A., 'Il "De Architectura" di Vitruvio nel primo Umanesimo (dal ms. Bodl. Auct. F. 5. 7)', in *Italia medioevale e umanistica*, iii, 1960, 59 ff.

COLASANTI, A., 'Gli artisti nella poesia del Rinascimento: fonti poetiche per la storia dell'arte italiana', in *Repertorium für Kunstwissenschaft*, xxvii, 1904, 193 ff.

CURTIUS, E. R., *European literature and the Latin Middle Ages*, trans. W. R. Trask, New York, 1953.

ELLENIUS, A., *De arte pingendi: Latin art literature in seventeenth-century Sweden and its international background*, Uppsala, 1960, Chapter A. 4.

ESSLING, PRINCE D', and MUENTZ, E., *Pétrarque; ses études d'art . . .*, Paris, 1902, Chapter I.

FERGUSON, W. K., *The Renaissance in historical thought: five centuries of interpretation*, Cambridge (Mass.), 1948, Chapter I.

FREY, C., *Il codice Magliabechiano cl. XVII. 17*, Berlin, 1892, pp. viii ff.

GILBERT, C. E., 'Antique frameworks for Renaissance art theory: Alberti and Pino', in *Marsyas*, iii, 1946, 87 ff.

GOMBRICH, E. H., *Norm and form: studies in the art of the Renaissance*, London, 1966.

—— 'From the revival of letters to the reform of the arts: Niccolò Niccoli and Filippo Brunelleschi', in *Essays in the history of art presented to Rudolf Wittkower*, London, 1967, pp. 71 ff.

GRINTEN, E. VAN DEN, *Inquiries into the history of art-historical writing*, Venlo, 1953.

HILL, G. F., *Pisanello*, London, 1905, Chapter VIII.

KRAUTHEIMER, R., 'Die Anfänge der Kunstgeschichtsschreibung in Italien', in *Repertorium für Kunstwissenschaft*, l, 1929, 49 ff.

—— *Lorenzo Ghiberti*, Princeton, 1956, Chapter XIX.

KRIS, E., and KURZ, O., *Die Legende vom Künstler*, Vienna, 1934.

KRISTELLER, P. O., 'The Modern System of the Arts', in *Renaissance Thought*, II, *Papers on humanism and the arts*, New York, 1965, pp. 163 ff.

LEE, R. W., '*Ut pictura poesis*: The Humanistic Theory of Painting', in *Art Bulletin*, xxii, 1940, 197 ff., and now also reprinted separately under the same title, New York, 1967.

MEISS, M., *Painting in Florence and Siena after the Black Death*, Princeton, 1951, Chapter I.

MURRAY, P., *An index of attributions made in Tuscan sources before Vasari*, Florence, 1959.

PAATZ, W., 'Die Bedeutung des Humanismus für die toskanische Kunst des Trecento', in *Kunstchronik*, vii, 1954, 114 ff.

PANOFSKY, E., *Renaissance and renascences in western art*, Stockholm, 1960, Chapter I.

PELLIZZARI, A., *I trattati attorno le arti figurative in Italia*, ii, Rome, 1942.

PRANDI, A., 'Il Boccaccio e la critica d'arte dell'ultimo Medioevo', in *Colloqui del Sodalizio*, ii, 1957, 90 ff.

SCHLOSSER, J. VON, *Lorenzo Ghibertis Denkwürdigkeiten, Prolegomena zu einer künftigen Ausgabe*, Vienna, 1910.

—— *Lorenzo Ghibertis Denkwürdigkeiten*, Berlin, 1912.

—— *Präludien*, Berlin, 1927, pp. 68 ff. and 248 ff.

—— *La letteratura artistica*, trans. F. Rossi and revised by O. Kurz, 2nd edition, Florence, 1956.

SPENCER, J. R., '*Ut rhetorica pictura*: A study in Quattrocento Theory of Painting', in *Journal of the Warburg and Courtauld Institutes*, xx, 1957, 26 ff.

TRINKAUS, C., 'Humanism', in *Encyclopedia of World Art*, vii, New York, 1963, 702 ff.

VENTURI, A. (ed.), *Le vite de' più eccellenti pittori, scultori, e architetti, scritte da M. Giorgio Vasari*, I, *Gentile da Fabriano e il Pisanello*, Florence, 1896.

VENTURI, L., 'La critica d'arte di Francesco Petrarca', in *L'Arte*, xxv, 1922, 238 ff.

—— 'La critica d'arte alla fine del '300', in *L'Arte*, xxviii, 1925, 237 ff.

—— *History of art criticism*, trans. C. Marriot, New York, 1936, Chapters 3–4, and *Storia della critica d'arte*, 2nd edition, Florence, 1948, Chapters 2–3.

WAŻBIŃSKI, Z., *Dzieło i twórca w koncepcji Renesansu*, Toruń, 1968, Chapter I.

WEISS, R., 'Jan van Eyck and the Italians', in *Italian Studies*, xi, 1956, 1 ff., and xii, 1957, 7 ff.

—— *The Renaissance discovery of classical antiquity*, Oxford, 1969.

WITTKOWER, R., *Architectural principles in the age of humanism*, 3rd edition, London, 1962.

Index

Aglaophon, 61.

Alberti, Leon Battista, 3, 7, 8, 29–31, 37–8, 49–50, 96, 99, 104 n., 106 n., 109, 114, 121–2, 125–39.

Alexander the Great, 39, 56, 63, 98.

Alfonso V of Aragon, King of Naples, 90, 99–100, 106, 108, 112–13.

Ambrose, St., 51.

Angelo da Siena, 89.

Antonio da Rho, 65–6.

Apelles, 30 n., 39, 51, 56, 59–60, 61, 63, 90, 98, 106 n.

Apollodorus, 77–8.

Architecture, 67, 75, 80–1, 94–5, 117–19, 130.

Aristotle, 23, 31, 39, 40, 41–3, 83, 95, 116, 124, 138.

Augustine, St., 57 n., 59.

Barbaro, Francesco, 8, 39.

Barozzi, Pietro, 121.

Bartolo da Sassoferrato, 114–16.

Barzizza, Gasparino, 8, 34, 65, 127, 146.

Basinio da Parma, 93.

Beccadelli, Antonio *called* Panormita, 39–40, 99–100, 112–13.

Belfiore, 89–90.

Bellini, Jacopo, 17–18.

Biondo, Flavio, 5, 8, 91 n.

Boccaccio, Giovanni, 3, 5, 8, 37, 60, 66, 73–4, 78.

Bono da Ferrara, 92 n.

Bracciolini, Poggio, 5, 8, 39, 124.

Brescia, 105.

Brunelleschi, Filippo, 126 n.

Bruni, Leonardo, 2, 3, 5, 8, 19–20, 22–7, 31, 41–3, 76 n., 122–4.

Brussels, 109.

Bussi, Giovandrea de', 129 n.

Caecilius Balbus, 60–1.

Carafa, Giovanni, 112–13.

Carda, Ottaviano della, 107.

Carrara, Francesco II da, Lord of Padua, 60.

Cartagena, Alonso de, 42–3.

Cennini, Cennino, 16 n., 77, 104 n.

Chares, 40–1.

Chria, 32–3.

Chrysoloras, Demetrius, 81.

Chrysoloras, John, 84.

Chrysoloras, Manuel, 5, 8, 78–84, 87, 90, 94–5, 98, 149–52.

Cicero, 1, 19, 21, 30 n., 34, 35–8, 39, 40, 57 n., 130.

Ciceronianism, 5–7, 43–4, 46–7, 68, 74, 111, 129–30.

Cimabue, 70, 75–7.

Ciriaco d'Ancona, 108 n.

Colour, 9, 26, 29–31, 47–8, 49–50, 62, 95, 106, 114–16, 136–7.

Comparison, 24–9, 31–7, 39–44, 49, 62–6, 88, 94–5, 103–4, 124.

Composition, 49, 129–39.

Constantinople, humanists at, 79–80, 84–5, 87–8.

Conversino, Giovanni, da Ravenna, 5, 8 62.

Cornazano, Antonio, 12.

Cossa, Francesco, 90 n.

Dagomari, Pagolo de', 72.

Dancing, 11–13.

Daniel, Samuel, 4–5.

Dante, 6, 19–20, 37, 67, 69, 71, 76.

Decembrio, Angelo, 8, 16, 17–18, 88.

Decembrio, Pier Candido, 8.

Demetrius, 37.

Description, *see* Ekphrasis.

Design (*disegno*), 11, 19, 49, 56, 61, 104, 125, 126.

Dionysius of Halicarnassus, 138.

Donatello, 109, 124.

Donatus, Aelius, 3.

Dondi, Giovanni, 52–3.

Dynocrates, 71.

Ebreo, Guglielmo, 12.

Ekphrasis, 85–7, 90–6, 135.

Erasmus, 3 n., 4, 6.

d'Este, Leonello, Marquis of Ferrara, 16, 17–18, 88, 89–90, 108.

Euclid, 126, 128.

Euphranor, 100.

Eyck, Jan van, 99, 106–7, 110.

Fabriano, Gentile da, 99, 104–6, 107, 130.

Fazio, Bartolomeo, 8, 9–10, 18–19, 39, 98–111, 163–8.

Federigo da Montefeltro, Count of Urbino, 11, 133.

Feltre, Vittorino da, 3, 127–9, 133, 138.

Ferrara:
 art at, 16, 89–90, 92.
 humanists at, 8, 41, 88–90, 108, 128.